艺术设计专业英语

第二版

高等院校艺术学门类
"十四五"规划教材

主　编　任康丽　常法辙
副主编　白歌乐　李　军

ART DESIGN

华中科技大学出版社
http://www.hustp.com
中国·武汉

内容简介

本书分八个单元进行详细介绍。单元1为建筑师与他们的作品，介绍了高迪、沙利文、赖特、格罗皮乌斯、密斯、路易斯·康、贝聿铭、安藤忠雄、李博斯金等10位建筑师及其优秀设计作品。单元2为景观设计师与他们的作品，介绍了美国景观设计之父奥姆斯特德、中国景观设计大师俞孔坚的设计作品，以及盖里、户田芳树、SWA景观设计公司的作品。单元3为室内设计师与他们的作品，主要介绍了尼尔森、赫本、斯达克、普特曼等人的设计作品。单元4为艺术家与他们的作品，介绍了达·芬奇、莫奈、凡·高、毕加索、达利等艺术家的生平及其作品。单元5为雕塑家与他们的作品，介绍了米开朗琪罗、罗丹、草间弥生、卡普尔、帕兰萨等人的艺术生平与作品。单元6为数码设计师与他们的作品，介绍了动画的发展历程、数字艺术，以及迪士尼、宫崎骏、白南准、莫奔、维奥拉等艺术家的设计作品。单元7为家具设计师与他们的作品，介绍了雅各布森、沙里宁、伊姆斯夫妇、阿尼奥等人的设计作品。单元8为建筑风格介绍，收录了罗马式、洛可可、文艺复兴、伊斯兰、日本、中国、意大利等各式建筑风格的历史渊源及重要案例。

《艺术设计专业英语教程(第二版)》(任康丽　常法辙)

图书在版编目(CIP)数据

艺术设计专业英语/任康丽,常法辙主编．—2版．—武汉：华中科技大学出版社,2021.7(2024.1重印)
ISBN 978-7-5680-7294-6

Ⅰ．①艺…　Ⅱ．①任…　②常…　Ⅲ．①艺术-设计-英语　Ⅳ．①J06

中国版本图书馆CIP数据核字(2021)第126828号

艺术设计专业英语(第二版)　　　　　　　　　　　　　　　任康丽　常法辙　主编
Yishu Sheji Zhuanye Yingyu (Di-er Ban)

策划编辑：彭中军	
责任编辑：彭中军	
封面设计：优　优	
责任监印：朱　玢	
出版发行：华中科技大学出版社(中国·武汉)	电话：(027)81321913
武汉市东湖新技术开发区华工科技园	邮编：430223
录　排：武汉创易图文工作室	
印　刷：武汉科源印刷设计有限公司	
开　本：880mm×1230mm　1/16	
印　张：17	
字　数：588千字	
版　次：2024年1月第2版第3次印刷	
定　价：89.00元	

本书若有印装质量问题，请向出版社营销中心调换
全国免费服务热线：400-6679-118　　竭诚为您服务
版权所有　侵权必究

前言

 本书的主要内容是介绍和评析国内外著名的建筑师、景观设计师、室内设计师、艺术家、雕塑家、数码设计师、家具设计师及其优秀作品，理论涵盖广泛、视点新颖。作为艺术设计专业实用的英文教材，本书比较全面地介绍了艺术设计学科中需要重点了解的建筑师、景观设计师、室内设计师、艺术家、雕塑家、数码设计师、家具设计师等，并对其优秀作品进行分析与评述。在了解专业知识的同时，学习专业英语词汇，提高英语阅读技巧，了解英语的写作方法。随着中国高校"双一流建设"的逐步发展，艺术设计专业的学生在英语技能上需要提高。本书对本科生、研究生学习、出国深造、对外交流都有指导意义。

 本书分八个单元：单元 1 为建筑师与他们的作品，单元 2 为景观设计师与他们的作品，单元 3 为室内设计师与他们的作品，单元 4 为艺术家与他们的作品，单元 5 为雕塑家与他们的作品，单元 6 为数码设计师与他们的作品，单元 7 为家具设计师与他们的作品，单元 8 为建筑风格介绍。

 本书将课文中重要的专业词汇进行总结和注释；对重要的句子做出解析，同时标明原文出处，以便学生自行查阅，拓展学习思路；有艺术分类词汇归纳。这样更有利于学生进行复习与熟练掌握。本书不仅是一本专业理论教材，而且有配图说明，对艺术设计专业的本科生、研究生英语技能的提高将起到指导作用。

<div style="text-align:right">
编 者

2021 年 6 月 24 日
</div>

Preface

This book introduces and analyzes Chinese and foreign famous artists, designers and their masterpieces. It covers a broad range of theories and explores artistic subjects with new perspectives. Intended as a textbook in English for art design major, this book carries on a comprehensive discussion on prominent architects, landscape architects, painters, sculptors, interior designers and furniture designers and makes case analyses and comments. By studying this textbook, readers can increase their English vocabulary, enhance their English reading skills and understand the way of English writing while they acquire professional knowledge. With the gradual development of "the double first class construction" in Chinese universities and colleges, art majors need to improve their English skills. This book is also beneficial to undergraduates and graduates study abroad and academic exchange.

This book is composed of eight units. Unit 1, Architects and Their Masterpieces, includes Antonio Gaudi, Louis Henry Sullivan, Frank Lloyd Wright, Walter Gropius, Ludwig Mies Van Der Rohe, Le Corbusier, Louis Isadore Kahn, I. M. Pei, Tadao Ando, Daniel Libeskind and their masterpieces. Unit 2, Landscape Architects and Their Masterpieces, introduces Frederick Law Olmsted, Frank Owen Gehry, SWA Group, Kongjian Yu, Yoshiki Toda and their masterpieces. Unit 3, Interior Designers and Their Masterpieces, mainly introduces the design of George Nelson and others. Unit 4, Artists and Their Masterpieces, covers Leonardo da Vinci's, Van Gogh's life stories and their major masterpieces. Unit 5, Sculptors and Their Masterpieces, introduces Auguste Rodin's and other sculptors' artistic life and analyzes their works. Unit 6, Digital Designers and Their Masterpieces, displays the development of animation, the history of the Walt Disney Company and the design works of artist Nam June Paik. Unit 7, Furniture Designers and Their Masterpieces, introduces Charles and Ray Eames' and others' design works. Unit 8, Architecture Styles, collects historical origins of various architectural styles including Romanesque, Rococo, Renaissance, Islamic and important cases.

Furthermore, this book lists core vocabulary and cited materials at the end of every unit for students' reference, so as to expand their study interests. Each unit concludes with a summary of the vocabulary used. To aid the students' study, we classified different vocabularies and displayed them in unit. Our book not only provides theoretical analysis but also is well adorned with illustration. It provides reliable guidance for art design majors to improve their English skills.

<div style="text-align: right;">
The Editor

June 24, 2021
</div>

目录

单元 1　建筑师与他们的作品
Unit 1　Architects and Their Masterpieces

1.1　Antonio Gaudi and His Masterpieces　/2
1.2　Louis Henry Sullivan and His Masterpieces　/6
1.3　Frank Lloyd Wright and His Masterpieces　/11
1.4　Walter Gropius and His Masterpieces　/15
1.5　Ludwig Mies Van Der Rohe and His Masterpieces　/18
1.6　Le Corbusier and His Masterpieces　/22
1.7　Louis Isadore Kahn and His Masterpieces　/25
1.8　I. M. Pei and His Masterpieces　/30
1.9　Tadao Ando and His Masterpieces　/34
1.10　Daniel Libeskind and His Masterpieces　/40

单元 2　景观设计师与他们的作品
Unit 2　Landscape Architects and Their Masterpieces

2.1　Frederick Law Olmsted and His Masterpieces　/46
2.2　Frank Owen Gehry and His Masterpieces　/50
2.3　An Introduction to SWA Group and Its Masterpieces　/53
2.4　Kongjian Yu and His Masterpieces　/55
2.5　Yoshiki Toda and His Masterpieces　/59

单元 3　室内设计师与他们的作品
Unit 3　Interior Designers and Their Masterpieces

3.1　George Nelson and His Masterpieces　/64
3.2　Kelly Hoppen and Her Masterpieces　/68
3.3　Philippe Starck and His Masterpieces　/73
3.4　Andree Putman and Her Masterpieces　/76

单元 4　艺术家与他们的作品
Unit 4　Artists and Their Masterpieces

4.1　Leonardo di ser Piero da Vinci and His Masterpieces　/84
4.2　Claude Monet and His Masterpieces　/88

4.3　Vincent Willem Van Gogh and His Masterpieces　/91
4.4　Pablo Picasso and His Masterpieces　/94
4.5　Salvador Dali and His Masterpieces　/98

单元 5　雕塑家与他们的作品
Unit 5　Sculptors and Their Masterpieces

5.1　Michelangelo Di Lodovico Buonarroti Simoni and His Masterpieces　/106
5.2　Auguste Rodin and His Masterpieces　/109
5.3　Yayoi Kusama and Her Masterpieces　/112
5.4　Anish Kapoor and His Masterpieces　/115
5.5　Jaume Plensa and His Masterpieces　/117

单元 6　数码设计师与他们的作品
Unit 6　Digital Designers and Their Masterpieces

6.1　The History of Animation　/122
6.2　Walt Disney and His Masterpieces　/131
6.3　Miyazaki Hayao and His Masterpieces　/134
6.4　An Introduction of Digital Art　/138
6.5　Nam June Paik and His Masterpieces　/140
6.6　Maurice Benayoun and His Masterpieces　/144
6.7　Bill Viola and His Masterpieces　/148

单元 7　家具设计师与他们的作品
Unit 7　Furniture Designers and Their Masterpieces

7.1　Arne Emil Jacobsen and His Masterpieces　/154
7.2　Eero Saarinen and His Masterpieces　/157
7.3　Charles and Ray Eames and Their Masterpieces　/160
7.4　Eero Aarnio and His Masterpieces　/165

单元 8　建筑风格介绍
Unit 8　Architecture Styles

8.1　Romanesque Architectures(8th Century—1150)　/170
8.2　Great Rococo(1715—1760)　/180
8.3　Islamic Architecture (7th—17th Centuries)　/193
8.4　Japanese Architecture　/210
8.5　Chinese Architecture　/224
8.6　Italian Renaissance Architecture(1400—1600)　/237

258　参考文献
Bibliography

260　致谢
Acknowledgements

单元1

建筑师与他们的作品

Unit 1　Architects and Their Masterpieces

1.1
Antonio Gaudi and His Masterpieces

Antonio Gaudi was born in Reus in 1852 and attended school there and in Tarragona. He left for Barcelona in 1869 for pre-university studies. In 1873, he was accepted at the New School of Architecture and in 1878 opened his office. His first commission, achieved through a competition, was for **lampposts** for the Plaza Real in Barcelona. He also undertook a number of commissions for furniture and **altarpieces** and a **showcase** for gloves for the Comella firm for the Paris Exhibition of 1878. An early house commission was the Casa Vicens which used **polychrome tile** on the exterior and in the smoking room. Another early work was the Villa El Capricio at the resort area of Comillas.

Antonio Gaudi was a unique architectural talent, not easily compared with other architects in the terms used by architectural historians.① Not only was his work strongly individualized, but also Antonio Gaudi was fortunate to have loyal clients to support him. From early in his career, wide attention was given to his work, although Antonio Gaudi shunned publicity(Fig. 1-1-1).

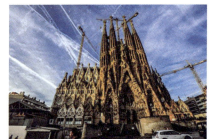
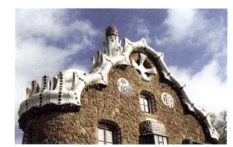

Fig. 1-1-1　Gaudi and Sagrada Familia Church and The Park Giiell

Antonio Gaudi has been identified with the **Catalan Modernism Movement** of the late nineteenth century and, by extension with the international **Art Nouveau** style. His strong personality drew **like-minded** people of talent to him, and the collaboration of structural engineers, **sculptors**, and metalworkers was needed to carry out his ideas. It is often possible to identify the artists and engineers involved.

The nationalist desires of Catalonians had been a problem of long standing for Spain. By the late nineteenth century, Barcelona had developed strong trade relationships with the UK and Western Europe. The wealth created contrasted with the difficult economic times in the rest of Spain and the loss of its last possessions in the war of 1898. The artistic activity in Barcelona was supported by business clients who by their travels were well acquainted with other countries, particular with the **Arts and Crafts Movement** in the United Kingdom. The development of illustrated periodicals further spread the art news to Barcelona. The cafe Els Quatre Gats, where Picasso's early work was shown and for which Antonio Gaudi designed menus in 1899, was an example of the international influences of the time.

Known for his understanding of structure and decoration using color、light and sculpture, Antonio Gaudi's work has been the subject of extensive investigation and analysis.

The Park Güell

One of Antonio Gaudi's loyal clients and friends was Eusebio Güell, for whom Antonio Gaudi designed many projects. For the housing development near Barcelona, Antonio Gaudi designed his famous park on a sloping site. The Park Güell extends over a market area and is supported on columns sloped to reflect the transfer of loads from the plaza above.② The use of colored tile is most remarkably evident in the curving bench at the edge of the plaza. The tile work was designed by Antonio Gaudi's collaborator, Josep Maria Jujol I Gibert and is considered an important work of art. The park was left incomplete because the development project failed to attract investors, particularly with the start of World War Ⅰ (Fig. 1-1-2).

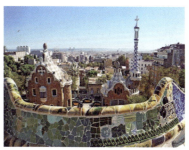

Fig. 1-1-2 Eusebio Güell and The Park Güell

Güell's house was greatly expanded and remodeled from Antonio Gaudi's designs from 1885 to 1890. The facades are more severe than in Antonio Gaudi's other work, except for the extensive **wrought-iron** work, the polychrome roof forms, and the principal internal event, a central space rising up through the house to the capping **cupola**. Drawings of sections of the palace were displayed in Paris in 1910.

Another project of Güell's was a worker's colony around his factory at Santa Coloma de Cervello. Antonio Gaudi made some designs for a chapel for colony, but it was not until 1908 that he became seriously involved in what had become a more ambitious undertaking. The design is closely related to Antonio Gaudi's other important religious commission, the Sagrada Familia Church in Barcelona. The Colonia Güell Chapel is irregular in form, with **sloping brick** and stone piers supporting the flat tile vaults in the crypt, which is the only completed portion. The structure evolved from structural analysis of a model, which resulted in a powerful spatial effect. The **crypt** was completed by 1914, but the church above was never built. The use of structural analysis to determine the forces on the columns resulted in original forms, which were modified in detail during construction.

Casa Mila Apartment House

The Casa Mila Apartment House was a late example of Antonio Gaudi's apartment house and his commercial design. On a corner site, the building facade is curvilinear in form and based on organic concepts. The heavy facade is tied to the floors behind. The most successful portions of the design were the roof vaults, clustered chimneys, and balcony railings designed by Jujol. This design caused much public comment, and Antonio Gaudi was forced to defend his organic forms in general terms③ (Fig. 1-1-3).

Sagrada Familia Church

A new church, the Sagrada Familia Church in Barcelona, was to be dedicated to the holy family. In 1883,

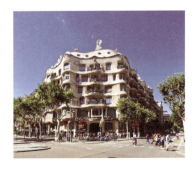 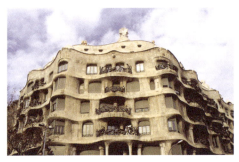 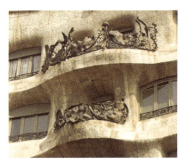

Fig. 1-1-3　Casa Mila Apartment

Antonio Gaudi was recommended to replace the original architect Francisco del Villar, who had resigned. At age 31, Antonio Gaudi undertook what became his life's work. During the years that Antonio Gaudi was working on the crypt, he was formulating design ideas to be expressed in the church. The east **transept** was selected for a presentation of the **Nativity**, and work began on the apse, the lower part of the towers, and the entrance doors. By 1901, work began on the upper part of the towers, and there the shift from a more traditional beginning to a new style can be seen. The square base of the towers was modified into the round towers, which grew ever freer in design as the work progressed①. After 1910, Antonio Gaudi spent all of his effort on religious commision, and the east front towers were completed after his death in 1926. Work continued until 1935, when it was stopped by the Spanish Civil War. Antonio Gaudi left a number of models for the completion of the **nave** and the two other main facades. His plans included a central tower higher than St. Peter's in Rome(Fig. 1-1-4).

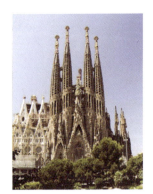 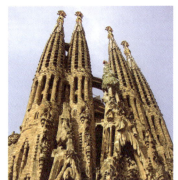 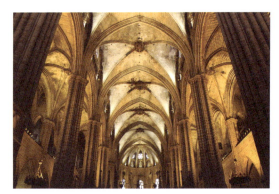

Fig. 1-1-4　Sagrada Familia Church

Much of Antonio Gaudi's attention was given to the design of **pinnacles** of the towers. As completed, the tops of the pinnacles use colored glass set in concrete, which is lit by internal **searchlights** to glow at night.

专业词汇

Catalan Modernism Movement　加泰罗尼亚现代主义运动
sculptor　['skʌlptə]　雕塑家
Arts and Crafts Movement　工艺美术运动
Art Nouveau　新艺术运动
illustrated periodical　画报期刊
lamppost　['læmp,poust]　路灯柱
showcase　['ʃoukeis]　陈列橱窗

polychrome tile　多彩瓷砖
altarpiece　[ˈɔːltərpiːs]　祭坛装饰
wrought-iron　热铁
cupola　[ˈkjupələ]　圆屋顶
sloping brick　倾斜的
curvilinear　[ˌkɜrviˈliniə(r)]　曲线的
crypt　[kript]　地下室
transept　[ˈtrænsept]　教堂翼部
pinnacle　[ˈpinəkl]　小尖塔
searchlight　[ˈsɜrtʃlait]　探照灯
nave　[neiv]　教堂中殿
apse　[æps]　拱点
nativity　[nəˈtivəti]　耶稣降生

难句翻译

① Antonio Gaudi was a unique architectural talent, not easily compared with other architects in the terms used by architectural historians.
安东尼奥·高迪是一位与众不同的建筑天才，他格外受到建筑史学家的青睐。

② The Park Güell extends over a market area and is supported on columns sloped to reflect the transfer of loads from the plaza above.
古埃尔公园与一片市场毗邻，倾斜的支柱与熙熙攘攘的上方广场相呼应。

③ This design caused much public comment, and Antonio Gaudi was forced to defend his organic forms in general terms.
这一设计引发了许多公众非议，安东尼奥·高迪不得不为其有机造型作简单辩护。

④ The square base of the towers was modified into the round towers, which grew ever freer in design as the work progressed.
方底塔楼逐渐改造成了圆塔，随着工程的展开其设计也越来越自由。

Antonio Gaudi（安东尼奥·高迪）

安东尼奥·高迪1852年出生于西班牙的加泰罗尼亚，1926年在巴塞罗那逝世。他是西班牙历史上天才般的建筑师，有人称他为巴塞罗那"建筑之父"。作为塑性建筑流派的代表人物，其初期作品近于维多利亚式，后采用历史风格，属哥特式。高迪认为自然界是没有直线存在的，直线属于人类，而曲线才属于上帝，因此依据其自然理论建成的建筑作品始终令人眼前一亮。在一百多年后的今天他的作品丝毫没有古老之感，充满着离奇、狂热和丰富的想象力。他常使用的建筑材料包括砖、瓦、玻璃、马赛克和水泥，其主要作品为圣家族大教堂（Sagrada Familia Church）、米拉公寓（Casa Mila Apartment House）和古埃尔公园（Güell Park）。

From
　　http://architect.architecture.sk/

1.2 Louis Henry Sullivan and His Masterpieces

Louis H. Sullivan was born in Boston, Massachusetts, on September 3, 1856. His formal education was erratic, but its scope and variety laid the foundation for Sullivan's monumental presence on the American urban landscape. In 1872, at the age of sixteen, Sullivan enrolled at the Massachusetts Institute of Technology to study architecture. Withdrawing after two semesters, Sullivan briefly became an apprentice in the office of Philadelphia architect Frank Furness before following his family to Chicago in November 1873. With architects in demand after the devastating 1871 Chicago fire, Sullivan quickly found work with William LeBaron Jenney, considered the father of the modern **skyscraper**. By the summer of 1874, Sullivan, following the lead of other young architects of the time, enrolled at the Ecole des Beaux-Arts in Paris to study European art and architecture (Fig. 1-2-1).

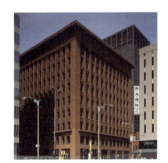
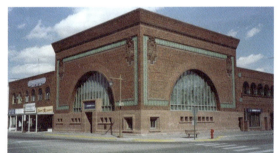

Fig. 1-2-1 Sullivan and his masterpieces

In 1879, Sullivan entered the Chicago office of architect and engineer Dankmar Adler, becoming his full partner in 1883. Together, Adler and Sullivan designed nearly two hundred residential, commercial, religious, and mixed-use buildings, primarily in the Midwest. Adler and Sullivan were highly regarded not only for their robustly modern and iconoclastic architecture—which illustrated Sullivan's dictum "**form follows function**"— but for Sullivan's complex and organic **ornament**.[①] Their best-known buildings include the Auditorium Building in Chicago; the Wainwright building in Saint Louis, Missouri; the Schiller Building and the Stock Exchange buildings, both in Chicago; and the Guaranty building in Buffalo, New York.

Following the dissolution of Adler and Sullivan's formal partnership in 1895, Sullivan's life was increasingly troubled and turbulent. After completing a final addition to Chicago's Schlesinger and Mayer Store, now Carson Pirie Scott, in 1904, his commissions became sparse and modest in budget. During the last decades of his life, his most important architectural work was a series of small but exquisitely detailed banks in rural communities throughout the Midwest. He devoted much of his remaining time to writing about architecture and philosophy, producing such works as *The Tall Office Building Artistically Considered*, *Kindergarten Chats*, *and The Autobiography of an Idea*. Toward the end of his life, Sullivan was commissioned by the Burnham Library of The Art Institute of Chicago to produce a large portfolio of his intricate and delicate drawings, which was published as *A System of Architectural Ornament*, *According*

With A Philosophy of Man's Powers, Sullivan died in Chicago on April 14, 1924. In 1944, he was awarded by the American Institute of Architects posthumously its Gold Medal.

Skyscraper Theory

The Chicago Auditorium was completed in detail in February 1890. Its enormous success transformed the nature of Adler & Sullivan's practice, bringing in larger commissions. One new project that year provided Louis Henry Sullivan with the opportunity to tackle a problem that would consume his interest for the rest of the decade. Its solution ensured his place in history(Fig. 1-2-2).

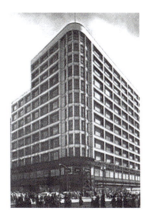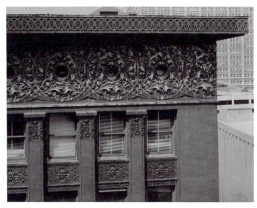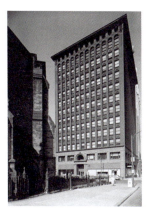

Fig. 1-2-2 Carson Pirie Scottbuilding and Wainwright Building, Chicago

The problem was the **high-rise office building**, the skyscraper, as it came to be called in the 1890s. The challenge for Louis Henry Sullivan was not so much structural, for most of the load-bearing and mechanical obstacles to great height had already been solved, as it was the aesthetics of structure. ② Louis Henry Sullivan was convinced that this historically new building type required a new design treatment, not one based on analogies to other kinds of buildings or one rooted in history, as most architects believed. Louis Henry Sullivan saw the skyscraper as a symbol of U. S. business that was the basis of the national culture, and therefore as an opportunity to create a **long-anticipated** indigenous architectural style. So when Adler and Louis Henry Sullivan received a commission in 1890 from St. Louis brewer and real estate promoter Ellis Wainwright for what came to be a 10-story rental structure, Louis Henry Sullivan made the most of it.

His solution to the skyscraper problem did not come easily. Frank Lloyd Wright, his principal assistant at the time, remembered how Louis Henry Sullivan struggled over the facade composition, leaving the office for long walks, throwing away sketch after sketch, until finally Louis Henry Sullivan burst into Wright's room and threw a drawing on the table.

Louis Henry Sullivan outlined his skyscraper theory six years later in his most famous essay, "The Tall Office Building Artistically Considered". By carefully analyzing the program requirements, he decided that skyscrapers had three major clusters of functions, each of which should be expressed separately. The first was public seen on the one or two storey base-consisting of entering and leaving, meeting and greeting, waiting, shopping, and locating the entrance from the outside. The second set of functions was private: various kinds of office work. And the third was architectural: the housing of mechanical equipment and storage in an **attic** that could also serve as an aesthetic device for terminating the facade in a decisive way. ③

Louis Henry Sullivan had in fact designed the Wainwright Building according to his as yet unwritten theory, with a two-story base treated in an expansive, **sumptuous** way with an easily identified entrance flanked

by broad display windows; a shaft of seven identically articulated doors to indicate the similar nature of work in the various offices; and a richly decorated attic suggesting a crisp termination, and that the functions there were of yet a third and different order.

All this was but one aspect of Louis Sullivan's thinking. It was necessary to differentiate the three principal functions, to be sure, but it was equally important to unite them harmoniously at the same time, because he believed, he had written earlier, that every building should reveal "a single, germinal impulse or idea, which shall permeate the mass and its every detail," so that "there shall effuse from the completed structure a single sentiment..." What was the skyscraper's single sentiment? Or, as Louis Henry Sullivan asked himself in his 1896 essay: "What is the chief characteristic of the tall office building?" he answered in some of his most direct but most memorable prose. "It is lofty... It must be tall, every inch of it tall... It must be every inch a proud and soaring thing, rising in sheer exultation... from bottom to top... without a single dissenting line." So Louis Henry Sullivan recessed the **horizontals**, projected forward the structural columns and nonstructural **mullions**, and took the corner piers all the way from sidewalk to **cornice**. His "system of **vertical construction**" was now complete.

But in his 1896 essay Louis Henry Sullivan had one more point to make, the most important point of all. Working from the particular to the general, he advanced his "final, comprehensive formula" for the solution of the skyscraper problem, indeed, of all architectural problems. All things in nature had shapes, forms, and outward appearances "that tell us what they are, that distinguishes them... from each other," Louis Henry Sullivan asserted. "Unfailingly in nature these shapes express the inner life," and when analyzed reveal that "the essence of things is taking shape in the matter of things." Life seeks form in response to needs, the life and the form being "absolutely one and inseparable." "Where function does not change," Louis Henry Sullivan insisted, "form does not change," so it was "the pervading law of all things... that form ever follows function. That," Louis Henry Sullivan emphasized, "is the law". With the Wainwright Building and the assertion of "form follows function," Louis Sullivan's place in architectural history was assured.④

Between 1890 and 1895 Adler & Sullivan designed some 13 high-rise projects, only 5 of which were built: the Wainwright and the Union Trust Building in St. Louis, the Schiller Building and the Stock Exchange in Chicago, and the Guaranty Building in Buffalo. But together with "The Tall Office Building Artistically Considered," they established Louis Henry Sullivan as the premier theorist of skyscraper design with a pioneering style of national importance.

One of the most significant unbuilt skyscraper projects was the 36-story Odd Fellows or Fraternity Temple Building for Chicago featuring a system of setbacks. Had it been built, the Temple would have been the tallest **edifice** in the nation. Its impressive scale-450 ft in height occupying an entire 177×210 ft block-dramatized certain social problems of which Louis Henry Sullivan was intensely aware, principally those of air and light for tenants and neighbors and of street congestion. In the December 1891 issue of The Graphic, a Chicago pictorial review, Louis Henry Sullivan proposed an innovative solution. The idea was that above a specified limit-twice the width, or 132 ft on a typical 66-ft thoroughfare, for example building area should be reduced to 50% of the lot. At twice the limit it should be halved again to 25% and so on indefinitely. To prevent the city from becoming a maze of walled canyons, Louis Henry Sullivan would apply the formula to frontage as well as area, and for corner lots with one narrow and one wide street suggested the distance before setback be the sum of the two. Louis Henry Sullivan had already incorporated the principle vertically and horizontally in his 1891 Schiller Building, possibly the first true setback high-rise in the United States. And 25 years later in 1916, New York City's zoning law, which became a model for the nation, incorporated a variation on the theme by dividing central Manhattan into districts with setbacks beginning from one and one-quarter to

twice the width of the streets.

By 1895 Louis Sullivan's reputation had crossed the Atlantic. His "Golden Doorway" on the Transportation Building at the 1893 Chicago World's Fair was awarded a medal the next year by the Union Centrale des Arts Decoratifs in Paris, which exhibited models of his work. The Russian School of Applied Arts in Moscow also asked him to loan examples of his designs. His skyscrapers, by now even more refined and coherent than the Wainwright Building, were applauded by critics at home, as were his other **buildings-tombs**, **synagogues**, hotels, and opera houses conspicuous among them. Much in demand as a speaker and essayist, Louis Henry Sullivan was elected to the Board of Directors of the American Institute of Architects in 1894 and in 1895 to the Board's Executive Committee. A good measure of his standing was Montgomery Schuyler's conclusion in an 1895 issue of The Architectural Record that Louis Henry Sullivan "is of the first rank among his contemporaries throughout the world" (Fig. 1-2-3).

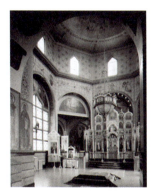
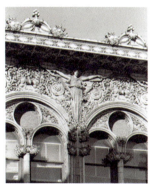
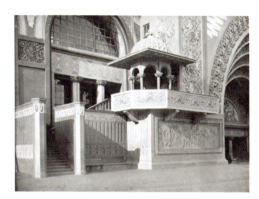

Fig. 1-2-3　Sullivan's Golden Door: 1893 World Columbian Exposition

专业词汇

skyscraper ['skaɪskreɪpə(r)]　摩天大楼
form follows function　形式追随于功能
high-rise office building　高层办公大楼
ornament ['ɔːnəmənt]　装饰
attic ['ætɪk]　阁楼
long-anticipated　期待已久
horizontal [ˌhɒrɪˈzɒntl]　水平的
mullion ['mʌliən]　竖框
cornice ['kɔːnɪs]　檐口
vertical construction　垂直结构
sumptuous ['sʌmptʃuəs]　豪华的，奢侈的
thoroughfare ['θʌrəfeə(r)]　大道
edifice ['edɪfɪs]　大厦，建筑物
synagogue ['sɪnəɡɒɡ]　犹太教堂

难句翻译

① Adler and Sullivan were highly regarded not only for their robustly modern and iconoclastic

architecture—which illustrated Sullivan's dictum "form follows function"—but for Sullivan's complex and organic ornament.

阿德勒与沙利文声名显赫,不仅是因为他们生机勃勃的现代性设计和反传统的建筑(充分体现了沙利文的名言"形式由功能而来"),而且因沙利文繁杂的有机装饰。

② The challenge for Louis Henry Sullivan was not so much structural, for most of the load-bearing and mechanical obstacles to great height had already been solved, as it was the aesthetics of structure.

对于路易斯·亨利·沙利文来说,建筑结构并不是最大的挑战,因为超高层建筑的承重及机械难题早已被解决,结构的美感才是真正的挑战。

③ The first was public seen on the one or two storey base-consisting of entering and leaving, meeting and greeting, waiting, shopping, and locating the entrance from the outside. The second set of functions was private: various kinds of office work. And the third was architectural: the housing of mechanical equipment and storage in an attic that could also serve as an aesthetic device for terminating the facade in a decisive way.

第一组用于公众可见的一、二楼底层,包括进出、会面、寒暄、等待、购物,并保证行人从外面找得到入口。第二组为私密性功能:开展各种办公事务。第三组是建筑性功能:放置机械设备并设储物阁楼。阁楼同时起到决定立面效果的美学作用。

④ All things in nature had shapes, forms, and outward appearances "that tell us what they are, that distinguishes them... from each other," Louis Henry Sullivan asserted. "Unfailingly in nature these shapes express the inner life," and when analyzed reveal that "the essence of things is taking shape in the matter of things." Life seeks form in response to needs, the life and the form being "absolutely one and inseparable." "Where function does not change," Louis Henry Sullivan insisted, "form does not change," so it was "the pervading law of all things... that form ever follows function. That," Louis Henry Sullivan emphasized, "is the law". With the Wainwright Building and the assertion of "form follows function," Louis Sullivan's place in architectural history was assured.

自然界的一切皆有形状、造型与外表,它们"告诉我们它们是什么……彼此有何区别",路易斯·亨利·沙利文如是说。"自然界的这些形状有效传达了其内在世界,"通过分析便知"物态反映物之本质"。生命应需而取形,生命与造型是"绝对一体不可分割"的。路易斯·亨利·沙利文坚持"功能不变,造型就不变",因此这是"统治一切事物的法则……形式总依功能而来"。路易斯·亨利·沙利文强调:"这是法则。"凭借温莱特大厦和"形式由功能而来"的名言,路易斯·沙利文在建筑史上占据了一席之地。

Louis Henry Sullivan(路易斯·沙利文)

路易斯·沙利文1856年9月3日出生于美国波士顿,是全世界第一批设计摩天大楼的建筑师,被称为"摩天大楼之父"和"现代主义之父"。他早年任职于芝加哥学派的建筑师詹尼的事务所,后赴巴黎进入艺术学院。1881年他与艾德勒组建建筑事务所,在共事的14年里,他们合作设计了百余栋建筑,其中许多商业建筑成为美国建筑史上的里程碑,如温赖特大厦(Wainwright Building)、希勒大楼(Aliiolani Hale)、芝加哥交易所大楼(Chicago Stock Exchange Building)等。1899年至1903年间,路易斯·沙利文设计并建造了他最重要的建筑作品芝加哥施莱辛格和迈耶百货商店(Schlesinger and Meyer Department Store)。

From

http://www.artic.edu/research/louis-sullivan-collection

1.3
Frank Lloyd Wright and His Masterpieces

Frank Lloyd Wright was born in Richland Center, Wisconsin in 1867. He and his family settled in Madison, Wisconsin in 1877. He was educated at Second Ward School, Madison from 1879 to 1883. After a brief sting at the University of Wisconsin where he took some **mechanical drawing** and basic mathematics courses, Wright departed for Chicago where he spent several months in J. L. Silsbee's office before seeking employment with Adler and Sullivan(Fig. 1-3-1).

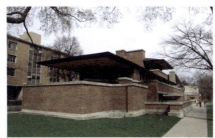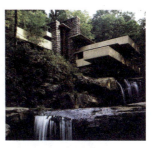

Fig. 1-3-1　Frank Lloyd Wright and Designed Robie House & Fillingwater

Wright evolved a new concept of interior space in architecture. Rejecting the existing view of rooms as single-function boxes, Wright created overlapping and interpenetrating rooms with **shared spaces**. He designated use areas with **screening devices** and subtle changes in **ceiling** heights and created the idea of **defined space** as opposed to **enclosed space**.

Through experimentation, Wright developed the idea of the prairie house—a long, low building with hovering planes and horizontal emphasis. He developed these houses around the basic crucifix, L or T shape and utilized a basic unit system of organization, and integrated simple materials such as brick, wood, and **plaster** into the designs.[①]

In 1914 Wright lost his wife and several members of his household when a servant burned down Taliesin, his home and studio in Wisconsin. Following the tragedy, he re-directed his architecture toward more solid, protective forms. Although he produced few works during the 1920s, Wright theoretically began moving in a new direction that would lead to some of his greatest works.

Walter Burley Griffin was among the many notable architects to emerge from the Wright studios. In 1932 Wright established the Taliesin Fellowship-a group of apprentices who did construction work, domestic chores, and design studies. Four years later, he designed and built both Falling Water and the Johnson Administration Building. These designs re-invigorated Wright's career and led to a steady flow of commissions, particularly for lower middle income housing. Wright responded to the need for low income housing with the Usonian house, a development from his earlier prairie house.

During the last part of his life, Wright produced a wide range of work. Particularly important was Taliesin West, a winter retreat and studio he built in Phoenix, Arizona. He died at Taliesin West in 1959.

Comments on Wright's Masterpieces

1. Robie Residence

Commentary

"The Robie house, as Wright's best expression of the Prairie masonry structure, is a national landmark... Sheathed in Roman brick and overhung so perfectly that a midsummer noon sun barely strikes the foot of the long, **glass-walled** southern exposure of the raised above-ground-level **living quarters**, it demonstrates Wright's total control and appreciation of **microclimatic** effects. This is coupled with a high degree of integration of the mechanical and electrical systems designed by Wright into the visual expression of the interior. Living and dining space are in-line, with only the fireplace-chimney block providing separation. Sleeping quarters are yet a floor above, play and billiard rooms below[②]. There is no 'basement.' Construction was begun in 1908 and completed the following year. The **garage and surrounding** wall were later altered from the original design."(Fig. 1-3-2).

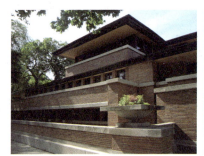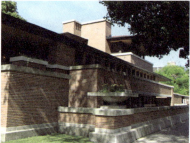

Fig. 1-3-2　Robie Residence

——William Allin Storrer.

The Frank Lloyd Wright's Words

"Architecture is the triumph of human imagination over materials, methods and men, to put man into possession of his own earth.

Machinery, materials and men-yes-these are the stuffs by means of which the so-called American architect will get his architecture... Only by the strength of his spirit's grasp upon all there—machinery, materials and men—will the architect be able so to build that his work may be worthy the great name architecture.

Bring out the nature of the materials, let their nature intimately into your scheme... Reveal the nature of the wood, plaster, brick or stone in your designs; they are all by nature friendly and beautiful."

——Frank Lloyd Wright.

2. Fallingwater

Commentary

"Wright sends out free-floating **platforms** audaciously over a small waterfall and anchors them in the natural rock. Something of the prairie house is here still; and we might also detect a grudging recognition of the **international style** in the interlocking **geometry** of the planes and the flat, textureless surface of the main shelves. But the house is thoroughly fused with its site and, inside, the rough stone walls and the flagged floors are of an elemental ruggedness."(Fig. 1-3-3).

——Spiro Kostof. A History of Architecture, Settings and Rituals. New York: Oxford University Press, 1985. p737.

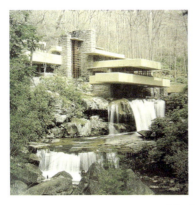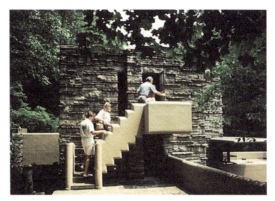

Fig. 1-3-3 The Fallingwater

3. Taliesin West

Commentary

"A great and poetic building designed in subtle harmony with its magnificent setting of desert and mountains, and with deep intuitive feeling for the nature of the chosen materials and for the way man might best live under the hard, bright Arizona sun." (Fig. 1-3-4).

"Taliesin West is the winter home and workshop of Mr. Wright and his students, and was built almost entirely by the students themselves. Walls are **concrete**, but of a special kind: **native boulders**, red, yellow and gray, were laid in rough wooden forms and cement poured over. Above these colorful, variously tapered walls are the great redwood trusses which support canvas-covered roof flaps. Glass is unnecessary, as the **canvas** admits a softly diffused light."

——from Elizabeth Mock, ed. *Built in the USA Since* 1932. p84.

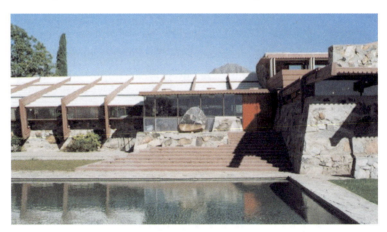

Fig. 1-3-4 Taliesin West

The Frank Lloyd Wright's Words

"Taliesin West is another one of those ventures in the general direction of the unknown in which this architect has so often indulged."

"There is probably more instruction concerning construction in the desert ways of plant life than in any books ever written."

——Frank Lloyd Wright. "Frank Lloyd Wright", The Architectural Forum, January, 1948, Vol 88 Number 1. p87.

专业词汇

mechanical drawing　机械制图
ceiling　['siːliŋ]　吊顶
defined space　限定空间
enclosed space　封闭空间
shared space　共享空间
plaster　['plɑːstə(r)]　石膏
screening devices　隔断
glass-wall　玻璃幕墙
canvas　['kænvəs]　帆布
platform　['plætfɔːm]　平台
microclimatic　[maikrouklai'mætik]　微气候的
sleeping quarters　卧室
garage　['gærɑːʒ]　车库
international style　国际主义风格
geometry　[dʒi'ɑmətri]　几何学
concrete　['kɒŋkriːt]　混凝土
native boulders　本地卵石

难句翻译

① Through experimentation, Wright developed the idea of the prairie house—a long, low building with hovering planes and horizontal emphasis. He developed these houses around the basic crucifix, L or T shape and utilized a basic unit system of organization. He integrated simple materials such as brick, wood, and plaster into the designs.

经过尝试赖特提出了草原住宅这一概念。建筑狭长低矮，格局开放并强调横向视觉。他的房屋设计以十字形、L 形及 T 形为主，由一套基础系统组合而成。他能够在设计中使用基础建材如砖、木和石膏。

② This is coupled with a high degree of integration of the mechanical and electrical systems designed by Wright into the visual expression of the interior. Living and dining space are in-line, with only the fireplace-chimney block providing separation…Sleeping quarters are yet a floor above, play and billiard rooms below.

室内设计的视觉表现还高度结合了赖特设计的机械及电路系统。客厅和餐厅畅通无阻，仅利用壁炉和烟囱作为隔断。卧室在楼上，娱乐场所和台球室在楼下。

Frank Lloyd Wright(弗兰克·劳埃德·赖特)

弗兰克·劳埃德·赖特1867年6月8日出生于美国威斯康星州。1886年赖特进入威斯康星大学麦迪逊分校攻读土木工程。1887年他前往芝加哥寻找工作，其中包括路易斯·沙利文的建筑事务所，随后独立营业。在芝加哥他设计了许多工薪阶层的住宅，很多住宅现在成为当地著名的旅游景点或博物馆。1959年4月9日，赖特于美国的凤凰城辞世。在建筑界业内，赖特对于传统的重新解释、环境因素的重视及对现代工业化材料的强调，为之后的建筑师提供了一个可探索的、非学院派的和非传统的典范。

From
　http://www.greatbuildings.com/architects

1.4 Walter Gropius and His Masterpieces

Walter Gropius was born in Berlin in 1883. The son of an architect, he studied at the Technical Universities in Munich and Berlin. He joined the office of Peter Behrens in 1910 and three years later established a practice with Adolph Meyer. For his early commissions he borrowed from the Industrial **Classicism** introduced by Behrens(Fig. 1-4-1).

After serving in the war, Gropius became involved with several groups of **radical** artists that sprang up in Berlin in the winter of 1918. In March 1919 he was elected chairman of the Working Council for Art and a month later was appointed Director of the Bauhaus.

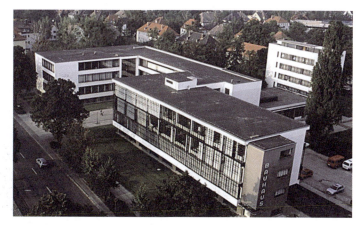

Fig. 1-4-1　Walter Gropius and Bauhaus

As war became eminent, Gropius left the Bauhaus and resumed private practice in Berlin. Eventually, he was forced to leave Germany for the United States, where he became a professor at Harvard University. From 1938 to 1941, he worked on a series of houses with Marcel Breuer and in 1945 he founded "The Architect's Collaborative", a design team that embodied his belief in the value of teamwork.

Gropius created innovative designs that borrowed materials and methods of construction from modern technology. This advocacy of industrialized building carried with it a belief in team work and an acceptance of **standardization** and **prefabrication**.① Using technology as a basis, he transformed building into a science of precise mathematical calculations.

An important theorist and teacher, Gropius introduced a screen wall system that utilized a **structural steel** frame to support the floors and which allowed the external glass walls to continue without interruption.

Gropius died in Boston, Massachusetts in 1969.

Comments on Gropius' Masterpieces

Commentary

Gropius' extensive facilities for the Bauhaus at Dessau combine teaching, student and faculty members' housing, an **auditorium**, and office spaces. The pinwheel configuration when viewed from the air represents in form the propellers of the airplanes manufactured in the Dessau area. This complex embodies various technological and design oriented advancements including a penchant for glazing, the creation of an architecture of transparency with the supporting structure rising behind the facing skin. It was a radical structure populated by progressive minds touting a unique group-oriented approach to learning.

——Darlene Levy. drawn from S. Giedion. Walter Gropius: Work and Teamwork. p54-56.

"The Bauhaus building provides an important landmark of architectural history, even though it was dependent on earlier projects of the architect... as well as on the basic outlines and concepts of Frank Lloyd Wright."

It consists of three connected wings or bridges... School and workshop are connected through a two-story bridge, which spans the approach road from Dessau. The administration was located on the lower level of the bridge, and on the upper level was the private office of the two architects, Walter Gropius and Adolf Meyer, which could be compared to the ship captain's "command bridge" due to its location. The **dormitories** and the school building are connected through a wing where the assembly hall and the dining room are located, with a stage between (Fig. 1-4-2).

——from Udo Kultermann. Architecture in the 20th Century. p37-38.

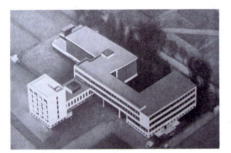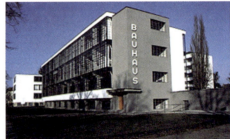

Fig. 1-4-2　Bauhaus airview & Building environment

The Walter Gropius's Words

"One of the outstanding achievements of the new constructional technique has been the abolition of the separating function of the wall. Instead of making the walls the element of support, as in a brick-built house, our new space-saving construction transfers the whole load of the structure to a steel or concrete framework.② Thus the role of the walls becomes restricted to that of mere screens stretched between the upright columns of this framework to keep out rain, cold, and noise. Systematic technical improvement in steel and concrete, and nicer and nicer calculation of their **tensile and compressive strength**, are steadily reducing the area occupied by supporting members. This, in turn, naturally leads to a progressively bolder opening up of the wall surfaces, which allows rooms to be much better lit. It is, therefore, only logical that the old type of window—a hole that had to be hollowed out of the full thickness of a supporting wall—should be giving place more and more to the continuous horizontal casement, subdivided by thin steel mullions, characteristic of the New Architecture. And

as a direct result of the growing preponderance of **voids** over solids, glass is assuming an ever greater structural importance... In the same way the flat roof is superseding the old penthouse roof with its tiled or slated **gables**. For its advantages are obvious: ① light normally shaped top-floor rooms instead of poky attics, darkened by **dormers** and sloping ceilings, with their almost unutilizable corners; ② the avoidance of timber rafters, so often the cause of fires; ③ the possibility of turning the top of the house to practical account as a sun loggia, open-air gymnasium, or children's playground; ④ simpler structural provision for subsequent additions, whether as extra stories or new wings; ⑤ elimination of unnecessary surfaces presented to the action of wind and weather, and therefore less need for repairs; ⑥ suppression of hanging gutters, **external rain-pipes**, etc., that often erode rapidly. With the development of air transport the architect will have to pay as much attention to the **bird's-eye perspective** of his houses as to their elevations. The utilization of flat roofs as "grounds" offers us a means of re-acclimatizing nature amidst the stony deserts of our great towns;... Seen from the skies, the leafy house-tops of the cities of the future will look like endless chains of **hanging gardens**."

——Walter Gropius. from Walter Gropius. The New Architecture and the Bauhaus. p25-30.

专业词汇

standardization [ˌstændədaiˈzeiʃn] 标准化,规格化
concrete framework 混凝土框架
gutter [ˈgʌtər] 排水沟,天沟
external rain-pipes 外挂雨水管
bird's-eye perspective 鸟瞰图
classicism [ˈklæsiˌsizəm] 古典主义
radical [ˈrædikəlˌrædikl] 激进的
steel frame 钢结构
prefabrication [ˌpriːfæbriˈkeiʃn] 预制件
Bauhaus [ˈbauhaus] 包豪斯
innovative design 创新设计
dormitory [ˈdɔːmətri] 集体宿舍
tensile and compressive strength 热胀冷缩
auditorium [ˌɔːdiˈtɔːriəm] 礼堂,会堂
elevation [ˌeliˈveiʃn] 正立面
void [vɔid] 空的,没人住的
dormer [ˈdɔːmə(r)] 老虎窗
gable [ˈgeibl] 山墙
hanging garden 空中花园

难句翻译

① Gropius created innovative designs that borrowed materials and methods of construction from modern technology. This advocacy of industrialized building carried with it a belief in team work and an acceptance of standardization and prefabrication.

格罗皮乌斯借助现代科技的施工材料及手段创造出了革新性设计。这种对工业化建筑的推崇体现了其对团队协作的信仰和对标准化和预制件建造的承认。

② One of the outstanding achievements of the new constructional technique has been the abolition of the separating function of the wall. Instead of making the walls the element of support, as in a brick-built house, our new space-saving construction transfers the whole load of the structure to a steel or concrete framework.

新兴建筑技巧的最卓越成就之一就是对墙壁隔断功能的摒弃。比起像砖瓦房那样把墙壁作为承重构件，新型空间节省型建筑一改以往的全承重结构，而采取钢筋或混凝土框架。

Walter Gropius(瓦尔特·格罗皮乌斯)

瓦尔特·格罗皮乌斯 1883 年 5 月 18 日生于德国柏林，是德国现代建筑师和建筑教育家，现代主义建筑学派的倡导人和奠基人之一。他也是包豪斯(Bauhaus)学院的创办人，格罗皮乌斯积极探提倡建筑设计与工艺的统一，艺术与技术的结合，讲究功能、技术和经济效益。1945 年瓦尔特·格罗皮乌斯同他人合作创办的协和建筑师事务所，发展成为美国最大的以建筑师为主的设计事务所。第二次世界大战后，他的建筑理论和实践为各国建筑界所推崇，1969 年 7 月 5 日他在美国波士顿逝世。

From

http://www.greatbuildings.com/architects

1.5 Ludwig Mies Van Der Rohe and His Masterpieces

Ludwig Mies Van der Rohe was born in Aachen, Germany in 1886. He worked in the family **stone-carving** business before he joined the office of Bruno Paul in Berlin. He entered the studio of Peter Behrens in 1908 and remained until 1912(Fig. 1-5-1).

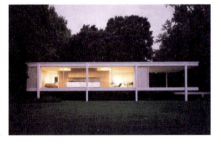
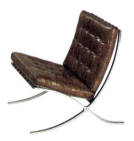

Fig. 1-5-1 Mies and his masterpieces

Under Behrens' influence, Mies developed a design approach based on advanced structural techniques and **Prussian Classicism**. He also developed a sympathy for the aesthetic credos of both **Russian Constructivism** and the Dutch De Stijl group. He borrowed from the post and lintel construction of Karl Friedrich Schinkel for his designs in steel and glass.

Mies worked with the magazine G which started in July 1923. He made major contributions to the architectural philosophies of the late 1920s and 1930s as artistic director of the Werkbund-sponsored Weissenhof project and as Director of the Bauhaus.

Famous for his **dictum 'Less is More'**, Mies attempted to create contemplative, **neutral spaces** through an architecture based on material honesty and **structural integrity**.① Over the last twenty years of his life, Mies achieved his vision of a monumental 'skin and bone' architecture. His later works provide a fitting denouement to a life dedicated to the idea of a universal, simplified architecture.

Mies died in Chicago, Illinois in 1969.

Comments on Mies's Masterpieces

1. Farnsworth House

Commentary

"The Farnsworth house is Mies's summary statement of those spatial and architectural concerns he first realized in the **Barcelona Pavilion**, and which he further developed in the Tugendhat house... However, contained in what is a pure expression of its age is another **vision**, that of a transparent house in a **verdant** landscape."(Fig. 1-5-2)

——David Spaeth. Mies Van Der Rohe. London: The Architectural Press, 1985. p125.

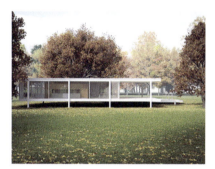
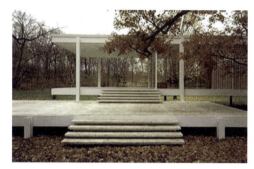

Fig. 1-5-2 Farnsworth House

2. Tugendhat House

Commentary

"The plan repeats that of the Barcelona Pavilion, the **onyx** wall and the curved one of Macassar ebony being independent of the **cruciform-shaped columns**. The floor is of white **linoleum**, the **rug** white wool. The curtains are of black and natural raw silk and white velvet. Behind the dining room a double glass partition serves as a light source for the interior space, as in the Barcelona design.

The hillside site suggested a two-story scheme with the entry and bedrooms above with the main floor below. Across the living and dining areas the entire wall is of glass. Two of these large panes slide down into pockets as in an automobile window. A **terrace** and flight of steps connect the house to the garden below. At one end the glass is doubled to provide a narrow **conservatory** running the depth of the plan. The juxtaposition of geometry with nature is most effective, the simplicity of forms enhancing the natural setting."(Fig. 1-5-3)

——A. James Speyer. Mies van der Rohe. p42.

The Ludwig Mies Van Der Rohe's Words

"Of my European work, the Tugendhat House is considered outstanding, but I think only because it was the first house to use rich materials, to have great elegance. At that time modern buildings were still **austerely**

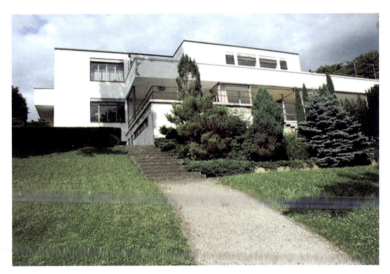

Fig. 1-5-3　Tugendhat House

functional. I personally don't consider the Tugendhat House more important than other works I designed considerably earlier."

——Mies van der Rohe. from Frank Russell, ed. Mies van der Rohe: European Works. p20.

"Architecture is the will of the epoch translated into space. Until this simple truth is clearly recognized, the new architecture will be uncertain and tentative. Until then it must remain a chaos of undirected forces. The question as to the nature of architecture is of decisive importance. It must be understood that all architecture is bound up with its own time, that it can only be manifested in living tasks and in the medium of its epoch. In no age has it been otherwise."②

——Mies van der Rohe. from John Zukowsky, organizer. Mies Reconsidered: His Career, Legacy, and Disciples. p17.

专业词汇

Prussian Classicism　普鲁士古典主义
stone-carving　石雕
neutral space　中性空间
Russian Construction　俄国构成主义
structural integrity　结构完整性
verdant　['vɜːdnt]　青翠的
cruciform-shaped column　十字形柱
linoleum　[liˈnəʊliəm]　油地毯
rug　[rʌg]　小块地毯
terrace　[ˈterəs]　露台
less is more　少即是多
Onyx　[ˈɑniks]　缟玛瑙
partition　[pɑːˈtiʃn]　隔断
austerely　[ɔˈstirli]　简朴的
medium　[ˈmidiəm]　媒介

epoch ['iːpɒk] 新纪元
Barcelona Pavilion 巴塞罗那展览馆
conservatory [kənˈsɜːvətri] 温室、暖房
dictum [ˈdɪktəm] 名言
vision [ˈvɪʒn] 洞察力

难句翻译

① Famous for his dictum 'Less is More', Mies attempted to create contemplative, neutral spaces through an architecture based on material honesty and structural integrity.

密斯因其"少即是多"的格言而闻名。他试图利用朴实的建材和坚固的结构创造富含启发性的中性空间。

② "Architecture is the will of the epoch translated into space. Until this simple truth is clearly recognized, the new architecture will be uncertain and tentative. Until then it must remain a chaos of undirected forces. The question as to the nature of architecture is of decisive importance. It must be understood that all architecture is bound up with its own time, that it can only be manifested in living tasks and in the medium of its epoch. In no age has it been otherwise."

"建筑是新世纪精神的空间体现。在这一简单真理为世人清楚认识前,新式建筑将会是模棱两可的、试行的。在那之前建筑理念一定是混乱无章的。建筑的本质为何这一命题至关重要。大家必须明白所有的建筑家皆为其时代所局限,建筑精神只能通过具体的作业在新纪元这一媒介中体现。任何一个时代都是如此。"

Ludwig Mies van der Rohe(密斯·凡·德·罗)

密斯·凡·德·罗 1886 年 3 月 27 日生于德国,是现代主义建筑大师之一,与赖特、柯布西耶、格罗皮乌斯并称四大现代建筑大师。密斯坚持"少即是多"的建筑设计哲学,建筑作品多整洁、骨架分明,室内空间灵活多变并具有精致的细节。他提倡用玻璃、石头、水以及钢材等物质介入建筑设计,在公共建筑如博物馆等建筑设计中,采用对称、正面描绘以及侧面描绘的方法进行设计,而对居住建筑则主要选用不对称、流动性以及连锁的方法进行设计。

From

http://www.greatbuildings.com/architects

单元分类词汇总结

Space:	Interior space; Shared space; Defined space; Enclosed space; Neutral space
Structure:	Free-standing pillars; Articulate; Column; Ferroconcrete grid; Steel frame; Standardization; Prefabrication; Auditorium; Ceiling; Cupola; Transept; Pinnacles; Apse; Mullions; Cornice; Vertical construction; Screening devices; Concrete framework; Gutter; Dormer; Gable; Cruciform-shaped column; Partition; Glass-walled
Shape:	Rectilinear; Oblong; Axial; Cruciform; Curvilinear; Horizontal
Material:	Plaster; Masonry; Linoleum; Onyx; Polychrome tile; Nativity boulders; Wrought-iron; Canvas; Concrete; Native boulders; Linoleum; Rug; Onyx

Exterior:	Glass-walled; Screen wall; Steel frame; Lampposts; Searchlight; Thoroughfare; Hanging garden; External rain-pipes
Interior:	Rug; Curtain; Partition; Showcase; Crypt; Nave; Living quarters; Garage; Auditorium; Conservatory; Ceiling
Style:	International Style; Classicism; Prussian Classicism
Movement:	Catalan Modernism Movement; Arts And Crafts Movement; Art Nouveau
Building:	Skyscraper; High-rise office building; Edifice; Synagogue; Dormitory; Platform; Balcony; Entrance; Pavilion; Attic; Terrace; Barcelona Pavilion
Design:	Bird's-eye perspective; Elevation; Mechanical drawing

1.6 Le Corbusier and His Masterpieces

Charles-Edouard Jeanneret-Gris was born in La Chaux de Fonds, Switzerland, 1887. Trained as an artist, he traveled extensively through Germany and the East. In Paris he studied under Auguste Perret and absorbed the cultural and artistic life of the city. During this period he developed a keen interest in the synthesis of the various arts. Jeanneret-Gris adopted the name Le Corbusier in the early 1920s (Fig. 1-6-1).

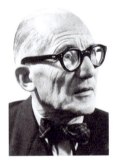
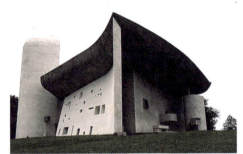
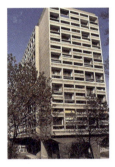

Fig. 1-6-1 Le Corbusier and His Ronchamp Church, United' Habitation

Le Corbusier's early work was related to nature, but as his ideas matured, he developed the Maison-Domino, a basic building prototype for mass production with **free-standing pillars** and rigid floors. In 1917 he settled in Paris where he issued his book *Vers une architecture* [Towards a New Architecture], based on his earlier articles in L'Esprit Nouveau.

From 1922 Le Corbusier worked with his cousin Pierre Jeanneret. During this time, Le Corbusier's ideas began to take physical form, mainly as houses which he created as "a machine for living in" and which incorporated his trademark five points of architecture.① (free plan, free elevation. roof Garden, ribbon window, pilots)

During World War II, Le Corbusier produced little beyond some theories on his **utopian ideals** and on his

modular building scale. In 1947, he started his United' Habitation. Although relieved with sculptural roof-lines and highly colored walls, these massive post-war dwelling blocks received justifiable criticism.

Le Corbusier's **post-war buildings** rejected his earlier industrial forms and utilized vernacular materials, brute concrete and articulated structure. Near the end of his career he worked on several projects in India, which utilized brutal materials and sculptural forms. In these buildings he readopted the recessed structural column, the expressive staircase, and the flat undecorated plane of his celebrated five points of architecture.

Le Corbusier did not fare well in international competition, but he produced **town-planning** schemes for many parts of the world, often as an adjunct to a lecture tour. In these schemes the vehicular and pedestrian zones and the functional zones of the settlements were always emphasized.

Comments on Corbusier's Masterpieces

1. Villa Savoye

Commentary

"Unlike the confined urban locations of most of Le Corbusier's earlier houses, the openness of the Poissy site permitted a freestanding building and the full realization of his five-point program. Essentially the house comprises two contrasting, sharply defined, yet interpenetrating external aspects. The dominant element is the square single-storied box, a pure, sleek, geometric envelope lifted buoyantly above slender **pilots**, its taut skin slit for **narrow ribbon windows** that run unbroken from corner to corner (but not over them, thus preserving the integrity of the sides of the square)."[②] (Fig. 1-6-2)

——Marvin Trachtenberg and Isabelle Hyman. Architecture: from Prehistory to Post-Modernism. p530.

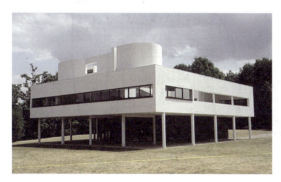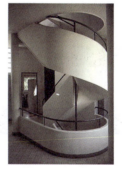

Fig. 1-6-2 Villa Savoye

2. United' Habitation

Commentary

"Le Corbusier's most influential late work was his first significant postwar structure—the United' Habitation in Marseilles of 1947—1952. The giant, twelve-story **apartment** block for 1600 people is the late modern counterpart of the mass housing schemes of the 1920s, similarly built to alleviate a severe postwar housing shortage. Although the program of the building is elaborate, structurally it is simple: a **rectilinear ferroconcrete grid**, into which are slotted individual apartment units, like 'bottles into a wine rack' as the architect put it. Through ingenious planning, twenty-three different apartment configurations were provided to accommodate single persons and families as large as ten, nearly all with double-height living rooms and the deep **balconies** that form the major external feature." (Fig. 1-6-3)

——Marvin Trachtenberg and Isabelle Hyman. Architecture: from Prehistory to Post-Modernism. p541.

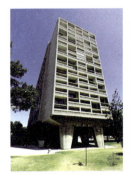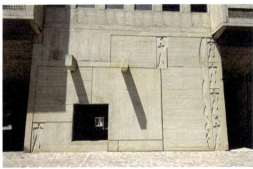

Fig. 1-6-3　Unite d'Habitation

3. Notre Dame du Haut, or Ronchamp

Commentary

"**Surrealism** is a key to other late works of Le Corbusier, most notably the church at Ronchamp, France, of 1950—1954... Notre-Dame-du-Haut was a more extreme statement of Le Corbusier's late style. Pragmatically,... the church is simple—an **oblong nave**, two side entrances, an axial main altar, and three **chapels** beneath towers—as is its structure, with rough masonry walls faced with whitewashed Gunite (sprayed concrete) and a roof of contrasting beton brut. Formally and symbolically, however, this small building, which is sited atop a hillside with access from the south, is immensely powerful and complex." (Fig. 1-6-4)

——Marvin Trachtenberg and Isabelle Hyman. Architecture: from Prehistory to Post-Modernism. p542-4.

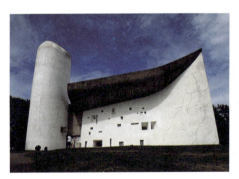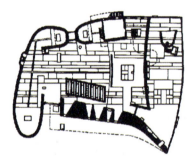

Fig. 1-6-4　Ronchamp Church

专业词汇

staircase　['steəkeis]　楼梯
narrow ribbon window　条状长窗
rectilinear　[ˌrekti'liniə(r)]　直线
ferroconcrete　['ferəʊkɒnkriːt]　钢筋混凝土
surrealism　[sə'riəˌlizəm]　超现实主义
oblong　['ɑblɔŋ]　长方形的,椭圆形的
nave　[neiv]　中殿
free standing pillars　自由柱网
vernacular materials　地方材料
articulate　[ɑː'tikjuleit]　枢接

modular ['mɒdjələ(r)] 组合式的;模块化的
Utopian ideals 理想主义
five points of architecture 建筑五点论
post-war building 战后建筑
town-planning 城市规划
balcony ['bælkəni] 阳台
chapel ['tʃæpl] 小教堂
apartment [ə'pɑːtmənt] 公寓

难句翻译

① From 1922 Le Corbusier worked with his cousin Pierre Jeanneret. During this time, Le Corbusier's ideas began to take physical form, mainly as houses which he created as "a machine for living in" and which incorporated his trademark five points of architecture.

勒·柯布西耶从1922年起与表弟皮埃尔·让纳雷合作。在此期间勒·柯布西耶的想法开始付诸实现,主要作品为被他称作"居住机器"的房屋。这些作品体现了他的建筑五点论的观点。

② The dominant element is the square single-storied box, a pure, sleek, geometric envelope lifted buoyantly above slender pilots, its taut skin slit for narrow ribbon windows that run unbroken from corner to corner (but not over them, thus preserving the integrity of the sides of the square).

最明显的特点是其单层方盒形的构造。纯粹而简洁的几何围屋被纤细的支柱轻盈地举起。条状长窗划开房屋平整的立面,并从墙面的一端到另外一端(为保证方体边棱的完整性,条状长窗没有开在房屋的四角边上)。

Le Corbusier(勒·柯布西耶)

勒·柯布西耶是20世纪最著名的建筑大师、城市规划家和作家。他是现代建筑运动的激进分子和主将。他也是现代主义建筑的主要倡导者,机器美学的重要奠基人。他是20世纪多才多艺的建筑大师,出版了50多部专著并撰写大量文章。1965年8月27日,勒·柯布西耶在Cap Martin海湾游泳时因心脏病发作而与世长辞。

From

http://www.greatbuildings.com/architects

1.7

Louis Isadore Kahn and His Masterpieces

Louis Isadore Kahn (1901—1974), U. S. architect, educator, and philosopher, is one of the foremost twentieth-century architects. Louis I. Kahn evolved an original theoretical and formal language that revitalized modern architecture. His best known works, located in the United States, India, and Bangladesh, were produced in

the last two decades of his life. They reveal an integration of structure, a reverence for materials and light, a devotion to archetypal geometry, and a profound concern for humanistic values(Fig. 1-7-1).

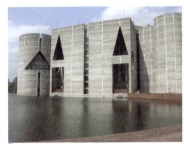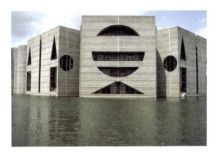

Fig. 1-7-1　Louis Isadore Kahn and The Salk Institute

Born on the Baltic island of Osel, Louis Isadore Kahn's family emigrated to Philadelphia, Pennsylvania, in 1905, where Louis Isadore Kahn lived the rest of his life. Trained in the manner of the Ecole des Beaux Arts under Paul Philippe Cret, Louis Isadore Kahn graduated from the University of Pennsylvania School of Fine Arts in 1924. Among his first professional experiences was the 1926 Philadelphia Sesquicentennial Exhibition. In the following years he worked in the offices of Philadelphia's leading architects, Paul Cret and Zantzinger, Borie and Medary. During the leaning years of the 1930s, Louis Isadore Kahn was devoted to the study of modern architecture and housing in particular.

In the later 1930s Louis I. Kahn served as a consultant to the Philadelphia Housing Authority and the United States Housing Authority. His familiarity with modern architecture was broadened while working with European emigres Alfred Kastner and Oskar Stonorov. In the early 1940s he associated with Stonorov and George Howe, with whom he designed several wartime housing projects such as Carver Court in Coatesville, Pennsylvania and Pennypack Woods in Philadelphia. His interest in public housing culminated in Philadelphia's Mill Creek Housing project. From these experiences, Louis Isadore Kahn developed a deep sense of social responsibility reflected in his later philosophy of the "institutions" of man.

The year 1947 was a turning point in Louis Isadore Kahn's career. Kahn established an independent practice and began a distinguished teaching career, first at Yale University as Chief Critic in Architectural Design and Professor of Architecture and then at the University of Pennsylvania as Cret Professor of Architecture. During those years, his ideas about architecture and the city took shape. Eschewing the international style **modernism** that characterized his earlier work, Kahn sought to redefine the bases of architecture through a reexamination of structure, form, space, and light.① Louis Isadore Kahn described his quest for meaningful form as a search for "beginnings," a spiritual resource from which modern man could draw inspiration. The powerful and evocative forms of **ancient brick** and stone ruins in Italy, Greece, and Egypt where Louis I. Kahn traveled in 1950—1951 while serving as Resident Architect at the American Academy in Rome were an inspiration in his search for what is timeless and essential. The effects of this European Odyssey, the honest display of structure, a desire to create a sense of place, and a vocabulary of abstract forms rooted in Platonic geometry resonate in his later masterpieces of brick and concrete, his preferred materials. Louis Isadore Kahn reintroduced geometric, axial plans, centralized spaces, and a sense of solid mural strength, reflective of his **beaux-arts** training and eschewed by modern architects(Fig. 1-7-2).

Louis Isadore Kahn's first mature work, the addition to the Yale University Art Gallery, indicates his interest in experimental structural systems. The floor slabs of poured-in-place concrete were inspired by **tetrahedral space** frames. The raw **texture** of the concrete reveals his belief that the method of construction should not be concealed. The hollow, pyramidal spaces in the ceiling, which accommodate lighting and

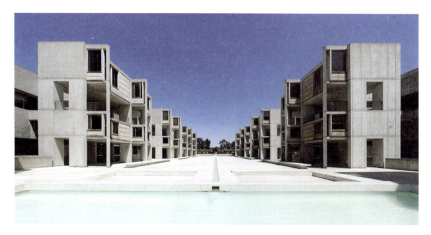

Fig. 1-7-2 Salk Institute

mechanical systems, anticipate his later idea of "served and servant spaces" the hierarchical definition of a building's functions. The expression of served and servant spaces is clearly enunciated in two later works, the Richards Medical Research Building at the University of Pennsylvania and the Salk Institute for Biological Studies. In the design of the Richards Building, Louis Isadore Kahn gave form to a brilliant structural system devised with the engineer August E. Komendant, with whom Louis Isadore Kahn collaborated on numerous projects. The laboratories were constructed of precast, post-tensioned reinforced concrete, a system that permitted large flexible laboratory spaces. The servant spaces containing stairs and exhaust **chimneys** become monumental brick towers attached to the perimeter of the cellular laboratory spaces. The towers form a silhouette complementing the chimneys and towers of the neighboring collegiate Gothic dormitories, and in an abstract guise they suggest the towers of medieval Italian towns that Louis Isadore Kahn admired.

In the design of the Salk Institute, Louis Isadore Kahn gives further expression to servant spaces with a 9-ft-high mechanical floor sandwiched between laboratory floors much more than the demonstration of service spaces. The Salk Institute is an example of Louis Isadore Kahn's desire to give form to the institutions of man. In a spectacular setting overlooking the Pacific Ocean, two long laboratory wings flank a stone-paved plaza bisected by a narrow rill. In accord with the wishes of the patron and founder Dr. Jonas Salk, Louis Isadore Kahn created an environment where the interdependency of scientific and humanistic disciplines could be realized. While he exhibited a compelling concern for structure, Louis Isadore Kahn sought to infuse his buildings with the symbolic meaning of the institutions they housed. Composed of austere geometries, his spaces are intended to evoke an emotional, empathetic response. "Architecture," Kahn said, "is the thoughtful making of spaces". Beyond its functional role, Louis Isadore Kahn believed architecture must also evoke the feeling and symbolism of timeless human values.② Louis I. Kahn attempted to explain the relationship between the rational and romantic dichotomy in his "form-design" thesis, a theory of composition articulated in 1959. In his personal philosophy, form is conceived as formless and unmeasur-able, a spiritual power common to all mankind. It transcends individual thoughts, feelings, and conventions.③

Form characterizes the conceptual essence of one project from another, and thus it is the initial step in the creative process. Design, however, is measurable and takes into consideration the specific **circumstances** of the program. Practical and functional concerns are contained in design. The union of form and design is realized in the final product, and the building's symbolic meaning is once again unmeasurable.

In his search for a formal vocabulary symbol of man's institutions, Louis Isadore Kahn consistently based his **compositions** on a centralized enclosed space surrounded by secondary spaces. Kahn created a cloistered,

contemplative atmosphere within the walls. This is seen most clearly in the design of the Jewish Community Center Bath House, the First Unitarian Church, Erdman Hall, Phillips Exeter Academy Library, and in one of Louis Isadore Kahn's most **monumental works**, the National Capital of Bangladesh.

Kahn's preference for the enclosed core is pervasive in his work, appearing at various scales. As a "hollow stone," it was the basic structural element in the City Tower project, a triangulated space frame structure designed with Anne G. Tyng. At Dacca, the concrete diamond-shaped Parliament Building rises from the head of the capital complex. Its center contains the assembly hall, which is surrounded by secondary rooms. Using universal abstract geometry, Louis Isadore Kahn evoked an archaic, awe-inspiring past to symbolize the unity inherent in his understanding of the institution of assembly. On a much larger scale, Louis Isadore Kahn envisioned Philadelphia's inner city surrounded by a wall of parking towers that serves to defend the symbolic institutions in the pedestrian core from the encroaching automobile. By means of the central enclosed core, often integrated with the idea of served and servant spaces, Louis Isadore Kahn established a sense of order that synthesizes differentiated and specific spaces.

Natural Light Design

Integral to Kahn's notion of timeless form in the making of significant architectural spaces is the role of **natural light**. Louis Isadore Kahn described structure as the giver of light. For several projects located in hot sunny climates, such as the U. S. Consulate in Luanda, Angola, the meeting houses of the Salk institute, the Indian Institute of Management, and the National Capital at Dacca, Louis Isadore Kahn developed visually dynamic sunscreens. Great walls with variously shaped openings shield inner rooms from the harsh light. The evocation of a wall in ruins suggests an ancient part Louis Isadore Kahn's handling of light is a central theme in two unrealized synagogue projects, Mikveh Israel and Hurva as well as in one of his greatest works the **Kimbell Art Museum**. In the art museum, light enters through narrow slits in the concrete cycloid vaults and is diffused through the gallery interiors, which are rich with travertine and oak(Fig. 1-7-3).

Fig. 1-7-3　Kimbell Art Museum

Several open **courtyards** also provide light, each containing different reflective surfaces such as **foliage** or water to convey a different quality of light. Light is the central theme as well in one of Louis Isadore Kahn's last philosophical concepts, "silence and light." Silence represents the darkness of the beginning, and light symbolizes the source of life, the inspiration of the creative act.

The greatest honors were bestowed on Louis Isadore Kahn for his achievements in architecture and education, among which was the Gold Medal from the **American Institute of Architects** in 1971. After Kahn's death his drawings and papers were purchased by the Commonwealth of Pennsylvania and placed in the custody of the Pennsylvania Historical and Museum Commission. They have been given a permanent home at the University of Pennsylvania(Fig. 1-7-3).

专业词汇

modernism [ˈmɒdənizəm] 现代主义
beaux-arts 学院派
slab [slæb] 厚板
tetrahedral space 四面体空间
ancient brick 古老的砖
chimney [ˈtʃimni] 烟囱
foliage [ˈfəʊliidʒ] 植物叶子
courtyard [ˈkɔːtjɑːd] 庭院
natural light 自然光
monumental works 不朽的作品
American Institute of Architects(AIA) 美国建筑师协会
texture [ˈtekstʃə(r)] 纹理
scale [skeil] 比例
circumstance [ˈsɜːkəmstəns] 境况，境遇
composition [ˌkɒmpəˈziʃn] 构图
Kimbell Art Museum 金贝尔艺术博物馆

难句翻译

① Eschewing the international style modernism that characterized his earlier work, Kahn sought to redefine the bases of architecture through a reexamination of structure, form, space, and light.

避开他早期作品的国际化现代主义风格，路易斯·康试图通过重审结构、造型、空间和光线来重新定义建筑的基础。

② Composed of austere geometries, his spaces are intended to evoke an emotional, empathetic response. "Architecture," Kahn said, "is the thoughtful making of spaces". Beyond its functional role, Louis Isadore Kahn believed architecture must also evoke the feeling and symbolism of timeless human values.

由朴素的几何形构成，他设计的空间试图唤起情绪性共鸣。路易斯·康说"建筑就是深思熟虑地构造空间"。除功能性外，路易斯·康还认为建筑应能唤起体现永恒人性价值的情感与象征。

③ In his personal philosophy, form is conceived as formless and unmeasur-able, a spiritual power common to all mankind. It transcends individual thoughts, feelings, and conventions.

他个人的哲学观认为，造型是无形的、不可测的，是一种全人类共享的精神力量。它能使个人的思想、感情和习惯得到升华。

Louis Isadore Kahn（路易斯·康）

路易斯·康是美国现代主义建筑大师，1901年2月出生于爱沙尼亚的萨拉马岛。1905年随父母移居美国费城，1924年毕业于费城宾夕法尼亚大学。1935年创立了自己的建筑事务所。路易斯·康发展了建筑设计中的哲学概念，被誉为建筑界的诗哲。他认为盲目崇拜技术和程式化设计会使建筑缺乏立面特征，主张每个建筑题目必须有特殊的约束性。他的作品坚实厚重，不表露结构功能，同时强调建筑中光影的运用，其代表作有耶鲁大学美术馆、金贝尔博物馆等。

From
http://architect.architecture.sk/

1.8

I. M. Pei and His Masterpieces

Ieoh Ming Pei (born 26 April 1917), commonly known by his initials I. M. Pei, is a Chinese American architect, often called a master of modern architecture. Born in Guangzhou and raised in Hong Kong and Shanghai, Pei drew inspiration at an early age from the gardens at Suzhou. In 1935 he moved to the United States and enrolled in the University of Pennsylvania's architecture school, but quickly transferred to the Massachusetts Institute of Technology. and spent his free time researching the emerging architects, especially Le Corbusier. After graduating, he joined the Harvard Graduate School of Design and became friends with the Bauhaus architects Walter Gropius and Marcel Breuer(Fig. 1-8-1).

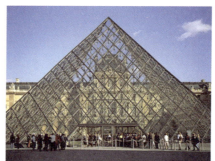
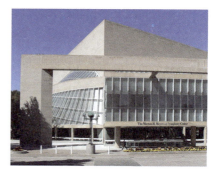

Fig. 1-8-1　Ieoh Ming Pei designed Louvre Museum entrance and The Morton H. Meyerson Symphony Center

Pei spent ten years working with New York real estate magnate William Zeckendorf before establishing his own independent design firm that eventually became Pei Cobb Freed & Partners. Among the early projects on which Pei took the lead were the L'Enfant Plaza Hotel in Washington, DC and the Green Building at MIT. His first major recognition came with the National Center for Atmospheric Research in Colorado; his new stature led to his selection as chief architect for the John F. Kennedy Library in Massachusetts. He went on to design Dallas City Hall and the East Building of the National Gallery of Art.

He returned to China for the first time in 1974 to design a hotel at **Fragrant Hills**, and designed a skyscraper in Hong Kong for the Bank of China fifteen years later. In the early 1980s, Pei was the focus of controversy when he designed a glass-and-steel **pyramid** for the **Louvre** museum in Paris. He later returned to the world of the arts by designing the Morton H. Meyerson Symphony Center in Dallas, the **Miho Museum** in Japan, and the Museum of Islamic Art in Qatar. Pei has won a wide variety of prizes and awards in the field of architecture, including the AIA Gold Medal in 1979, the first Praemium Imperiale for Architecture in 1989, and the Lifetime Achievement Award from the Cooper-Hewitt, National Design Museum in 2003. In 1983 he won the **Pritzker Prize**.

Dallas City Hall

Working with his associate Theodore, Pei developed a design centered on a building with a top much wider than the bottom; the **facade** leans at an angle of 34 degrees. A plaza stretches out before the building, and a series of support **columns** holds it up. It was influenced by Le Corbusier's High Court building in Chandigarh, India; Pei sought to use the significant overhang to unify building and plaza. The project cost much more than initially expected, and took 11 years. Revenue was secured in part by including a **subterranean parking garage**. The interior of the city hall is large and spacious; windows in the ceiling above the eighth floor fill the main space with light① (Fig. 1-8-2).

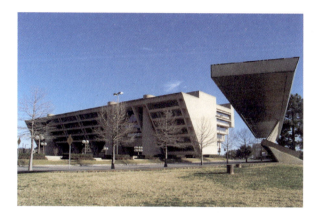
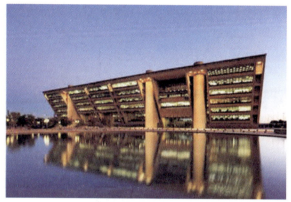

Fig. 1-8-2 Dallas City Hall

Louvre Pyramid

The Louvre Pyramid is a large glass and metal pyramid, surrounded by three smaller pyramids, in the main courtyard (Cour Napoleon) of the Louvre Palace (Palais du Louvre) in Paris. The large pyramid serves as the main entrance to the Louvre Museum. Completed in 1989, it has become a **landmark** of the city of Paris. The structure, which was constructed entirely with glass segments, reaches a height of 20.6 meters; its square base has sides of 35 meters. It consists of 603 **rhombus**-shaped and 70 **triangular** glass segments.

The pyramid and the underground lobby beneath it were created because of a series of problems with the Louvre's original main entrance, which could no longer handle an enormous number of visitors on an everyday basis.② Visitors entering through the pyramid descend into the spacious lobby then re-ascend into the main Louvre buildings. Several other museums have duplicated this concept, most notably the Museum of Science and Industry in Chicago.

The construction of the pyramid triggered considerable controversy because many people felt that the futuristic edifice looked quite out of place in front of the Louvre Museum with its classical architecture. Others lauded the **juxtaposition** of contrasting architectural styles as a successful merger of the old and the new, the classical and the **ultra-modern**.

The main pyramid is actually only the largest of several glass pyramids that were constructed near the museum, including the downward-pointing La Pyramide Inversée that functions as a **skylight** in an underground mall in front of the museum (Fig. 1-8-3).

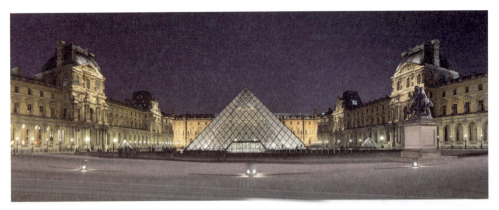

Fig. 1-8-3　Ieoh Ming Pei's pyramid

National Gallery of Art

The National Gallery of Art is a national art museum, located on the National Mall in Washington, D. C. Open to the public free of charge, the museum was established in 1937 for the people of the United States of America by a joint resolution of the United States Congress.

Two buildings comprise the museum: the West Building (1941) and the East Building (1978) linked by a spacious underground passage. The West Building, composed of pink Tennessee marble, was designed in 1937 by architect John Russell Pope in a **neoclassical** style. (as is Pope's other notable Washington, D. C. building, the Jefferson Memorial). Designed in the form of an elongated H, the building is centered on a domed rotunda modeled on the interior of the Pantheon in Rome. Extending west from the **rotunda**, a pair of high, skylit sculpture halls provide its main circulation spine. Bright garden courts provide a counterpoint to the long main axis of the building.

In contrast, the design of the East Building by architect I. M. Pei is rigorously geometrical, dividing the trapezoidal shape of the site into two triangles: one isosceles and the other a smaller right triangle. The space defined by the isosceles triangle came to house the museum's public functions. That outlined by the right triangle became the study center. The triangles in turn became the building's organized motif, echoed and repeated in every dimension. The building's most dramatic feature is its high atrium designed as an open interior court, enclosed by a sculptural space frame spanning 16 000 square feet (1 500 m^2). The **atrium** is centered on the same axis that forms the circulation spine for the West Building and constructed in the same Tennessee marble. The East Building focuses on modern and contemporary art, with a collection including works by Pablo Picasso, Henri Matisse, Jackson Pollock, Andy Warhol, Roy Lichtenstein and Alexander Calder. The East Building also contains the main offices of the NGA and a large research facility, Center for the Advanced Study in the Visual Arts (CASVA).

The two buildings are connected by a walkway beneath 4th street, called "the Concourse" on the museum's map. In 2008, the National Gallery of Art commissioned American artist Leo Villareal to transform the Concourse into an artistic installation. Today, Multiverse is the largest and most complex light sculpture by Villareal featuring approximately 41 000 computer-programmed LED nodes that run through channels along the entire 200-foot (61 m)-long space. The concourse also includes the food court and a gift shop[3] (Fig. 1-8-4).

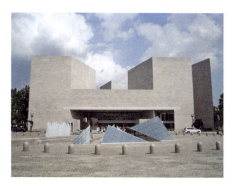 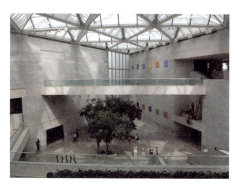

Fig. 1-8-4　The East Wing of the National Gallery of Art in Washington D. C.

专业词汇

Fragrant Hills　香山
Miho Museum　美秀博物馆
crystalline　['krɪstəlaɪn]　透明的、水晶制的
façade　[fə'sɑːd]　建筑物的正面
pyramid　['pɪrəmɪd]　金字塔
drawing skills　草图技法
The Pritzker Prize　普利兹克奖
minimalism　['mɪnɪməlɪzəm]　极简主义
column　['kɑləm]　圆柱
tangible　['tændʒəbl]　有形的
subterranean parking garage　地下停车场
landmark　['lændmɑrk]　地标、里程碑
rhombus　['rɑmbəs]　菱形
triangular　[traɪ'æŋgjələr]　三角(形)的
juxtaposition　[ˌdʒʌkstəpə'zɪʃn]　毗邻
Ultra-modern　超现代
neoclassical　[ˌniːəʊ'klæsɪkl]　新古典主义的
rotunda　[rəʊ'tʌndə]　圆形大厅
trapezoid　['træpəzɔɪd]　梯形
concourse　['kɒŋkɔːs]　中央大厅
skylight　['skaɪˌlaɪt]　天窗
atrium　['eɪtrɪəm]　中庭

难句翻译

① Pei sought to use the significant overhang to unify building and plaza. The project cost much more than initially expected, and took 11 years. Revenue was secured in part by including a subterranean parking garage. The interior of the city hall is large and spacious; windows in the ceiling above the eighth floor fill the main space with light.

贝聿铭试图利用巨大的屋檐来连接楼房与广场。项目开销比预期多出许多，并且花了11年才竣工。收支得以平衡的一部分原因来自附建的地下停车场。市政厅内部巨大宽敞，八楼顶上的天窗为主体空间提供了充足的光线。

② The pyramid and the underground lobby beneath it were created because of a series of problems with the Louvre's original main entrance, which could no longer handle an enormous number of visitors on an everyday basis.

之所以建造金字塔和下方的地下大厅是因为卢浮宫原入口有许多问题，无法承载每日出入的数量巨大的参观者。

③ Today, Multiverse is the largest and most complex light sculpture by Villareal featuring approximately 41 000 computer-programmed LED nodes that run through channels along the entire 200-foot (61 m)-long space. The concourse also includes the food court and a gift shop.

现今"多元宇宙"是维拉甲尔创作的最大型且最复杂的灯具雕塑。在200英尺(61米)长的空间里4.1万盏电控LED节点布满通道。中央大厅还设置了餐饮区和礼品店。

I. M. Pei（贝聿铭）

贝聿铭1917年4月26日出生于中国广州，祖籍苏州，是苏州望族之后。作为20世纪最成功的美籍华人建筑师，他设计了大量划时代的作品。其中以公共建筑、文教建筑为主要代表，如华盛顿国家美术馆东馆、法国巴黎卢浮宫扩建工程等。贝聿铭的建筑设计有四个特色：一是建筑造型与所处环境自然协调；二是空间处理独具匠心；三是建筑材料考究；四是建筑内部空间细节精巧。贝聿铭设计的大型建筑有百项以上，且获奖无数。1983年，他获得了建筑界的最高奖项普里兹克奖。2019年5月16日，贝聿铭在美国纽约去世，享年102岁。

From

http://wenku.baidu.com/link?url=ZrbrfkHf0AKw6_SqOHJaNFOyTdKvXcJg4CMExPNnZnCROSbpQ5t4rV7KvKvcfSZqhrjoWXEd64KQXdvUUAO6GjpuGRCjWzxJussT-Y5uWpq

1.9

Tadao Ando and His Masterpieces

Tadao Ando was born in 1941 in Osaka, Japan. Growing up in that city as Japan recovered from the war, Tadao Ando spent the most of time out of doors, and was raised by his grandmother, whose name was "ando". From the age of 10 to 17 Tadao Ando worked at local carpenter, where Tadao Ando learned how to work with wood and built a number of models of airplanes and ships. His studying was very unusual. "I was never a good student. I always preferred learning things on my own outside of class. When I was about 18, I started to visit temples, shrines and tea houses in Kyoto and Nara; There's a lot of great traditional architecture in the area. I was studying architecture by going to see actual building, and reading books about them." His first interest in architecture was nourished by buying a book of Le Corbusier sketches. "I traced the drawings of his early period so many times, that all pages turned black," says Tadao Ando: "in my mind I quite often wonder how

Le Corbusier would have thought about this project or that."(Fig. 1-9-1)

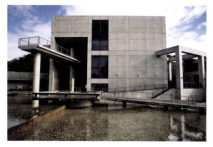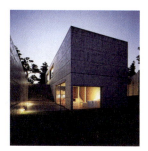

Fig. 1-9-1 Tadao Ando and his masterpieces

Tadao Ando took a number of visits to the United States, Europe and Africa in the period between 1962 and 1969. It was certainly at that time that Tadao Ando began to form his own ideas about architectural design, before founding Tadao Ando Architectural & Associates in Osaka in 1969. Tadao Ando's winner of many prestigous architectural awards, for example Carlsberg Prize (1992), Pritzker Prize (1995), Praemium Imperiale (1996), Gold Medal of Royal Institute of British Architects (1997) and now is one of the most highly respected architect in the world, influencing an entire generation of students.

The first impression of his architecture is its **materiality**. His large and powerful walls set a limit. A second impression of his work is the **tactility**. His hard walls seem soft to touch, admit light, wind and stillness. Third impression is the **emptiness**, because only light space surrounds the visitor in Tadao Ando's building.①

Other things that had influenced his work and vocabulary of architecture is the **Pantheon** in Rome and "enso", which is mysterious circle drawn by **Zen-Buddhists** and symbolizing emptiness, loneliness, oneness and the moment of enlightment. The circle and other rigorous geometrical forms are the basic forms of Tadao Ando's art presentation.

Tadao Ando is the world's greatest living architect. If Tadao Ando has one weakness, it maybe a difficulty in translating the **grandeur** of his smaller buildings to a larger scale.

Row House

Tadao Ando's first design work was **Row House** in Sumiyoshi, Osaka in 1975. This mentioned building was a simple block building, inserted into a narrow street of row houses. This residence is immediately noticeable because of its blank concrete facade punctuated only by doorway. The whole object space is divided into a three equal **rectangular** spaces, while the central part is atrium. The space nearest the doorway contains the living room at ground level, and the bedroom above.② The last final space contains the kitchen and bathroom below, and the master bedroom above, built in the wooden residential area above the port city of Kobe(Fig. 1-9-2).

Koshino House

The Koshino House, second realisation of Tadao Ando, was completed in two phrases. This house is a masterpiece, and collects all fragments of Tadao Ando's architectonical vocabulary, mainly the light. "Such things as light and wind only have meaning when they are introduced inside a house in a form cut off from the outside world. The forms I have created have altered and acquired meaning through elementary nature (light

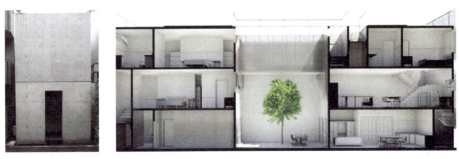

Fig. 1-9-2　Sumiyoshi Row House

and air) that gives indications of the passage of time and changing of the seasons."③ (Fig. 1-9-3)

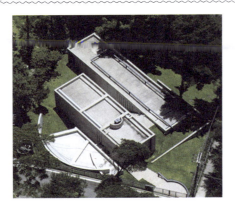 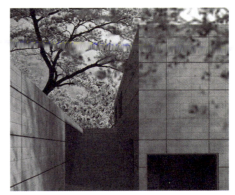

Fig. 1-9-3　Koshino House

All Tadao Ando's work is characteristically simple, and we can find similar forms in the first half of 20th century: "I am interested in a dialogue with the architecture of the past", Tadao Ando says, "but it must be filtered through my own vision and my own experience. I am indebted to Le Corbusier and Ludwig Mies van der Rohe, but the same way, I take what they did and interpret it in my own fashion."

Rokko Housing Ⅰ

One of the first projects to bring international attention to Tadao Ando was his Rokko Housing Ⅰ, which is situated much further down the slope of the Rokko Mountains than the Koshino house. This complex is wedged into a restricted site on a south-facing 60 degrees slope. Each of the 20 units is 5.4×4.8 m in size, and each has a terrace looking out towards the bush harbour of Kobe. Why was this monumental resident building so successful? Tadao Ando thought architecture becomes interesting when it has a double character, that is, when it is as simple as possible but, at the same time as complex as possible.

Some years later, Tadao Ando built a second housing complex, adjacent to Rokko Housing Ⅰ. (Rokko Housing Ⅱ.). Four times larger than the original building, this structure includes 50 dwellings, designed on a 5.2 m square grid. A third and even larger structure is now under way above Rokko Housing Ⅱ. (Rokko Housing Ⅲ.), under construction(Fig. 1-9-4).

Christian chapels

Tadao Ando's most remarkable works are certainly the religions buildings. "I feel that the goal of most religions is similar, to make men happier and more at ease with themselves. I see no contradiction in my

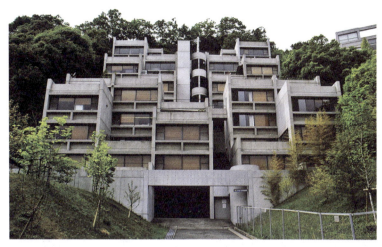

Fig. 1-9-4　Rokko Housing I

designing christian churches. " Tadao Ando has built a number of christian chapels and other places of religion and contemplation. One of the most amazing church is also one of his simplest. The church of the light is located in a residential suburb 40 km to the north-east of the center of Osaka. It consists from a rectangular concrete box crossed at 15 degrees angle by freestanding wall. The bisecting wall obliges the visitor to turn to enter the chapel. As ever with Tadao Ando, entering a building requires an act of will and an awareness of the architecture. In an unusual configuration, the floor descends in stages toward the altar, which is next to the rear wall, whose horizontal and **vertical** openings form a cross, flooding the space with light(Fig. 1-9-5).

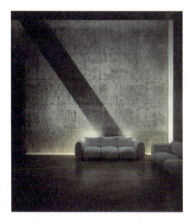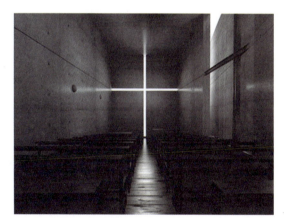

Fig. 1-9-5　Christian chapel

Water Temple

Awaji is the largest island of the inland sea, set 600 km to the south-west of Tokyo opposite Kobe in the bay of Osaka. Here, on hill above a small port, Tadao Ando built his Water Temple. Following a small footpath, the visitor first sees a long concrete wall, 3 m high, with a single opening. Through this door one does not find an entrance, but rather another wall, blank, but carved this time, bordered by a white **gravel** path. Having walked past this new screen of concrete, the visitor discovers an oval lotus pond, 40 m long and 30 m wide. In the centre of the pond, a stair way descends to the real entrance of the temple. Below the Lotus Pond, within a circle 18 m in **diameter**, the architect has inscribed a 17.4 m square. Here, within a grid of red

wood, a statue of buddha turns its back to the west, where the only openings admit the glow of the setting sun. In this place at sunset the words of Tadao Ando can be more clearly understood: "architecture," Tadao Ando says, "has forgotten that space can be a source of inspiration." The other religious buildings are: Water Temple in Hyiogo, Meditation space UNESCO in Paris, etc(Fig. 1-9-6).

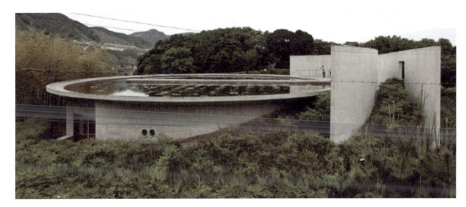

Fig. 1-9-6　Water Temple

Museums

The Children's museum is located on a large wooded hillside site **overlooking** a lake near the city of Himeji. In this mature work of Tadao Ando, the visitor is invited to discover the architecture in relation to its natural setting. The main unit of the museum contains a library, indoor and outdoor theatres, an exhibition gallery, a multipurpose hall and a restaurant. The outdoor theater is located on the rooftop, with a spectacular view of the lake. A stepped waterfall and pool near the building also serve to make a connection between the museum and the scenery of the lake. A path, marked by a long concrete wall leads the visitor away from the main structure toward a workshop complex consisting of a **two-story square building**.

Along this path Tadao Ando has placed a surprising group of 16 concrete columns in a square grid. In their wooded setting, these 9 m high **pillars** recall that the first columns in architectural history were inspired by trees. Just down the road from the children's museum, Tadao Ando designed the Children's Seminar House, a residence for schoolchildren on vacation, which is capped by a small observatory. The other museums are: The Museum of Literature, Naoshima Contemporary Art museum, Chikatsu-Asuka Historical museum, etc.

There are many islands in the inland sea of Japan that are architectonically designed into a small cities. There are projects like Naoshima Museum and hotel located at the southern end of island Naoshima, and the great project for Awaji island, Hyogo. It was designed in 1992 and from year 1997 is under construction. This north-eastern shore of Awajishima, Tadao Ando describes it: "The program is for multi-use facility including a **botanic garden**, a place for the study of **horticulture**, an **open-air theater**, a **convention hall**, a hotel and a guest house. Our first idea was to restore the greenery, more specifically to hold a flower exposition there and to develop the idea into a permanent garden. We called this the **millenium garden**, and the project was developed on the basis of that **concept**. It was decided that the facilities would be linked by living things, that is, plants such as trees and flowers, and the flow of water and people. The Alhambra in Granada provides a historical model.④"

专业词汇

grandeur ['grændʒər,-dʒʊr] 伟大、宏伟
materiality [mə,tɪəri'æliti] 物质性
tactility [tæk'tiliti] 触知性、触感
emptiness ['emptinəs] 空虚
Zen-Buddhist 禅宗佛教
row house 长屋、排屋
rectangular [rek'tæŋgjələ(r)] 矩形
adjacent [ə'dʒeisnt] 邻近的、毗邻的
vertical ['vɜːtikl] 垂直的
gravel ['grævl] 砾石
pantheon ['pænθiən] 万神殿
overlooking [əuvə'lukiŋ] 俯视
pillar ['pilər] 柱、台柱
concept ['kɑnsept] 概念
Millennium garden 千禧花园
open-air theater 露天剧场
botanic garden 植物园
convention hall 市政大厅
horticulture ['hɔːtikʌltʃə(r)] 园艺(学)、园艺学的
two-story square building 两层楼面积的建筑

难句翻译

① The first impression of his architecture is its materiality. His large and powerful walls set a limit. A second impression of his work is the tactility. His hard walls seem soft to touch, admit light, wind and stillness. Third impression is the emptiness, because only light space surrounds the visitor in Tadao Ando's building.

他的建筑给人的第一印象是其材料性。他利用巨大宏伟的墙壁设限。他的建筑给人的第二印象是触觉性。坚硬的墙壁看上去触感柔软,明亮、通风且沉稳。他的建筑给人的第三印象是空旷性,因为置身于安藤忠雄的建筑中时参观者视野开阔。

② The whole object space is divided into a three equal rectangular spaces, while the central part is atrium. The space nearest the doorway contains the living room at ground level, and the bedroom above.

整体空间分成三个长方体,中间为中庭。门口的空间包括一楼的客厅和楼上的卧房。

③ "Such things as light and wind only have meaning when they are introduced inside a house in a form cut off from the outside world. The forms I have created have altered and acquired meaning through elementary nature (light and air) that gives indications of the passage of time and changing of the seasons."

"光与风只有与外界隔绝、被引入屋内才获得意义。自然元素(如光线和空气)提示了时间的流逝和季节的变化。我设计的结构也因此而改变并获得意义。"

④ It was decided that the facilities would be linked by living things, that is, plants such as trees and flowers, and the flow of water and people. The Alhambra in Granada provides a historical model.

设施应与活物相连,比如树木花朵等植物,比如流水与人流。格拉纳达的阿尔罕布拉宫就是一个历史典型。

Tadao Ando(安藤忠雄)

安藤忠雄,日本著名建筑师,1941 年 9 月 13 日出生于日本大阪,1969 年创办安藤忠雄建筑研究所。安藤忠雄被称为"没有文化的建筑鬼才",他虽然从未接受过正规的科班教育,却开创了一套独特、崭新的建筑风格,成为当今最为活跃、最具影响力的世界建筑大师之一。安藤忠雄相信建筑必须具备三要素:第一要素是可靠的材料,如纯粹朴实的清水混凝土,所以他也有"清水混凝土诗人"的美称;第二要素是正宗完全的几何形式,这种形式为建筑提供基础和框架;第三要素是人工化自然。他的代表作有住吉的长屋(Sumiyoshi Row House)、光之教室(Church of the Light)等。

From

http://architect.architecture.sk/

1.10
Daniel Libeskind and His Masterpieces

Daniel Libeskind is a Polish American architect, artist, professor and **setting designer** of Polish Jewish descent. His buildings include the Jewish Museum in Berlin, Germany, the **extension** to the Denver Art Museum in the United States, the Grand Canal Theatre in Dublin, the Imperial War Museum North in Greater Manchester, England, the Michael Lee-Chin Crystal at the Royal Ontario Museum in Toronto, Canada, the Felix Nussbaum Haus in Osnabrück, Germany, Dresden's Military History Museum(Fig. 1-10-1 & Fig. 1-10-2) the Danish Jewish Museum in Copenhagen, Denmark, and the Wohl Centreat the Bar-Ilan University in Ramat-Gan, Israel. His portfolio also includes several residential projects. Libeskind's work has been exhibited in major museums and galleries around the world, including the Museum of Modern Art, the Bauhaus Archives, the Art Institute of Chicago, and the Centre Pompidou. On February 27, 2003, Libeskind won the competition to be the master plan architect for the reconstruction of the World Trade Center site in Lower Manhattan(Fig. 1-10-1).

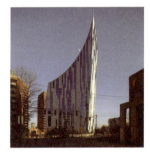
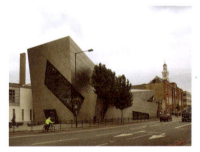

Fig. 1-10-1 Daniel Libeskind and his masterpieces

Libeskind began his career as an architectural theorist and professor, holding positions at various

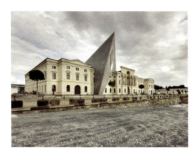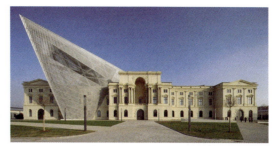

Fig. 1-10-2　Dresden's Military History Museum

institutions around the world. His practical architectural career began in Milan in the late 1980s, where he submitted to architectural competitions and also founded and directed Architecture Intermundium, Institute for Architecture & Urbanism. Libeskind completed his first building at the age of 52, with the opening of the Felix Nussbaum Haus in 1998. Prior to this, critics had dismissed his designs as "**unbuildable** or unduly assertive." In 1987, Libeskind won his first design competition for housing in West Berlin, but the Berlin Wall fell shortly thereafter and the project was canceled.

Berlin Jewish Museum

In 1987, the Berlin government organized an anonymous competition for an expansion to the original Jewish Museum in Berlin that opened in 1933. The program wished to bring a Jewish presence back to Berlin after WW Ⅱ. In 1988, Daniel Libeskind was chosen as the winner among several internationally renowned architects. His design was the only project that implemented a radical, formal design as a conceptually expressive tool to represent the Jewish lifestyle before, during, and after the Holocaust.

The original Jewish Museum in Berlin was established in 1933, but it wasn't open very long before it was closed during Nazi rule in 1938. Unfortunately, the museum remained vacant until 1975 when a Jewish cultural group vowed to reopen the museum attempting to bring a Jewish presence back to Berlin. It wouldn't be until 2001 when Libeskind's addition to the Jewish Museum finally opened (completed in 1999) that the museum would finally establish a Jewish presence embedded culturally and socially in Berlin.

For Libeskind, the extension to the Jewish Museum was much more than a competition/commission. It was about establishing and securing an identity within Berlin, which was lost during WW Ⅱ. Conceptually, Libeskind wanted to express feelings of absence, emptiness, and **invisibility**-expressions of disappearance of the Jewish Culture.① It was the act of using architecture as a means of **narrative** and emotion providing visitors with an experience of the effects of the **Holocaust** on both the Jewish culture and the city of Berlin.

The project begins to take its **form** from an abstracted Jewish Star of David that is stretched around the site and its context. The form is established through a process of connecting lines between locations of historical events that provide structure for the building resulting in a literal extrusion of those lines into a "**zig-zag**" building form.

Even though Libeskind's extension appears as its own separate building, there is no formal exterior entrance to the building. In order to enter the new museum extension, one must enter from the original Baroque museum in an underground **corridor**. A visitor must endure the anxiety of hiding and losing of the sense of direction before coming to a cross roads of three routes. The three routes present opportunities to witness the Jewish experience through the continuity with German history, emigration from Germany, and the Holocaust.② Libeskind creates a promenade that follows the "zig-zag" formation of the building for visitors to

walk through and experience the spaces within(Fig. 1-10-3).

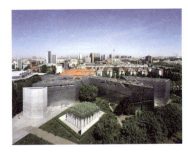 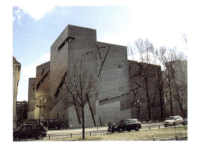 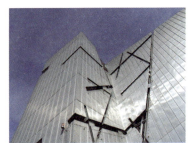

Fig. 1-10-3 The Jewish Museum airview

From the **exterior**, the interior looks as if it will be similar to the exterior perimeter, however, the interior spaces are extremely complex. Libeskind's formulated promenade leads people through galleries, empty spaces, and dead ends. A significant portion of the extension is void of windows and difference in materiality.

The interior is composed of reinforced concrete which reinforces the moments of the empty spaces and dead ends where only a **sliver** of light is entering the space. It is a symbolic gesture by Libeskind for visitors to experience what the Jewish people during WWⅡ felt, such that even in the darkest moments where you feel like you will never escape, a small trace of light restores hope.③

One of the most emotional and powerful spaces in the building is a 66 meters tall **void** that runs through the entire building. The concrete walls add a cold, overwhelming atmosphere to the space where the only light **emanates** from a small slit at the top of the space. The ground is covered in 10 000 coarse iron faces. A **symbol** of those lost during the Holocaust; the building is less of a museum but an experience depicting what most cannot understand(Fig. 1-10-4).

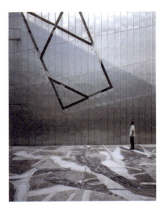 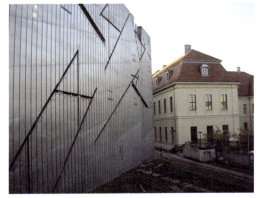 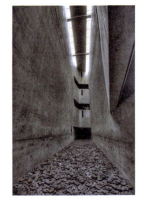

Fig. 1-10-4 The Jewish Museum Wall Details

Libeskind's extension leads out into the Garden of **Exile** where once again the visitors feel lost among 49 tall **concrete pillars** that are covered with plants. The overbearing pillars make one lost and confused, but once looking up to an open sky there is a moment of **exaltation**. Libeskind's Jewish Museum is an emotional journey through history. The architecture and the experience are a true testament to Daniel Libeskind's ability to translate human experience into an architectural composition.

"The Jewish Museum is conceived as an emblem in which the invisible and the visible are the structural features which have been gathered in this space of Berlin and laid bare in an architecture where the unnamed remains the name which keeps still."

——Daniel Libeskind

专业词汇

setting designer　舞台布景设计师
extension　[ikˈstenʃn]　伸展、扩大
embedded　[imˈbedid]　嵌入式的
form　[fɔːm]　形式
corridor　[ˈkɒridɔː(r)]　走廊
Jewish Museum　犹太人博物馆
unbuildable　[ʌnˈbildeibl]　名不见经传的
concrete pillar　混凝土柱子
invisibility　[inˌvizəˈbiləti]　透明性
emanate　[ˈeməneit]　发出、散发
sliver　[ˈslivər]　长条、细片
symbol　[ˈsimbl]　象征
exile　[ˈeɡˌzail, ˈekˌsail]　流放
narrative　[ˈnærətiv]　记叙文
exaltation　[ˌeɡzɔːlˈteʃn]　兴奋、得意扬扬
anonymous　[əˈnɑnıməs]　匿名的
holocaust　[ˈhɑləkɔst]　大屠杀
exterior　[ikˈstiəriə(r)]　外面的
void　[vɔid]　空的、没人住的

难句翻译

① For Libeskind, the extension to the Jewish Museum was much more than a competition/commission. It was about establishing and securing an identity within Berlin, which was lost during WWⅡ. Conceptually, Libeskind wanted to express feelings of absence, emptiness, and invisibility-expressions of disappearance of the Jewish Culture.

对李博斯金来说扩建犹太人博物馆不仅仅是一项比赛或一件委任。它的意义是在柏林建立并维护第二次世界大战中失去的一种身份。李博斯金的设计概念是表达缺席之空虚感和隐形——表现犹太文化的消失。

② The three routes present opportunities to witness the Jewish experience through the continuity with German history, emigration from Germany, and the Holocaust.

三条路线提供了观察犹太人经历的途径：德国历史脉络、德国移民与大屠杀。

③ It is a symbolic gesture by Libeskind for visitors to experience what the Jewish people during WWⅡ felt, such that even in the darkest moments where you feel like you will never escape, a small trace of light restores hope.

李博斯金的这种安排具有象征意义。他让参观者体验了第二次世界大战时犹太人的经历，在没有出路的最黑暗时刻，一小束光仍能重振希望。

Daniel Libeskind(丹尼尔·李博斯金)

丹尼尔·李博斯金1946年出生于波兰一个纳粹大屠杀幸存者的犹太人家庭，13岁跟随家人迁往以色列，

之后又移民美国。丹尼尔·李博斯金在纽约读完中学后，进入大学学习音乐，后来转到建筑系。毕业后，李博斯金以德国柏林为基地，组建了自己的建筑设计所。他曾任教于哈佛大学、耶鲁大学，在北美、欧洲、日本、澳大利亚等地进行过演讲。其博物馆建筑设计备受世人青睐，特别是德国柏林犹太人博物馆（Berlin Jewish Museum）、英国曼彻斯特帝国战争博物馆（Imperial War Museum North）及以色列特拉维夫展览中心（Tel Aviv Museum of Art）。

From

http://www.archdaily.com/91273/ad-classics-jewish-museum-berlin-daniel-libeskind/
https://en.wikipedia.org/wiki/Daniel_Libeskind

单元分类词汇总结

Space：	Tetrahedral space
Structure：	Free-standing pillars；Column；Ferroconcrete grid；Square grid；Concrete Pillar；Nave；Cloistered；Atrium；Terrace；Corridor；Staircase；Narrow ribbon window；Articulate；Balcony；Chimney；Courtyard；Skylight；Embedded
Shape：	Zig-zag；Oblong；Rectangular；Rectilinear；Rhombus；Triangular；Trapezoidal
Material：	Slab；Travertine；Gravel；Vernacular materials；Ancient brick
Exterior：	Concrete wall；Freestanding wall；Curtain wall；Millenium garden；Facade；Horticulture；Botanic garden
Interior：	Staircase；Subterranean parking garage；Concourse；Atrium；Rotunda；Concourse
Style：	Surrealism；Utopian ideals；Modernism；Beaux-arts；Minimalism；Ultra-modern；Neoclassical；Functionalism
Building：	Post-war building；Chapel；Apartment；Pyramid；Row house；Pantheon；Open-air theater；Convention hall；Two-story square building
Design：	Composition；Drawing skills；Overlooking；Setting designer；Five Points of Architecture；Scale
Museum：	Kimbell Art Museum；Louvre；Miho Museum；Jewish Museum；Military History Museum；The Children's Museum

单元2

景观设计师与他们的作品

Unit 2　Landscape Architects and Their Masterpieces

2.1 Frederick Law Olmsted and His Masterpieces

Frederick Law Olmsted (1822—1903) was an American **landscape architect**, journalist, social critic, and public administrator. He is popularly considered to be the father of American landscape architecture. Olmsted was famous for co-designing many well-known urban parks with his senior partner Calvert Vaux, including Prospect Park and **Central Park** in New York City, as well as Elm Park (Worcester, Massachusetts), considered by many to be the first municipal park in America(Fig. 2-1-1).

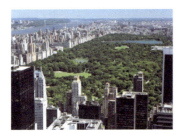
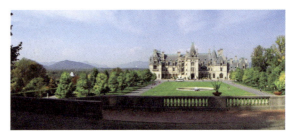

Fig. 2-1-1　Frederick Law Olmsted and his masterpieces

Other projects that Olmsted was involved in include the country's first and oldest coordinated system of public parks and parkways in Buffalo, New York; the country's oldest state park, the Niagara Reservation in Niagara Falls, New York; one of the first planned **communities** in the United States, Riverside, Illinois; Mount Royal Park in Montreal, Quebec; the Emerald Necklace in Boston, Massachusetts; Highland Park in Rochester, New York; Belle Isle Park, in the Detroit River for Detroit, Michigan; the Grand Necklace of Parks in Milwaukee, Wisconsin; Cherokee Park and entire parks and **parkway system** in Louisville, Kentucky; the 735-acre (297 ha) Forest Park in Springfield, Massachusetts, featuring America's first public "**wading pool**"; the George Washington Vanderbilt II Biltmore Estate in Asheville, North Carolina; the master plans for the University of California, Berkeley and Stanford University near Palo Alto, California as well as for The Lawrenceville School; and Montebello Park in St. Catharines, Ontario. In Chicago his projects include: Jackson Park; Washington Park; the Midway Plaisance for the 1893 World's Columbian Exposition; the **south portion** of Chicago's "emerald necklace" **boulevard** ring; Cadwalader Park in Trenton, New Jersey; and the University of Chicago **campus**. In Washington, D.C., he worked on the landscape surrounding the United States Capitol building.

The quality of Olmsted's landscape architecture was recognized by his contemporaries, who showed him with prestigious commissions. His work, in Central Park in New York City, set a standard of excellence that continues to influence landscape architecture in the United States. His second line of achievement involves his activism in conservation, including work at Niagara Falls, the Adirondack region of upstate New York, and the National Park system. Thirdly, he played a major role in organizing and providing medical services to the Union Army in the Civil War.

Comments on Frederick Law Olmsted's Masterpieces

Commentary

Central Park is an urban park in middle-upper Manhattan, New York City. Central Park is the most visited **urban park** in the United States as well as one of the most **filmed locations** in the world.

It opened in 1857 on 778 acres (315 ha) of city-owned land. In 1858, Frederick Law Olmsted and Calvert Vaux, two soon-to-be famed national landscapes and architects, won a design competition to improve and expand the park with a plan they titled the "Greensward Plan". Construction began the same year, continued during the American Civil War **further south**, and was expanded to its current size of 843 acres in 1873 (Fig. 2-1-2).

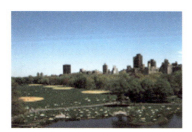 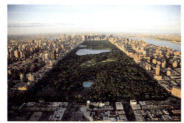 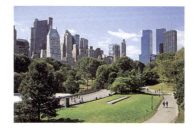

Fig. 2-1-2 Central Park

It was designated a National Historic Landmark (listed by the U. S. Department of the Interior and administered by the National Park Service) in 1962. The Park was managed for decades by the New York City Department of Recreation and Parks and is currently managed by the Central Park Conservancy under contract with the **municipal** government in a public-private partnership. The Conservancy is a non-profit organization that contributes 75% of Central Park's $57 million annual budget and employs 80.7% of the Park's **maintenance** staff.

Central Park, which has been a National Historic Landmark since 1962, was designed by landscape architect and writer Frederick Law Olmsted and the English architect Calvert Vaux in 1858 after winning a design competition. They also designed Brooklyn's Prospect Park. Central Park is one of the most famous **sightseeing spots** in New York. It is bordered on the north by Central Park North, on the south by Central Park South, on the west by Central Park West, and on the east by Fifth Avenue. Only Fifth Avenue along the park's eastern border retains its name; the other streets bordering the park (110th Street, 59th Street, and Eighth Avenue, respectively) change names while they are adjacent to the park. The park, with a perimeter of 6.1 miles (9.8 km), was opened on 770 acres (3.1 km^2) of city-owned land and was expanded to 843 **acres** (3.41 square kilometer; 1.317 square miles). It is 2.5 miles (4 km) long between 59th Street (Central Park South) and 110th Street (Central Park North), and is 0.5 miles (0.8 km) wide between Fifth Avenue and Central Park West. Central Park also constitutes its own United States **census tract**, number 143. According to Census 2000, the park's population is eighteen people, twelve male and six female, with a median age of 38.5 years, and a household size of 2.33, over 3 households. However Central Park officials have rejected the claim of anyone **permanently living** there. The real estate value of Central Park was estimated by property appraisal firm Miller Samuel to be about $528.8 billion in December 2005.

Central Park's **size** and **cultural position**, similar to London's Hyde Park and Munich's Englischer Garten, has served as a model for many urban parks, including San Francisco's Golden Gate Park, Tokyo's **Ueno Park**, and Vancouver's Stanley Park.

The park is maintained by the Central Park Conservancy, a private, not-for-profit organization that manages the park under a contract with the New York City Department of Parks and Recreation, in which the president of the Conservancy is ex officio Administrator of Central Park. Today, the conservancy employs 80% of maintenance and operations staff in the park. It effectively oversees the work of both the private and public employees under the authority of the Central Park administrator (publicly appointed), who reports to the parks commissioner, conservancy's president.[①] As of 2007, the conservancy had invested approximately $450 million in the restoration and management of the park; the organization presently contributes approximately 85% of Central Park's annual operating budget of over $37 million. The system was functioning so well that in 2006 the conservancy created the Historic Harlem Parks initiative, providing horticultural and maintenance support and mentoring in Morningside Park, St. Nicholas Park, Jackie Robinson Park, and Marcus Garvey Park.

The park has its own NYPD precinct, the Central Park Precinct, which employs both regular police and auxiliary officers. In 2005, **safety measures** held the number of crimes in the park to fewer than one hundred per year (down from approximately 1 000 in the early 1980s). The New York City Parks Enforcement Patrol also patrols Central Park. There is also an all-volunteer **ambulance service**, the Central Park Medical Unit, that provides free emergency medical service to patrons of Central Park and the surrounding streets. It operates a rapid-response **bicycle patrol**, particularly during major events such as the New York City Marathon, the 1998 Goodwill Games, and concerts in the park.

While planting and land form in much of the park appear natural, it is in fact almost entirely landscaped. The park contains several **natural-looking** lakes and ponds that have been created artificially, extensive **walking tracks**, **bridle paths**, two **ice-skating** rinks (one of which is a swimming pool in July and August), the Central Park Zoo, the Central Park Conservatory Garden, a wildlife sanctuary, a large area of natural woods, a 106-acre (43 ha) billion-gallon reservoir with an encircling running track, and an outdoor **amphitheater**, the Delacorte Theater, which hosts the "Shakespeare in the Park" summer festivals. **Indoor attractions** include Belvedere Castle with its nature center, the Swedish Cottage Marionette Theatre, and the historic Carousel. In addition there are seven major lawns, the "meadows", and many minor grassy areas; some of them are used for informal or team sports and some are set aside as **quiet areas**; there are a number of enclosed **playgrounds** for children. The 6 miles (9.7 km) of drives within the park are used by joggers, cyclists, skateboarders, and inline skaters, especially when automobile traffic is prohibited, on weekends and in the evenings after 7:00 pm.

专业词汇

landscape architect　景观建筑师
urban parks　城市公园
communities　[kəˈmjuːnitiz]　社区
parkway system　游路系统
wading pool　涉水池
south portion　南部
boulevard　[ˈbuːləvɑːd]　林荫大道
campus　[ˈkæmpəs]　校园
filmed locations　拍摄地点
further south　偏南
municipal　[mjuːˈnisipl]　市

maintenance ['meintənəns] 维护、修护
sightseeing spot 观光景点
acre ['eikə(r)] 土地、英亩
census tract 人口普查区
permanently living 固定居住区
size [saiz] 尺寸
cultural position 文化定位
safety measures 安全措施
ambulance service 救护车服务
bicycle patrol 单车巡逻
natural-looking 自然视线
walking tracks 行走轨道
bridle ['braidl] 控制
path [pæθ] 路径
ice-skating ['ais,skeitiŋ] 滑冰
amphitheater [,æmfiθiətə(r)] 半圆形露天剧场
indoor ['indɔ:(r)] 室内
attraction [ə'trækʃn] 吸引
quiet areas 安静区域
playground ['pleigraʊnd] 操场、游戏场地

难句翻译

① It effectively oversees the work of both the private and public employees under the authority of the Central Park administrator (publicly appointed), who reports to the parks commissioner, conservancy's president.

在民选中央公园管理员的带领下它有效地监督了私人和公共雇员的工作。工作情况由管理员向公园理事和管理委员会主席汇报。

Frederick Law Olmsted（弗雷德里克·劳·奥姆斯特德）

弗雷德里克·劳·奥姆斯特德(1822—1903)被普遍认为是美国景观设计学的奠基人，是美国最重要的公园景观设计师。他最著名的作品是其与合伙人沃克斯(Calvert Vaux)在一百多年前共同完成的纽约中央公园(1858—1876)。这一作品开辟了现代景观设计学之先河，它标志着普通人生活景观的到来，现代景观不再是少数人赏玩的奢侈品，而是普通民众身心愉悦的空间。奥姆斯特德是美国城市美化运动原则最早的倡导者之一，也是将美国景观引进郊外发展思考的最早实践者。奥姆斯特德的理论和设计实践推动了美国自然风景园林的发展。

From

https://en.wikipedia.org/wiki/Frederick_Law_Olmsted
https://en.wikipedia.org/wiki/Central_Park

2.2 Frank Owen Gehry and His Masterpieces

Frank Owen Gehry is a Canadian-born American **architect**, residing in Los Angeles (Fig. 2-2-1).

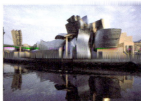
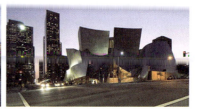

Fig. 2-2-1　Frank Owen Gehry and his masterpieces

A number of his buildings, including his private residence, have become **world-renowned attractions**. His works are cited as being among the most important works of **contemporary architecture** in the 2010 World Architecture Survey, which led Vanity Fair to label him as "the most important architect of our age".

Gehry's best-known works include the titanium-clad Guggenheim Museum in Bilbao, Spain; Walt Disney Concert Hall in downtown Los Angeles; Louis Vuitton Foundation in Paris, France; MIT Ray and Maria Stata Center in Cambridge, Massachusetts; The Vontz Center for Molecular Studies on the University of Cincinnati campus; Experience Music Project in Seattle; New World Center in Miami Beach; Weisman **Art Museum** in Minneapolis; Dancing House in Prague; the Vitra Design Museum and the museum MART a Herford in Germany; the Art Gallery of Ontario in Toronto; the Cinémathèque Française in Paris; and 8 Spruce Street in New York City.

It was his private residence in Santa Monica, California, that jump-started his career. Gehry is also the designer of the future National Dwight D. Eisenhower Memorial and Millennium Park in Chicago.

Comments on Frank Owen Gehry's Masterpieces

1. Millennium Park

Commentary

Millennium Park is a public park located in the Loop community area of Chicago in Illinois, US, and originally intended to celebrate the second millennium. It is a prominent **civic center** near the city's Lake Michigan shoreline that covers a 24.5 acres (99 000 m^2) section of **northwestern** Grant Park. The **area** was previously occupied by **parkland**, Illinois Central rail **yards**, and parking lots. The park, which is bounded by Michigan Avenue, Randolph Street, Columbus Drive and East Monroe Drive, features a variety of public art. As of 2009, Millennium Park trailed only Navy Pier as a Chicago **tourist attraction**. In 2015, the park became the location of the city's annual Christmas **tree lighting** (Fig. 2-2-2).

Planning of the park began in October 1997. Construction began in October 1998, and Millennium Park was opened in a ceremony on July 16, 2004, four years behind schedule. The three-day opening celebrations

 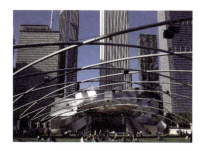 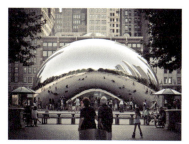

Fig. 2-2-2　Millennium Park

were attended by some 300 000 people and included an inaugural concert by the Grant Park Orchestra and Chorus. The park has received awards for its accessibility and **green design**. Millennium Park has free admission, and features the Jay Pritzker Pavilion, Cloud Gate, the Crown **Fountain**, the Lurie Garden, and various other attractions. The park is connected by the BP Pedestrian Bridge and the Nichols Bridgeway to other parts of Grant Park. Because the park sits at the top of a **parking garage** and the commuter rail Millennium Station, it is considered the world's largest **rooftop garden.**

Some observers consider Millennium Park to be the city's most important project since the World's Columbian Exposition of 1893. It far exceeded its originally proposed budget of ＄150 million. The final cost of ＄475 million was borne by Chicago taxpayers and private donors. The city paid ＄270 million; private donors paid the rest, and assumed roughly half of the financial responsibility for the cost overruns. The construction delays and cost overruns were attributed to poor planning, many design changes, and cronyism. Many critics have praised the **completed park.**

2. Schnabel Residence

In order to appreciate the creative universe of Frank O. Gehry it is necessary to understand a number of factors which affect his designs for houses in a very special way. Firstly, his choice since the beginning of his career of a particular area (California), his efforts to provide a solution to some very specific social needs, and his acceptance of the limitations imposed by modern production systems. This Canadian architect is considered to be one of the proponents of impoverished technology, advocating the use of low cost, industrially manufactured materials (chain link, corrugated cardboard and metal siding). ①

One of the most famous examples of Gehry's work in the field of domestic architecture is the Schnabel Residence in Brentwood (Los Angeles). The construction of this building started in July 1987 and it took almost two years to complete. The building's unusual morphology and atypical typology and the surprising choice of materials were made possible by the comprehension of the clients, who were more concerned with the cultural, aesthetic and pragmatic aspects of the process of habitation than by any mindless submission to conventional mores and general trends in domestic architecture.

The site selected was a property of approximately 530 square meters with no remarkable topographic features. At one end, the roughly rectangular site terminates in an irregular trapezoidal area where the slope was cut back to form a lower, more private terrace. The absence of significant external conditioning factors meant that the architect enjoyed total liberty and could design the project using the site to the best advantage.

The architect responded to the elaborate building program (private, service, and leisure areas in addition to garage and outdoor installations), with a solution based on independent structures, treating some of the different program elements as distinct objects. This relationship extends into the conceptual and aesthetic sphere. By changing both the shape and surface, each of these buildings (laid out in a wide two-level garden) is infused with its own specific architectural style, and the objects are played against each other in a tense and

expressive spatial and sculptural dialogue.

Once this close connection between building and function has been explained, it is possible to trace a natural route through the different blocks in this composition. Due to the geographic orientation this itinerary runs west to east.

Attached to the northern side of this cruciform element is a two-storey building housing a variety of rooms. The kitchen is situated on the ground floor of this rectangular structure (closely connected to the main dining room), and at the center there is a double-height skylight family room. The ground floor plan is completed by a small study. The upper floor contains two bedrooms with suite bathrooms. This block has been finished on the outside with a simple gray stucco used to create an intentional visual austerity which contrasts with the artificiality of the lead finish on the adjacent block.

In the entrance area on the west side of the property connected to the street, a small stucco box has been constructed to house the garage. A smaller structure, which has been placed on top of this and rotated at an angle, contains the staff living quarters. Gehry has designed an arcade supported by pillars clad in natural copper, which crosses the garden to link this building to a door into the kitchen.

The focal point of the eastern part of the property is a shallow lake which echoes the trapezoidal shape of this end of the site and provides a charming setting for the more private areas of the house. This is the area where the slope was cut back in order to form a lower, more private terrace, and to improve the views from the rest of the site. It is also the site of two other structures of inescapable architectural interest.

The play of the reflections mirrored in the sheet of water enhances the fascinating visual effect of the whole.

专业词汇

architect ['ɑːkitekt] 建筑师
world-renowned Attraction 举世闻名的旅游景观
contemporary Architecture 同时代的建筑师
street [striːt] 街道、道路
area ['eəriə] 地区、领域、范围
civic center 市民中心
northwestern ['nɔːθwestən] 西北
parkland ['pɑːklænd] 公园场地
tourist attraction 游览胜地
tree lighting 树灯
green design 绿色设计
fountain ['faʊntən] 喷泉
parking garage 车库
rooftop garden 屋顶花园
completed park 完整的公园

难句翻译

① In order to appreciate the creative universe of Frank O. Gehry it is necessary to understand a number of factors which affect his designs for houses in a very special way. Firstly, his choice since the beginning of

his career of a particular area (California), his efforts to provide a solution to some very specific social needs, and his acceptance of the limitations imposed by modern production systems. This Canadian architect is considered to be one of the proponents of impoverished technology, advocating the use of low cost, industrially manufactured materials (chain link, corrugated cardboard and metal siding).

要想领略弗兰克·盖里的创意世界,就必须了解一些在意想不到之处影响他房屋设计的因素。首先,他从事业起步之初就专门选择了加利福尼亚为根据地;其次,他致力于解决几种特定的社会需求;此外他能够接受并利用现代产业体系的局限性。这位加拿大建筑师被认为是单调工业技术的支持者之一,他提倡使用价格低廉的工业材料(如锁链,瓦楞纸板,金属壁板)。

Frank Owen Gehry(弗兰克·盖里)

弗兰克·盖里1929年2月28日生于加拿大多伦多一个犹太人家庭,17岁后移民美国加利福尼亚,成为当代著名的解构主义建筑师。他以设计具有奇特不规则曲线造型外观的建筑而著称。盖里的设计风格源自晚期现代主义(Late Modernism),其中最著名的建筑,是位于西班牙毕尔巴鄂,有着钛金属屋顶的毕尔巴鄂古根海姆博物馆。

From

https://en.wikipedia.org/wiki/Frank_Gehry

https://en.wikipedia.org/wiki/Millennium_Park

2.3
An Introduction to SWA Group And Its Masterpieces

For nearly 50 years, the SWA Group has produced outstanding work, recognized with more than 400 awards. A collaborative group practice of landscape architects, urban designers, and planners, the firm has worked in 48 states and more than 40 countries on projects that range widely in scale and type. With 120 employees, SWA operates from five studios in California and Texas, and a **representative** office in Shanghai (Fig. 2-3-1).

The firm's name reflects its origin in 1959 as the West Coast office of Sasaki, Walker and Associates. The legacy of its leadership has influenced the development of the firm's culture: from Hideo Sasaki came the idea of a **collaborative** design practice, from Peter Walker, the belief that ideas are the foundation of the work; and from Kalvin Platt, a strong sense of social responsibility.

As a group practice, the firm values diverse viewpoints and encourages individual members to pursue their talents and aspirations, "When you have different kinds of people working," says Kevin Shanley, president of the firm, "you get the very best projects," SWA believes in experimentation, No single style or attitude dominates, Yet despite varied perspectives and the diversity of scale, three common threads run though the firm's work: **deep appreciation** of the land, **willingness** to look beyond the client's immediate program, artful design that **enriches** human experience.① A connection to the land is part of the individual and **collective** history

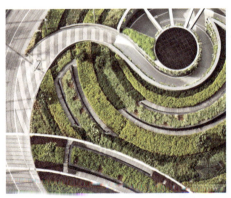 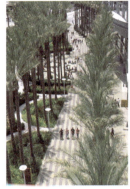 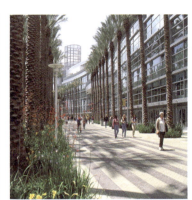

Fig. 2-3-1 SWA Group's Masterpieces

of the firm's leaders.

Creative problem solving is central to SWA's approach. The firm operates in the belief that it is always the designer's responsibility to look beyond the immediate requirements of the client's program to the next level of **context**.

While SWA is intent on **implementation**, the firm is continually looking for ways to infuse its work with new ideas, stretch its thinking, and keep current. In the tradition of its founders—Sasaki and Walker both served as chair of Harvard University's department of landscape architecture—SWA has maintained a **long-standing** connection with Harvard and now with other top programs. Many of the firm's **principals** teach and lecture, and staff members continually return for graduate study.

SWA Group has studios in California, Texas, China and the United Arab Emirates.

专业词汇

representative [ˌrepriˈzentətiv] 典型的
collaborative [kəˈlæbərətiv] 协助的, 合作的
deep appreciation 深度欣赏
willingness [ˈwiliŋnəs] 意愿
enrich [inˈritʃ] 使肥沃、提升
context [ˈkɒntekst] 环境
implementation [ˌimplimenˈteiʃn] 实现
principal [ˈprinsəpl] 主要的、资本的
collective [kəˈlektiv] 集体的
long-standing [lɒŋˈstædiŋ] 长期存在的、为时甚久的

难句翻译

① SWA believes in experimentation, No single style or attitude dominates, Yet despite varied perspectives and the diversity of scale, three common threads run though the firm's work: deep appreciation of the land, willingness to look beyond the client's immediate program, artful design that enriches human experience.

SWA集团推崇尝试，不为单一风格或理念所束缚。不过尽管他们的设计角度各异、大小不一，公司的作品

仍有三项共同点：对自然的欣赏、对客户短期项目的超越、充实人生的艺术设计。

AN INTRODUCTION TO SWA GROUP(SWA 景观设计公司)

SWA 景观设计公司于 1957 年创立，分支机构遍布美国各地。SWA 景观设计公司作为全球最重要的景观建筑、城市设计和规划事务所之一，擅于提供巧妙处理用地、环境和城市空间的规划设计方案，以及为客户创造与众不同的场所。SWA 景观设计公司的核心精神是一种设计热情，本着这种热情不断寻求富有想象力并能够在实际中解决问题的设计方案，从而明显地提升地块、建筑物、城市、地区和人们生活的价值与品质。

From

World Architecture Review

http：//photo.zhulong.com/proj/detail33740.html

2.4
Kongjian Yu and His Masterpieces

Kongjian Yu received his Doctor of **Design Degree** at Harvard Graduate School of Design(GSD) in 1995, with the **dissertation**, "Security Patterns in **Landscape Planning**: With a Case in South China". He has been a professor of **urban** and **regional planning** at Peking University(PKU) since 1997, is the founder and Dean of the School of Landscape Architecture at PKU, and is now the College of Architecture and Landscape Architecture. He founded Turenscape in 1998, an internationally awarded firm with about 600 professionals. Yu and Turenscape's practice covers architecture, landscape architecture, and urban design, across scales. (Fig. 2-4-1).

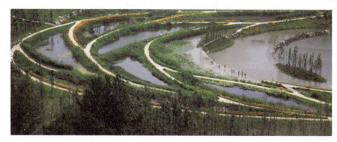

Fig. 2-4-1　Kongjian Yu and his masterpieces

Yu's projects received both 2009 and 2010 World Architectural Festival Awards of Landscape, the 2009 ULI Global Award for Excellence, the 2010 ASLA award of Excellence, and 7 ASLA Honor Awards (American Society of Landscape Architects), 4 Excellence on the Waterfront Awards, the 2004 National Gold Medal of Fine Arts of China, and he was a juror for the 2010 Aga Khan Award for Architecture. Yu publishes widely; his current publications include The Beautiful Big Foot, Landscape as **Ecological Infrastructure** and The Art of Survival. Through his works, Yu tries to reconstruct ecological infrastructure across scales and to define a new aesthetics based on environmental ethics.

Zhongshan Shipyard Park

Zhongshan Shipyard Park covers eleven hectares (twenty-seven acres) in Zhongshan in Guangdong Province. It was built on the site of an abandoned shipyard originally constructed in the 1950s, bankrupt in 1999, seemingly insignificant in Chinese history, and therefore likely to be razed to give space for urban development and a grand "Baroque" garden. But the shipyard reflected the remarkable fifty-year history of socialist China, including the Cultural Revolution of the 1960s and '70s, and recorded the experiences of common people.

The principle of reducing, reusing, and recycling natural and man-made materials is followed. Original vegetation and natural habitats were preserved, just as only native plants were used throughout. Machines, docks, and other industrial structures were recycled for educational, aesthetic, and functional purposes. The design addressed several challenges of the site including accommodating variable water levels and balancing river-width regulations for flood control with protecting old riverbank banyan trees. It helped reuse the remnants of rusty docks and machinery. Completely different from the classical Chinese scholar gardens, this park, since its inauguration in 2002, has become an attraction to tourists and local residents. It has been used all day and year long, has become a favored site for wedding photographs, and has even been used for fashion shows. It demonstrates how landscape architects can create environmentally friendly public places full of cultural and historical meaning but not on sites previously singled out for attention and preservation. It supports the common people and the environmental ethic "Weeds are beautiful."

1. Its unique history: " A small site with big stories"

The shipyard was originally built in the 1950s and went bankrupt in 1999. Though small on scale, it reflects the remarkable 50 year history of socialist China, including the cultural revolution of the 1960s and 70s. It is therefore a space to remember and tell stories to those who did not experience this period of history (Fig. 2-4-2).

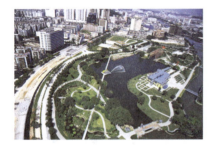 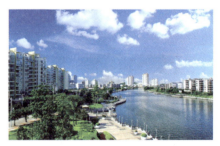

Fig. 2-4-2　Zhongshan Shipyard Park landscape design

2. A challenging setting: Water level fluctuations, tree preservation and design with machines

The site inventory of this small former shipyard included an existing lake of fluctuating water levels, existing trees and **vegetation**, and the wreckages of **docks, cranes, rails, water towers** and other machinery. These factors challenged the design in three ways:

Challenge 1: fluctuating water levels: With the existing lake connected through the Qijiang River to the sea, water levels fluctuate up to 1.1 meters daily. To meet this challenge, a network of **bridges** was **constructed** at various **elevations** and integrated with terraced **planting beds** so that **native weeds** from the salt march can be grown and visitors can feel the breath of the ocean.

Challenge 2: Balance river width regulations for flood control while protecting old **ficus trees** along the **riverbank**. Regulations of the Water Management Bureau required the river corridor at the east side of the site to be **expanded** from 60 meters to 80 meters to manage water flow. This meant that a series of old **banyan trees** were to be cut down in order to widen the **river channel**.① The designer's approach was to dig a **parallel ditch** of 20 meters **width** on the other side of the trees, leaving them intact as an island of preservation.

Challenge 3: Remnant **rust** docks and machinery—nothing as gigantic or unusual as a gas works or steel factory. These elements, if left intact because of a pure preservation or **ecological** restoration ethic, might actually be a distraction or nuisance for local residents. Three approaches are taken to artistically and ecologically dramatize the spirit of the site using these elements: preservation, modification of old forms and **creation** of new forms. New forms include a network of **straight paths**, a red box and a green box that dramatize the character of the site in an artistic way.

3. The design especially pays attention to the following aspects

1) Site opportunities and design in details

From the preservation of vegetation along the old **lake shore**, the protection of old banyan trees along the river side, the reuse of rails, the decoration of water towers and the placing and reuse of dilapidated machines, to the creation of the red box, all original required elements are carefully designed to fulfill the design intention set forth at project inception.

2) Functionalism

Function reigns supreme in this design. This is evident in the network of paths that link unique locations and exits, the reuse of docks for tea houses and club houses, the accessible terraces planted with native plants, the light tower made from the former water tower, and the paving under trees where **shadow** boxing can be practiced.

3) Relationship to the urban context

The park merges into the urban fabric through a network of paths and urban facilities that were extended into the park, such as docks that are reused for tea houses (local people customarily drink tea in tea houses). Water elements merge via the **inlet** from the sea that fluctuates along with **ocean tides**.

4. Environmental responsibility

The principle of **reducing**, **reusing** and **recycling natural** and man-made materials is well followed in this project. Original vegetation, soil and natural habitats were preserved, just as only native plants were used throughout the park. Machines, docks and other structures were reutilized for educational, aesthetic and functional purposes.②

This park is **environmentally friendly**, educational, and full of cultural and historical meanings. It calls people to pay attention to culture and history that have not yet been designated as formal or "traditional". It is about the common man, as well as an environment ethic that states, "Weeds are beautiful."

专业词汇

design Degree　设计等级
dissertation　[ˈdisəˈteiʃn]　论文
landscape Planning　景观规划
urban　城市
regional planning　地区规划

ecological Infrastructure　生态基础设施
tree preservation　树木保护
vegetation　[ˈvedʒəteiʃn]　植被、草木
dock　[dɒk]　码头
crane　[krein]　起重机
rail　[reil]　铁路
water towers　水塔
bridge　[bridʒ]　桥
constructed　建造的
planting bed　种植床
native weed　自然杂草
ficus tree　无花果树
riverbank　[ˈrivəbæŋk]　河堤
expanded　[ikˈspændid]　扩大的、展开的
banyan tree　榕树
river channel　河道
parallel ditch　平行沟
width　[widθ]　宽度
rust　[rʌst]　生锈
ecological　[ˈikəlɒdʒikl]　生态学
creation　[kriˈeiʃn]　创造
straight path　直路
lake shore　湖滨
functionalism　[ˈfʌŋkʃənəlizəm]　机能主义
shadow　[ʃædəu]　阴影
inlet　[inlet]　入口
ocean tide　潮汐
reducing　[riˈduːsiŋ]　减少
reuse　[ˌriːjuːz]　重新利用
recycling natural　物质循环利用
environmentally friendly　有利于环境保护的

难句翻译

① Balance river width regulations for flood control while protecting old ficus trees along the riverbank. Regulations of the Water Management Bureau required the river corridor at the east side of the site to be expanded from 60 meters to 80 meters to manage water flow. This meant that a series old banyan trees were to be cut down in order to widen the river channel.

满足拓宽防洪规定的同时保护沿岸的老榕树。水资源管理局要求工程东边的水道从60米拓宽至80米以管理水流。这意味着许多老榕树会因拓宽河道而被砍伐。

② Original vegetation, soil and natural habitats were preserved, just as only native plants were used throughout the park. Machines, docks and other structures were reutilized for educational, aesthetic and functional purposes.

原有的植被、土壤和自然栖息地被保存了下来,整个公园仅种植当地植物。机器、码头和其他设施被再利用,服务于教育、装饰和其他功能性用途。

Kongjian Yu(俞孔坚)

俞孔坚1995年获哈佛大学设计学博士,中国风景园林硕士专业学位教育指导委员会委员。1997年回国创办北京大学景观设计学研究院,并在北京大学创办两个硕士学位点。1998年创办国家甲级规划设计单位——北京土人景观与建筑规划设计研究院,目前已成为国际知名设计院。他出版著作15部,并完成大量城市与景观的设计项目,如岐江公园、沈阳建筑大学稻田校园。

From

　　https://en.wikipedia.org/wiki/Kongjian_Yu
　　http://www.landezine.com/index.php/2012/07/zhongshan-shipyard-park-by-turenscape

2.5
Yoshiki Toda and His Masterpieces

Yoshiki Toda graduated from Faculty of Landscape, Tokyo University of Agriculture in 1970. After training as a gardener in Tokyo and Kyoto, he worked at Urban Design Consultant (headed by Kisho Kurokawa); then he **established** his own firm Yoshiki Toda Landscape Design Office in 1980, later renamed Yoshiki Toda Landscape and Architect Co. Ltd (Fig. 2-5-1).

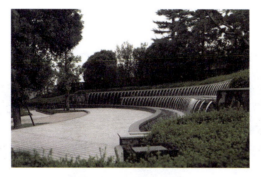
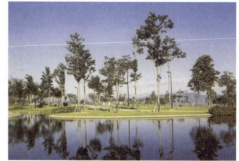

Fig. 2-5-1　Yoshiki Toda and his masterpieces

He has been creating many finely detailed works with simple and **dynamic** forms, yet with warm and soft **ambience**. Major awards he received include: Grand Prize of Landscape at Tokyo University of Agriculture in 1989, and the Japanese Institute of Landscape Architecture Award in 1995 with "Niji no Sato" in Shuzenji. He has been Lecturer at the Faculty of Landscape (currently Faculty of Landscaping Science), Tokyo University of Agriculture since 1996; also at the Faculty of **Green Environment**, Chiba University from 1999 to 2003, and the Faculty of Design, Tokyo National University of Fine Arts and Music since 2007. In Aichi EXPO 2005, he was nominated as Landscape Director and supervised the overall site creation.

In recent years, he has been working on many projects in China and actively holding lecture meetings in Beijing, Shanghai and Nanjing.

Comments on Yoshiki Toda's Masterpieces

1. Tateshina Outdoor Sculpture Museum

Representational sculptures will lose impact outdoors likely to submerge completely in the landscape. Therefore, in this project, landscape design was addressed to the sculptures with functions as elements of the landscape. And landscape has been divided by **designed stream**, pond, **drawbridge**, and **walkway** creating sequence of each (Fig. 2-5-2).

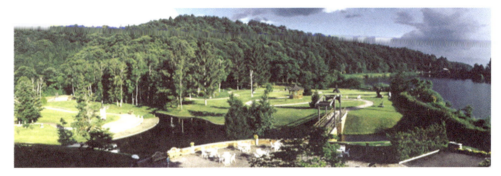

Fig. 2-5-2 Tateshina Outdoor Sculpture Museum

2. Greenpia Tsunan

In designing a site surrounded by a rich natural landscape, **magnificence** of nature should be embraced, and without disturbing, the humble human occupation should be expressed. Simplicity of design is essential in a snow deep area of Tsunan. The Design was **inspired** by the mountain stream nearby. In the 4ha area of gradual sloping land adjacent to the **hotel** complex, life of water springing from earth, flowing into a **stream** and falling into a pool are expressed in a sweep of a **brush** manner. Excessiveness was avoided in order to allow the sky and its **reflection** in the water as the main element (Fig. 2-5-3).

Fig. 2-5-3 Greenpia Tsunan

3. Chongqing Longhu Yuanzhu

This is a project to **accomplish** a **garden** providing healthy and relaxing **environment** embraced with rich **greenery**. High-rise buildings lined up by adjacent athletic field stands in front of vast greenery. Meantime,

residences with intermediate height densely stand at the center of **property**.

In contrast to providing a **spatial** margin around the high-rise buildings attuned to the athletic field, intricate circulation of paths, on which various types of spatial arrangements were applied, wove the scenery axes implicated in water and vegetation among paths. Minimized amount of paved area have achieved a sense of freshness and relaxation by plantings, which enhance residences.

Although Chongqing, characterized by its varied elevation, carefully organized grading execution found in the cascade at the entrance definitely improved status to live in the property. Various differently designated places were versatile in terms of relation between residents and environment, and sequentially mutualized each other to respond diverse **life styles** found in urban setting(Fig. 2-5-4).

Fig. 2-5-4　Chongqing Longhu Yuanzhu

专业词汇

established　[iˈstæbliʃt]　建立的
dynamic　[daiˈnæmik]　动态的
ambience　[ˈæmbiəns]　气氛、布景、周围环境
green environment　绿色环境
sculpture　[ˈskʌlptʃə(r)]　雕塑
designed stream　设计溪流
drawbridge　[ˈdrɔːbridʒ]　吊桥、开合桥
walkway　[ˈwɔːkwei]　人行走道
magnificence　[mægˈnifisns]　富丽堂皇
inspired　[inˈspaiəd]　灵感的
hotel　[həʊˈtel]　宾馆
stream　[striːm]　溪流

reflection [riˈflekʃn] 反射
accomplish [əˈkʌmpliʃ] 完成、视线
garden [ˈgɑːdn] 花园
environment [inˈvairənmənt] 环境的
greenery [ˈgriːnəri] 绿色植物、温室
property [ˈprɒpəti] 性质
spatial [ˈspeiʃl] 空间的
life styles 生活方式
brush [brʌʃ] 灌木丛

户田芳树

户田芳树,日本广岛县尾道市出生,1970年毕业于东京农业大学造园学科,在东京、京都等地从事庭园师的实践活动后,加入城市设计顾问公司 Urban Design Consultant,Inc.(公司法人黑川纪章)。1980年成立户田芳树造园设计室,长期创作大量体现空间线条、简单却富有动感的设计作品,尤其注重细节的处理。他设计的风格是充满柔和、温暖的氛围却不失细腻。1989年荣获东京农业大学颁发的造园大奖,1995年以作品修善寺"虹之乡"获得日本造园协会大奖。1996年任教于东京农业大学造园科学科,1999年至2003年任教于千叶大学绿地环境学科。2004年于日本爱知万国博览会出任景观总监、并负责会场整体景观的监修工作。近年来参与多项中国的环境景观建设项目,并在北京、上海、南京、台北等地举办多场演讲会。

From

http://www.todafu.co.jp/eng/yoshiki_toda/index.html
http://www.todafu.co.jp/eng/works/place/china/138.html

单元词汇总结

Street space:	Boulevard;Parkway system;Urban parks;Communities;Filmed locations;Tree lighting;Sightseeing spot;Amphitheater;Quiet areas;Playgrounds;Northwestern;Parkland;Rail yard;Garden;Designed stream;Infrastructure;Walkway;Wading pool;Garbage Can
Nomenclature of landscape:	South portion;Further south;Acre;Census tract;Permanently living;Cultural position;Safety measures;Ambulance service;Bicycle patrol;Natural-looking;Tourist attraction;Green design;Deep appreciation;Willingness;Artful design;Landscape Planning;Regional planning;Ecological;Originally built;Tree preservation;Rust;Creation;Ocean tide;Reutilizing;Recycling natural;Environmentally friendly;Green Environment;Reflection;Landscape architect;World-renowned attraction
Landscape Design:	Walking track;Fountain;Path;Parking garages;Rooftop garden;Dock;Rail;Water towers;Bridge;Planting bed;Native weed;Riverbank;River channel;Parallel ditch;Straight path;Lake shore;Inlet;sculpture;Designed stream;Drawbridge;Greenery;Ambience;Sculpture;Green Environment
Plant & Flower	Bamboo;Banyan tree;Ticus tree;Ginkgo;Pine tree;Cyperess cedar;Maidenhair tree;Maple tree;Cyclamen;Calla;Hydrangea;Poney;Palm Blossom;Tulip;Bridle;Geranium;White trumpet lily;Pansy;Carnation;Hibiscus;Ornamental cabbage;Osmanthus blossom;Brush

单元3

室内设计师与他们的作品

Unit 3　Interior Designers and Their Masterpieces

3.1 George Nelson and His Masterpieces

George Nelson (1908—1986) was an American **industrial designer** and one of the founders of American Modernism. As the Director of Design for the Herman Miller furniture company, Nelson and his design studio, George Nelson Associates, Inc. designed much of the 20th century's most **iconic modernist furniture** (Fig. 3-1-1).

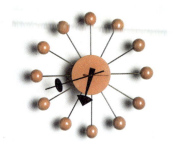
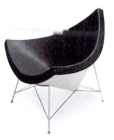

Fig. 3-1-1 George Nelson and his masterpieces

George Nelson graduated from Hartford Public High school in 1924, thereafter attending Yale University. Nelson did not originally set out to become an **architect**. He happened upon the **architecture** school at Yale because of a rain storm, ducking into the building in order to get out of the rain. Walking through the building, he came upon an **exhibit** of students' works entitled "A Cemetery Gateway". Nelson met with some early recognitions while still an undergraduate, being published in Pencil Points and Architecture magazine. He graduated with a degree in architecture in 1928. During his final year at Yale, Nelson was hired by the architecture firm Adams and Prentice as a drafter.

In 1929, Nelson was hired as a Teacher's Assistant while getting his second bachelor's degree at Yale. He received a degree in **Fine Arts** in 1931. The next year, while preparing for the Paris Prize competition, he won the Rome Prize. The award for the Rome Prize was a year studying architecture with a healthy stipend and accommodations in a **palace** in Rome.

Based in Rome, Nelson traveled through Europe, where he met a number of the modernist pioneers, whom he **interviewed** for articles for Pencil Points magazine. While interviewing, Ludwig Mies Van Der Rohe asked about Frank Lloyd Wright whom Nelson was embarrassed to say, he did not know much about. Years later he would work with Wright on a special issue of Architectural Forum which would come to be Wright's comeback from relative obscurity. While in Rome Nelson married Frances Hollister. A few years later he returned to the United States to devote himself to writing. Through his articles in Pencil Points, he introduced the work of Walter Gropius, Mies van Der Rohe, Le Corbusier and Gio Ponti to North America.

In 1935 Nelson joined Architectural Forum, where he was first associate editor (1935—1943), and later consulting editor (1944—1949). There he defended the modernist principles, arguing against colleagues who, as "industrial designers", made too many concessions to the commercial forces of the industry. Nelson believed that the work of a designer should be better to the world. In his view, "nature was already perfect, but man ruined it by making things that didn't follow the rules of nature. "The **contemporary** architect, cut off from

symbols, **ornaments** and meaningful elaborations of structural form, all of which earlier periods processed in abundance, has desperately chased every functional requirement, every change in sight or ornamentation, every technical improvement, to provide some basis for starting his work, where the limitations were most rigorous, as for example in a factory, or in a skyscraper where every inch had to yield its profit, there the designers were happiest and the results were most satisfying. [1]But, let a religious belief or a social ideal replace the **cubic** foot costs or radiation losses, and nothing happened. There is not a single modern **church** in the entire country that is comparable to a first-rate **cafeteria**, as far as solving the problem is concerned." At this point Nelson's career still mainly involved writing for architecture magazines, and not actually designing the solutions to modern living that he would later become famous for. During this period George Nelson spent a great deal of time interviewing and exchanging ideas with the other founders of the modernist architecture movement of the forties, including Eliot Noyes, Charles Eames, and Walter B. Ford, all of whom he would later collaborate with.

Tomorrow's House

By 1940 George Nelson had become known for several innovative concepts. In his post-war book Tomorrow's House, co-authored with Henry Wright, he introduced the concept of the "**family room**", and the "**storage wall**". The storage wall was essentially the idea of recessed, built-in bookcases or shelving occupying space previously lost between walls. It was an idea developed while writing the book, when Nelson's publisher was pressuring him to finish the section on storage. Neither Wright nor Nelson could find any new **innovations** when Nelson posed the question, "What's inside the wall?", It was then that the idea of utilizing the space in between walls for storage was born. Tomorrow's House was innovative because it didn't look at modern design as a case of styles, but instead looked at the way problems needed to be solved.

Herman Miller

In 1945, the Herman Miller **furniture** company was producing mostly conventional, wood-based designs. After reading "Tomorrow's House" D. J. Depree, the Chairman of Herman Miller, selected Nelson to be the company's next Director of Design, despite Nelson having no experience designing furniture. Depree was more interested in Nelson's insight into the best way to make furniture innovative and useful. Nelson was offered a contract that allowed him the freedom to work outside of Herman Miller and to use designs from other architects that Nelson had worked with. He became the Director of Design for Herman Miller in 1947, and held the position until 1972. The first Herman Miller catalog produced by Nelson was released in 1945. Over the following years it would include some of the most iconic home furnishings of the 20th century. Ray and Charles Eames, Harry Bertoia, Richard Schultz, Donald Knorr, and Isamu Noguchi all worked for Herman Miller, under Nelson's supervision. Although both Bertoia and Noguchi later expressed regrets about their involvement, it became a successful period for the company, and for George Nelson.

Fairchild House

New York, USA 1941-The Fairchild House was built for the Airplane **manufacturer** Sherman Fairchild and was meant to be a "machine for living". What made the Fairchild House different from every other Brown Stone in New York was its views. There was a courtyard in the middle of the building and all the windows

faced in toward it. This made the home feel more tranquil and the view provided use for Nelson's signature floor to **ceiling** windows. Much of the house is designed in style not necessarily common in early modern design. This is evidence of Nelson's philosophy that "good design is timeless".

Sling Sofa

Sling Sofa by Herman Miller is made of **leather** and filled with **solid foam cushions**. The joints are all held with epoxy so that it can be more easily mass-produced and sold for a cheaper price. There is no need for hand crafting with this sofa. Because of its perfect proportions and light appearance, it doesn't look like just an elongated chair. Nelson's use of a single welt along the perimeter of the padding gives the seating an approachable softness and yet, there is more going on that cannot be seen.② The padding is held up by rubber bands that allow for more comfort and the use of epoxy for the joints to give the shape a much smoother feel. Like most of Nelson's work, it was only designed to be as useful and comfortable as possible(Fig. 3-1-2).

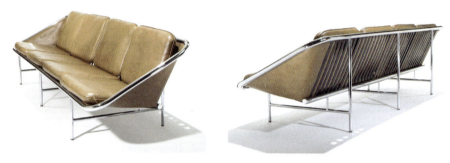

Fig. 3-1-2　Sling Sofa

Marshmallow Sofa

Marshmallow Love Seat, commonly known as the Marshmallow sofa, is a modernist sofa produced by the American furniture company, Herman Miller, that was originally **manufactured** between 1956 and 1961.③ It is considered the most iconic of all modernist sofas. The sofa was designed by Irving Harper of George Nelson Associates. It was produced in two lengths from 1956 to 1961. It consists of a **metal frame** with round discs of covered foam, or "marshmallows", spread across the seat and back in a **lattice** arrangement.

The design was created in 1954 when a salesman for a Long Island plastics company presented to George Nelson's New York City studio an example of the company's ability to create round 12 inch foam discs that became "self-skinned". The limited manufacturing costs made the item inviting, and designer Irving Harper was asked to design a piece of furniture around the discs. Over a weekend Harper designed a sofa, incorporating 18 of the discs arranged over a metal frame. The invention did not live up to its promise, as covering the individual seat pads proved costly and time consuming, turning the intended budget piece into a **luxury** product. Nevertheless, Herman Miller went ahead with the sofa's production, and introduced it in 1956.

The Marshmallow sofa was originally issued by Herman Miller in 1956, and appeared in their 1957 catalog. The sofa was dropped in 1961. Despite its popularity, and visibility in Herman Miller publications, only 186 Marshmallow sofas were produced between 1956 and 1961. The 52 **version** was re-issued in the 1980s as part of the "Herman Miller Classics" line, and continues in production today, though in limited numbers

(Fig. 3-1-3).

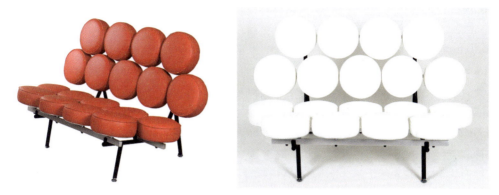

Fig. 3-1-3　Marshmallow Sofa

专业词汇

industrial designer　工业设计师
iconic modernist furniture　标志性的现代家具
architect　[ˈɑːkitekt]　建筑师
architecture　[ˈɑːkitektʃə(r)]　建筑学
exhibit　[igˈzibit]　展示、呈现、陈列
fine arts　美术
palace　[ˈpæləs]　宫殿
interviewed　采访
contemporary　[kənˈtemprəri]　当代的
ornament　[ˈɔːnəmənt]　装饰
cubic　[ˈkjuːbik]　立方体的
church　[tʃɜːtʃ]　教堂
cafeteria　[ˌkæfəˈtiəriə]　自助餐厅
family room　家庭活动室
storage wall　存储墙
innovation　[ˌinəˈveiʃn]　创新
furniture　[ˈfɜːnitʃə(r)]　家具
manufacturer　[ˌmænjuˈfæktʃərər]　制造商
ceiling　[ˈsiːliŋ]　天花
sling sofa　吊索沙发
leather　[ˈleðə(r)]　皮革
solid foam　固体泡沫
cushion　[ˈkʊʃn]　垫子
manufacture　[ˈmænjʊˈfæktʃə(r)]　加工、制造、生产
metal frame　金属框架
lattice　[ˈlætis]　格子框架
luxury　[ˈlʌkʃəri]　奢侈、豪华
version　[ˈvɜːʃn]　版本

难句翻译

① The contemporary architect, cut off from symbols, ornament and meaningful elaborations of structural form, all of which earlier periods processed in abundance, has desperately chased every functional requirement, every change in sight or ornamentation, every technical improvement, to provide some basis for starting his work, where the limitations were most rigorous, as for example in a factory, or in a skyscraper where every inch had to yield its profit, there the designers were happiest and the results most satisfying.

当代建筑师摒弃了前人所滥用的符号、装饰及对造型的意义化,在开工以前他们孜孜不倦地追求功能性、视觉或装饰上的改进和技术革新。而当代建筑的限制十分严苛,建造一间工厂或一栋摩天大楼的成本寸尺寸金。接手这样工程的设计师是最快乐最满足的。

② Because of its perfect proportions and light appearance, it doesn't look like it's just an elongated chair. Nelson's use of a single welt along the perimeter of the padding gives the seating an approachable softness and yet, there is more going on that cannot be seen.

因造型完美外形轻盈它看上去并不像长椅。尼尔森的单压边坐垫使座椅柔软宜坐,同时具有许多看不到的功能。

③ Marshmallow Love Seat, commonly known as the Marshmallow sofa, is a modernist sofa produced by the American furniture company, Herman Miller, that was originally manufactured between 1956 and 1961.

棉花糖恋爱椅俗称棉花糖沙发是美国家具公司赫曼米勒所生产的现代主义沙发。最早在1956年至1961年间制造。

George Nelson(乔治·尼尔森)

乔治·尼尔森既是一位很有成就的建筑师,又是一位多产的家具设计大师。1936年至1941年尼尔森与好友在纽约成立建筑事务所,而后又任教于耶鲁大学建筑系,此间发展出一系列建筑设计和城市规划的新观念,包括最早的绿色设计的概念。1941年至1944年他任教于纽约哥伦比亚大学建筑系,1946年又担任纽约帕森斯设计学校室内设计系的顾问,同年他受聘担任赫曼·米勒公司的设计部总监,直到1972退休。在任职米勒公司期间,他成功地聘请了许多一流的家具设计师加盟米勒公司,如查尔斯·伊姆斯等,使米勒公司成为世界上最有影响的家具制作公司之一。1947年尼尔森在纽约建立自己的设计事务所,不仅设计家具,而且设计灯具、钟表、塑料制品等工业产品。1957年以后他开始关注建筑中的环境设计,是最早研究建筑生态学的建筑师之一。

From

http://www.georgenelson.org/georgenelsonbiography.html

3.2

Kelly Hoppen and Her Masterpieces

Kelly Hoppen is a world-renowned British designer who has pioneered a simple yet **opulent style** that has

permeated interior design at every level. As well as designing **apartments**, houses and **yachts** for an ever-expanding international private client list, Kelly also undertakes **commercial design** projects including hotels, **restaurants**, **office spaces** and **aircraft interiors**[①] (Fig. 3-2-1).

Fig. 3-2-1　Kelly Hoppen and her masterpieces

In March 2009, Kelly received an MBE for services to **Interior Design** which has so far marked the pinnacle of her 33-year **design career**. As well as sharing her knowledge in the Kelly Hoppen Design School, Kelly also designs ranges of **home accessories**, furniture, **taps**, lighting, **carpets**, fabrics, paints, **bed linen**, **scented candles** as well as a highly successful QVC range. In November, she released her first iPhone application "Home Style by Kelly Hoppen" offering design tips and inspiration.

Hoppen began her career at the age of 16 when she was given the opportunity to design a family friend's kitchen. She has designed for a number of celebrities, including David and Victoria Beckham and Martin Shaw, who was one of her early clients. She has designed the homes, yachts and jets of private clients, as well as commercial projects in several countries. Some of Hoppen's most recent projects include a collaboration with Pearl Motor Yachts and the design of a LUX Belle Mare hotel resort in Mauritius.

Hoppen is the author of eight design books to date. She became famous on the back of her 1997 book. In November 2013, Hoppen published *Kelly Hoppen Design Masterclass-How to Achieve the Home of Your Dreams*.

In 1996, Hoppen was awarded the Andrew Martin Interior Design Award by Andrew Martin International. She has subsequently won a number of other awards including European Woman Of Achievement in 2007, ELLE Decoration Award and Grazia Designer of the Year. In March 2009, she was appointed a Member of the Order of the British Empire (MBE) in the 2009 New Year Honours. The award was given for services to Interior Design. Hoppen is an ambassador for the Prince's Trust, the Government's GREAT campaign and now works with UK Trade & Investment and other parts of the government, as an adviser and mentor to small businesses. In December 2013, Hoppen was awarded the Natwest Everywoman Ambassador award for inspiring more young women to excel.

Comments on Kelly Hoppen's Masterpieces

Bathroom

Playing with **symmetry**, the **slim-line**, **linear**, **cantilevered washbasin** from London's Alternative Plans is **juxtaposed** with a wenge-wood shelf for everyday **toiletries**, while other necessities are concealed behind the custom **cabinet** by Paul Glover to Hoppen's design (Fig. 3-2-2).

Fig. 3-2-2　Bathroom design

Kitchen

Kitchen window treatments are chain mail over **cotton blinds**. A huge Marilyn fan, Kelly Hoppen chose a limited-edition Gene Korman photo from brother Michael Hoppen's South Kensington **gallery**. The Monroe image is seen here through the rings of a screen that Hoppen designed as part of her line for Century(Fig. 3-2-3).

Fig. 3-2-3　Kitchen design

Bathtub

A bathtub designed by Andrée Putman is a white-on-white sculpture against a subtly **gridded marble wall**. An **underlit** cantilevered seating shelf creates the feeling of a Turkish steam bath. **Stools** are by Mies van der Rohe and India Madhavi(Fig. 3-2-4).

Fig. 3-2-4　Bathtub

Dining Corner

In the eat-in kitchen, white leather Plaza **armchairs** and a circular wenge-finish table create a casual dining corner (the mirror is from Artemis, the **pendant lamp** shade by Ochre)(Fig. 3-2-5).

Fig. 3-2-5　Dining corner design

Living Room

Hoppen anchored the living room's main seating area under the soaring ceiling **gables** with suede-covered Christian Liaigre sofas and a coffee table of her own design(Fig. 3-2-6).

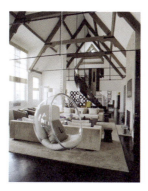
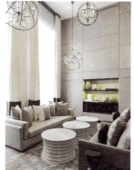
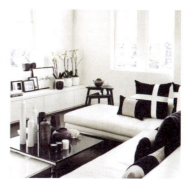

Fig. 3-2-6　Living room interior design

专业词汇

opulent style　华丽的风格
apartment　[əˈpɑːtmənt]　公寓
yacht　[jɒt]　游艇
commercial design　商业设计
restaurant　[ˈrestrɒnt]　餐厅
office space　办公空间
aircraft interiors　飞机内饰
interior design　室内设计
design career　设计生涯
home accessory　家居饰品
tap　[tæp]　水龙头
carpet　[ˈkɑːpit]　地毯

bed linen　床单
scented candles　香薰蜡烛
symmetry　['sɪmətri]　对称
slim-line　超薄
linear　['lɪniə(r)]　线性
cantilevered　['kæntiliːvəd]　悬臂式的
washbasin　[wɒʃbeɪsn]　盥洗池
juxtapose　[dʒʌkstəpəʊz]　并列
toiletry　['tɔɪlətri]　化妆品
cabinet　['kæbɪnət]　橱柜
cotton blinds　棉质窗帘
gallery　['ɡæləri]　画廊
bathtub　['bɑːθtʌb]　浴缸
gridded marble wall　网格大理石墙
underlit　[ˌʌndə'lɪt]　照明不足的
stool　[stuːl]　凳子
armchair　['ɑːmtʃeə(r)]　扶手椅
pendant lamp　吊灯
gable　['ɡeɪbl]　山墙

难句翻译

① Kelly Hoppen is a world-renowned British designer who has pioneered a simple yet opulent style that has permeated interior design at every level. As well as designing apartments, houses and yachts for an ever-expanding international private client list, Kelly also undertakes commercial design projects including hotels, restaurants, office spaces and aircraft interiors.

凯丽·赫本是举世闻名的英国设计师。她所开创的奢华简约风格已经渗透到了室内设计的各个层面。赫本不但为日益增多的国际私人客户设计公寓、房屋和游艇,而且承接了包括旅馆、餐厅、办公空间和机舱在内的商业设计。

Kelly Hoppen(凯丽·赫本)

凯丽·赫本出生于1959年,是英国乃至国际上炙手可热的设计师。她设计的作品冷静、简洁、优雅并富有创意,在世界上赢得了很多赞誉。早在1997年,她就获得了安德鲁·马丁"年度国际设计师奖";2006年,获得"Ella室内设计奖";2007获得了"Homes & Garden Awards""GRAZIA年度设计师"。但是在这些奖项中最为重要的还是她在同年6月获得的欧洲妇女联盟颁发的最杰出女性企业家奖。这个奖项让她的名字与田径运动员Paula Radcliffe、女帆船运动员Ellen MacArthu、成功穿越南北极的探险家Fiona Thorne、畅销书作家Kate Mosse和播音员Angela Rippon这些杰出女性联系在了一起,成为欧洲最杰出的女性之一。

From

　　http://www.homeportfolio.com/Designers/Details/29494/kelly-hoppen
　　https://en.wikipedia.org/wiki/Kelly_Hoppen

3.3 Philippe Starck and His Masterpieces

Philippe Starck (born in 1949) is a French designer known since the start of his career in the 1980s for his interior product, industrial and architectural design including furniture and objects that have a simple but inventive structures(Fig. 3-3-1).

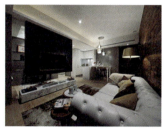
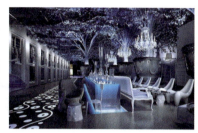

Fig. 3-3-1 Philippe Starck and his masterpieces

The son of an **aeronautical engineer**, Starck studied at the École Camondo in Paris. An inflatable structure he imagined in 1969 was the first incursion into questions of **materiality**, and an early indicator of Starck's interest in where and how people live. Starck's designs brought him to the attention of Pierre Cardin who offered him a job as artistic director of his publishing house.

While working for Cardin, Starck set up his first industrial design company, Starck Product-which he later renamed Ubik after Philip K. Dick's novel-and began working with manufacturers in Italy-Driade, Alessi, Kartell-and internationally, including Austria's Drimmer, Vitra in Switzerland and Spain's Disform. His concept of **democratic design** led him to focus on mass-produced consumer goods rather than one-off pieces, seeking ways to reduce cost and improve quality in mass-market goods.[①]

In 1983, the French President Francois Mitterrand, on the recommendation of his Minister of Culture Jack Lang, chose Starck to refurbish the president's private apartments at the Élysée. The following year he designed the Café Costes.

Starck's output expanded to include furniture, **decoration**, architecture, **street furniture**, industry (wind turbines, photo booths), **bathroom fittings**, kitchens, floor and wall coverings, lighting, **domestic appliances**, **office equipment** such as staplers, **utensils** (including a **juice squeezer** and a toothbrush), **tableware**, clothing, **accessories** (shoes, eyewear, luggage, watches) toys, glassware (perfume bottles, mirrors), graphic design and publishing, even food (Panzani pasta, Lenôtre Yule log), and vehicles for land, sea, air and space (bikes, motorbikes, yachts, planes). The buildings he designed in Japan, starting in 1989, went against the grain of traditional forms. The first, Nani Nani, in Tokyo, is an anthropomorphic structure, clad in a living **material** that evolves over time. The thesis being: design should take its place within the environment but without impinging on it; an object must serve its context and become part of it.

A year later he designed the Asahi Beer Hall in Tokyo, a building topped with a golden flame. This was followed in 1992 by Le Baron Vert office complex in Osaka. Starck's buildings, while dedicated to work, are no

less instilled with life and its constant effervescence. In France he designed the extension of the École Nationale Supérieure des Arts Décoratifs (ENSAD) in Paris (1998).

For the past thirty years Philippe Starck has been designing hotels all over the world, including the Royalton in New York in 1988, the Delano in Miami in 1995, the Mondrian in Los Angeles, the St Martin's Lane in London in 1999, the Sanderson, also in London, in 2000, and the complete 2001 renovation of the historic Clift in San Francisco with its updated **art deco bar**, the Redwood Room. In South America, Philippe Starck designed the inside and outside of the Hotel Fasano in Rio de Janeiro in 2007 using materials such as wood, glass and **marble**. He then turned his attention to luxury hotels: in 2008, Hotel Maurice and the Royal Monceau in 2010.

Comments on Philippe Starck's Masterpieces

1. Hotel Maurice and Royal Monceau(Fig. 3-3-2)

 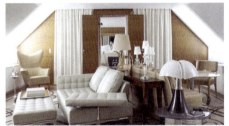

Fig. 3-3-2 Hotel Maurice and Royal Monceau interior design

Commentary

From 1990, Philippe Starck has worked to democratize quality "designer" hotels, beginning with the Paramount in New York. Offering rooms at $100/night, it became a **classic** in its **genre**. In 2008, Starck brought this humanist concept to Paris as the Mama Shelter. A second Mama Shelter opened in Marseille in 2012, with a further three scheduled for 2013 in Lyon, Bordeaux and Istanbul.

In North America, in the 2000s, Philippe Starck with entrepreneur Sam Nazarian created the concept for SLS, a chain of luxury hotels. The Bazaar lobby at SLS Hotel in Beverly Hills quickly became a public space with its tapas restaurants, Norwegian health bar, **patisserie** and a Moss concept store.

2. Restaurants

Commentary

Philippe Starck has several restaurants to his credit: Bon, Mori Venice Bar (Fig. 3-3-3) and Le Paradis du Fruit in France, and the notable launch of Katsuya in Los Angeles in 2006, the first in a series of Japanese restaurants. The A'trego opened in Cap d'Ail in 2011. He designed the interior and exterior of Ma Cocotte, a restaurant that launched in September 2012 at the Saint-Ouen flea market near Paris. In 2013, he designed Miss Ko, an Asian-centric concept restaurant in Paris.

In November 2011, Lodha Group appointed Phillippe Starck for "yoo inspired by Starck", to design the residential development at New Cuffe Parade, Mumbai.

3. Furniture

Commentary

The French architect and industrial designer Philippe Starck is famously known with his ability to refine

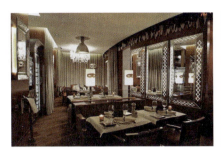 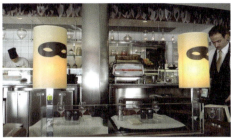

Fig. 3-3-3　Mori Venice Bar design

the look of centuries old designs using modern materials(Fig. 3-3-4).

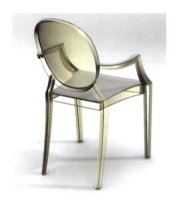

Fig. 3-3-4　Louis Ghost Chair

专业词汇

aeronautical engineer　航空工程师
materiality　[mə,tiəri'æliti]　重要性、物质性
democratic design　大众的设计、民主设计
decoration　[,dekə'reiʃn]　装饰
street furniture　城市家具、街具
bathroom fitting　浴室配件
domestic appliance　家用电器
office equipment　办公用品
utensil　[juːˈtensl]　用具
juice squeezer　榨汁机
tableware　['teiblweə(r)]　餐具
accessory　[əkˈsesəri]　饰品
art deco bar　装饰艺术风格的酒吧
material　[məˈtiəriəl]　材料
marble　['mɑːbl]　大理石
classic　['klæsik]　典型的、传统的、优秀的典范
genre　['ʒɒnrə]　类型、种类、体裁
patisserie　[pəˈtiːsəri]　法式糕点

难句翻译

① His concept of democratic design led him to focus on mass-produced consumer goods rather than one-off pieces, seeking ways to reduce cost and improve quality in mass-market goods.

受民主设计理念的影响他专攻大批量生产的消费品而非设计单品。他追求的是降低大众商品的成本和提升其质量。

Philippe Starck(菲利普·斯达克)

菲利普·斯达克1949年出生于法国巴黎,是20世纪末西方最有影响的设计师,也是一个发明家和思想家。在他30多年的设计生涯里,创作了许多别出心裁、令人耳目一新的作品。其设计作品涵盖了建筑设计、室内设计、家具设计、灯具、高科技产品、服装设计、平面设计、食品包装等。菲利普·斯达克认为"设计是拒绝任何规则与典范的,本质就是不断地超越与探索"。

From

https://en.wikipedia.org/wiki/Philippe_Starck

3.4 Andree Putman and Her Masterpieces

Andree Putman was a French interior and **product designer**. She was the mother of Olivia Putman and Cyrille Putman(Fig. 3-4-1).

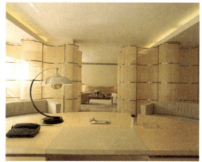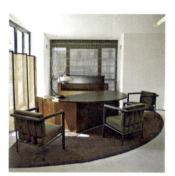

Fig. 3-4-1　Andree Putman and her masterpieces

Life and Work

Childhood and Youth (1925—1944)

Andree Putman was born into a wealthy family of bankers and notables from Lyon. Her paternal

grandfather, Edouard Aynard, founded the Maynard & Sons Bank. Her paternal grandmother, Rose de Montgolfier, was a descendant of the hot-air balloon inventors' family. Her father was a graduate from the prestigious Ecole Normale Supérieure who spoke seven languages but swore to a life of austerity and seclusion to protest against his own milieu. Her mother, Louise Saint-René Taillandier, was a concert pianist who found comfort in the frivolity of "being a great artist without a stage".

Her formal artistic education first came, however, through music. Her mother took her and her sister to concerts and urged them to learn the piano. But she was later told that her hands were not suited to the piano. As a consequence, she would never be a virtuoso. She then switched her focus to studying composition at the National Conservatory of Paris. At the age of nineteen, she received the First Harmony Prize of the Conservatory from Francis Poulenc himself. On that occasion, he told her that at least 10 more years of unremitting work and ascetic life would be necessary before she could-maybe-aspire to a career as a composer. Picturing herself living like a Carmelite nun at the Fontenay Abbey, she cut short the musical career she had undertaken as a tribute to her mother. Putman decided to satisfy her curiosity and creative instincts another way.

Professional beginnings (1945—1978)

At the age of 20 she had a serious bike accident, which she barely survived. Her characteristic posture stemmed from this event: she was a tall woman who stood straight and walked as if on a tightrope. Soon after the accident, she broke free from her initial career in music and from the illusion of safety her social environment offered her and decided to discover the world. One day, she emptied her bedroom and furnished it with just a hard **iron bed**, a chair and a Miró poster on the white walls. This early expression of her desire of independence led to a confrontation with her family who wondered "if she realizes the sorrow she makes them feel?"

"What can one do when one did not go to school and is a musician who stopped playing music?", she asked her maternal grandmother, Madeleine Saint-René Taillandier. "Nothing except messenger", was the reply. Taking her grandmother's advice, Andrée started working as a messenger for Femina magazine. While taking care of all the dirty little jobs of the office, she observed with a sharp eye the social theatre which takes place during meetings. She worked for *Elle* and *L'Oeil*, a prestigious art magazine where the still-lives she imagined with objects of various styles and from different periods attracted attention.① She identified what is sophisticated and innovative, widened her knowledge of designers... and walked by the Café de Flore everyday. "We could see Antonin Artaud, Juliette Greco, Giacometti, Sartre and Simone de Beauvoir... — people who looked free and were emancipated from conventions."

These first jobs allowed Andrée to meet artists, characters more familiar to her than intellectuals. At the time, she was not confident enough to fully express herself. She therefore stayed in the background rather to put the talents of others in the limelight, something for which she showed great talent since she was raised in an **artistically-rich environment**. Personally knowing what it is to "be trapped into the beaten tracks", she was moved by "people whose work is not understood", "impressed by these artists who do not look for anything else but remaining in the depth of their sincerity, their risk". She only wished to help them and establish a connection between them and the rest of the world. In the late 1950s, Andrée Aynard married Jacques Putman, an **art critic, collector** and **publisher**. Together they associated with artists such as Pierre Alechinsky, Bram van Velde, Alberto Giacometti and Niki de Saint Phalle.

In 1958, Putman collaborated with the retail chain Prisunic as Art Director of the Home Department, where her motto was to "design beautiful things for nothing". Her wish of making art available to a larger public also became a reality through Prisunic as she organised with her husband editions of lithographs by

famous artists sold for only 100 Francs (15 €). In 1968, she distinguished herself in the style agency Mafia until Didier Grumbach spotted her in 1971 and hired her to start a new company which was aimed at developing the textile industry: Créateurs & Industriels. Her intuition led her to reveal many talented designers such as Jean-Charles de Castelbajac, Issey Miyake, Ossie Clark, Claude Montana and Thierry Mugler. It is at that moment that she went into interior design as she converted the former SNCF premises into a **showroom** and offices for the company.

Ecart (1978—1995)

In the late 1970s, Créateurs & Industriels went bankrupt, Putman got divorced. She tried to materialise her intense feeling of emptiness: at the time she lived in a room furnished with only a bed and two **lamps** "in total austerity, because I no longer knew what I liked". Taking her friend Michel Guy's advice, she decided to found Ecart (which backwards is Trace). It is therefore at the age of 53 that Andrée Putman really started the career which made her famous from Hong Kong to New York. She started by giving life again to forgotten designers from the 1930s: René Herbst, Jean-Michel Frank, Pierre Chareau, Robert Mallet-Stevens, Gaudi, Eileen Gray... "My only concern was to interest at least ten persons and I would have accomplished something which would carry me for all my life". These pieces of furniture won over not ten, but thousands of people. From releasing furniture to designing interiors, the evolution of activity came quite naturally. She then took the next logical step: "I loathe pompous luxury. I take interest in the essential, the framework, the basic elements of things."

The interior design of the Morgans Hotel in New York in 1984 marked a turning point in Andrée Putman's career: she managed to make a high-standard hotel with a small budget and asserted her style with sober rooms and visual effects. "Because I started working in New York, the French suddenly asked for me." From the 1980s, she led more and more interior design projects: hotels such as Le Lac in Japan, Im Wasserturm in Germany and the Sheraton in Roissy-Charles de Gaulle airport in Paris; stores for Azzedine Alaia, Balenciaga, Bally and Lagerfeld; offices, particularly the one for French Minister of Culture Jack Lang in 1984; and museums like the CAPC, Bordeaux's contemporary **art museum**.

In her work, not only did Putman reconcile "rich" and "poor" materials, and find a new way to use light and cleared spaces to rediscover their origin, she also tackled the ways of living. The private residences she designed enabled her to break the rules: why dine in the **dining room**, cook in the kitchen and sleep in the bedroom when one can overcome obstacles and change one's ways? "It is not about bathing in the living room and cooking in the bedroom but rather about opening spaces to various activities. Why should places be reduced to one **function** instead of favoring the sensations they bring us?" Putman was among the first in France to live in a **loft**.

The Andree Putman Studio (1997—nowadays)

In 1997, Andree Putman created her eponymous Studio, specializing in interior design, product design and **scenography**. When she imagined objects, she refused the excess of striving to **re-design** pieces which were perfectly designed by others in the past. "We have to accept that many things can no longer be changed—or very slightly. If we change them, we have to add humour, detachment. What interests me: a joke in a collection, a sign of complicity." For example, when she began collaborating with Christofle in 2000, she designed a collection of **silver cutlery**, **objects** and **jewellery** named Vertigo. The common element of this collection was a slightly twisted ring: "the fact that this ring is twisted brings life to it: did it fall? Why is it asymmetrical? Life is made of imperfections." She created a Champagne bucket for Veuve Clicquot and reinterpreted the iconic Louis Vuitton Steamer Bag. In 2001, Putman created "Préparation Parfumée". In 2003, she launched her own line of furniture "Préparation meublée" where the pieces were ironically named

"Croqueuse de diamants", "Jeune bûcheron", "Bataille d'oreillers"... ("Gold digger", "Young lumberjack" and "Pillow fight"). In 2004, she creates a stunning Russian tea set for Gien: Polka. An interior designer, she carried out the projects for Pershing Hall in Paris, the Morgans Hotel in Manhattan, and the Blue Spa at the Hotel Bayerischer Hof in Munich. In 2005, Guerlain chooses the Studio Putman to re-design its **flagship store** on the Champs Elysées. Among notable private commissions are the Pagoda House in Tel Aviv, the vast SoHo penthouse for Serge and Tatiana Sorokko, and a cliff-house in Tangier for Bernard-Henri Lévy and Arielle Dombasle, for whom Putman completely restructured the building.

In 2007, a new era began as Andrée's daughter Olivia Putman agreed to take over the Art Direction of the Studio, a wish its founder had expressed for a long time. "We realised that time and Andrée's fame had turned our family name into an adjective. Qualified in History of Art and **landscape** architecture, Olivia wishes to perpetuate the eclecticism and curiosity her mother always claimed. In 2008, Paris Mayor Bertand Delanoë made Andree president of the first Paris Design Comity, which aims at rethinking street furniture, Parisian public equipments and employees' uniforms. That same year, she presented Voie Lactée ("Milky Way"), the grand piano she designed for France's oldest piano **manufacturer** Pleyel and unveiled Entrevue, her creation for Bisazza at the Salone del Mobile in Milan. In June, the store she designed for fashion designer Anne Fontaine in New York was inaugurated, following the ones designed in Paris and Tokyo.

The following year, Andrée and Olivia present the chair they designed for the American firm Emeco, a line of sunglasses for RAC Paris, a collection of carpets for Toulemonde Bochart, a knife for the Forge de Laguiole, as well as furniture for Fermob and Silvera. The Studio was also called upon to imagine the scenography for French singer Christophe's concerts at the Olympia and at Versailles, and the Madeleine Vionnet exhibition at the Musée des Arts Décoratifs in Paris. In October 2009, a new monograph dedicated to Andrée Putman's career is published by Rizzoli Editions. In 2010, Paris' City Hall paid tribute to Andrée Putman by hosting a great exhibition about her life, for which Olivia is curator. The event for Andrée Putman, ambassador of style attracted more than 250 000 visitors.

Death

Putman died at her apartment in the sixth arrondissement of Paris, on 19 January 2013, aged 87.

Comments on Andree Putman's Masterpieces

1. Morgans Hotel

Commentary

Morgans Hotel is a **boutique hotel** located on Madison Avenue, New York City, USA. Owned by Morgans Hotel Group, this was the first property in the group and opened in 1984. Andrée Putman served as interior designer for the 1984 renovation of this 1927 structure.

New **design features** are evident throughout Morgans' public spaces. A sampling of these features includes.

A "Living-Room" Lobby, with textured **taupe-colored glass walls** with overlaid bronze mullions, featuring a custom Putman-designed **wool** rug of black, rich camel and taupe in a bold three-dimensional **cubist pattern**; floors in three varied shades of imported Italian granite in different finishes; groupings of antique French leather club chairs, including a **teak** and caned plantation chair from the 1940s, all culled from Paris' top flea markets; Putman-designed **dark wood** end tables. ② Spherical-shaped desk lamps in nickel-plated brass were created by Félix Aublet in 1925. Candles in the evening coupled with black-and-white checkerboard patterned

wool throws loosely draped over the French club chairs further accentuate the "lived-in" feel(Fig. 3-4-2).

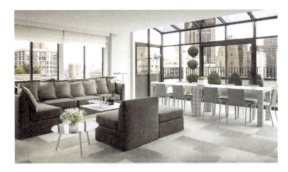 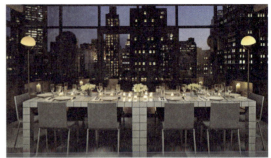

Fig. 3-4-2　Morgans Hotel interior design

2. CAPC Museum

Commentary

The museum is housed in the Entrepôt Lainé, a former **warehouse** for colonial goods such as sugar, coffee, cocoa, cotton, spices and oils. The warehouse was built in 1820 by the architect Claude Deschamps. It is built of brick, stone and wood in a style inspired by Italian architecture. There is a **grand nave** that is reminiscent of a medieval church and that is used to present temporary exhibitions. The building was restored by the architects Denis Valode and Jean Pistre in the 1980s, the second project that this architectural team had undertaken. Their treatment was unusual for the time, emphasizing shadows and depth.

The designer Andrée Putman renovated the interior. The Café Putnam, named after the **decorator**, has a **minimalist** decor of metal, concrete and natural materials such as teak and **wicker**. It has a **terrace**(Fig. 3-4-3).

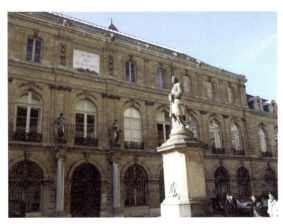 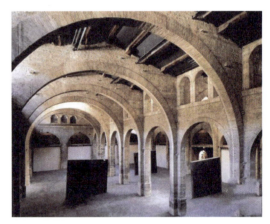

Fig. 3-4-3　CAPC Museum

专业词汇

product designer　产品设计师
iron bed　铁艺床
artistically-rich environment　艺术感丰富的环境
art critic　艺术评论家
collector　[kəˈlektə(r)]　收藏家
publisher　[ˈpʌblɪʃə(r)]　出版者

showroom ［ˈʃəʊruːm］ 展厅
lamp ［læmp］ 灯
art museum 艺术博物馆
dining room 餐厅
function ［ˈfʌŋkʃn］ 功能
loft ［lɒft］ 阁楼
scenography ［siːˈnɒgrəfi］ 透视画法
re-design 再设计
silver cutlery 银餐具
object ［ˈɒbdʒikt］ 对象
jewelry ［ˈdʒuːəlri］ 珠宝
flagship store 旗舰店
landscape ［ˈlændskeip］ 景观
manufacture ［ˈmænjuˈfæktʃə(r)］ 制造
boutique hotel 精品酒店
design feature 设计形态
taupe-colored glass wall 灰褐色的玻璃墙
wool ［wʊl］ 羊毛
cubist pattern 立体主义的模式
teak ［tiːk］ 柚木
dark wood 红木
warehouse ［ˈweəhaʊs］ 仓库
grand nave 中央广场
decorator ［ˈdɛkəretər］ 装饰者
minimalist ［ˈminiməlist］ 极简主义
wicker ［ˈwikə(r)］ 柳条
terrace ［ˈterəs］ 露台

难句翻译

① She worked for *Elle* and *L'Oeil*, a prestigious art magazine where the still-lives she imagined with objects of various styles and from different periods attracted attention.
她受聘于《ELLE》和著名艺术杂志《L'OEIL》，因风格、时代各异的静物作品而备受瞩目。

② A "Living-Room" Lobby, with textured taupe-colored glass walls with overlaid bronze mullions, featuring a custom Putman-designed wool rug of black, rich camel and taupe in a bold three-dimensional cubist pattern; floors in three varied shades of imported Italian granite in different finishes; groupings of antique French leather club chairs, including a teak and caned plantation chair from the 1940s, all culled from Paris' top flea markets; Putman-designed dark wood end tables.
一个"客厅式"大堂，环绕着灰褐色凸纹玻璃墙，上面重叠着铜制中梃。大堂里铺着普特曼设计的羊毛地毯，地毯的纹样为黑、深驼、灰褐三色的三维立方图案。地板用色深、抛光不同的意大利进口花岗岩所铺成。还有几组古董法式俱乐部皮椅，其中有一把是20世纪40年代的柚木编织椅。这些椅子全部来自巴黎最好的跳蚤市场。此外还有普特曼设计的暗色木茶几。

Andree Putman(安德莉·普特曼)

安德莉·普特曼是国际顶尖设计大师,曾获美国室内设计师协会设计成就奖,以及法国文化部长颁发的国家工业创新设计大奖。其作品包括纽约摩根斯(Morgans)大酒店,巴黎 Pershing Hall 大酒店(原巴黎的美国驻军处),Peter Greenaway 电影《枕边书》场景设计,法国航空公司最著名的"协和"飞机机舱体等。安德莉的作品还包括香水、LV 围巾、施华洛世奇水晶、Swatch 手表、Hoesch 浴缸、无数的家居用品等。

From

https://en.wikipedia.org/wiki/Andr%C3%A9e_Putman

https://en.wikipedia.org/wiki/CAPC_mus%C3%A9e_d%27art_contemporain_de_Bordeaux

单元词汇总结

Interior:	Staircase;Bedroom;Warehouse;Apartment;Restaurant;Office;Showroom;Dining room;Loft;Flagship store;Warehouse;Curtain wall;Cushion;Kitchen;Cabinet
Building:	Public space;Hotel;Flagship store;Showroom;Grand nave;Art museum;Boutique hotel;Skyscraper;Cafeteria;Family room;Terrace
Structure:	Gable; Column; Flagship grid; Square grid; Concrete pillar; Glass wall; Metal frame; Cantilevered washbasin
Material:	Teak;Wool;Natural material;Wool;Red wood;Dark wood;Cotton
Design:	Industrial designer;Exhibition;Concrete wall;Contemporary Art;Landscape;Taupe-colored glass wall;Grand nave
Furniture:	Iron bed;Stool;Armchair;Lamp;Silver cutlery;Wicker furniture

单元4

艺术家与他们的作品

Unit 4　Artists and Their Masterpieces

4.1 Leonardo di ser Piero da Vinci and His Masterpieces

Leonardo di ser Piero da Vinci, more commonly Leonardo da Vinci or simply Leonardo (April 1452—2 May 1519), was an Italian polymath whose areas of interest included invention, painting, sculpting, architecture, science, music, mathematics, engineering, literature, **anatomy**, geology, **astronomy**, botany, writing, history, and **cartography**. He has been variously called the father of **paleontology**, **ichnology**, and architecture, and is widely considered one of the greatest painters of all time. Sometimes credited with the inventions of the parachute, helicopter and tank, his genius epitomized the Renaissance humanist ideal(Fig. 4-1-1).

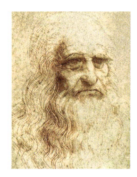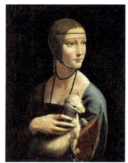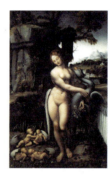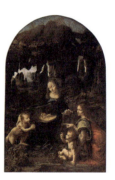

Fig. 4-1-1 Leonardo di ser Piero da Vinci and his masterpieces

Many historians and scholars regard Leonardo as the prime exemplar of the "Universal Genius" or "**Renaissance** Man", an individual of "unquenchable curiosity" and "feverishly inventive imagination". According to art historian Helen Gardner, the scope and depth of his interests were without precedent in recorded history, and "his mind and personality seem to us superhuman, while the man himself mysterious and remote". Marco Rosci, however, notes that while there is much speculation regarding his life and personality, his view of the world was logical rather than mysterious, and that the empirical methods he employed were unorthodox for his time.

Born out of wedlock to a notary, Piero da Vinci, and a peasant woman, Caterina, in Vinci in the region of **Florence**, Leonardo was educated in the studio of the renowned Florentine painter Andrea del Verrocchio. Much of his earlier working life was spent in the service of Ludovico il Moro in Milan. He later worked in Rome, Bologna and Venice, and he spent his last years in France at the home awarded to him by Francis I.

Leonardo was, and is, renowned primarily as a painter. Among his works, the **Mona Lisa** is the most famous and most parodied portrait and *The Last Supper* is the most reproduced religious painting of all time, with their fame approached only by Michelangelo's *The Creation of Adam*. Leonardo's drawing of the Vitruvian Man is also regarded as a cultural icon, being reproduced on items as varied as the euro coin, textbooks, and T-shirts. Perhaps fifteen of his paintings have survived. Nevertheless, these few works, together with his notebooks, which contain drawings, scientific diagrams, and his thoughts on the nature of painting, compose a contribution to later generations of artists rivaled only by that of his contemporary, Michelangelo.

Leonardo is revered for his technological ingenuity. He **conceptualized** flying machines, a type of armoured fighting vehicle, concentrated solar power, an adding machine, and the double hull, also outlining a rudimentary theory of plate tectonics. Relatively few of his designs were constructed or were even feasible during his lifetime, as the modern scientific approaches to metallurgy and engineering were only in their infancy during the Renaissance, but some of his smaller inventions, such as an automated bobbin winder and a machine for testing the tensile strength of wire, entered the world of manufacturing unheralded. A number of Leonardo's most practical inventions are nowadays displayed as working models at the Museum of Vinci. He made substantial discoveries in anatomy, **civil engineering**, optics, and hydrodynamics, but he did not publish his findings and they had no direct influence on later science.

Today, Leonardo is widely recognized as one of the most diversely talented individuals ever to have lived.

Comments on Leonardo di ser Piero da Vinci's Masterpieces

1. Annunciation

Annunciation (Fig. 4-1-2), by the Italian Renaissance artists Leonardo da Vinci and Andrea del Verrocchio, dates from circa 1472—1475 and is housed in the **Uffizi Gallery of Florence**, Italy.

Fig. 4-1-2　Annunciation

The subject matter is drawn from Luke 1. 26-39 and depicts the angel Gabriel, sent by God to announce to a virgin, Mary, that she would miraculously conceive and give birth to a son, to be named **Jesus**, and to be called "the Son of God" whose reign would never end. The subject was very popular for artworks and had been depicted many times in the art of Florence, including several examples by the Early Renaissance painter Fra Angelico. The details of its commission and its early history remain obscure.

In 1867, following Gustav Waagen methods, Baron Liphart identified this Annunciation, newly arrived in the Uffizi Gallery from a convent near Florence, as by the young Leonardo, still working in the studio of his master Verrocchio. The painting has been attributed to different artists, including Leonardo and Verrocchio's contemporary Domenico Ghirlandaio. It was more recently determined to be a collaboration between Leonardo and his master Verrocchio, with whom Leonardo collaborated on the Baptism of Jesus.

2. The Last Supper

Leonardo's most famous painting of the 1490s is The Last Supper (Fig. 4-1-3), painted for the refectory of the Convent of Santa Maria della Grazie in **Milan**. The painting represents the last meal shared by Jesus with his disciples before his capture and death. It shows specifically the moment when Jesus has just said "one

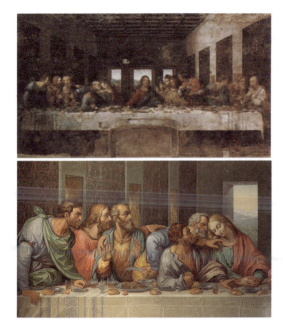
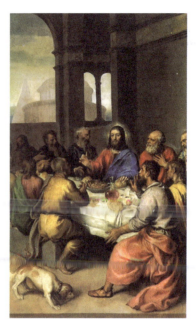

Fig. 4-1-3　The Last Supper

of you will betray me". Leonardo tells the story of the consternation that this statement caused to the twelve followers of Jesus.

The novelist Matteo Bandello observed Leonardo at work and wrote that some days he would paint from dawn till dusk without stopping to eat and then not paint for three or four days at a time. This was beyond the comprehension of the prior of the convent, who hounded him until Leonardo asked Ludovico to intervene. Vasari describes how Leonardo, troubled over his ability to adequately depict the faces of Christ and the traitor Judas, told the Duke that he might be obliged to use the prior as his model.

When finished, the painting was acclaimed as a masterpiece of design and characterization, but it deteriorated rapidly, so that within a hundred years it was described by one viewer as "completely ruined". Leonardo, instead of using the reliable technique of **fresco**, had used tempera over a ground that was mainly **gesso**, resulting in a surface which was subject to molding and to flaking. Despite this, the painting has remained one of the most reproduced works of art, countless copies being made in every medium from carpets to **cameos**.

3. Mona Lisa

Among the works created by Leonardo in the 16th century is the small portrait known as the Mona Lisa (Fig. 4-1-4) or "la Gioconda", the laughing one. In the present era it is arguably the most famous painting in the world. Its fame rests, in particular, on the elusive smile on the woman's face, its mysterious quality brought about perhaps by the fact that the artist has subtly shadowed the corners of the mouth and eyes so that the exact nature of the smile cannot be determined. The **shadowy** quality for which the work is renowned came to be called "sfumato" or Leonardo's smoke. Vasari, who is generally thought to have known the painting only by repute, said that "the smile was so pleasing that it seemed divine rather than human; and those who saw it were amazed to find that it was as alive as the original". Other characteristics found in this work are the unadorned dress, in which the eyes and hands have no competition from other details, the dramatic landscape background in which the world seems to be in a state of flux, the subdued coloring and the extremely smooth nature of the painterly technique, employing oils, but laid on much like tempera and blended

on the surface so that the brushstrokes are indistinguishable. Vasari expressed the opinion that the manner of painting would make even "the most confident master... despair and lose heart". [①] The perfect state of preservation and the fact that there is no sign of repair or over painting is rare in a panel painting of this date.

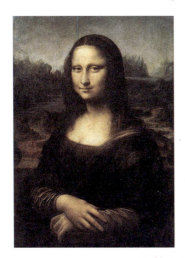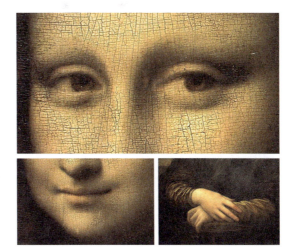

Fig. 4-1-4　Mona Lisa painting and details

In the painting Virgin and Child with St. Anne, the composition again picks up the theme of figures in a landscape which Wasserman describes as "breathtakingly beautiful" and taken back to the St Jerome picture with the figure set at an oblique angle. What makes this painting unusual is that there are two obliquely set figures superimposed. Mary is seated on the knee of her mother, St. Anne. She leans forward to restrain the Christ Child as he plays roughly with a lamb, the sign of his own impending sacrifice. This painting, which was copied many times, influenced Michelangelo, Raphael, and Andrea del Sarto, and through them Pontormo and Correggio. The trends in composition were adopted in particular by the Venetian painters Tintoretto and Veronese.

专业词汇

renaissance　[ˈrenəsɑːns]　文艺复兴
Florence　[ˈflɒrəns]　佛罗伦萨
conceptualized　[kənˈseptjuəlaizd]　概念化
Milan　[miˈlæn]　米兰
astronomy　[əˈstrɒnəmi]　天文学
anatomy　[əˈnætəmi]　剖析, 解剖
civil engineering　[ˌsiv(ə)l endʒiˈniəriŋ]　土木工程
Uffizi Gallery　乌菲齐美术馆
Jesus　[ˈdʒiːzəs]　耶稣
fresco　[ˈfreskəʊ]　壁画
cartography　[kɑːˈtɒgrəfi]　制图学
gesso　[ˈdʒesəʊ]　(绘画、雕刻用的)石膏粉
cameo　[ˈkæmiəʊ]　浮雕
Mona Lisa　[ˈməʊnə ˈliːsə]　蒙娜丽莎
shadowy　[ˈʃædəʊi]　有阴影的
paleontology　[ˌpælɪɒnˈtɒlədʒi]　古生物学

ichnology [ik'nɒlədʒi] 足迹化石学

难句翻译

① Other characteristics found in this work are the unadorned dress, in which the eyes and hands have no competition from other details, the dramatic landscape background in which the world seems to be in a state of flux, the subdued coloring and the extremely smooth nature of the painterly technique, employing oils, but laid on much like tempera and blended on the surface so that the brushstrokes are indistinguishable. Vasari expressed the opinion that the manner of painting would make even "the most confident master... despair and lose heart".

作品的其他特点有突显眼睛与手部细节的朴素裙子，有仿佛置身于多变的状态下的戏剧化风景布景，还有节制的着色和极平滑的用笔。虽然用的是油料，但叠色的方式好似蛋彩画，颜色在画面调和而笔触微不可见。瓦萨里认为其作画的方式会使"最自信的大师……绝望并丧失信心"。

Leonardo di ser Piero da Vinci(列奥纳多·迪·皮耶罗·达·芬奇)

列奥纳多·迪·皮耶罗·达·芬奇是欧洲文艺复兴时期杰出的画家、科学家、发明家、哲学家、建筑工程师，而现代学者称他为"文艺复兴时期最完美的代表"，是人类历史上绝无仅有的全才。他在绘画艺术上取得了很高的成就，代表作有《蒙娜丽莎》《最后的晚餐》《岩间圣母》等。他认为自然中最美的研究对象是人体，人体是大自然的奇妙作品，画家应以人为研究绘画对象的核心。其最著名的作品《蒙娜丽莎》成为卢浮宫的镇馆之宝。

From

https：//en. wikipedia. org/wiki/Leonardo_da_Vinci

4.2
Claude Monet and His Masterpieces

Claude Monet, born in Paris, the son of a grocer, grew up in Le Havre. Contact with Eugène Boudin in about 1856 introduced Monet to painting from nature. He was in Paris in 1859 and three years later he entered the studio of Charles Gleyre, where he met Pierre-Auguste Renoir, Alfred Sisley and Frédéric Bazille. He was an influence on whose figure compositions of the 1860s, while the informal style of whose later landscapes originated in works such as "Bathers at La Grenouillère", painted in 1869 when Monet worked with Renoir at Bougival. Monet was the leading French **impressionist landscape painter**. Like Camille Pissarro and Charles-Francois Daubigny, Monet moved to **London** during the Franco-Prussian war. After his return to France he lived at Argenteuil(Fig. 4-2-1).

He exhibited in most of the impressionist **exhibitions**, beginning in 1874, where the title of one of his paintings led to the naming of the movement. A period of travel followed in the 1880s, and in 1883 he acquired a property at Giverny, north-west of Paris. Thereafter Monet concentrated on the production of the famous

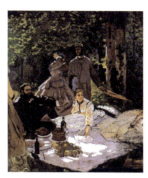

Fig. 4-2-1　Claude Monet and his masterpieces

series showing a single subject in different lighting conditions, including poplars, haystacks, **Rouen Cathedral**, and his own garden at Giverny.

Comments on Claude Monet's Masterpieces

1. The Water-Lily Pond in 1899

Commentary

In 1883 Monet moved to Giverny where he lived until his death. There, on the grounds of his property, he created a water garden (Fig. 4-2-2) "for the purpose of cultivating aquatic plants", over which he built an **arched bridge** in the Japanese style.

In 1899, once the garden had matured, the painter undertook 17 views of the motif under different light conditions. Surrounded by luxuriant foliage, the bridge is seen here from the pond itself, among an artful arrangement of reeds and willow leaves.

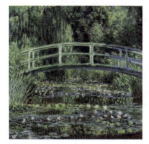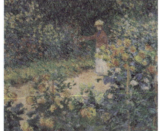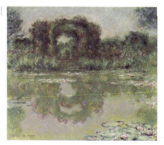

Fig. 4-2-2　Monet's garden

2. Water-Lilies in 1918

Commentary

In 1916 Monet had a new studio built at Giverny in order to work on huge canvases; large-scale, **close-up** views of the surface of his water-lily pond. In 1918, the day after the Armistice was signed, the painter promised a group of the paintings to the French nation as a "monument to peace". It was a war memorial, but of a personal, unprecedented kind (Fig. 4-2-3).

Monet described his "Water-Lilies" as "producing the effect of an endless whole, of a watery surface with no horizon and no shore". **Distance** and **perspective** are abolished; a limitless expanse of water occupies our entire field of vision. Closely related to that project, this monumental canvas was not included in Monet's gift, which hangs today in the Orangerie of the Tuileries in Paris.

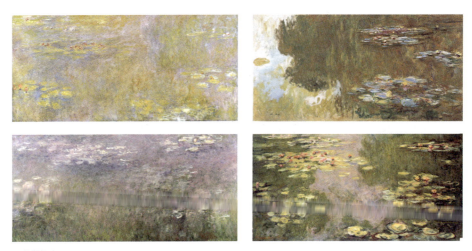

Fig. 4-2-3 Series of water-lilies in different lights

3. The Beach at Trouville in 1870

Commentary

This painting is one of five beach scenes produced by Monet in the summer of 1870, which may have been preparatory **sketches** for a larger painting that Monet intended to submit to the Salon. The figure to the left is probably Monet's wife Camille, and the woman on the right may be the wife of Eugène Boudin, whose own beach scenes influenced the work of Monet (Fig. 4-2-4).

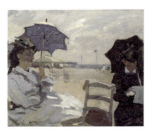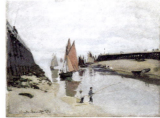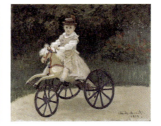

Fig. 4-2-4 The Beach at Trouville

The painting is unusual in its composition: a close-up of **symmetrically** disposed figures and in the bravura of its technique. The white dashes of paint indicating the dress of the left-hand figure are prominent. They contrast with the **shadowed** face, probably concealed by a veil, and the parasol shading the flowered hat.①

Grains of sand are present in the **paint**, confirming that it must have been at least partly executed outside on the beach.

专业词汇

perspective [pəˈspektiv] 视角
sketches [ˈsketʃiz] 草图
close-up 特写镜头
shadowed [ˈʃædəud] 附有阴影的
paint [peint] 颜料
exhibition [ˌeksiˈbiʃn] 展览,展览会,展览品
impressionist [imˈpreʃənist] 印象派画家,印象主义的

London ['lʌndən] 伦敦
Rouen Cathedral 鲁昂大教堂
arched bridge 拱桥
landscape painter 风景画家
symmetrically [si'metrikli] 对称性地
distance ['distəns] 距离

难句翻译

① The painting is unusual in its composition: a close-up of symmetrically disposed figures and in the bravura of its technique. The white dashes of paint indicating the dress of the left-hand figure are prominent. They contrast with the shadowed face, probably concealed by a veil, and the parasol shading the flowered hat.

这幅画的布局不同寻常：一对人物特写对称地绘于图上，笔触大胆新颖。画家突出地使用了几抹白色颜料来表现左侧人物的裙子。这与似被面纱遮住的脸庞和阳伞阴影下的花帽形成了明暗对比。

Claude Monet（克劳德·莫奈）

克劳德·莫奈被誉为"印象派领导者"，是法国历史上最重要的画家之一。印象派的理论和实践大部分都有他的推广。莫奈擅长光与影的实验与表现技法。他最重要的风格是改变了阴影和轮廓线的画法，在莫奈的画作中看不到非常明确的阴影，也看不到突显或平涂式的轮廓线。除此之外，莫奈对色彩的运用相当细腻。他用许多相同主题的画作来实验色彩与光完美的表达。其代表作有《日出·印象》《翁费勒的塞纳河口》《草地上的午餐》等。

From
　　https://www.nationalgallery.org.uk/artists/claude-monet

4.3 Vincent Willem Van Gogh and His Masterpieces

Van Gogh is today one of the most popular **post-impressionist** painters, although he was not widely appreciated during his lifetime. He is now famed for the great vitality of his works which are characterized by **expressive** and **emotive** use of brilliant color and energetic application of impastoed paint. The traumas of his life, documented in his letters, have tended to dominate and distort modern perceptions of his art(Fig. 4-3-1).

Van Gogh was born in Holland, the son of a pastor. He travelled to London in 1873, and first visited Paris in 1874. Over the next decade, he was employed in various ways, including as a lay preacher. By 1883 he had started painting, and in 1885—1886 he attended the academy in Antwerp where he was impressed by **Japanese prints** and by the work of Rubens. On his return to Paris in 1886, he met artists such as Degas, Gauguin and Seurat, and as a result lightened the colors he used.

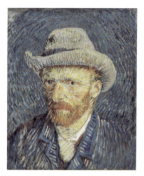 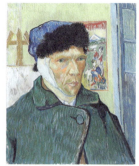 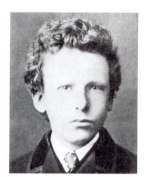

Fig. 4-3-1 Van Gogh

In 1888 Van Gogh settled in Arles in Provence, where he was visited by Gauguin and painted his now famous series of "**Sunflowers**". In the following year, a nervous breakdown brought him to a **sanatorium** at St Remy. It was at this period that he executed "A Wheatfield, with Cypresses". In 1890, suffering from a new bout of depression, he shot himself in the chest and died two days later.

Comments on Van Gogh's Masterpieces

1. Sunflowers in 1888

Commentary

This is one of four paintings of sunflowers (Fig. 4-3-2) dating from August and September 1888. Van Gogh intended to **decorate** Gauguin's room with these paintings in the so-called **Yellow** House that he rented in Arles in the south of France. He and Gauguin worked there together between October and December 1888.

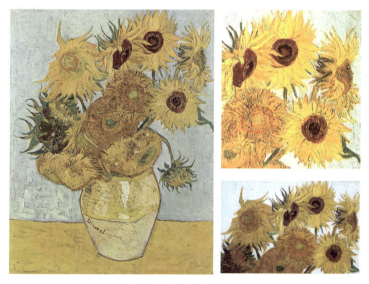

Fig. 4-3-2 Sunflowers

Van Gogh wrote to his brother Theo in August 1888: "I am hard at it, painting with the enthusiasm of a Marseillais eating bouillabaisse, which won't surprise you when you know that what I'm at is the painting of some sunflowers. If I carry out this idea, there will be a dozen panels. So the whole thing will be a **symphony** in blue and yellow. I am working at it every morning from sunrise on, for the flowers fade so quickly. I am now on the fourth picture of sunflowers. This fourth one is a bunch of 14 flowers... it gives a **singular** effect."

The dying flowers are built up with thick **brushstrokes** (impasto). The impasto evokes the **texture** of the

seed-heads. Van Gogh produced a replica of this painting in January 1889, and perhaps another one later in the year. The various versions and replicas remain much debated among Van Gogh scholars.

2. A Wheatfield, with Cypresses in 1889

Commentary

This was painted in September 1889, when Van Gogh was in the St-Rémy mental asylum, near Arles, where he was a patient from May 1889 until May 1890. It is one of three almost identical versions of the composition. Another painting of the cypresses (New York, Metropolitan Museum of Art) was painted earlier in July 1889, and was probably painted directly in front of the subject (Fig. 4-3-3).

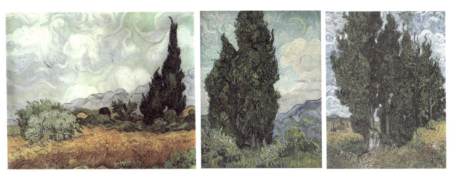

Fig. 4-3-3　A Wheatfield, with Cypresses in 1889

3. Two Crabs in 1889

Commentary

This is thought to have been painted soon after Van Gogh's release from hospital in Arles in January 1889. On 7 January, he wrote to his brother Theo: "I am going to set to work again tomorrow. I shall start by doing one or two **still lifes** to get used to painting again." He was probably also inspired by a **woodcut** by Hokusai, "Crabs", which was reproduced in the May 1888 issue of "Le Japon Artistique", sent to Vincent by Theo in September of that year. In a related painting in the Van Gogh Museum, Amsterdam, the crab is shown lying on its back. Here it is probably the same crab shown both on its back and upright. The **artist** has used varied brushstrokes to convey texture. Parallel strokes sculpt the creature's form on an exuberant sea-like surface① (Fig. 4-3-4).

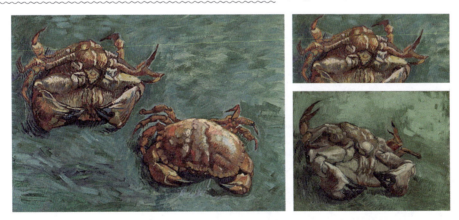

Fig. 4-3-4　Two Crabs

专业词汇

post-impressionist　后印象派

sunflower ['sʌn,flauə(r)] 向日葵
texture ['tɛkstʃər] 纹理
Japanese print 日本版画
expressive [ik'sprɛsiv] 有表现力的
emotive [i'məutiv] 感情的，情绪的
still life 静物
woodcut ['wʊdkʌt] 木刻，版画
sanatorium [,sænə'tɔːriəm] 疗养院
blue [bluː] 蓝色
yellow ['jeləu] 黄色
symphony ['simfəni] 交响乐
singular ['siŋgjələr] 奇异的
decorate ['dekəreit] 装饰，布置
brushstrokes [brʌʃstrəuks] 笔触
artist ['ɑːtist] 艺术家

难句翻译

① The artist has used varied brushstrokes to convey texture. Parallel strokes sculpt the creature's form on an exuberant sea-like surface.

艺术家用不同的笔触来表现质感。他用平行的笔法在生机勃勃的海洋般布景上塑造出了物形。

Vincent Willem Van Gogh（文森特·威廉·凡·高）

文森特·威廉·凡·高1853年出生于荷兰，是后印象主义的先驱。他的绘画风格深深地影响了20世纪的艺术，尤其是野兽派与表现主义。凡·高敏感易怒，聪敏过人，却一直贫穷潦倒，几乎没有受过什么正规的绘画训练。他是继印象主义之后在画坛上产生重要影响的革新者，其艺术特色是点彩画法。但是，他生前的作品一直没有引起人们注意，直到去世后，才引起了评论家一致的好评。凡·高的作品，如《星空》《向日葵》《有乌鸦的麦田》现已成为全球最著名、最广为人知的艺术作品。1890年7月凡·高因精神疾病的困扰，在法国瓦兹河畔结束了37岁的年轻生命。

From

https://www.nationalgallery.org.uk/artists/vincent-van-gogh

4.4 Pablo Picasso and His Masterpieces

Pablo Ruiz Picasso, also known as Pablo Picasso (25 October 1881—8 April 1973), was a Spanish painter, **sculptor, printmaker, ceramist**, stage designer, poet and playwright who spent most of his adult life in France. Regarded as one of the greatest and most influential artists of the 20th century, he is known for co-

founding the **cubist** movement, the invention of constructed sculpture, the co-invention of collage, and for the wide variety of styles that he helped develop and explore. Among his most famous works are the proto-Cubist Les Demoiselles d'Avignon (1907), and Guernica (1937), a portrayal of the Bombing of Guernica by the German and Italian air forces at the behest of the Spanish nationalist government during the Spanish Civil War(Fig. 4-4-1).

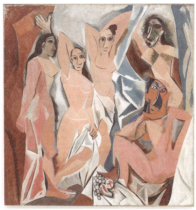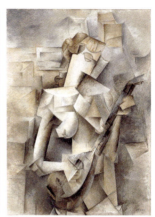

Fig. 4-4-1 Pablo Picasso and his masterpieces

Picasso, Henri Matisse and Marcel Duchamp are regarded as the three artists who most defined the revolutionary developments in the plastic arts in the opening decades of the 20th century, responsible for significant developments in painting, sculpture, printmaking and ceramics.

Picasso demonstrated extraordinary artistic talent in his early years, painting in a naturalistic manner through his childhood and adolescence. During the first decade of the 20th century, his style changed as he experimented with different theories, techniques, and ideas. His work is often categorized into periods. While the names of many of his later periods are debated, the most commonly accepted periods in his work are the Blue Period (1901—1904), the Rose Period (1904—1906), the African-influenced Period (1906—1909), Analytic Cubism (1909—1912), and Synthetic **Cubism** (1912—1919), also referred to as the Crystal Period.

Exceptionally prolific throughout the course of his long life, Picasso achieved universal renown and immense fortune for his revolutionary artistic accomplishments, and became one of the best-known figures in 20th-century art.

Comments on Pablo Picasso's Masterpieces

1. Blue Period

Commentary

Picasso's Blue Period (1901—1904), characterized by somber paintings rendered in **shades** of blue and blue-green, only occasionally warmed by other colors, began either in Spain in early 1901, or in Paris in the second half of the year. Many paintings of gaunt mothers with children date from the Blue Period, during which Picasso divided his time between Barcelona and Paris. In his austere use of color and sometimes doleful subject matter—prostitutes and beggars are frequent subjects—Picasso was influenced by a trip through Spain and by the suicide of his friend Carlos Casagemas. ① Starting in autumn of 1901, he painted several posthumous portraits of Casagemas, culminating in the gloomy allegorical painting La Vie (1903), now in the Cleveland Museum of Art(Fig. 4-4-2).

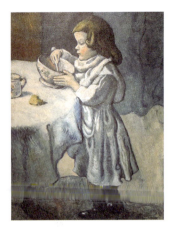 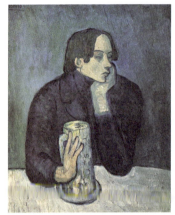 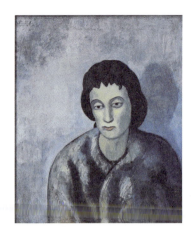

Fig. 4-4-2 Picasso's Blue Period

The same mood pervades the well-known etching *The Frugal Repast* (1904), which depicts a blind man and a sighted woman, both emaciated, seated at a nearly bare table. Blindness is a recurrent theme in Picasso's works of this period, also represented in The Blindman's Meal (1903, the Metropolitan Museum of Art) and in the portrait of Celestina (1903). Other works include Portrait of Soler and Portrait of Suzanne Bloch.

2. Rose Period

Commentary

The Rose Period (Fig. 4-4-3) (1904—1906) is characterized by a more cheery style with orange and **pink** colors, and featuring many circus people, acrobats and harlequins known in France as saltimbanques. The harlequin, a comedic character usually depicted in checkered patterned clothing, became a personal symbol for Picasso.② Picasso met Fernande Olivier, a bohemian artist who became his mistress, in Paris in 1904. Olivier appears in many of his Rose Period paintings, many of which are influenced by his warm relationship with her, in addition to his increased exposure to French painting. The generally upbeat and optimistic mood of paintings in this period is reminiscent of the 1899—1901 period (i.e. just prior to the Blue Period) and 1904 can be considered a transition year between the two periods.

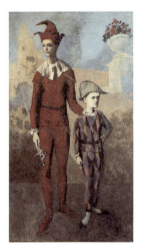 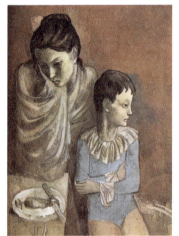 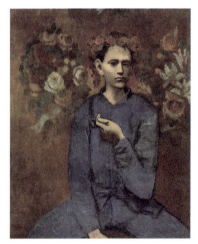

Fig. 4-4-3 Picasso's Rose Period portrait paintings

Portrait of Gertrude Stein is collected by Metropolitan Museum of Art, New York City. When someone commented that Stein did not look like her portrait, Picasso replied, "She will".

By 1905, Picasso became a favorite of American art collectors Leo and Gertrude Stein. Their older brother Michael Stein and his wife Sarah also became collectors of his work. Picasso painted portraits of both Gertrude Stein and her nephew Allan Stein. Gertrude Stein became Picasso's principal patron, acquiring his drawings and paintings and exhibiting them in her informal salon at her home in Paris. At one of her gatherings in 1905, he met Henri Matisse, who was to become a lifelong friend and rival. The Steins introduced him to Claribel Cone and her sister Etta who were American art collectors. They also began to acquire Picasso and Matisse's paintings. Eventually Leo Stein moved to Italy. Michael and Sarah Stein became patrons of Matisse, while Gertrude Stein continued to collect Picasso's works.

In 1907 Picasso joined an **art gallery** that had recently been opened in Paris by Daniel Henry Kahnweiler. Kahnweiler was a German art historian and **art collector** who became one of the premier French art dealers of the 20th century. He was among the first champions of Pablo Picasso, Georges Braque and the Cubism that they jointly developed. Kahnweiler promoted burgeoning artists such as André Derain, Kees van Dongen, Fernand Léger, Juan Gris, Maurice de Vlaminck and several others who had come from all over the globe to live and work in **Montparnasse** at the time.

专业词汇

sculptor [ˈskʌlptə] 雕塑家
pink [piŋk] 粉色
printmaker [ˈprintmeikə(r)] 版画家
ceramicist [siˈræmist] 陶艺家
cubist [ˈkjuːbist] 立体派的，立体派艺术家
shades [ʃeidz] 色调
cubism [ˈkjuːbizəm] 立体主义
art gallery 艺术画廊
Montparnasse [mɔntˈpɑːnəsi] 蒙帕纳斯
art collector 艺术收藏家

难句翻译

① In his austere use of color and sometimes doleful subject matter—prostitutes and beggars are frequent subjects—Picasso was influenced by a trip through Spain and by the suicide of his friend Carlos Casagemas.

毕加索用色沉闷且有时忧郁的作画对象——妓女和乞丐常常出现在他的作品中。影响毕加索的是一次穿越西班牙的旅行和他的朋友卡洛斯·卡萨吉玛斯的自杀。

② The Rose Period (1904—1906) is characterized by a more cheery style with orange and pink colors, and featuring many circus people, acrobats and harlequins known in France as saltimbanques. The harlequin, a comedic character usually depicted in checkered patterned clothing, became a personal symbol for Picasso.

玫瑰时代(1904—1906)的特点是风格活泼，多用橘色和粉色。作品常常刻画马戏团成员，如杂技演员和在法国被称为江湖艺人的人物。小丑是一种喜剧角色，在画中常常穿着格纹衣服，这成了毕加索的个人象征。

Pablo Diego José Francisco de Paula Juan Nepomuceno María de los Remedios Cipriano de la Santísima Trinidad Ruiz Picasso(巴勃罗·迭戈·何塞·弗朗西斯科·德·保拉·胡安·尼波穆切诺·玛丽亚·德·洛斯雷梅迪奥斯·西普里亚诺·德拉圣蒂西马·特林尼达德·鲁伊斯·毕加索)

巴勃罗·迭戈·何塞·弗朗西斯科·德·保拉·胡安·尼波穆切诺·玛丽亚·德·洛斯雷梅迪奥斯·西普里亚诺·德拉圣蒂西马·特林尼达德·鲁伊斯·毕加索，西班牙画家、雕塑家，法国共产党党员，是现代艺术的创始人，西方现代派绘画的主要代表。他于1907年创作的《亚威农少女》是第一张被认为有立体主义倾向的作品，是一幅具有里程碑意义的杰作。它不仅标志着毕加索个人艺术历程中的重大转折，而且是西方现代艺术史上的一次革命性突破，引发了立体主义运动的诞生。这幅画在以后的十几年中使法国立体主义绘画得到空前发展，甚至还波及芭蕾舞、舞台设计、文学、音乐等其他领域。《亚威农少女》开创了法国立体主义的新局面，毕加索与勃拉克也成为这一画派的风云人物。

From

https://en.wikipedia.org/wiki/Pablo_Picasso

4.5 Salvador Dali and His Masterpieces

Salvador Dali was born at 8:45 on the morning of May 11, 1904 in the small agricultural town of Figueres, Spain. Figueres is located in the foothills of the Pyrenees. Dali spent his boyhood in Figueres and at the family's summer home in the coastal fishing village of Cadaques where his parents built his first studio. As an adult, he made his home with his wife Gala in nearby Port Lligat. Many of his paintings reflect his love of this area of Spain(Fig. 4-5-1).

The young Dali attended the San Fernando Academy of Fine Arts in Madrid. Early recognition of Dali's talent came with his first one-man show in Barcelona in 1925. He became internationally known when three of his paintings, including The Basket of Bread (now in the Museum's collection), were shown in the third annual Carnegie international exhibition in Pittsburgh in 1928.

In the following year, Dali held his first one-man show in Paris. He also joined the **surrealists**, led by former Dadaist Andre Breton. Dali met Gala Eluard in the same year when she visited him in Cadaques with her husband, poet Paul Eluard. She became Dali's lover, muse, business manager, and chief **inspiration**.

Dali soon became a leader of the surrealist movement. His painting, The Persistence of Memory, with the soft or melting watches is still one of the best-known surrealist works. But as the war approached, the apolitical Dali clashed with the surrealists and was "expelled" from the surrealist group during a "trial" in 1934. However, he did exhibit works in international surrealist exhibitions throughout the decade but by 1940. Dali was moving into a new type of painting with a preoccupation with science and religion.

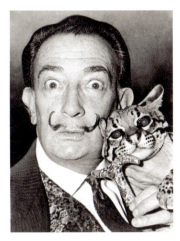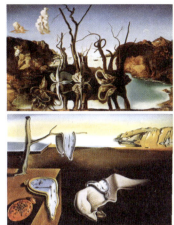

Fig. 4-5-1 Salvador Dali and his masterpieces

Dali and Gala escaped from Europe during World War II, spending 1940—1948 in the United States. These were very important years for the artist. The Museum of Modern Art in New York gave Dali his first major retrospective exhibit in 1941. This was followed in 1942 by the publication of Dali's autobiography, The Secret Life of Salvador Dali.

As Dali moved away from surrealism and into his classic period, he began his series of 19 large canvases, many concerning scientific, historical or religious themes. Among the best known of these works are The Hallucinogenic Toreador, The Discovery of America by Christopher Columbus in the museum's collection, and The Sacrament of the Last Supper in the collection of the National Gallery in Washington, D. C.

In 1974, Dali opened the **Teatro Museo** in Figueres, Spain. This was followed by retrospectives in Paris and London at the end of the decade. After the death of his wife, Gala in 1982, Dali's health began to fail. It deteriorated further after he was burned in a fire in his home in Pubol in 1984. Two years later, a pace-maker was implanted. Much of this part of his life was spent in **seclusion**, first in Pubol and later in his apartments at Torre Galatea, adjacent to the Teatro Museo. Salvador Dali died on January 23, 1989 in Figueres from heart failure with respiratory complications.

As an artist, Salvador Dali was not limited to a particular style or media. The body of his work, from early impressionist paintings through his transitional surrealist works, and to his classical period, reveals a constantly growing and evolving artist. Dali worked in all media, leaving behind a wealth of **oils**, **watercolors**, **drawings**, **graphics**, **sculptures**, **films**, photographs, performance pieces, jewels and objects of all descriptions.[①] As important, he left for posterity the permission to explore all aspects of one's own life and to give them artistic expression.

Whether working from pure inspiration or on a commissioned illustration, Dali's matchless insight and symbolic complexity are apparent. Above all, Dali was a superb draftsman. His excellence as a creative artist will always set a standard for the art of the twentieth century.

The famous Spanish surrealist painter, Salvador Dali had artistic repertoire that included sculpture, painting, photography, **multimedia work**, and collaborations with other artists, most notably independent surrealist films. Dali was born in a quasi-surreal existence. His brother, also named Salvador, died as a toddler, nine months before Dali's birth. His parents told him he was the reincarnation of his older brother, which he also came to believe. As a child, Dali attended drawing school, by the age of thirteen, Dali's father was arranging exhibitions of his charcoal drawings. In 1922, Dali went to study at the School of Fine Arts in San Fernando, where he was known as a bit of a dandy, wearing long hair and sideburns, and stockings with knee breeches in the style of 19th century aesthetes.

During his stay at the academy, Dali tried his hand in cubism and dada. But his stay was short lived, after he was expelled a few weeks before final exams, for stating that no one in the school was qualified enough to examine him. After his expulsion, he traveled to Paris, where he met Pablo Picasso and Joan Miro, who heavily influenced his painting styles. Dali continually borrowed many painting styles from them. From impressionism to renaissance works, he combined all elements into single compositions, raising interesting critiques from art critics, who were unsure as how to receive his works. Always a dandy, Dali grew a large moustache, which was a trademark of his appearance for the rest of his life.

In 1929, Dali began a relationship with the woman who would later become his wife, Gala. His father disapproved, and saw his connection with surrealism as a demoralizing influence on his son. Upon hearing reports that Dali had created a work with an inscription insulting his mother, who had died eight years earlier of breast cancer, the elder Dali disowned and disinherited his son, telling him never to return home. Dali then married Gala and moved into a house at Port Lligat.

Dali's first surreal painting, Honey Is Sweeter Than Blood, shows a marked progression away from cubism toward the depiction of subconscious obsessions. Dali's preoccupations with decadence, death, and immortality returned repeatedly in future works. This painting was made between Dali's first visits to Paris where he was socializing with artists who would found the surrealist movement.

Comments on Salvador Dali's Masterpieces

1. Satirical Composition

Date: 1923 **Dimensions**: 138 cm×105 cm
Medium: Oil on cardboard **Collection**: Dali Theatre Museum
Commentary

Satirical Composition was clearly inspired by Matisse that fully coincides with the French artist's The Dance. Moreover, it is worth pointing out the presence of rather satirical characters, in the lower left hand corner of the oil painting, related to the **popular aesthetic** of ceramics. Dali reminds us of popular Russian iconography, especially that presented by Marc Chagall, in a work not exempt of both irony and satire given the double meaning of one of the instruments being played by the characters② (Fig. 4-5-2).

Fig. 4-5-2 Satirical Composition

2. Naugural Gooseflesh

Date: 1928 **Dimensions**: 76 cm×63.2 cm
Medium: Oil on cardboard **Collection**: Dali Theatre Museum

Commentary

This work, advance notice of Dali's great pictorial production in the thirties, is the one he showed to André Breton and the surrealist group. There is a certain resonance of Tanguy, both in the way of constructing the space and in the soft, white shapes that float on the oil painting. ③They are corpuscular forms in line with a hypnagogic vision, which combines the arithmetic rigidity of a numerical series, confronting, in this way, the dominant **romanticism** of his origins with the initial submission to a strict set of rules he learned in the magazine L'Esprit Nouveau by Ozenfant and Jeanneret (Le Corbusier)(Fig. 4-5-3).

3. Atomic Leda

Date: 1949 **Dimensions**: 61 cm×46 cm
Medium: Oil on canvas **Collection**: Dali Theatre Museum

Commentary

In the catalogue of the exhibition in the Bignou Gallery in New York, held from the 25th of November 1947 until the 31st of January 1948, Dali announced that he was now 44 years old and had finally decided to start his first master works. He added that he was showing this work while it was still in progress, thus enabling those interested in his technique to study the development of his work coinciding with the publication of his book 50 Secrets of Magic Craftsmanship. We are once again before a work of mythological echoes, which interested Dali so much. Produced according to Fra Luca Paccioli's "Divine Proportion", there are also references calculated by the mathematician Matila Ghyka. In contrast to what his contemporaries believed, that mathematics "distracted" from the artistic discourse, Dali thought that any work of art with foundation had to be based on the composition and the calculus. ④Of note here is that all the elements are shown weightless, suspended in air, floating(Fig. 4-5-4).

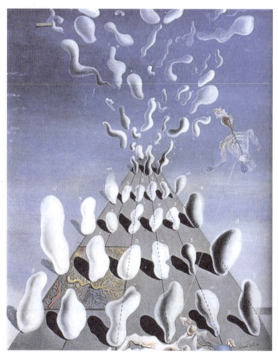

Fig. 4-5-3 Naugural Gooseflesh

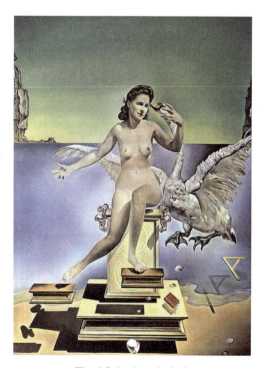

Fig. 4-5-4 Atomic Leda

专业词汇

surrealist [səˈriːəlist] 超现实主义者
inspiration [ˌinspəˈreiʃn] 灵感
oils [ɔilz] 油画颜料
watercolor [ˈwɔtəkʌlə] 水彩画
drawing [ˈdrɔːiŋ] 素描
graphic [ˈɡræfik] 图形
sculpture [ˈskʌlptʃə(r)] 雕塑
film [film] 电影
popular aesthetic 大众审美
romanticism [rəʊˈmæntisizəm] 浪漫主义
multimedia work 多媒体作品
seclusion [siˈkluːʒən] 隐居

难句翻译

① As an artist, Salvador Dali was not limited to a particular style or media. The body of his work, from early impressionist paintings through his transitional surrealist works, and to his classical period, reveals a constantly growing and evolving artist. Dali worked in all media, leaving behind a wealth of oils, watercolors, drawings, graphics, sculptures, films, photographs, performance pieces, jewels and objects of all descriptions.

艺术家萨瓦多·达利不局限于某种风格或媒介。他的主体作品,从早期印象派绘画到过渡期的超现实主义作品直到其古典主义时期的创作,反映出他是一个在不断成长进化的艺术家。达利用各种媒介创作,他为后世留下了丰富的油画、水彩、素描、图形、雕塑、电影、摄影、表演艺术、珠宝和各种作品。

② Dali reminds us of popular Russian iconography, especially that presented by Marc Chagall, in a work not exempt of both irony and satire given the double meaning of one of the instruments being played by the characters.

达利让人们联想到著名的俄罗斯肖像画,特别是马克·夏加尔的一幅作品。这幅画既具讽刺又含嘲讽,为其中一个人物手上弹奏的乐器赋予了双重含义。

③ This work, advance notice of Dali's great pictorial production in the thirties, is the one he showed to André Breton and the surrealist group. There is a certain resonance of Tanguy, both in the way of constructing the space and in the soft, white shapes that float on the oil painting.

这件作品预示了达利在而立之年后的杰出图画成就,他给安德烈·布勒东和超现实主义派艺术家看了这件作品。这幅画在空间的构建上和其悬在油画上部的柔软白色物形都在某种程度上呼应了唐吉的作品。

④ Dali thought that any work of art with foundation had to be based on the composition and the calculus.

达利认为所有有基底的艺术作品都应小心构图和计算。

Salvador Domingo Felipe Jacinto Dali i Domènech, Marqués de Dalí de Pubol（萨尔瓦多·多明哥·菲利普·哈辛托·达利-多梅内克,普波尔侯爵）

萨尔瓦多·多明哥·菲利普·哈辛托·达利-多梅内克,普波尔侯爵(1904—1989),是著名的西班牙加泰罗

尼亚画家,因其超现实主义作品而闻名。达利是一位具有非凡才能和想象力的艺术家。他的作品将怪异梦境般的形象与卓越的绘图技术巧妙地结合在一起。其作品中也能发现其文艺复兴大师影响的绘画痕迹。1982年西班牙国王胡安·卡洛斯一世封他为普波尔侯爵,与毕加索、马蒂斯一起被认为是20世纪最有代表性的三位画家。

From

http://www.dali.com/about-us/about-salvador-dali/

单元词汇总结

Color:	Blue; Yellow; Pink; Black; White; Brown; Purple; Orange; Red; Rose; Green; Gray; Monochromatic
Style:	Impressionist; Post-impressionist; Expressive; Japanese print; Cubism; Romanticism; Conceputualism; Surrealism
Medium:	Watercolor; Oil; Pastel; Gesso; Woodcut
Artist's tools:	Easel; Sketchbook; Charcoal; Palette cup; Canvas; Painting knife; Flat pastel; Oil paint; Brush; Smock; Tracing paper; T-square
Artist title:	Sculptor; Printmaker; Ceramicist; Artist; Scholar; Painter; Drawer; Craftsman; Stage designer; Playwright; Art collector; Art dealer
Art form:	Fresco; Cameos; Figure; Portrait; Still life; Landscape; Brushstrokes; Symphony; Woodcut; Film; Multimedia work
Subject:	Civil engineering; Paleontology; Ichnology; Astronomy; Botany; Literature; Anatomy; Geology
Design:	Cartography; Perspective; Sketches; Shades; Graphic design

单元5

雕塑家与他们的作品

Unit 5　Sculptors and Their Masterpieces

5.1 Michelangelo Di Lodovico Buonarroti Simoni and His Masterpieces

Michelangelo Di Lodovico Buonarroti Simoni, born in Italy in 1475, was an Italian sculptor, painter, architect, poet, and engineer of the High Renaissance who exerted an unparalleled influence on the development of western art. Considered as the greatest living artist in his lifetime, he has since been held as one of the greatest artists of all time. Despite making few forays beyond the arts, his versatility in the disciplines he took up was of such a high order that he is often considered a contender for the title of the archetypal Renaissance man, along with his fellow Italian Leonardo da Vinci(Fig. 5-1-1).

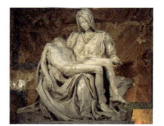

Fig. 5-1-1　Michelangelo Di Lodovico Buonarroti Simoni and his masterpieces

As a young boy, Michelangelo was sent to Florence to study grammar under the humanist Francesco da Urbino. The young artist, however, showed no interests in his schooling, preferring to copy paintings from churches and seek the company of painters. In 1488, at the age of 13, Michelangelo was apprenticed to Ghirlandaio. The next year, his father persuaded Ghirlandaio to pay Michelangelo as an artist, which was rare for someone of fourteen.

From 1490 to 1492, Michelangelo attended the humanist academy which the Medici had founded along **neo-platonic** lines. At the academy, both Michelangelo's outlook and his art were subject to the influence of many of the most **prominent philosophers** and writers of the day including Marsilio Ficino, Pico della Mirandola and Poliziano.

Michelangelo returned to Florence in 1499. The republic was changing after the fall of **anti-Renaissance** Priest and leader of Florence, Girolamo Savonarola, (executed in 1498) and the rise of the gonfalonier Piero Soderini.

Michelangelo responded by completing his most famous work, The Statue of David, in 1504. The masterwork definitively established his prominence as a sculptor of extraordinary technical skill and strength of **symbolic imagination**. A team of consultants, including Botticelli and Leonardo da Vinci, was called together to decide upon the statue's placement, ultimately the Piazza della Signoria, in front of the Palazzo Vecchio. It now stands in the academia while a replica occupies its place in the square.

In 1546, Michelangelo was appointed architect of St. Peter's Basilica, Rome. The **dome**, not completed until after his death, has been called by Banister Fletcher, "the greatest creation of Renaissance".

Michelangelo died in his studio in 1564.

Comments on Michelangelo's Masterpieces

1. Madonna and Child

Commentary

The Madonna of the Steps is Michelangelo's earliest known work. It is carved in shallow relief, a technique often employed by the master-sculptor of the early 15th century, Donatello and others such as Desiderio da Settignano(Fig. 5-1-2).

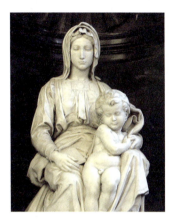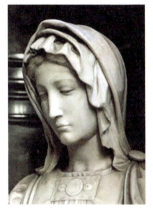

Fig. 5-1-2 Madonna and Child

While the Madonna is in profile, the easiest aspect for a **shallow relief**, the child **displays** a twisting motion that was to become characteristic of Michelangelo's work. The Taddeo Tondo of 1502 shows the Christ Child frightened by a bullfinch, a symbol of the **crucifixion**. The lively form of the child was later adapted by Raphael in the Bridgewater Madonna. The Bruges Madonna was, at the time of its creation, unlike other such statues which show the Virgin proudly presenting her son. Here, the Christ Child, restrained by his mother's clasping hand, is about to step off into the world.

2. The Statue of David

Commentary

The kneeling angel is an early work, one of several that Michelangelo created as part of a large decorative scheme for the Arca di San Domenico in the church dedicated to that saint in Bologna. Several other artists had worked on the scheme, beginning with Nicola Pisano in the 13th century. In the late 15th century, the project was managed by Niccolò dell'Arca. An angel holding a candlestick, by Niccolò, was already in place. Although the two angels form a pair, there is a great contrast between the two works, the one depicting a delicate child with flowing hair clothed in gothic robes with deep folds, and Michelangelo's depicting a robust and muscular youth with eagle's wings, clad in a garment of classical style. Everything about Michelangelo's angel is dynamic.

Michelangelo's Bacchus was a commission with a specified subject, the youthful God of Wine. The sculpture has all the traditional attributes, a vine wreath, a cup of wine and a fawn, but Michelangelo ingested an air of reality into the subject, depicting him with bleary eyes, a swollen bladder and a stance that suggests he is unsteady on his feet. While the work is plainly inspired by classical sculpture, it is innovative for its rotating movement and strongly three-dimensional quality, which encourages the viewer to look at it from every angle.①

In the so-called Dying Slave, Michelangelo has again utilized the figure with marked contrapposto to

suggest a particular human state, in this case waking from sleep. With the Rebellious Slave, it is one of two such earlier figures for the Tomb of Pope Julius II, now in the Louvre, that the sculptor brought to an almost finished state (Fig. 5-1-3).

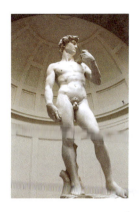
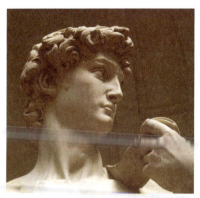
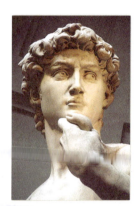

Fig. 5-1-3 The Statue of David

专业词汇

neo-platonic lines　新柏拉图线
prominent philosopher　杰出的哲学家
dome　[dəʊm]　圆屋顶
anti-Renaissance　反文艺复兴
crucifixion　[ˌkruːsəˈfikʃn]　苦难,刑罚
symbolic imagination　想象力,创造力
shallow relief　浅浮雕
display　[diˈsplei]　陈列,展览

难句翻译

① While the work is plainly inspired by classical sculpture, it is innovative for its rotating movement and strongly three-dimensional quality which encourages the viewer to look at it from every angle.
虽然作品的灵感完全来自古典主义雕塑，其创造性体现在旋转的动态和强烈的三维性，这鼓励了观众从不同角度来欣赏作品。

Michelangelo Di Lodovico Buonarroti Simoni（米开朗琪罗·博那罗蒂）

米开朗琪罗·博那罗蒂(1475—1564)，意大利文艺复兴时期伟大的绘画家、雕塑家、建筑师和诗人，文艺复兴时期雕塑艺术最高峰的代表。他与拉斐尔和达·芬奇并称为文艺复兴后三杰。他一生追求艺术的完美，坚持自己的艺术思路。他的风格影响了几乎三个世纪的艺术家。罗曼·罗兰曾写过《米开朗琪罗传》，归入《名人传》中。米开朗琪罗于1564年在罗马去世，其著名作品有雕塑《大卫》、绘画《创世纪》。

From

https://en.wikipedia.org/wiki/Michelangelo

5.2 Auguste Rodin and His Masterpieces

François Auguste Rodin, born in France in 1840, known as Auguste Rodin, was a French sculptor. Although Rodin is generally considered the progenitor of **modern sculpture**, he did not set out to rebel against the past. He was schooled traditionally, took a **craftsman**-like approach to his work, and desired academic recognition, although he was never accepted into Paris's foremost school of art (Fig. 5-2-1).

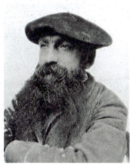
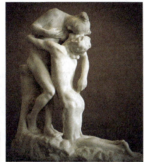
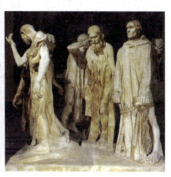

Fig. 5-2-1 Auguste Rodin and his masterpieces

From the unexpected realism of his first major figure 1 m Dash inspired by his 1875 trip to Italy 1 m Dash to the unconventional memorials whose commissions he later sought, Rodin's reputation grew, such that he became the **preeminent** French sculptor of his time.

By 1900, he was a **world-renowned artist**. Wealthy private clients sought Rodin's work after his World's Fair exhibit, and he kept company with a variety of high-profile intellectuals and artists. He married his lifelong companion, Rose Beuret, in the last year of both their lives.

Auguste Rodin died in 1917.

His sculptures suffered a decline in popularity after his death in 1917, but within a few decades, his legacy solidified. Rodin remains one of the few sculptors widely known outside the visual arts community.

Comments on Auguste Rodin's Masterpieces

1. The Age of Bronze

In Brussels, Rodin created his first **full-scale** work, The Age of Bronze (Fig. 5-2-2), having returned from Italy. Modeled by a Belgian soldier, the figure drew inspiration from Michelangelo's Dying Slave, which Rodin had observed at the Louvre. Attempting to combine Michelangelo's mastery of the human form with his own sense of human nature, Rodin studied his model from all angles, at rest and in motion.① He mounted a ladder for additional perspective, and made **clay** models, which he studied by candlelight. The result was a life-size, well-proportioned **nude figure**, posed unconventionally with his right hand atop his head, and his left arm held out at his side, forearm parallel to the body.

In 1877, the work debuted in Brussels and then was shown at the Paris Salon. The statue's apparent lack of a theme was troubling to critics—commemorating neither mythology nor a noble historical event—and it is not clear whether Rodin intended a theme.

He first titled the work The Vanquished, in which form the left hand held a spear, but he removed the spear because it obstructed the torso from certain angles. After two more intermediary titles, Rodin settled on **The Age of Bronze**, suggesting the Bronze Age, and in Rodin's words, "man arising from nature".

Later, however, Rodin said that he had had in mind "just a simple piece of sculpture without reference to subject".

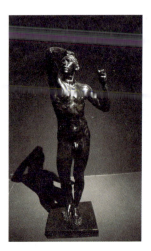
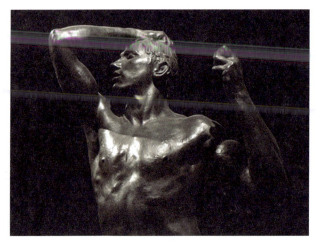

Fig. 5-2-2　The Age of Bronze

2. The Thinker

The Thinker is a bronze sculpture by Auguste Rodin, usually placed on a stone **pedestal**. The work shows a nude male figure of over life-size sitting on a rock with his chin resting on one hand as though deep in thought, and is often used as an image to represent philosophy. There are about 28 full size **castings**, in which the figure is about 186 centimetres high, though not all were made during Rodin's lifetime and under his supervision, as well as various other versions, several in **plaster**, studies, and **posthumous** castings, in a range of sizes. Rodin first conceived the figure as part of another work in 1880, but the first of the familiar monumental bronze castings did not appear until 1904 (Fig. 5-2-3).

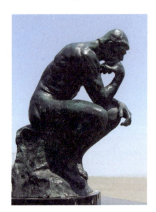
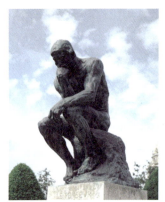
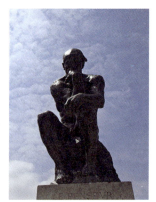

Fig. 5-2-3　The Thinker

The Auguste Rodin's Quotes

"The artist must create a spark before he can make a fire and before art is born. The artist must be ready

to be consumed by the fire of his own creation."

"Art is contemplation. It is the pleasure of the mind which searches into nature and which there divines the spirit of which nature herself is animated."

"It is not the lack of beauty with our eyes but the lack of observation. Our eyes are blind to beauty, because we are unable to discover it."

"It is the so-called master, they use their eyes to watch others saw something in common, what can be found in a beautiful."

专业词汇

modern sculpture　现代雕塑
craftsman　['kræftsmən]　工匠
casting　['kɑːstɪŋ]　铸造,铸件
world-renowned artist　世界著名艺术家
full-scale　全尺寸,完全的
clay　[kleɪ]　黏土,泥土
The Age of Bronze　青铜时代
pedestal　['pedɪstl]　基架,基座
posthumous　['pɒstʃəməs]　死后的,遗腹的
preeminent　[priːˈemɪnənt]　卓越的,超群的
nude figure　裸体
plaster　['plɑːstə(r)]　灰泥,熟石膏

难句翻译

① Modeled by a Belgian soldier, the figure drew inspiration from Michelangelo's *Dying Slave*, which Rodin had observed at the Louvre. Attempting to combine Michelangelo's mastery of the human form with his own sense of human nature, Rodin studied his model from all angles, at rest and in motion.

模特是一位比利时士兵,人物灵感来自米开朗琪罗的《垂死的奴隶》。罗丹曾在卢浮宫研究过这座雕塑。罗丹试图将米开朗琪罗对人类造型的卓越掌控力与他本人对人性的感悟结合起来,他从各种角度、从静态和动态研究了模特。

Auguste Rodin(奥古斯特·罗丹)

奥古斯特·罗丹(1840—1917)是19世纪法国最有影响力的雕塑家。他一生勤奋工作;敢于突破官方学院派的束缚,走自己的路。他善于吸收一切优良传统,对古希腊雕塑的优美及对比的手法,理解非常深刻。他在很大程度上以纹理和造型表现其作品,被认为是19世纪和20世纪初最伟大的现实主义雕塑家。罗丹在欧洲雕塑史上的地位,正如诗人但丁在欧洲文学史上的地位。罗丹与他的两个学生马约尔和布德尔,被誉为欧洲雕刻"三大支柱",其作品架构了西方近代雕塑与现代雕塑之间的桥梁。

From

https://en.wikipedia.org/wiki/Auguste_Rodin

5.3 Yayoi Kusama and Her Masterpieces

Yayoi Kusama (Fig. 5-3-1), born in Nagano Prefecture in 1929, is a Japanese artist and writer. Throughout her career she has worked in a wide variety of media, including painting, **collage**, **soft sculpture**, **performance art**, and **environmental installations**, most of which exhibit her thematic interest in **psychedelic colors**, **repetition** and **pattern**. As a **precursor** of the **pop art**, **minimalist** and **feminist** art movements, Kusama influenced contemporaries such as Andy Warhol and Claes Oldenburg. Although largely forgotten after departing the New York art scene in the early 1970s, Kusama is now acknowledged as one of the most important living artists to come out of Japan, and an important voice of the **avant-garde**.

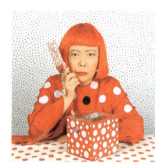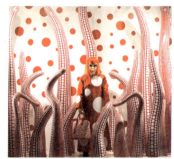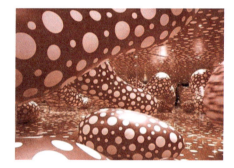

Fig. 5-3-1 Yayoi Kusama and her masterpieces

Kusama started creating art at an early age, going on to study Nihonga painting in Kyoto in 1948. Frustrated with this distinctly Japanese style, she became interested in the European and American avant-garde, staging several solo exhibitions of her paintings in Matsumoto and Tokyo during the 1950s. In 1957 she moved to the United States, settling down in New York City where she produced a series of paintings influenced by the **abstract expressionist** movement. Switching to sculpture and installation as her primary mediums, Kusama became a fixture of the New York avant-garde, having her works exhibited **alongside** the likes of Andy Warhol, Claes Oldenburg and George Segal during the early 1960s, where she became associated with the **pop art** movement. Embracing the rise of the **hippie counterculture** of the late 1960s, Kusama came to public attention when she organized a series of happenings in which naked participants were painted with brightly colored **polka dots**.

In 1973, Kusama moved back to her native Japan, where she found the art scene far more conservative than that in New York. Becoming an art dealer, her business folded after several years, and after experiencing psychiatric problems. In 1977, she voluntarily admitted herself to a hospital, where she has spent the rest of her life.

Kusama's work is based on **conceptual art** and shows some **attributes** of **feminism**, minimalism, **surrealism**, **art brut**, pop art, and **abstract expressionism** and is infused with autobiographical, psychological, and sexual content. Kusama is also a published novelist and poet and has created notable work in film and fashion design.

Comments on Kusama's Masterpieces

1. Narcissus Garden

Commentary

Kusama arrived in New York City from Japan in 1957 and immediately approached dealers and artists alike to promote her work. Within the first few years, she began to exhibit and associate herself with seminal artists and critics, such as Donald Judd, Joseph Cornell, Yves Klein, and Lucio Fontana who later was instrumental in her realizing Narcissus Garden(Fig. 5-3-2).

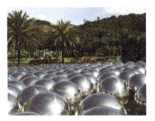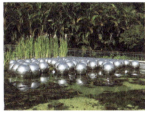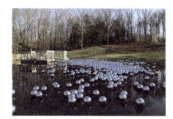

Fig. 5-3-2　Narcissus Garden

The tightly arranged 1 500 shimmering balls constructed an infinite reflective field in which the images of the artist, the visitors, the architecture, and the landscape were repeated, distorted, and projected by the convex mirror surfaces that produced virtual images appearing closer and smaller than reality. The size of each sphere was similar to that of a fortune-teller's crystal ball. When gazing into it, the viewer only saw his/her own reflection staring back, forcing a confrontation with one's own vanity and ego. ①

2. Yellow Pumpkin

Commentary

A yellow pumpkin dotted in black, the icon of Naoshima island. If asked about pop art, who's the first artist that comes up to mind? Yayoi Kusama, one of the most acclaimed Japanese artists, is a precursor of pop art and she influenced Andy Warhol as well as Claes Oldenburg. Her yellow pumpkin, dotted in black, has become somehow the icon of Naoshima, the Japanese island transformed in a cradle of modern and contemporary art(Fig. 5-3-3).

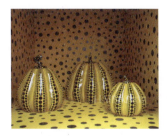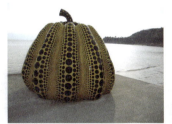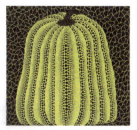

Fig. 5-3-3　Yellow Pumpkin

Arriving at Miyanoura Port by ferry, you'll see Kusama's red dotted pumpkin just a few steps from the terminal. However, the yellow and most famous pumpkin is showcased on the pier facing the Benesse Hotel, the most famous (and expensive) accommodation on Naoshima island. Overlooking the sea, with the surrounding islands as a backdrop, it's no wonder that Yayoi Kusama's yellow pumpkin has become in a way the island symbol.

专业词汇

precursor [prɪˈkɜːsə(r)] 先驱
pattern [ˈpætn] 图案
attribute [əˈtrɪbjuːt] 特性
collage [kɒˈlɑːʒ] 拼贴画
soft sculpture 软雕塑
performance art 行为艺术
hippie [ˈhɪpi] 嬉皮士
environmental installations 环境装置
psychedelic [ˌsaɪkəˈdelɪk] 引起幻觉的
pop art 波普艺术
minimalist [ˈmɪnɪməlɪst] 极简抽象派艺术家
feminist [ˈfemənɪst] 女权主义者
avant-garde 前卫，先锋
abstract expressionism 抽象表现主义
alongside [əˌlɒŋˈsaɪd] 在旁边
counterculture [ˈkaʊntəkʌltʃə(r)] 反主流文化
polka dot 圆点花纹
conceptual art 概念艺术
feminism [ˈfemənɪzəm] 女权主义
art brut 原生艺术

难句翻译

① The size of each sphere was similar to that of a fortune-teller's crystal ball. When gazing into it, the viewer only saw his/her own reflection staring back, forcing a confrontation with one's own vanity and ego.

每一弧面的大小与预言家的水晶球相似。当观众注视它的时候，只能看到镜像中自己的回视，迫使观众面对自身的虚荣与自大。

Yayoi Kusama（草间弥生）

草间弥生出生于日本长野县松本市，毕业于日本长野县松本女子学校。1957年移居美国纽约市，并开始展露她占有领导地位的前卫艺术创作。她曾与当代卓越的艺术家安迪·沃霍尔（Andy Warhol）、克勒斯·欧登柏格（Claes Oldenburg）、贾斯培·琼斯（Jasper Johns）一起联展。草间弥生的创作被评论家归类到相当多的艺术派别，包含女权主义、极简主义、超现实主义、原生艺术、波普艺术和抽象表现主义等。但在草间弥生对自己的描述中，她仅是一位"精神病艺术家"，其作品企图呈现的是一种自传式的、深入心理的、性取向的内容。草间弥生所用的创作手法则有绘画、软雕塑、行为艺术与装置艺术等。

From

https://www.pinterest.com/19klida47/yayoi-kusama/

5.4 Anish Kapoor and His Masterpieces

Anish Kapoor, born in Bombay in 1954, is a British-Indian sculptor. Kapoor has lived and worked in London since the early 1970s when he moved to study art, first at the Hornsey College of Art and later at the Chelsea School of Art and Design(Fig. 5-4-1).

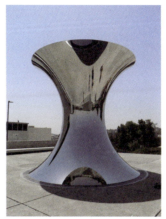
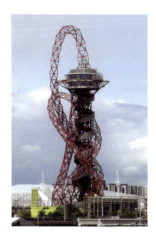

Fig. 5-4-1　Anish Kapoor and his masterpieces

He represented Britain in the XLIV Venice Biennale in 1990, when he was awarded the Premio Duemila Prize. In 1991 he received the Turner Prize and in 2002 received the Unilever Commission for the Turbine Hall at Tate Modern. Notable public sculptures include Cloud Gate (colloquially known as "the Bean") in Chicago's Millennium Park; Sky Mirror, exhibited at the Rockefeller Center in New York City in 2006 and Kensington Gardens in London in 2010. Temenos, at Middlehaven, Middlesbrough; Leviathan, at the Grand Palais in Paris in 2011; and Arcelor Mittal Orbit, commissioned as a permanent artwork for London's Olympic Park and completed in 2012.

Anish Kapoor became known in the 1980s for his **geometric** or **biomorphic** sculptures made using simple materials such as **granite**, **limestone**, **marble**, **pigment**, and **plaster**. These early sculptures are frequently simple, **curved forms**, usually **monochromatic** and brightly coloured, using **powder** pigment to define and permeate the form.

"While making the pigment pieces, it occurred to me that they all form themselves out of each other. So I decided to give them a generic title, A Thousand Names, implying **infinity**, a thousand being a symbolic number. The powder works sat on the floor or projected from the wall. The powder on the floor defines the surface of the floor and the objects appear to be partially submerged, like icebergs. That seems to fit inside the idea of something being partially there." Such use of pigment characterized his first high-profile exhibit as part of the New Sculpture exhibition at the Hayward Gallery London in 1978.

In the late 1980s and 1990s, he was acclaimed for his explorations of matter and non-matter, specifically evoking the void in both **free-standing** sculptural works and ambitious installations. Many of his sculptures

seem to recede into the distance, disappear into the ground or distort the space around them.① In 1987, he began working in stone.

His later stone works are made of solid, quarried stone, many of which have carved apertures and cavities, often alluding to, and playing with dualities (earth-sky, matter-spirit, lightness-darkness, visible-invisible, conscious-unconscious, male-female, and body-mind). "In the end, I'm talking about myself, and thinking about making nothing, which I see as a void. But then that's something, even though it really is nothing."

Since 1995, he has worked with the highly reflective surface of **polished stainless steel**. These works are mirror-like, reflecting or distorting the viewer and surroundings. Over the course of the following decade, Kapoor's sculptures ventured into more ambitious manipulations of form and space. He produced a number of large works, including Taratantara (1999), a 35-meter-high piece installed in the Baltic Flour Mills in Gateshead, England, before renovation began there; and Marsyas (2002), a large work consisting of three steel rings joined by a single span of PVC membrane that reached end to end of the 3 400-square-foot (320 m²) Turbine Hall of Tate Modern.

Kapoor received a knighthood in the 2013 Birthday Honours for services to visual arts. He was awarded an honorary doctorate degree from the University of Oxford in 2014.

Comments on Anish Kapoor's Masterpieces

Commentary

The Bean has the **uncanny** perfection of a **metaphysical** object, of a digital effect circa terminator approaching the Bean from the south. One sees only a distortion of space, an incredible inconsistency (Fig. 5-4-2).

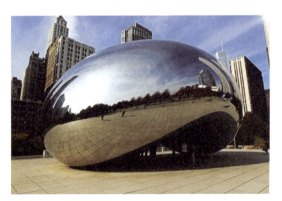 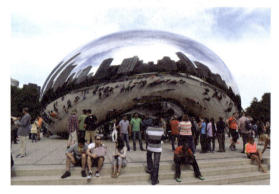

Fig. 5-4-2 Cloud Gate (The Bean) at Millennium Park

It is so perfect that it seems to have arrived from another planet. One sympathizes with Kapoor's distress at its premature unveiling in 2004, before construction was complete. Just as the Bean is perfect in space, it should be perfect in time as well: its polished surface is designed to erase its own origin.

Coming nearer, one sees that it has **panoptic** properties: its elliptic geometry replicates on its surface the entire visible city. But the city is not absorbed by the Bean without transformation.

All of the straight lines curve. It witnesses the intrusion of another world into our own. In this world, mighty skyscrapers bend, steel and stone and glass shimmer and dance. The Bean allows us to see that Chicago-as-it-is is not eternal. That new things can happen in the world. The Bean returns to us the comprehension that things, be they never so great, can still be otherwise.

专业词汇

geometric　[ˌdʒiːəˈmetrik]　几何学的
biomorphic　[baɪəˈmɔrfik]　生物形态的
granite　[ˈɡrænit]　花岗岩
limestone　[ˈlaimstəʊn]　石灰岩
pigment　[ˈpiɡmənt]　颜料,色素
curved　[kɜːvd]　弯曲的
monochromatic　[ˌmɒnəkrəˈmætik]　单色的
powder　[ˈpaʊdə(r)]　粉
infinity　[inˈfinəti]　无限,无穷
marble　[ˈmɑːbl]　大理石

难句翻译

① In the late 1980s and 1990s, he was acclaimed for his explorations of matter and non-matter, specifically evoking the void in both free-standing sculptural works and ambitious installations. Many of his sculptures seem to recede into the distance, disappear into the ground or distort the space around them.

20世纪八九十年代末,他因探索物质与非物质的界限而闻名,特别受到赞誉的是其独立雕塑作品和雄心勃勃的装置作品所唤起的空洞感。他的许多雕塑作品都好像能消退到远方、消失入地下或造成四周的空间的弯曲。

Anish Kapoor(安尼施·卡普尔)

安尼施·卡普尔1954年出生于印度孟买,20世纪70年代初来到伦敦开始学习艺术,是当代英国雕塑界一位极其重要的人物。自20世纪70年代以来,他的雕塑作品参加了许多国际性大展,并获得了国际雕塑界的一致好评。基于其独特的生活经历,安尼施·卡普尔的作品中往往会将印度的传统精神与西方艺术的精髓相互融合。为了充分表达自己的艺术观念,他常常会在作品中运用不同的材质,如石、钢、玻璃等。在表现形式上,他以简洁的造型饰以鲜艳的色彩,给人一种雕塑与绘画融为一体的视觉冲击。

From
　　https://en.wikipedia.org/wiki/Anish_Kapoor

5.5 Jaume Plensa and His Masterpieces

Jaume Plensa was born in **Barcelona** in 1955, Catalonia and studied art there, in the "Llotja" School and in the Escola Superior de Belles Arts de Sant Jordi.

His works include the Crown Fountain at **Millennium Park** in Chicago, Illinois, United States. It opened in

July 2004. The **fountain** is composed of a black granite reflecting pool placed between a pair of **glass brick towers**. The towers are 50 feet (15 m) tall, and they use **light-emitting diodes** (LEDs) to display digital videos on the **inward** faces(Fig. 5-5-1).

 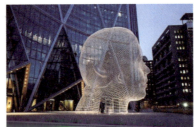 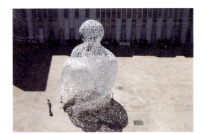

Fig. 5-5-1　Jaume Plensa and his masterpieces

Another Plensa piece is Blake in Gateshead, in the northeast of **England**, a laser beam that on special occasions shines high into the night sky over Gateshead's Baltic Centre for Contemporary Art. In the summer of 2007 he participated in the **Chicago Public Art Exhibit** with his Cool Globes: Hot Ideas for a Cooler Planet.

On 16 June 2008, Jaume's sculpture of a listening glass entitled Breathing was dedicated by the incumbent Secretary-General of the United Nations, Ban Ki-moon, as a memorial to journalists killed whilst undertaking their work. The **sculpture** in **steel** and **glass** sits atop a new wing of Broadcasting House in London. At 22:00 GMT each evening a beam of light will be projected from the sculpture extending 1 km into the sky for 30 minutes to coincide with the BBC News at Ten.

Elalma del Ebro was created for the **International Exposition** in Zaragoza, the theme of which was "Water and Sustainable Development". It is eleven meters high, the sculpted letters representing cells of the human body which is over 60% water. Its white letters and hollow structure invite the viewer to look inside and reflect on the relationship between human beings and water. A similar sculpture entitled Singapore Soul (2011) was installed in front of the Ocean Financial Centre in Singapore.

In November 2012, the Albright Knox **Art Gallery** in Buffalo, New York unveiled a 32-ton sculpture by Plensa entitled "Laura". The 20-foot (6.1 m) tall sculpture is composed of 20 massive pieces of marble from the south of Spain.

Comments on Jaume Plensa's Masterpieces

Commentary

Designed by Spanish artist Jaume Plensa, the Crown Fountain in Millennium Park is a major addition to the city's world-renowned **public art** collection.

The fountain consists of two 50-foot glass block towers at each end of a shallow reflecting pool. The towers project video images from a broad social spectrum of Chicago citizens, a reference to the traditional use of gargoyles in fountains, where faces of mythological beings were sculpted with open mouths to allow water, a symbol of life, to flow out.

Plensa adapted this practice by having faces of Chicago citizens projected on LED screens and having water flow through an outlet in the screen to give the illusion of water spouting from their mouths.[①] The collection of faces, Plensa's tribute to Chicagoans, was taken from a cross-section of 1 000 residents.

The fountain's water features operate during the year between mid-spring and mid-fall, while the images remain on view year-round(Fig. 5-5-2).

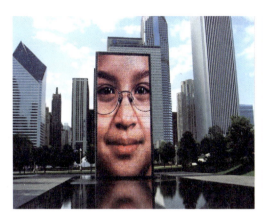
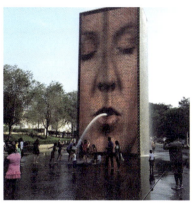

Fig. 5-5-2 Crown Fountain in Chicago

专业词汇

light-emitting diodes 发光二极管
inward ['inwəd] 向内的，内部的
fountain ['faʊntən] 喷泉
Barcelona [ˌbɑːsiˈləʊnə] 巴塞罗那
Millennium Park 千禧公园
Chicago [ʃiˈkɑːgəʊ] 芝加哥
glass brick towers 玻璃砖塔
England ['ɪŋglənd] 英格兰
public art exhibit 公共艺术展
sculpture ['skʌlptʃə(r)] 雕塑
steel [stiːl] 钢
glass [glɑːs] 玻璃
international exposition 国际博览会
art gallery 美术馆
public art 公共艺术

难句翻译

① Plensa adapted this practice by having faces of Chicago citizens projected on LED screens and having water flow through an outlet in the screen to give the illusion of water spouting from their mouths.

帕兰萨就采用了这种设计。他将芝加哥市民的头像投射在LED屏幕上，并引流水自屏幕开口而出，制造了一种他们口中喷水的假象。

Jaume Plensa(乔玛·帕兰萨)

乔玛·帕兰萨,西班牙当代著名艺术家和雕塑家,1955年出生于巴塞罗那,1993年被法国文化部授予艺术及文学勋章。2005年,芝加哥艺术学院授予他荣誉博士学位。乔玛·帕兰萨擅长运用各种创新材质进行现代雕塑艺术品的创作,其作品注重环境的光线、视觉因素的协调等问题。他的雕塑作品可以分为两类,一类是被

拉长的人像雕塑，另一类是用各种镂空或透明材质塑造的作品。

From

https://en.wikipedia.org/wiki/Millennium_Park

单元词汇总结

Space:	Opening space; Public space
Structure:	Pagoda; Penthouse; Dome; Castings; Pedestal; Light-emitting diodes; Glass brick towers
Shape:	Neo-platonic lines; Crucifixion; Geometric; Biomorphic; Curved; Full-scale; Form; Nude figure
Style:	Anti-renaissance; High renaissance; Western art; Classical style; Art installation; The Age of Bronze; Performance art; Environment installation; Avant-garde; Abstract expression movement; Pop art; Feminism; Art brut; Hippie; Counterculture
Material:	Plaster; Clay; Granite; Limestone; Pigment; Marble; Stainless steel; Steel; Glass; Polished stainless steel
Art form:	Collage; Soft sculpture; Pattern; Curved forms; Mirror-like

单元6

数码设计师与他们的作品

Unit 6　Digital Designers and Their Masterpieces

6.1 The History of Animation

Animation refers to the creation of a sequence of images—drawn, painted, or produced by other artistic methods—that change over time to portray the illusion of motion. It is a word that has practically stormed the film industry these days.[①] Everyone, right from the 8-year-old kids to 80-year-old granddads, loves to watch an animation flick. Have you ever wondered what animation exactly is and how did it come into existence? Animation is basically the rapid that it creates an illusion of movement in the viewers. **The phenomenon of persistence of vision** is the main basis behind the development of animation. In case of want to further explore the origin and history of animation, make use of the information provided in the lines below.

The earliest instance of animation dates back to the Paleolithic times, when attempts were made to capture motion in drawings. The cave paintings of that time depict animals in superimposed positions, drawn with an aim of conveying the perception of motion. Persistence of vision, the basis behind animation, was unknown Chinese inventor created an early animation device, which we later come to know as the zoetrope.

Phenakistoscope, **praxinoscope** and **the flip book** are the early animation devices, which were invented during the 1800s. All these devices made use of technological means for the purpose of producing movement from sequential drawings. However, it was the introduction of motion picture films, in the late 1890s that gave a boost to the concept of animation. There is no single person who can be credited with the title of the "Creator" of animation. This is because when animation was developed, many people were involved in the same thing at the same time.

J. Stuart Blackton was the first person to make an animated film, which he called "humorous phrase of funny faces". For the purpose, he used to draw comical faces on a blackboard, one after the other, and film them. In 1990, Emile Cohl came out with the first paper cutout animation. The development of celluloid, around 1913, made animation much easier to manage. While talking about the history of animation, three names that are definitely worth mentioning are those of Winsor McCay of the United States and Emile Cohl and Georges Melies of France.

Emile Cohl's Fantasmagorie(1908) was the first animated film that was made using "traditional (hand-drawn) animation". Georges Melies, a creator of special-effect films, was the first person to use animation, along with special effects. He was the one who gave the idea of **stop-motion animation**. McCay also created a number of animation films, with the most noted ones being *Little Nemo* (1911), *Gertie the Dinosaur* (1914) and *The Sinking of the Lusitania* (1918). In fact, many people take "*The Sinking of the Lusitania*" to be the first animated feature film.

However, it was Walt Disney who took animation to an entirely new level altogether. In 1928, with the premiere of "*Steamboat Willie*", he became the first animator to add sound to his movie cartoons. Walt Disney achieved another milestone in 1937, when he produced the first full length animated feature film, named "*Snow White and the Seven Dwarfs*". The year 1955 saw Art Clokey producing "*Gumby*", a stop-motion clay animation. Introduction of computers marked a step further in the concept of animation.

In 1951, an MIT student Ivan Sutherland created a computer drawing program, Sketchpad, further giving

a boost to animation. With time, computer started gaining an increasing importance in the field of animation. Movies like "*Star Wars*" relied on computer animation for many of its special effects. In 1995 came "*Toy Story*", produced by Walt Disney Productions and **Pixar Animation Studios**, the first full length feature film animated totally on computers. Since that time, animation and computer have gone hand in hand, creating new milestones with time.

Look at these pictures and short expression, you will understand the history of animation easily.

30000 B. C. —1500 A. D.

EARLY WAYS OF SHOWING MOTION

Archeological artifacts prove that we've been attempting to depict things in motion as long as we've been able to draw. Some notable examples are from ancient times, as well as an example from the European Renaissance (Fig. 6-1-1).

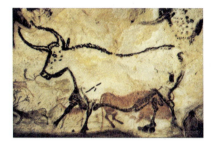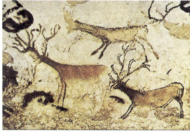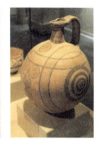

Fig. 6-1-1　Early ways of showing motion

3000 B. C.

SHAHR-E SUKHTEH

A bronze-age pottery bowl depicts goats leaping (Shahr-e Sukhteh, Iran) (Fig. 6-1-2).

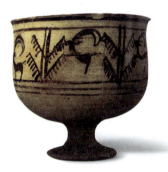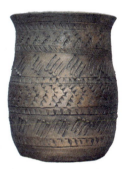

Fig. 6-1-2　A bronze-age pottery bowl

1500 A. D.

VITRUVIAN MAN

Leonardo da Vinci's Vitruvian man drawing shows multiple angles, implying movement. Seven drawings by Leonardo da Vinci (c. 1510) extending over two folios in the Windsor Collection, *Anatomical Studies of the Muscles of the Neck, Shoulder, Chest, and Arm*, have detailed renderings of the upper body and less-detailed facial features(Fig. 6-1-3).

1600—1877

ANIMATION BEFORE FILM

With the spread of the Industrial Revolution in Europe and North America in the 18th and 19th centuries came experimentation with machines that would make images appear to move(Fig. 6-1-4).

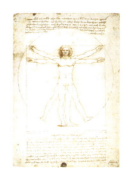

Fig. 6-1-3 Vitruvian man

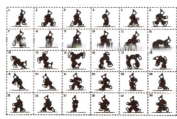

Fig. 6-1-4 Animation before film

1603
MAGIC LANTERN

The **Magic Lantern** is an image projector using pictures on sheets of glass. Since some sheets contain moving parts, it is considered the first example of projected animation (Fig. 6-1-5).

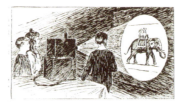

Fig. 6-1-5 Magic lantern

1824
THAUMATROPE

The **thaumatrope** housed a rotating mechanism with a different picture on each side. When rotated, you saw a combined picture (known as persistence of vision) (Fig. 6-1-6).

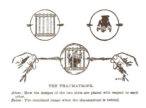
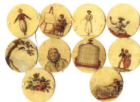
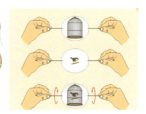

Fig. 6-1-6 Thaumatrope

1831
PHENAKISTOSCOPE

The **phenakistoscope** featured spinning disks reflected in mirrors that made it seem like the pictures were

moving(Fig. 6-1-7).

Fig. 6-1-7 Phenakistoscope

1834
ZOETROPE

The **zoetrope** was a hollow drum that housed images on long interchangeable strips that spun and made the images appear to move(Fig. 6-1-8).

Fig. 6-1-8 Zoetrope

1868
FLIP-BOOK

The **flip-book**, also known as the kinetograph, reached a wide audience and is credited with inspiring early animators more than the machines developed in this era(Fig. 6-1-9).

Fig. 6-1-9 Flip-book

1877
MOVIEOLA/PRAXINOSCOPE

The **praxinoscope** expanded on the zoetrope, using multiple wheels to rotate images. It is considered to have shown the first prototypes of the animated cartoon(Fig. 6-1-10).

1900—1930
THE SILENT ERA

The early 20th century marks the beginning of theatrical showings of cartoons, especially in the United

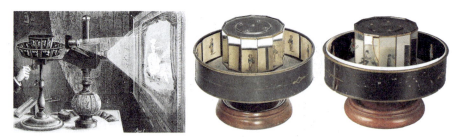

Fig. 6-1-10　Movieola

States and France. Many animators form studios, with Bray Studios in New York proving the most successful in this era. Bray helped launch the careers of the cartoonists that created Mighty Mouse, Betty Boop, and Woody Woodpecker(Fig. 6-1-11).

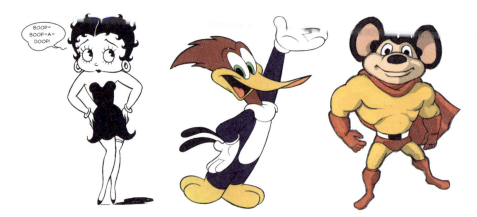

Fig. 6-1-11　The silent era

1906

HUMOROUS PHASES OF FUNNY FACES

Humorous Phases of Funny Faces marks the first entirely animated film, using stop-motion photography to create action(Fig. 6-1-12).

Fig. 6-1-12　Humorous Phases of Funny Faces

1908

FANTASMAGORIE

Fantasmagorie is the first animated film using hand-drawn animation, and is considered by film historians to be the first animated cartoon(Fig. 6-1-13).

1914

GERTIE THE DINOSAUR

Gertie the Dinosaur is considered the first cartoon to feature an appealing character(Fig. 6-1-14).

Fig. 6-1-13　Fantasmagorie

Fig. 6-1-14　Gertie the Dinosaur

1919
FELIX THE CAT

Musical Mews and Feline Follies introduced Felix the Cat—often considered the first animated movie star (Fig. 6-1-15).

Fig. 6-1-15　Felix the Cat

1928
STEAMBOAT WILLIE

The film featuring Mickey Mouse becomes the first cartoon with the sound printed on the film, and is the first notable success for Walt Disney Studios, founded in Los Angeles in 1923 (Fig. 6-1-16).

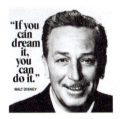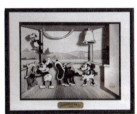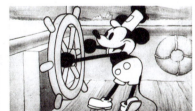

Fig. 6-1-16　Steamboat Willie

1930—1950s
THE GOLDEN AGE OF AMERICAN ANIMATION

During what many consider to be the "Golden Age" of animation, theatrical cartoons became an integral part of popular culture. These years are defined by the rise of Walt Disney (Mickey Mouse, Donald Duck, and Silly Symphonies), Warner Brothers, MGM, and Fleischer (Betty Boop, Popeye).

1930

MERRIE MELODIES

Warner Brothers Cartoons founded and created Merrie Melodies series(Fig. 6-1-17).

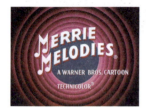

Fig. 6-1-17　Merrie Melodies

1937

SNOW WHITE

Walt Disney releases Snow White and the Seven Dwarfs, the first animated, feature to use hand-drawn animation(Fig. 6-1-18).

 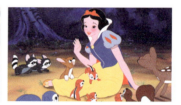

Fig. 6-1-18　Snow White

1960—1980s

THE AMERICAN TELEVISION ERA

The animation industry began to adapt to the fact that television continued its rise as the entertainment medium of choice for American families. Studios created many cartoons for TV, using a "limited animation" style. By the mid-1980s, with help from cable channels such as The Disney Channel and Nickolodeon, cartoons were **ubiquitous** on TV.

1960

THE FLINTSTONES

Hanna Barbera releases The Flintstones, the first animated, series on prime-time television(Fig. 6-1-19).

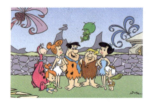 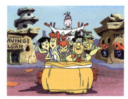 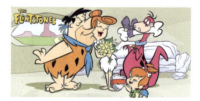

Fig. 6-1-19　The Flintstones

1961

YOGI BEAR

Yogi Bear, a **spin-off** of Huckleberry Hound (another Hanna-Barbera production), debuts on national TV (Fig. 6-1-20).

1964

THE PINK PHINK

DePatie-Freleng Enterprises wins the Academy Award for Best Short Film for The Pink Phink (of the

Fig. 6-1-20 Yogi Bear

Pink Panther series) and continues to create shorts for theatrical release(Fig. 6-1-21).

Fig. 6-1-21 The Pink Phink

1972

FRITZ THE CAT

Fritz the Cat is released as the first animated adult (**X-rated**) feature film(Fig. 6-1-22).

Fig. 6-1-22 Fritz the Cat

1980—2014

MODERN AMERICAN ERA

The CGI (computer generated imagery) revolutionized animation. A principal difference of CGI animation compared to traditional animation is that drawing is replaced by 3D modeling, almost like a virtual version of **stop-motion**. A form of animation that combines the two and uses 2D computer drawing can be considered computer-aided animation.

1984

THE ADVENTURES OF ANDRE & WALLY B.

This short film was the first fully CGI-animated film, created by The Graphics Group, the precursor to Pixar(Fig. 6-1-23).

1987

THE SIMPSONS

The Simpsons is an American adult animated sitcom created by Matt Groening for the Fox Broadcasting Company. It is the longest-running American **sitcom**, the longest-running American animated program, and in 2009 it surpassed Gunsmoke as the longest-running American scripted primetime television series (Fig. 6-1-24).

Fig. 6-1-23　The Adventures of Andre & Wally B.

Fig. 6-1-24　The Simpsons

1995

TOY STORY

Toy Story, the first fully **computer-animated** feature film, was released(Fig. 6-1-25).

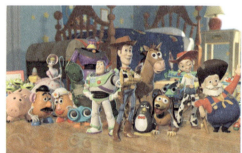

Fig. 6-1-25　Toy Story

2014

BIG HERO 6

Big Hero 6 is the first Disney animated film to feature Marvel Comics characters(Fig. 6-1-26).

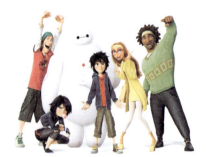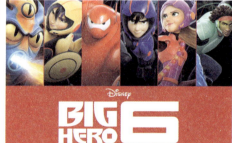

Fig. 6-1-26　Big Hero 6

专业词汇

cartoonist ［kɑːˈtuːnist］ 漫画家
animation ［ˌæniˈmeiʃn］ 动画片
flip-book 手翻书
the silent era 默片时代
spin-off 副产品
X-rated 限制级
stop-motion animation 逐格动画（定格动画）
computer-aided animation 计算机辅助动画
Magic Lantern 早期放映机
thaumatrope ［ˈθɔːməˌtroup］ 留影盘
zoetrope ［ˈzoʊiˌtroup］ 西洋镜
the phenomenon of persistence of vision 视觉暂留现象
phenakistoscope ［ˈpræksinəˌskəup］ 费纳奇镜
praxinoscope ［præksiˈnɒskoup］ 普拉克辛视镜
the flip book 手翻书
Pixar Animation Studios 皮克斯动画工作室

难句翻译

① Animation refers to the creation of a sequence of images—drawn, painted, or produced by other artistic methods—that change over time to portray the illusion of motion. It is a word that has practically stormed the film industry these days.

动画是指用一连串图像表现动态的艺术形式。这些图像或描绘而成或涂画而成，随时代改变新的艺术手法也被应用其中。如今动画正强烈地冲击着电影产业。

From

http://history-of-animation.webflow.io/

6.2
Walt Disney and His Masterpieces

Try to imagine a world without Walt Disney, a world without his magic, whimsy, and optimism. Walt Disney transformed the entertainment industry into what we know today. He **pioneered** the fields of animation, and found new ways to teach, and educate(Fig. 6-2-1).

Producer, Entrepreneur Walt Disney (1901—1966), was an American motion-picture and television

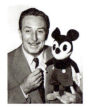 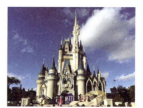

Fig. 6-2-1　Walt Disney and Disneyland

producer and showman, famous as a pioneer of **cartoon films** and as the creator of Disneyland.

Early Life: Walt Disney was born on December 5, 1901, in the Hermosa section of Chicago, Illinois. His father was Elias Disney, an Irish-Canadian, and his mother, Flora Call Disney, was German-American. Disney was one of five children, four boys and a girl. He lived most of his childhood in Marceline, Missouri, where he began drawing, painting and selling pictures to neighbors and family friends. In 1911, his family moved to Kansas City, where Disney developed a love for trains. His uncle, Mike Martin, was a train engineer who worked the route between Fort Madison, Iowa and Marceline. Later, Disney would work a summer job with the railroad, selling snacks and newspapers to travelers.

Disney attended Mckinley High School in Chicago, where he took drawing and photography classes and was a contributing cartoonist for the school paper. At night, he took courses at the Chicago Art Institute. When Disney was 16, he dropped out of school to join the army but was rejected for being underage. Instead, he joined the Red Cross and was sent to France for a year to drive an ambulance.

When Disney returned from France in 1919, he moved back to Kansas City to pursue a career as a newspaper artist. His brother Roy got him a job at the Pesmen-Rubin Art Studio, where he met cartoonist Ubbe Eert Iwerks, better known as Ub Iwerks. From there, Disney worked at the Kansas City Film Ad Company, where he made commercials based on **cutout animation**. Around this time, Disney began experimenting with a camera, doing **hand-drawn** cel animation, and decided to open his own animation business. From the ad company, he recruited Fred Harman as his first employee.

Disney and Harman made a deal with a local Kansas City theater to screen their cartoons, which they called Laugh-O-Grams. The cartoons were hugely popular, and Disney was able to acquire his own studio, upon which he bestowed the same name. Laugh-O-Grams hired a number of employees, including Harman's brother Hugh and Iwerks. They did a series of seven-minute **fairy tales** that combined both **live action** and animation, which they called Alice in Cartoonland. By 1923, however, the studio had become burdened with debt, and Disney was forced to declare bankruptcy.

Disney and his brother Roy soon pooled their money and moved to Hollywood. Iwerks also relocated to California, and there the three began the Disney Brothers' Studio. Their first deal was with New York distributor Margaret Winkler, to distribute their Alice cartoons. They also invented a character called Oswald the Lucky Rabbit, and contracted the shorts at $1,500 each.

In 1925, Disney hired an **ink-and-paint** artist named Lillian Bounds. After a brief courtship, the couple married.

Death: Within a few years of the opening, Disney began plans for a new theme park and Experimental Prototype Community of Tomorrow in Florida. It was still under construction when, in 1966, Disney was diagnosed with lung cancer. He died on December 15, 1966, at the age of 65. Disney was cremated, and his ashes interred at Forest Lawn Cemetery in Los Angeles, California. After his brother's death, Roy carried on the plans to finish the Florida theme park, which opened in 1971 under the name Walt Disney World.

Walt Disney's Masterpieces

1. Mickey Mouse & Other Characters

The Disney brothers, their wives and Iwerks produced three cartoons featuring a new character Walt had been developing called Mickey Mouse. The first animated shorts featuring Mickey were Plane Crazy and The Gallopin' Gaucho, both silent films for which they failed to find distribution. When sound made its way into film, Disney created a third, **sound-and-music-equipped** short called Steamboat Willie. With Walt as the voice of Mickey, the cartoon was an instant sensation.

In 1929, Disney created Silly Symphonies, which featured Mickey's newly created friends, including Minnie Mouse, Donald Duck, Goofy and Pluto. One of the most popular cartoons, Flowers and Trees, was the first to be produced in color and to win an Oscar. In 1933, The Three Little Pigs and its title song "Who's Afraid of the Big Bad Wolf?" became a theme for the country in the midst of the Great Depression.

On December 21, 1937, Snow White and the Seven Dwarfs, the first **full-length** animated film, **premiered** in Los Angeles. It produced an **unimaginable** $1.499 million, in spite of the Depression, and won a total of eight Oscars. During the next five years, Walt Disney Studios completed another string of full-length animated films, Pinocchio (1940), Fantasia (1940), Dumbo (1941) and Bambi (1942).

In December 1939, a new campus for Walt Disney Studios was opened in Burbank. A setback for the company occurred in 1941, however, when there was a strike by Disney animators. Many of them resigned, and it would be years before the company fully recovered. During the mid-1940s, Disney created "packaged features", groups of shorts strung together to run at feature length, but by 1950, he was once again focusing on animated features. Cinderella was released in 1950, followed by a live-action film called Treasure Island (1950), Alice in Wonderland (1951), Peter Pan (1953), Lady and the Tramp (1955), Sleeping Beauty (1959) and 101 Dalmatians (1961). In all, more than 100 features were produced by his studio.

Disney was also among the first to use television as an entertainment medium. The Zorro and Davy Crockett series were extremely popular with children, as was The Mickey Mouse Club, a variety show featuring a cast of teenagers known as the Mouseketeers. Walt Disney's Wonderful World of Color was a popular Sunday night show, which Disney used to begin promoting his new theme park. Disney's last major success that he produced himself was the motion picture Mary Poppins (1964), which mixed live action and animation.

2. Disneyland Theme Park

Disney's $17 million Disneyland theme park opened on July 17, 1955, in Anaheim, California, with actor (and future U.S. president) Ronald Reagan presiding over the activities on what was once an orange grove. After a tumultuous opening day involving several mishaps (including the distribution of thousands of counterfeit invitations), the site became known as a place where children and their families could explore, enjoy rides and meet the Disney characters.

In a very short time, the park had increased its investment tenfold, and was entertaining tourists from around the world. With the original site having some attendance ups and downs over the years, Disneyland has expanded its rides over time and branched out globally with parks in Tokyo, Paris and Hong Kong, with a Shanghai location slated to open in the spring of 2016. Sister property California Adventure also opened in 2001.

专业词汇

cartoon film　动画电影
hand-drawn　手绘
fairy tales　童话故事
live action　现场录制
ink-and-paint　油漆和涂料
sound-and-music-equipped　声音和音乐装备
premiere　[premieə(r)]　首演
cutout animation　剪纸动画
full length　全长的
unimaginable　[ˌʌnɪˈmædʒɪnəbl]　无法想象的
pioneer　[ˌpaɪəˈnɪə(r)]　先锋，拓荒者

Walt Disney（华特·迪士尼）

华特·迪士尼(1901年12月5日—1966年12月15日)，美国著名动画大师、企业家、导演、制片人、编剧、配音演员、卡通设计者，举世闻名的迪士尼公司创始人。他的名字随着米老鼠和唐老鸭一起进入千家万户，成为世界顶级的电影业和娱乐业大亨。他创作了《白雪公主和七个小矮人》《木偶奇遇记》等很多知名的电影，还有米老鼠等动画角色。也是他，让迪士尼乐园成为可能，开创了主题乐园这种形式，而且他在电视节目《迪士尼奇妙世界》中的主持也让无数美国人无法忘怀。他获得了56个奥斯卡奖提名和7个艾美奖，是世界上获得奥斯卡奖最多的人。

From

http://www.biography.com/people/walt-disney-9275533#disneyland

6.3 Miyazaki Hayao and His Masterpieces

Sometimes, people call the filmmaker Miyazaki Hayao the "Japanese Walt Disney" (even though he's said to hate it). In his 40-year career, Miyazaki has created such films as Castle in the Sky, Kiki's Delivery Service, Howl's Moving Castle, and Spirited Away. "His aim wasn't to make films that spoke down to children. His aim was to make films that would help us all understand the human condition," Lewis Bond says (Fig. 6-3-1).

Miyazaki Hayao(born on January 5, 1941) is a Japanese film director, producer, **screenwriter**, **animator**, author, and **manga artist**. Through a career that has spanned five decades, Miyazaki has attained international **acclaim** as a **masterful storyteller** and as a maker of anime feature films and, along with Isao Takahata, co-

Fig. 6-3-1　Miyazaki Hayao

founded Studio Ghibli, a film and animation studio. The success of Miyazaki's films has invited **comparisons** with American animator Walt Disney, and American directors Steven Spielberg and Orson Welles.

In April 1963, Miyazaki got his first job at **Toei Animation**, working **as an in-between artist** on the anime *Wanwan Chushingura*. He was a leader in a labor dispute soon after his arrival, becoming chief secretary of Toei's labor union in 1994.

Miyazaki first gained recognition while working as an in-between artist on the Toei production *Gulliver's Travels Beyond the Moon*. He later played an important role as chief animator, concept artist, and scene designer on *Hols: Prince of the Sun* in 1968, a landmark animated film directed by Isao Takahata, with whom he continued to collaborate for the next three decades.

In 1971, he left Toei for A Pro studio with Isao Takahata, then to Nippon Animation in 1973, where he was heavily involved in the World Masterpiece Theater TV animation series for the next five years. In 1978, he directed his first TV series, **Mirai shônen Konan** (1978) (Conan, The Boy in Future), then moved to Tôkyô Movie Shinsha in 1979 to direct his first movie, the classic Rupan sansei: Kariosutoro no shiro (1979). In 1984, he released **Nausicaä of the Valley of the Wind** (1984), based on the **manga** (comic) of the same title he had started two years before. The success of the film led to the establishment of a new animation studio, Studio Ghibli (Sutajio Jiburi), at which Miyazaki has since directed, written, and produced many other films with Takahata and, more recently, Toshio Suzuki. All of these films enjoyed critical and box office successes. In particular, Miyazaki's Princess Mononoke (1997) received the Japanese **equivalent** of the Academy Award for Best Film and was the **highest-grossing** (about USD＄150 million) **domestic film** in Japan's history at the time of its release.

In addition to animation, Miyazaki also draws manga. His major work was the Nausicaä manga, an epic tale he worked on **intermittently** from 1982 to 1984 while he was busy making animated films.① Another manga, Hikoutei Jidai, was later evolved into his 1992 film Porco Rosso (1992).

Miyazaki's latest film is Howl's The Wind Rises (2013), a fictionalized **biopic** of Jiro Horikoshi (1903—1982), designer of the **Mitsubishi A5M** fighter aircraft and its successor. Even though he has said this would be his last film, a statement he has said before after the completion of some of his earlier films, one hopes that additions to his extraordinary body of work will continue to be produced as long as he remains alive (Fig. 6-3-2).

Fig. 6-3-2　Howl's The Wind Rises

His Animation Style

Miyazaki's works are characterized by the recurrence of progressive themes, such as environmentalism, **pacifism**, **feminism**, and the absence of villains. His films are also frequently concerned with childhood transition and a marked **preoccupation** with flight.

Miyazaki's **narratives** are notable for not pitting a hero against an **unsympathetic antagonist**. In Spirited Away, Miyazaki states "the heroine thrown into a place where the good and bad dwell together. She manages not because she has destroyed the 'evil', but because she has acquired the ability to survive." Even though Miyazaki sometimes feels **pessimistic** about the world, he prefers to show children a positive worldview instead, and rejects simplistic stereotypes of good and evil. Miyazaki's films often emphasize **environmentalism** and the Earth's **fragility**.② In an interview with The New Yorker, Margaret Talbot stated that Miyazaki believes much of modern culture is "thin and shallow and fake", and he "not entirely jokingly" looked forward to "a time when Tokyo is submerged by the ocean and the NTV tower becomes an island, when the human population **plummets** and there are no more high-rises". Growing up in the **Showa era** was an unhappy time for him because "nature—the mountains and rivers—was being destroyed in the name of economic progress". Miyazaki is critical of **capitalism**, **globalization**, and their impacts on modern life. Commenting on the 1954 Animal Farm animated film, he has said that "**exploitation** is not only found in communism, capitalism is a system just like that. I believe a company is common property of the people that work there. But that is a **socialistic idea**." Nonetheless, he suggests that adults should not impose their vision of the world on children.

Nausicaä, Princess Mononoke and Howl's Moving Castle feature anti-war themes. In 2003, when Spirited Away won the Academy Award for Best Animated Feature, Miyazaki did not attend the awards show personally. He later explained that it was because he "didn't want to visit a country that was bombing Iraq".

Miyazaki has been called a feminist by Studio Ghibli President Toshio Suzuki, in reference to his attitude to female workers. This is evident in the all-female factories of Porco Rosso and Princess Mononoke, as well as the **matriarchal bathhouse** of Spirited Away. Many of Miyazaki's films are populated by strong female **protagonists** that go against gender roles common in Japanese animation and fiction (Fig. 6-3-3).

Fig. 6-3-3　Miyazaki's films

In the field of theatrical animation, where talent abounds and everyone has his or her own style, the art

and creativity of Miyazaki Hayao are unrivaled. For decades, he has arguably been Japan's leading cult figure to fans of manga (comic books) and anime (animated films)—in a nation where those art forms are held in the highest regard.

专业词汇

animator ['ænimeitə(r)] 动画片绘制者
genius ['dʒiːniəs] 天才
screenwriter ['skriːnraitə(r)] 编剧
manga artist 漫画艺术家
acclaim [ə'kleim] 好评
masterful storyteller 高超的讲故事的人
comparison [kəm'pærisn] 比较
Mirai shônen Konan 未来少年柯南
Nausicaä of the Valley of the Wind 风之谷
equivalent [i'kwivələnt] 等价物
highest-grossing 最卖座
domestic film 国产电影
manga ['mæŋɡə] 漫画
intermittently [ˌintə'mitəntli] 间歇性地
biopic ['baiəʊpik] 传记片
Mitsubishi A5M 三菱 A5M(舰载战机)
pacifism ['pæsifizəm] 和平主义
feminism ['femənizəm] 女性主义
narrative ['nærətiv] 叙事
pessimistic [ˌpesi'mistik] 悲观的
environmentalism [inˌvairən'mentəlizəm] 环境保护论
fragility [frə'dʒiləti] 脆弱性
plummet ['plʌmit] 骤降
Shōwa period 昭和时代
capitalism ['kæpitəlizəm] 资本主义
globalization [ˌɡləʊbəlai'zeiʃn] 全球化
exploitation [ˌeksplɔi'teiʃn] 开发
socialistic idea 社会主义理论
matriarchal bathhouse 母系澡堂
protagonist [prə'tæɡənist] 主角
nomination [ˌnɒmi'neiʃn] 提名
sirocco [si'rɒkəʊ] 热风
Mediterranean [ˌmedɪtə'reniən] 地中海
artwork ['ɑːtwɜːk] 艺术品

难句翻译

① In addition to animation, Miyazaki also draws manga. His major work was the Nausicaä manga, an epic tale he worked on intermittently from 1982 to 1984 while he was busy making animated films.

宫崎骏不仅制作动画也绘制漫画。他主要的漫画作品是《风之谷》,描绘了一个史诗般的故事。1982年至1984年间宫崎骏在制作动画电影的同时断断续续地创作了这部作品。

② Even though Miyazaki sometimes feels pessimistic about the world, he prefers to show children a positive worldview instead, and rejects simplistic stereotypes of good and evil. Miyazaki's films often emphasize environmentalism and the Earth's fragility.

虽然宫崎骏偶尔对世界前景感到悲观,他还是喜欢为孩子们展现积极的世界观,并反对将人性的善恶简单化。宫崎骏的电影常常凸显环保主义与地球生态的脆弱。

Miyazaki Hayao(宫崎骏)

宫崎骏1941年1月5日出生于日本东京都文京区,日本动画师、动画制作人、漫画家、动画导演、动画编剧。1963年进入东映动画公司,从事动画师工作,代表作有《天空之城》《龙猫》《幽灵公主》《千与千寻》等。2013年执导《起风了》,该片荣获第37届日本电影学院奖最优秀动画作品奖等8项大奖。2014年11月8日荣获第87届奥斯卡金像奖终身成就奖。宫崎骏的每部作品虽然题材不同,但是将梦想、环保、人生、生存这些令人反思的信息融合其中,他是第一位将动画上升到人文高度的思想者。

From

https://en.wikipedia.org/wiki/Hayao_Miyazaki#Filmography

https://en.wikipedia.org/wiki/The_Wind_Rises

http://www.imdb.com/name/nm0594503/bio

https://en.wikipedia.org/wiki/Studio_Ghibli#Name

http://www.theatlantic.com/video/index/416703/hayao-miyazaki/

6.4 An Introduction of Digital Art

Digital art is an artistic work or practice that uses digital technology as an essential part of the creative or presentation process.① Since the 1970s, various names have been used to describe the process including computer art and **multimedia art**, and digital art is itself placed under the larger umbrella term **new media art**.

After some **initial resistance**, the impact of **digital technology** has transformed activities such as painting, drawing, sculpture and **music/sound art**, while new forms, such as **net art**, digital **installation art**, and **virtual reality**, have become recognized artistic practices. In an expanded sense, "digital art" is a term applied to contemporary art that uses the methods of mass production or digital media(Fig. 6-4-1).

 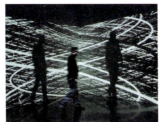

Fig. 6-4-1　Digital art

The techniques of digital art are used extensively by the **mainstream** media in advertisements, and by **film-makers** to produce visual effects. Both digital and traditional artists use many sources of **electronic information** and programs to create their work. Given the parallels between visual and musical arts, it is possible that general acceptance of the value of digital art will progress in much the same way as the increased acceptance of electronically produced music over the last three decades.

Digital art can be purely computer-generated (such as **fractals** and **algorithmic art**) or taken from other sources, such as a scanned photograph or an image drawn using **vector graphics** software using a mouse or **graphics tablet**. Though technically the term may be applied to art done using other media or processes and merely scanned in, it is usually reserved for art that has been non-trivially modified by a computing process (such as a computer program, **microcontroller** or any electronic system capable of interpreting an input to create an output); digitized text data and raw audio and video recordings are not usually considered digital art in themselves, but can be part of the larger project of computer art and information art. Artworks are considered digital painting when created in similar fashion to **non-digital** paintings but using software on a computer platform and digitally outputting the resulting image as painted on canvas.

专业词汇

digital art　数字艺术
multimedia art　多媒体艺术
new media art　新媒体艺术
net art　网络艺术
virtual reality　虚拟现实
graphic design　平面设计
fractal　['fræktl]　分形
algorithmic art　算法艺术
microcontroller　[maikroʊkɒnt'roʊlər]　单片机
initial resistance　初始电阻
music/sound art　音乐/声音艺术
installation art　装置艺术
digital technologies　数字技术
mainstream　['meinstri:m]　主流
film-makers　电影制作人
electronic information　电子信息
vector graphics　矢量图形
graphics tablet　绘图板
non-digital　非数字的

难句翻译

① Digital art is an artistic work or practice that uses digital technology as an essential part of the creative or presentation process.

数码艺术指主要采用数码技术进行创作或演示的艺术作品或艺术行为。

② Digital art can be purely computer-generated (such as fractals and algorithmic art) or taken from other sources, such as a scanned photograph or an image drawn using vector graphics software using a mouse or graphics tablet.

数码艺术可以完全使用计算机制作(如分形艺术和算法艺术),也可以利用其他创作素材,如照片扫描件或利用鼠标或数码绘图板所画的矢量图。

From

https://en.wikipedia.org/wiki/Digital_art

6.5 Nam June Paik and His Masterpieces

Nam June Paik (1932—2006) was a Korean American artist. He worked with a variety of media and is considered to be the founder of **video art**. He is credited with an early usage (1974) of the term "electronic super highway" in application to **telecommunications** (Fig. 6-5-1).

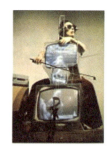
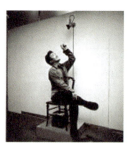

Fig. 6-5-1 Nam June Paik and his masterpieces

Born in Seoul in 1932, the youngest of five **siblings**, Paik had two older brothers and two older sisters. His father owned a major textile manufacturing firm. As he was growing up, he was trained as a classical **pianist**. In 1950, Paik and his family had to flee from their home in Korea, during the Korean War. His family first fled to Hong Kong, but later moved to Japan. Six years later he graduated from the University of Tokyo where he wrote a thesis on the composer Arnold Schoenberg.

Paik then moved to West Germany to study music history with composer Thrasybulos Georgiades at Munich University. While studying in Germany, Paik met the composers Karlheinz Stockhausen and John Cage and the conceptual artists George Maciunas, Joseph Beuys and Wolf Vostell and was from 1962 on, a member of Fluxus.

Nam June Paik then began participating in the **Neo-Dada** art movement, known as **Fluxus**, which was inspired by the composer John Cage and his use of everyday sounds and noises in his music. He made his big debut in 1963 at an exhibition known as Exposition of Music-Electronic Television at the Galerie Parnass in Wuppertal in which he scattered televisions everywhere and used magnets to alter or distort their images. In a 1960 piano performance in Cologne, he played Chopin, threw himself on the piano and rushed into the audience, attacking Cage and pianist David Tudor by cutting their clothes with scissors and dumping shampoo on their heads.

Paik's latest creative deployment of new media is through laser technology. He has called his most recent installation a "**post-video** project", which continues the articulation of the **kinetic image** through the use of **laser** energy projected onto **scrims**, **cascading water**, and **smoke-filled** sculptures. At the beginning of the twenty-first century, Paik's work shows us that the cinema and video are fusing with electronic and **digital media** into new image technologies and forms of expression. The end of video and television as we know them signals a transformation of our visual culture.

Performance and film are integrally linked to Paik's transformation of the institutional context of television and video. Paik put the video image into a vast array of formal configurations, and thus added an entirely new dimension to the form of sculpture and the **parameters of installation art**. He transformed the **instrumentality** of the video medium through a process that expressed his deep insights into electronic technology and his understanding of how to reconceive television, to "turn it inside out" and render something entirely new. Paik's imagery has not been predetermined or limited by the technologies of video or the system of television.① Rather, he altered the materiality and composition of the **electronic image** and its placement within a space and on television and, in the process, defined a new form of creative expression. Paik's understanding of the power of the moving image began as an intuitive perception of an emerging technology, which he seized upon and transformed. In addition to collaborating with a number of technicians such as Shuya Abe, Norman Ballard, and Horst Bauman to make new tools to rework the electronic image, Paik also incorporated sophisticated computer and digital technologies into his art to continue to refashion its content, visual vocabulary, and plastic forms(Fig. 6-5-2).

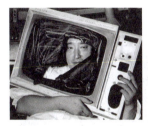 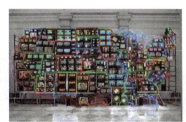 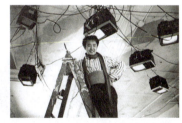

Fig. 6-5-2 Nam June Paik's video art

This introduction concludes with a photograph documenting Paik's Robot K-456 (1964) in an "accident" staged in front of the Whitney Museum of American Art in 1982. Paik removed his **remote-controlled robot** from his retrospective exhibition at the Whitney and guided it up the sidewalk along Madison Avenue. As the robot crossed the avenue, it was struck by a car and fell to the ground. Paik declared this to represent a "catastrophe of technology in the twentieth century", stating that the lesson to be gained from these tentative technological steps is that "we are learning to cope with it". Paik's staged event drew attention to the fragility of humankind and of technology itself. Twenty years after his first experiments with the television set, this street performance was made for television; after the performance, he was interviewed by television news reports; Paik took this playful moment as an opportunity to recall the need to understand technology and make

sure that it does not control us.

Paik's staged event with his manmade robot was a humanist expression of a technology that subverted the dominant post institutions. Paik, who remade the television into an artist's instrument, reminded us that we must recall the **avant-garde** movements of the 1960s and learn from their conceptual foundation, which expressed the need to create alternative forms of expression out of the very technologies that impact our lives. Robot K-456 is a statement of liberation, demonstrating that the potential for innovation and new possibilities must not be lost, but must be continually reimagined and remade by the artist(Fig. 6-5-3).

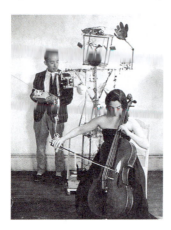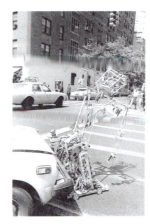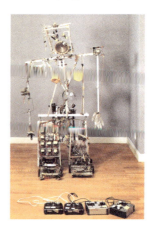

Fig. 6-5-3　Nam June Paik's installation design

TV Garden, one of his seminal installations, illustrates Paik's profound grasp of technology's capacity for composition and the new **aesthetic** discourse that he helped to create. To enter the piece is to experience an uncanny fusion of the natural and the scientific, as hidden amid an undergrowth of live plants are **video monitors** of various sizes. All are playing the artist's 1973 collaboration with John J. Godfrey, Global Groove, which **montages** performers from around the world into a gyrating visual mix, and the **videotape's sound track** serves as musical and spoken counterpoint to the monitors' flickers of light. TV Garden set a new standard for immersive, site-specific video installations.② Restaged for the artist's exhibition at the Guggenheim Museum in 2000, its influence can be seen decades later in ambient, room-sized installations by such artists as Gary Hill and Bill Viola(Fig. 6-5-4).

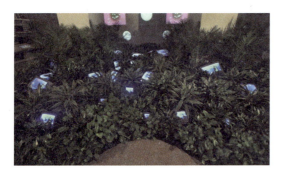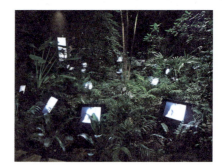

Fig. 6-5-4　Nam June Paik's masterpieces

As a pioneer of video art and a father of video art, the artwork and ideas of Nam June Paik were a major influence on late 20th-century art and continue to inspire a new generation of artists.③ Contemporary artists considered to be influenced by Paik include Christian Marclay, Jon Kessler, Cory Arcangel, Ryan Trecartin, and Haroon Mirza(Fig. 6-5-5).

Fig. 6-5-5　Nam June Paik's video art

专业词汇

video art　视频艺术
laser　[ˈleɪzə(r)]　激光
Fluxus　激浪派
Neo-Dada　新达达主义
post-video　录像
kinetic image　图像动力学
digital media　数字媒体
parameter　[pəˈræmɪtər]　参数
installation art　装置艺术
electronic image　电子图像
dynamic visual　动态视觉
videotape　[ˈvɪdɪəʊteɪp]　录像带
telecommunication　[ˌtelɪkəˌmjuːnɪˈkeɪʃn]　电信
sibling　[ˈsɪblɪŋ]　兄弟姐妹
pianist　[ˈpɪənɪst]　钢琴家
scrim　[skrɪm]　粗布
cascading water　层叠水
smoke-filled　烟雾缭绕
instrumentality　[ˌɪnstrʊmenˈtælɪti]　媒介
remote-controlled robot　遥控机器人
avant-garde　前卫
video monitors　视频监视器
montage　[ˌmɒnˈtɑːʒ]　蒙太奇
sound track　音轨

难句翻译

① He transformed the instrumentality of the video medium through a process that expressed his deep insights into electronic technology and his understanding of how to reconceive television, to "turn it inside out" and render something entirely new. Paik's imagery has not been predetermined or limited by the technologies of video or the system of television.

他改变了视频媒介的功能。这是因为他对电子技术有深入洞察，对如何重构电视也有深刻理解，他能够把事物"翻个底朝天"并做出全新的开创。白南准的意象并没受到录像技术或电视系统的局限。

② TV Garden set a new standard for immersive, site-specific video installations.

《电视花园》开创了浸入式定点录像装置艺术的新篇章。

③ As a pioneer of video art and a father of video art, the artwork and ideas of Nam June Paik were a major influence on late 20th-century art and continue to inspire a new generation of artists.

作为录像艺术的先驱及开创者,白南准的作品对 20 世纪晚期的艺术界有巨大影响,如今他的作品仍然启发着后人。

Nam June Paik(白南准)

白南准是堪称典范的激浪派艺术家,在 1945 年以后兴起的最重要的先锋派艺术——音乐先锋派、电影先锋派、行为先锋派和媒体先锋派中,他是一位核心成员。1963 年,白南准成为用电视来表现艺术的第一人。他的作品将艺术、媒体、技术、流行文化和先锋派艺术结合在一起,影响着当代艺术、视频和电视。他被称为录像艺术的创造者。白南准第一个运用当代艺术思想来改造活动影像,如今,录像艺术被广泛运用。韩国为了纪念他对当代艺术的贡献,专门创立了白南准美术馆。

From

https://en.wikipedia.org/wiki/Nam_June_Paik

http://www.paikstudios.com/

6.6 Maurice Benayoun and His Masterpieces

Maurice Benayoun is a French pioneer new-media artist and theorist based in Paris and Hong Kong. His work employs various media, including (and often combining) video, immersive virtual reality, the Web, **wireless technology**, performance, large-scale urban **art installations** and interactive exhibitions (Fig. 6-6-1).

Fig. 6-6-1 Maurice Benayoun and his masterpieces

Born in Mascara, Algeria in March 1957, he moved to France in 1958. Graduating in Fine Arts (Pantheon-Sorbonne University) in the early 1980s, Benayoun directed video installations and short videos about

contemporary artists, including Daniel Buren, Jean Tinguely, Sol LeWitt and Martial Raysse. In 1987 he co-founded Z-A, a computer graphics and virtual reality private lab. Between 1990 and 1993, Benayoun collaborated with Belgian graphic novelist François Schuiten on Quarxs, a computer **graphics world** that explores variant worlds with alternate **physical laws**. In 1993, he received the Villa Medicis Hors Les Murs for his Art After Museum project, a virtual reality **contemporary art** collection.

After 1994 Benayoun was involved with more virtual-reality and **interactive-art** installations, one of which was described by Jean-Paul Fargier in Le Monde (1994) as "the first Metaphysical Video Game". One important work from this period includes The Tunnel under the Atlantic, finished in 1995, which was a **tele-virtual** project linking the Pompidou Center in Paris and the Museum of Contemporary Art in Montreal. More than a technical performance, as the first intercontinental virtual reality artwork (called "televirtuality", Philippe Quéau, 1994), this installation was one-of-a-kind example of what Maurice Benayoun calls **architecture of communication**, as another way to explore limits of communication, after Hole in Space by Kit Galloway and Sherrie Rabinovitz. The Tunnel under the Atlantic introduces the concept of dynamic semantic shared space.

In 1997 he created with Jean-Baptiste Barrière World Skin, a Photo Safari in the Land of War, an **immersive** installation, often mentioned as a reference **in virtual art**, which was awarded with the Golden Nica, Ars Electronica 1998.

Benayoun conceived and directed the exhibition Cosmopolis, Overwriting the City (2005), a **giant art** and science immersive installation presented for French Year in China in Shanghai, Beijing, Chengdu and Chongqing. In 2008, a large scale urban installation in Shanghai converted people into flash codes then becoming the city itself. Initiated in 2005, the series of works, Mechanics of Emotions presented Internet as the world nerve system and world emotions as a possible material for the new metaphoric model of economy.

As a **theorist**, Maurice Benayoun coined the concepts of **critical fusion**, as "the fusion of fiction and reality to **decipher** the world" and extended relativity, a model from physics to understand the process of subjective data mining and urban navigation. He considered his recent works as a form of open media art, paraphrasing Jon Ippolito, not limited to the traditional forms, media and economic schemes of art.

He also created world Skin, an interactive artwork presented for the first time at **Ars Electronica**. It won the Golden Nica Award in the interactive art category in 1998(Fig. 6-6-2).

Fig. 6-6-2 Maurice Benayoun's masterpieces

Armed with cameras, we are making our way through a **three-dimensional** space. The **landscape** before our eyes is scarred by war-demolished buildings, armed men, tanks and artillery, piles of rubble, the wounded and the maimed. This arrangement of photographs and news pictures from different zones and theaters of war depicts a universe filled with mute violence. The audio reproduces the sound of a world in which to breathe is to suffer. Special effects? Hardly. We, the visitors, feel as though our presence could disturb this chaotic

equilibrium, but it is precisely our intervention that stirs up the pain. We are taking pictures; and here, photography is a weapon of erasure(Fig. 6-6-3).

Fig. 6-6-3　Art installations by Maurice Benayoun

The land of war has no borders. Like so many tourists, we are visiting it with camera in hand. Each of us can take pictures, capture a moment of this world that is wrestling with death. The image thus recorded exists no longer. Each photographed fragment disappears from the screen and is replaced by a black **silhouette**. With each click of the shutter, a part of the world is extinguished. Each exposure is then **printed** out. As soon as an image is printed to paper, it is no longer visible on the projection screen. All that remains is its eerie shadow, cast according to the viewer's perspective and concealing fragments of future photographs. The farther we penetrate into this universe, the more strongly aware we become of its infinite nature. And the chaotic elements renew themselves, so that as soon as we recognize them, they recompose themselves once again in a tragedy without end.

In French, "prise de vues." Shooting, taking. In the case of a material storage medium, "taking" something is the equivalent of taking it with you. Photography captures the light reflected by the world. It constitutes an individual process of capturing and arranging. The image is adapted to the **viewfinder**.

The picture neutralizes the content. Media bring everything onto one and the same level. **Physical memory-paper**, for example, is the door that remains open to a certain kind of forgetting. We interpose the lens ("objectif" in French) between ourselves and the world. We protect ourselves from the responsibility of acting. One "takes" the picture, and the world "**proffers**" itself as a theatrical event. The world and the destruction constitute the preferred stage for this drama-tragedy as a play of nature in action.

Here, the viewer/tourist contributes to an amplification of the tragic dimension of the drama. Without him, this world is **forsaken**, left to its pain. He jostles this pain awake, exposes it. Through the media, war becomes a public stage, in the sense in which a whore might be referred to as a "public woman". Pain reveals its true identity on this obscene stage, and all are completely devoured. The sight of the wounded calls to mind the image of a human being as a construct which can be dismantled. Material, more or less. The logic of the material holds the upper hand over the logic of the spirit, the endangered connective tissue of the social fabric.

War is a dangerous, interactive community undertaking. Interactive creation plays with this chaos, in which placing the body at stake suggests a relative vulnerability. The world falls victim to the viewer's glance, and everyone is involved in its disappearance.① The collective unveiling becomes a personal pleasure, the object of fetishistic satisfaction. We keep to ourselves what we have seen (or rather, the traces of what we have seen). To possess a printed vestige, to possess the image inherent in this is the paradox of the virtual, which is better suited to the glorification of the ephemeral. The soundtrack is there to enable us to go beyond

the play of images and to experience this immersion as real participation in the drama. In sharp contrast to the video games that transform us into passionate warriors, here the audio unmasks the true nature of apparently harmless gestures and seeks to provide not so much a form of comprehension as a form of experience. Some things cannot be shared. Among them are the pain and the image of our remembrance. The worlds to be explored here can bring these things closer to us—but always simply as metaphors, never as a simulacrum.

专业词汇

wireless technology　无线技术
interactive-art　互动艺术
virtual art　虚拟艺术
art installations　艺术装置
graphics world　图形世界
physical laws　物理规律
tele-virtual　远程虚拟
architecture of communication　通信体系结构
immersive ［i'mɜrsiv］　沉浸式的
giant art　巨型艺术
theorist ［'θiərist］　理论家
critical fusion　临界融合
decipher ［di'saifə(r)］　解码
Ars Electronica　奥地利电子艺术节
three-dimensional　三维
landscape ［'lændskeip］　景观
silhouette ［ˌsiluˈet］　轮廓
printed ［'printid］　印刷
viewfinder ［'vjuˌfaindər］　取景器
physical memory-paper　物理内存纸
contemporary art　当代艺术
proffer ［'prɒfə(r)］　提供, 提议
forsaken ［fə'seikən］　遗弃, 抛弃

难句翻译

① War is a dangerous, interactive community undertaking. Interactive creation plays with this chaos, in which placing the body at stake suggests a relative vulnerability. The world falls victim to the viewer's glance, and everyone is involved in its disappearance.
　　战争是一种危险的族群互动。交互式作品利用了这种混乱,因为置身危险意味着某种相对脆弱性。在参观者的视角下,整个世界成为受害者,所有人都得为其消失负责。

Maurice Benayoun（莫里斯·贝纳永）

　　莫里斯·贝纳永,又被称为莫奔(MoBen),是法国的先驱新媒体艺术家和理论家,现居香港。他的作品常采用不同的媒体,包括(而且经常配合)视频、虚拟现实、网络、无线技术、表演、大型城市艺术装置和互动展览等。

From

https://en.wikipedia.org/wiki/Maurice_Benayoun

http://www.benayoun.com/projet.php?id=16

6.7 Bill Viola and His Masterpieces

As a contemporary video artist, Bill Viola's artistic expression depends upon electronic, sound, and image technology in new media. His works focus on the ideas behind fundamental human experiences such as birth, death and aspects of consciousness.①

Bill Viola was born in 1951 in New York. From 1969, he studied at the College of Visual and Performing Arts of Syracuse University, Syracuse, New York, graduating with a BFA in 1973 (Fig. 6-7-1).

Fig. 6-7-1 Bill Viola

During the 1970s, Viola assisted Nam June Paik and Peter Campus with various projects, and between 1973 and 1980 worked with the composer David Tudor and the avant-garde music group Composers Inside Electronics. From 1974 to 1976, he was the technical production manager of the Art/Tapes/22 Video Studio in Florence and from 1976 to 1983 was a visiting artist at the WNET/Thirteen Television Laboratory in New York. During this time, Viola traveled frequently to the South Pacific, Indonesia, Australia, Tunisia, and India.

In 1978, and again in 1983 and 1989, the National Endowment for the Arts awarded Viola a Visual Artist Fellowship for his work in video. From 1980 to 1981, he lived in Japan on a fellowship from the U.S./Japan Friendship Commission, and was an **artist-in-residence** at the Sony Corporation's Atsugi Laboratories in Atsugi, Japan. He received a Video Artist Fellowship from the Rockefeller Foundation in 1982. In 1983, he taught video at the California Institute for the Arts in Valencia. He received the Polaroid Video Award for

outstanding achievement in 1984, and spent part of that year as artist-in-residence at the San Diego Zoo. Also in 1984, he traveled to Fiji to document the fire-walking ceremony of the South Indian community in Suva. The John Simon Guggenheim Memorial Foundation presented Viola with a video stipend in 1985. In 1987, he won the American Film **Institute** Maya Deren Award, and two years later, a John D. and Catherine T. MacArthur Foundation Award. That year, he traveled throughout the American Southwest to study ancient native American archeological sites and **rock art**. In 1993, he was the first recipient of the Medienkunstpreis, awarded by ZKM Karlsruhe, Germany, and the Siemens Kulturprogramm. In 1995, he was awarded an Honorary Doctor of Fine Arts degree from Syracuse University.

Underlying Bill Viola's video work of the past two decades is the conviction that advanced media technologies have the capacity to channel direct experience of spiritual phenomena.② In his **immersive** video and sound environments, Viola aims to externalize the internal realm of the unconscious, providing space for the contemplation of what he sees as the universal, mystical truths that ground many eastern and western religious traditions. To do so, he uses modern methods of media production such as large-scale projection, slow motion, precise sound editing, or looping. Archetypal cycles and perceived dualities, such as creation and destruction, represent his core subject matter.

Initially installed in England's Durham Cathedral, The Messenger reveals some of Viola's central thematic concerns and formal techniques. **Projected** on a large scale and played on a continuous loop, the video pictures a watery zone within which a **naked** man slowly **materializes**. Upon surfacing, he takes a rejuvenating breath only to descend again, his form dissolving into the dark water. Implied here are the universal cycles of birth and death as well as the basic act of speech itself. The elemental force of water is made more explicit in the two-channel work The Crossing, which revolves around a freestanding, double-sided projection screen. On one side, a man walks in slow motion out of the blackness to eventually confront the viewer at over life-size. Dripping water from above gradually becomes a torrent, overwhelming the figure, whose form is eradicated. The scene replays after the water dissipates. On the reverse side, the same man approaches, this time to be consumed by rising flames. Part violent destruction, part peaceful transcendence, The Crossing is indicative of Viola's use of nonspecific spiritual processes drawn from a host of disparate belief systems(Fig. 6-7-2).

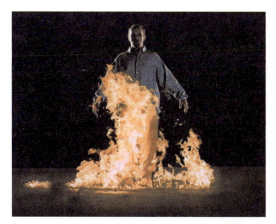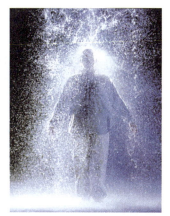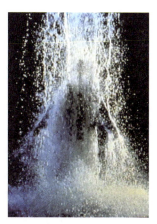

Fig. 6-7-2　Bill Viola's masterpieces

Going Forth by Day is an epic, five-part projection-based installation that addresses the complexity of human existence and explores cycles of birth, death, and rebirth. A different phase is embodied in each of the five looped projections with audio accompaniment. In one sequence, a community is shown anticipating and then fleeing from a deluge while another panel predicts a hopeful future as dawn illuminates a ravaged

landscape. Each video is projected directly onto the wall of the exhibition space, just as the paint of a **fresco** adheres to the surface of a plaster wall. Viola acknowledges the influence of Giotto's fresco cycle in the Scrovegni Chapel in Padua, a Renaissance work that, like Viola's installation, occupies an architectural space through which the viewer may physically pass(Fig. 6-7-3).

Fig. 6-7-3　Bill Viola's video art work

Bill Viola is a pioneer in the use of the moving image. He employs video, film, and audio technology to reveal his interest in conceptual and perceptual issues, as well as to realize his desire to engage with the history of art. Having worked with video since the early 1970s, Viola said that he has "never lost faith in the image", and he has embraced new **mediums** while maintaining classical aesthetic values. Viola's imagery has an immediate, visceral impact, but his temporal stretching and slowing of sensory experience through the use of art and technology deepens his works as vehicles of spiritual meditation.③ Viola's installations and artworks invoke both primal archetypes and a mystical spirituality.

专业词汇

medium　['miːdiəm]　媒介
artist-in-residence　进驻艺术家
projected　[prə'dʒektid]　投影
fresco　['freskəʊ]　壁画
rock art　岩石艺术
immersive　[i'mɜrsiv]　沉浸式的
institute　['institjuːt]　协会, 学院
naked　['neikid]　裸体的
materialize　[mə'tiəriəlaiz]　使具体化

难句翻译

① As a contemporary video artist, Bill Viola's artistic expression depends upon electronic, sound, and image technology in new media. His works focus on the ideas behind fundamental human experiences such as birth, death and aspects of consciousness.

作为一位当代录像艺术家, 比尔·维奥拉利用新媒体的电子、声音、成像技术来进行艺术表达。他的作品关注一些基本人生经验背后的含义, 如生育、死亡和意识的方方面面。

② Underlying Bill Viola's video work of the past two decades is the conviction that advanced media technologies have the capacity to channel direct experience of spiritual phenomena.

比尔·维奥拉过去二十年的录像艺术作品都体现了一种信念, 即先进媒体技术能够让人直接体验精神现象。

③ Viola's imagery has an immediate, visceral impact, but his temporal stretching and slowing of sensory experience through the use of art and technology deepens his works as vehicles of spiritual meditation.

维奥拉的意象能引发一种即刻的生理反应,但他运用艺术与技术延缓了节奏并延续了感官体验,因此加重了其作品在精神冥想方面的载体价值。

Bill Viola(比尔·维奥拉)

比尔·维奥拉,1951年生于美国纽约,1973年取得了雪城大学(Syracuse University)的实验影像工作室的美术学士学位,是国际公认的视像装置艺术先驱。20世纪70年代,作为欧洲第一批录像艺术工作室的技术指导,维奥拉在意大利的佛罗伦萨工作了整整18个月。此后,他周游世界,先后在所罗门岛、爪哇、巴厘岛和日本等地停留,对当地传统的表演艺术进行深入细致的研究和记录。1984年,维奥拉在美国圣地亚哥动物园做客座艺术家,参与"动物意识"研究与创作计划。1995年,维奥拉作为美国艺术家的代表,参加了第46届威尼斯双年展,作品《埋葬的秘密》(Buried Secrets)在美国厅展出。1997年,美国纽约惠特尼美术馆为他举办了大型作品回顾展——"比尔·维奥拉:25年的回顾"。在长达两年的时间里,该展览先后在美国及欧洲的6个博物馆展出,维奥拉的艺术举世瞩目。

From

https://www.guggenheim.org/artwork/artist/bill-viola

https://en.wikipedia.org/wiki/Bill_Viola

单元词汇总结

Style:	Digital art; Multimedia art; New media art; Net art; Music/Sound art; Installation art; Rock art; Interactive-art; Virtual art; Giant art; European Renaissance
Concept:	Fluxus; Neo-dada; Pacifism; Feminism; Environmentalism; Unsympathetic antagonist; Pessimistic
Technology:	Post-video; Virtual reality; Wireless technology; Tele-virtual; Decipher; Projected; Montages; Motion; Magic Lantern; Thaccmarope; Zoetrope; Phenakitoscops; Praxinoscope; Sound-and-music-equipped; Videotape; Microcontroller; Video monitors; Tablet Viewfinder; Physicalmemory-pape
Works:	Masterful storyteller; Mirai shônen Konan; Nausicaä of the Valley of the Wind
Form:	Cutout animation; Flip-book; Hand-drawn; Computer-aided animation; Biopic; Domestic film; Intermittently; Three-dimensional; Full-length
Cartoon character:	Snow White; Mickey Mouse; Donald Duck; Symphonies; Warner Brother; Yogi Bear; Big Hero
Title:	Cartoonist; Animator; Manga artist; Screenwriter

单元7

家具设计师与他们的作品

Unit 7　Furniture Designers and Their Masterpieces

7.1 Arne Emil Jacobsen and His Masterpieces

Arne Emil Jacobsen, Hon. FAIA (1902—1971) was a Danish architect and designer. He is remembered for his contribution to **architectural functionalism** as well as for the worldwide success he enjoyed with simple but effective chair designs (Fig. 7-1-1).

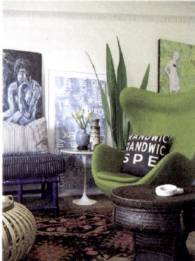

Fig. 7-1-1　Arne Emil Jacobsen and Egg Chair

Arne Jacobsen was born on 11 February 1902 in Copenhagen. His father Johan was a wholesale trader in safety pins and snap fasteners. His mother Pouline was a bank teller whose hobby was painting floral **motifs**. He first hoped to become a painter but was dissuaded by his father who encouraged him to opt instead for the more secure domain of architecture. After a spell as an apprentice mason, Jacobsen was admitted to the Architecture School at the Royal Danish Academy of Fine Arts where from 1924 to 1927 he studied under Kay Fisker and Kaj Gottlob, both leading architects and designers. Still a student, in 1925 Jacobsen participated in the Paris Art Deco Fair, Exposition Internationale des Arts Décoratifs et Industriels Modernes, where he won a silver medal for a chair design. On that trip, he was struck by the pioneering **aesthetic** of Le Corbusier's L'Esprit Nouveau pavilion. Before leaving the Academy, Jacobsen also travelled to Germany, where he became acquainted with the **rationalist** architecture of Mies van der Rohe and Walter Gropius. Their work influenced his early designs including his graduation project, an **art gallery**, which won him a gold medal. In 1929, in collaboration with Flemming Lassen, he won a Danish Architect's Association competition for designing the "House of the Future" which was built full scale at the subsequent exhibition in Copenhagen's Forum. It was a **spiral-shaped, flat-roofed** house in glass and concrete, incorporating a private garage, a boathouse and a helicopter pad. Other striking features were windows that rolled down like car windows, a conveyor tube for the mail and a kitchen stocked with ready-made meals. A Dodge Cabriolet Coupé was parked in the garage, there was a Chris Craft in the boathouse and an Autogyro on the roof. Jacobsen immediately

became recognized as an ultra-modern architect.

Furniture and Product Design

Today, Arne Jacobsen is remembered primarily for his **furniture designs**. However, he believed he was first and foremost an architect. According to Scott Poole, a professor at Virginia Tech, Arne Jacobsen never used the word "designer", notoriously disliking it.

His way into product design came through his interest in Gesamtkunst and most of his designs which later became famous in their own right were created for architectural projects.① Most of his furniture designs were the result of a cooperation with the furniture manufacturer Fritz Hansen with which he initiated a collaboration in 1934 while his lamps and light fixtures were developed with Louis Poulsen. In spite of his success with his chair at the Paris Exhibition in 1925, it was during the 1950s that his interest in furniture design peaked.

A major source of inspiration stemmed from the **bent plywood** designs of Charles and Ray Eames. He was also influenced by the Italian design historian Ernesto Rogers, who had proclaimed that the design of every element was equally important "from the spoon to the city" which harmonized well with his own ideals.②

In 1951, he created the Ant Chair for an extension of the Novo pharmaceutical factory and in 1955, came the Seven Series. Both matched modern needs perfectly, being light, compact and easily stackable. Two other successful chair designs, the Egg and the Swan, were created for the SAS Royal Hotel which he also designed in 1956.

Other designs were made for Stelton, a company founded by his foster son Peter Holmbl. These include the now classic Cylinda Line stainless steel cocktail kit and tableware.

Style and Legacy

According to R. Craig Miller, author of *Design* 1935—1989, *What Modern Was*, Jacobsen's work "is an important and original contribution both to modernism and to the specific place Denmark and the Scandinavian countries have in the modern movement" and continues "One might in fact argue that much of what the modern movement stands for, would have been lost and simply forgotten if Scandinavian designers and architects like Arne Jacobsen would not have added that humane element to it"(Fig. 7-1-2).

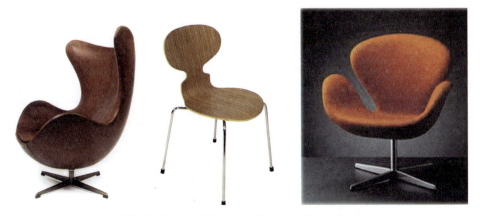

Fig. 7-1-2 Egg Chair, Ant Chair and Swan Chair

专业词汇

architectural functionalism　建筑功能主义
furniture designer　家具设计师
bent plywood　弯曲胶合板
motif　[məuˈtiːf]　（文艺作品等）的主题
aesthetic　[iːsˈθetik]　美学的
pioneering　[ˌpaiəˈniəriŋ]　首倡的，带头的
rationalist　[ˈræʃ(ə)nəlist]　理性主义者
art gallery　艺术画廊
spiral-shaped　螺旋状的
flat-roofed　平顶的

难句翻译

① His way into product design came through his interest in Gesamtkunst and most of his designs which later became famous in their own right were created for architectural projects.

基于对综合艺术的兴趣，他开始涉足产品设计。他的许多著名设计原本都是为建筑项目而制的。

② A major source of inspiration stemmed from the bent plywood designs of Charles and Ray Eames. He was also influenced by the Italian design historian Ernesto Rogers, who had proclaimed that the design of every element was equally important "from the spoon to the city" which harmonized well with his own ideals.

他的一大灵感源泉是伊姆斯夫妇的弯曲胶合板设计。另一影响是意大利设计史学家厄内斯托·罗格斯，罗格斯宣称任何设计都同样重要，"无论一根小勺还是一座城市"，这正与他本人的设计理念相吻合。

Arne Jacobsen（阿诺·雅各布森）

阿诺·雅各布森（1902—1971）生于丹麦首都哥本哈根。他是20世纪最具影响力的北欧建筑师和丹麦国宝级设计大师，北欧现代主义之父。他也是"丹麦功能主义"的倡导人，后与勒·柯布西耶、密斯凡德罗等共同倡导"简约"设计风格。他在家具、灯饰、衣料以及各类装饰艺术上皆有很深造诣与很大成就，并成为国际上享誉盛名的传奇人物。1968年，他获得国际设计大奖（International Design Award）的殊荣。他将自身对建筑的独特见解延伸至家居饰品，其著名的设计作品有蚁形椅（Ant Chair）、蛋椅（Egg Chair）、天鹅椅（Swan Chair）等。

From
　　https://en.wikipedia.org/wiki/Arne_Jacobsen

7.2 Eero Saarinen and His Masterpieces

Eero Saarinen (1910—1961) was a Finnish American architect and industrial designer of the 20th century famous for shaping his **neo-futuristic style** according to the demands of the project: simple, sweeping, arching structural curves or **machine like rationalism**(Fig. 7-2-1).

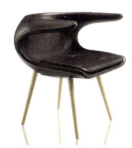
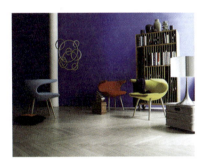

Fig. 7-2-1 Eero Saarinen and Potato Chair

Eero Saarinen, the son of influential Finnish architect Eliel Saarinen and his second wife, Louise, was born on his father's 37th birthday, August 20, 1910. They immigrated to the United States in 1923, when Eero was thirteen. He grew up in Bloomfield Hills, Michigan, where his father was a teacher at the Cranbrook Academy of Art and he took courses **in sculpture** and furniture design there. He had a close relationship with fellow students Charles and Ray Eames, and became good friends with Florence Knoll.

Beginning in September 1929, he studied sculpture at the Académie de la Grande Chaumière in Paris, France. He then went on to study at the Yale School of Architecture, completing his studies in 1934. Subsequently, he toured Europe and North Africa for a year and returned for a year to his native Finland, after which he returned to Cranbrook to work for his father and teach at the academy. He became a **naturalized citizen** of the United States in 1940. Saarinen was recruited by Donal McLaughlin, an architectural school friend from his Yale days, to join the military service in the Office of Strategic Services (OSS). Saarinen was assigned to draw illustrations for bomb disassembly manuals and to provide designs for the Situation Room in the White House. Saarinen worked full-time for the OSS until 1944. After his father's death in 1950, Saarinen founded his own architect's office, "Eero Saarinen and Associates". Eero Saarinen died of a brain tumor in 1961 at the age of 51.

Work

Saarinen first received critical recognition, while still working for his father, for a chair designed together with Charles Eames for the "Organic Design in Home Furnishings" competition in 1940, for which they received first prize. The "**Tulip Chair**", like all other Saarinen chairs, was taken into production by the Knoll furniture company, founded by Hans Knoll, who married Saarinen family friend Florence (Schust) Knoll.

Further attention came also while Saarinen was still working for his father, when he took first prize in the 1948 competition for the design of the Jefferson National Expansion Memorial, St. Louis, not completed until the 1960s. The competition award was mistakenly sent to his father. He designed furniture with organic architecture.

During his long association with Knoll, he designed many important pieces of furniture including the "Grasshopper" lounge chair and ottoman (1946), the "Womb" chair and ottoman (1948), the "Womb" settee (1950), side and arm chairs (1948—1950), and his most famous "Tulip" or "Pedestal" group (1956), which featured side and arm chairs, dining, coffee and side tables, as well as a stool.① All of these designs were highly successful except for the "Grasshopper" lounge chair, which, although in production through 1965, was not a big success.

One of Saarinen's earliest works to receive international acclaim is the Crow Island School in Winnetka, Illinois (1940). The first major work by Saarinen, in collaboration with his father, was the General Motors Technical Center in Warren, Michigan. It follows the rationalist design **Miesian style**: incorporating steel and glass, but with the added accent of panels in two shades of blue. The GM Technical Center was constructed in 1956, with Saarinen using models. These models allowed him to share his ideas with others, and gather input from other professionals. With the success of the scheme, Saarinen was then invited by other major American corporations such as John Deere, IBM, and CBS to design their new **headquarters**. Despite their rationality, however, the interiors usually contained more **dramatic sweeping staircases**, as well as furniture designed by Saarinen, such as the Pedestal Series. In the 1950s he began to receive more commissions from American universities for campus designs and individual buildings; these include the Noyes dormitory at Vassar, Hill College House at the University of Pennsylvania, as well as an ice rink, Ingalls Rink, Ezra Stiles & Morse Colleges at Yale University, the MIT Chapel and neighboring Kresge Auditorium at MIT and the University of Chicago Law School building and grounds.

He served on the jury for the Sydney Opera House commission and was crucial in the selection of the now internationally known design by Jorn Utzon. A jury which did not include Saarinen had discarded Utzon's design in the first round. Saarinen reviewed the discarded designs, recognized a quality in Utzon's design which had eluded the rest of the jury and ultimately assured the commission of Utzon.

Saarinen also designed one of the best-known thin-shell concrete structures in America—Kresge Auditorium (MIT). Another thin-shell structure that he created is Yale's Ingalls Rink, which has suspension cables connected to a single concrete backbone and is nicknamed "the whale". Undoubtedly, his most famous work is the TWA Flight Center, which represents the culmination of his previous designs and demonstrates **his neo-futuristic expressionism** and the technical marvel in concrete shells (Fig. 7-2-2, Fig. 7-2-3).

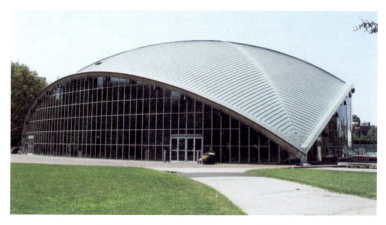

Fig. 7-2-2 Kresge Auditorium (MIT)

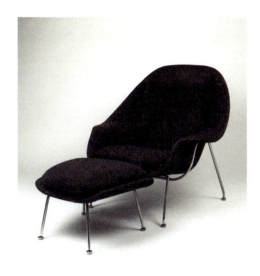
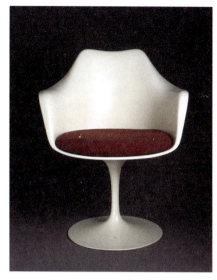

Fig. 7-2-3　Womb Chair and Tulip Chair

专业词汇

neo-futuristic style　新未来主义风格
machine like rationalism　机械般的理性
naturalized citizen　入籍公民
Tulip Chair　郁金香椅
headquarters　[ˈhedˈkwɔːtəz]　总部
dramatic sweeping staircase　戏剧性的楼梯
neo-futuristic expressionism　新未来表现主义
Miesian style　密斯风格

难句翻译

① During his long association with Knoll, he designed many important pieces of furniture including the "Grasshopper" lounge chair and ottoman (1946), the "Womb" chair and ottoman (1948), the "Womb" settee (1950), side and arm chairs (1948—1950), and his most famous "Tulip" or "Pedestal" group (1956), which featured side and arm chairs, dining, coffee and side tables, as well as a stool.

在与诺尔的长期合作中，他设计了许多重要的家具作品，包括草蜢椅组(1946)、子宫椅组(1948)、子宫短沙发(1950)、侧椅和扶手椅(1948—1950)以及他最出名的郁金香家具组(1956)，其中包括侧椅、扶手椅、餐桌、咖啡桌、边桌和一个小凳子。

Eero Saarinen(埃里·沙里宁)

埃里·沙里宁，美国建筑师，生于芬兰一个艺术家家庭。其父亲埃利尔·沙里宁(Eliel Saarinen)是建筑师，母亲是雕塑家，1923年全家移居美国。他的作品富于独创性，作品之间很难找到相同的痕迹。沙里宁一生中不断地创立新风格，他被誉为20世纪中叶美国最有创造性的建筑师之一。其主要作品包括通用汽车公司技术中心(General Motors Technical Center)(1948—1956)、圣路易市杰斐逊国家纪念碑(St. Louis Jefferson

National Memorial Chorten)(1960)、麻省理工学院礼堂和小教堂(Kresge Auditorium)(1950)、美国环球航空公司候机楼(Trans World Airline)(1956—1962)以及华盛顿杜勒斯国际机场候机楼(Washington Dulles International Airport)等。

From
https://en.wikipedia.org/wiki/Eero_Saarinen

7.3 Charles and Ray Eames and Their Masterpieces

Charles Ormond Eames, Jr (1907—1978) and Bernice Alexandra "Ray" (née Kaiser) Eames (1912—1988) were husband and wife American designers who made significant historical contributions to the development of modern architecture and furniture. Among their most well-known designs is the Eames Lounge Chair. They also worked in the fields of industrial and graphic design, fine art and film[①] (Fig. 7-3-1).

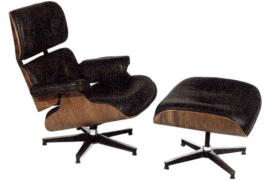

Fig. 7-3-1 Charles and Ray Eames and Eames Lounge Chair

Charles Ormond Eames, Jr, briefly studied architecture at Washington University in St. Louis on an architecture scholarship. After two years of study, he left the university. Many sources claim that he was dismissed for his advocacy of Frank Lloyd Wright and his interest in modern architects. The university reportedly dropped him because of his "too modern" views. Other sources, less frequently cited, note that while a student, Charles Eames also was employed as an architect at the firm of Trueblood and Graf. The demands on his time from this employment and from his classes led to sleep-deprivation and diminished performance at the university.

While at Washington University, he met his first wife, Catherine Woermann, whom he married in 1929. A year later, they had a daughter, Lucia Jenkins.

In 1930, Charles began his own architectural practice in St. Louis with partner Charles Gray. They were later joined by a third partner, Walter Pauley.

Charles Eames was greatly influenced by the Finnish architect Eliel Saarinen (whose son Eero, also an architect, would become a partner and friend). At the elder Saarinen's invitation, Charles moved in 1938 with

his wife Catherine and daughter Lucia to Michigan, to further study architecture at the Cranbrook Academy of Art, where he would become a teacher and head of the industrial design department. In order to apply for the Architecture and Urban Planning Program, Eames defined an area of focus—the St. Louis waterfront. Together with Eero Saarinen, he designed **prize-winning furniture** for New York's Museum of Modern Art "Organic Design in Home Furnishings" competition. Their work displayed the new technique of wood **moulding** (originally developed by Alvar Aalto) that Eames would further develop in many **moulded plywood** products, including chairs and other furniture, **splints** and **stretchers** for the US Navy during World War Ⅱ.

In 1941, Charles and Catherine divorced, and he married his Cranbrook colleague Bernice ("Ray") Kaiser, who was born in Sacramento, California. He then moved with her to Los Angeles, California, where they worked and lived until their deaths. In the late 1940s, as part of the Arts & Architecture magazine's "Case Study" program, the Eames designed and built the groundbreaking Eames House, Case Study House #8, as their home. Located upon a cliff overlooking the Pacific Ocean and **hand-constructed** within a matter of days entirely of **pre-fabricated steel parts** intended for industrial construction, it remains a **milestone** of modern architecture.

Charles Eames died of a heart attack on August 21, 1978 while on a consulting trip in his native Saint Louis, and was buried in the Calvary Cemetery there. He now has a star on the St. Louis Walk of Fame.

Ray Kaiser Eames

Ray-Bernice Alexandra Kaiser Eames (1912—1988) was an American artist, designer, and filmmaker. Along with her husband Charles Eames, she is responsible for groundbreaking contributions in the field of architecture, furniture design, industrial design, manufacturing and the photographic arts. She was born in Sacramento, California to Alexander and Edna Burr Kaiser, and had a brother named Maurice. She spent her early childhood years with her parents in their apartment, and then moved to a bungalow outside of the town. Her parents taught her the quality of enjoyment which later led to inventions in furniture design and toys. Her parents also instilled the value of enjoyment of nature. After having lived in a number of cities during her youth and after her father's death, in 1933 she graduated from Bennett Women's College in Millbrook, New York, and moved to New York City, where she studied **abstract expressionist painting** with Hans Hofmann. She was a founder of the American Abstract Artists group in 1936 and displayed paintings in their first show a year later in 1937 at Riverside Museum in Manhattan. One of her paintings is in the permanent collection of The Whitney Museum of American Art. Ray lived alone in New York City until she was called home to be with her ailing mother, who passed away in 1940.

In September 1940, Ben Baldwin recommended her to begin studies at the Cranbrook Academy of Art in Bloomfield Hills, Michigan. She learned a variety of arts, not limiting herself to abstract painting. She worked with Harry Bertoia, Eero Saarinen, Charles Eames and others on the display panels for the exhibition "**Organic Design in Home Furnishings**" at **Museum of Modern Art**. Ray married Charles Eames in 1941. Settling in Los Angeles, California, Charles and Ray Eames began an outstanding career in design and architecture.

The design process between Ray and Charles was strongly collaborative. After marriage the couple moved to California to continue their **molded plywood furniture design** and, in a later period, plastic. The graphic and commercial artwork can be clearly attributed to Ray, who designed twenty-six cover designs for the journal Arts & Architecture during 1942 to 1948, and a major part of the Eames furniture advertisements at Herman Miller (since 1948).

In the late 1940s, Ray Eames created several **textile designs**, two of which, "Crosspatch" and "Sea

Things", were produced by Schiffer Prints, a company that also produced textiles by Salvador Dalí and Frank Lloyd Wright. Two of her textile patterns were distinguished with awards in a textile competition (organized by MoMa). She worked on graphics for advertising, magazine covers, posters, timelines, game boards, invitations and business cards. Original examples of Ray Eames textiles can be found in many art museum collections. The Ray Eames textiles have been re-issued by Maharam as part of their textiles of the twentieth.

Century Collection

The Eames Lounge Chair Wood (LCW) (also known as Low Chair Wood or Eames Plywood Lounge Chair) is a low seated easy chair designed by husband and wife team Charles and Ray Eames.

The chair was designed using technology for molding plywood that the Eames developed before and during the Second World War. Before American involvement in the war, Charles Eames and his friend, architect Eero Saarinen, entered a furniture group into the Museum of Modern Art's "Organic Design in Home Furnishings" competition in 1940, a contest exploring the natural evolution of furniture in response to the rapidly changing world. Eames & Saarinen won the competition. However, production of the chairs was postponed due to production difficulties, and then by the United States' entry into WWⅡ. Saarinen left the project due to frustration with production.

Charles Eames and his wife Ray Kaiser Eames moved to Venice Beach, CA in 1941. Charles took a job as a set painter for MGM Studios to support them. Ray, formally trained as a painter and sculptor, continued experiments with molded plywood designs in the spare room of their apartment. In 1942 Charles left MGM to begin making molded plywood splints for the U.S. Air Force. The splints used compound curves to **mimic** the shape of the human leg. The experience of shaping plywood into compound curves contributed greatly to the development of the LCW.

The entries Charles Eames & Eero Saarinen submitted into the Organic Furniture competition were designed with the seat and backrest joined together in a single "shell". The plywood, however, was prone to crack when bent into the sharp curves the furniture demanded. The competition entries were covered with upholstery to hide these cracks.

Through extensive trial and error, Charles and Ray arrived at an alternate solution: create two separate pieces for the seat and backrest, joined by a plywood spine and supported by plywood legs. The result was a chair with a sleek and honest appearance. All of the connections were visible and the material was not hidden beneath upholstery. The seat was joined to the spine and legs with a series of four heavy rubber washers with nuts embedded in them (later these came to be called "**shock mounts**").② The shock mounts were glued to the underside of the seat, and screwed in through the bottom of the chair. The backrest was also attached using shock mounts. From the front and top the seat and back are uninterrupted by fasteners. The rubber mounts were pliable, allowing the backrest to flex and move with the sitter. This unique technology is also one of the chair's greatest flaws. The shock mounts are glued to the wooden backrest, but may tear free for various reasons. A common response to this problem was to drill directly through the backrest and insert fasteners between the backrest and the lumbar support. This greatly devalues the chair, since it changes the original aesthetic of smooth, uninterrupted wooden forms.

Even though the plywood chair was a compromise of the Eames' vision to create a single shell chair, it constituted a successful design. In tandem with the LCW, the Eames created a family of plywood chairs, tables, and folding screens. The all-plywood Dining Chair Wood (DCW) was constructed in the same manner as the LCW, but with a narrower seat, and longer legs to bring the seat up to dining height. The Lounge Chair

Metal (LCM) and Dining Chair Metal (DCM) were constructed of the same plywood seats and backrests as the LCW & DCW set on a welded metal frame. The success of "The Plywood Group" caught the attention of George Nelson, design director of Herman Miller. Nelson convinced D. J. DePree, the owner of Herman Miller, to hire the Eames Office as designers and bring on production of the Eames plywood furniture.

Coming out of an age where furniture was heavy and complex, made from multiple materials and then covered in upholstery, the Eames design was a striking new way of looking at furniture and furniture design.③ The chair was produced from 1946 until 1947 by Evans Molded Plywood of Venice Beach, California for the Herman Miller furniture company in Zeeland, Michigan. In 1947 Herman Miller moved the production of the chairs to Michigan and has continued producing them until the present day (a brief period existed when the chairs were out of production). In Europe, Vitra became the producers of Eames furniture. Herman Miller and Vitra are the only two companies producing chairs licensed by the Eames estate as represented by the Eames Office.

Eames Fiberglass Armchair

The Eames Molded Plastic & Fiberglass Armchair is a **fiberglass** chair, designed by Charles and Ray Eames, that appeared on the market in 1950. The chair was intentionally designed for the "International Competition for Low-Cost Furniture Design". This competition, sponsored by the Museum of Modern Art, was motivated by the urgent need in the post-war period for low-cost housing and furnishing designs adaptable to small housing units.

The chair was offered in a variety of colors and bases, such as the "Eiffel Tower" metal base, a wooden base, and a rocker base. The plastic fiberglass armchair is one of the most famous designs of Charles and Ray Eames, and is still popular today.

"Getting the most of the best to the greatest number of people for the least"—with these words, Charles and Ray Eames described one of their main goals as furniture designers. Of all their designs, the Plastic Chairs come closest to achieving this ideal. They found that the use of plastic in furniture design has several advantages: it has pleasant tactile qualities, it has malleability and static strength combined with a high-degree of flexibility, and it makes feasible, via mass-production, their goal of low-cost furniture (Fig. 7-3-2).

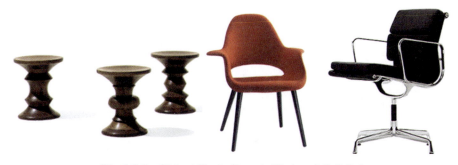

Fig. 7-3-2 Walnut Stools, Organic Chair and Soft Pad

专业词汇

prize-winning furniture　　获奖家具作品
splint　[splint]　夹板
stretcher　['stretʃə(r)]　担架

hand-construct　手工构建
pre-fabricated steel part　预制钢件
milestone ['mailstəun]　里程碑
abstract expressionist painting　抽象表现绘画
Organic Design in Home Furnishings　有机家居陈设设计
molded plywood furniture design　模铸胶合板家居设计
textile design　纺织品设计
moulding ['məuldiŋ]　模制件
mimic ['mimik]　仿制品，模仿
shock mounts　减震支座
fiberglass ['faibəgla:s]　玻璃纤维

难句翻译

① Among their most well-known designs is the Eames Lounge Chair. They also worked in the fields of industrial and graphic design, fine art and film.

其最出名的作品是伊姆斯休闲椅。他们还参与工业设计和图案设计，兼创作艺术与电影作品。

② Through extensive trial and error, Charles and Ray arrived at an alternate solution: create two separate pieces for the seat and backrest, joined by a plywood spine and supported by plywood legs. The result was a chair with a sleek and honest appearance. All of the connections were visible and the material was not hidden beneath upholstery. The seat was joined to the spine and legs with a series of four heavy rubber washers with nuts embedded in them (later these came to be called "shock mounts").

反复的试验与失败后查尔斯和蕾想到了另一种办法：先分开制作座位和靠背，再用胶合板椅轴相接，最后用胶合板椅腿支撑。成品是一只时髦而简洁的椅子。所有连接部位都清晰可见，用料一览无遗。连接座位和椅椎、椅腿的是四只一组的厚橡胶垫圈，螺丝钉旋在垫圈中。后来这种零件被称为减震块。

③ Coming out of an age where furniture was heavy and complex, made from multiple materials and then covered in upholstery, the Eames design was a striking new way of looking at furniture and furniture design.

在当时家具设计厚重复杂，制料繁多且套在外罩内。伊姆斯夫妇为家具设计提供了崭新的思路，改变了人们对家具的看法。

Charles Eames and Ray Eames(查尔斯·伊姆斯与蕾·伊姆斯)

夫妻档设计师Charles(1907—1978)及Ray Eames(1912—1988)是20世纪最有影响力的设计师。他们在建筑、家具和工业设计等现代设计领域都有卓越成就。他们从第二次世界大战中美国海军的实验中学习经验并发展工业中使用的模铸胶合板。1940年，他们参与了由MOMA举办的有机家具设计大赛。自今已有近百件他们的作品被各大博物馆永久典藏。其主要设计作品有伊姆斯住宅(Eames House)、伊姆斯躺椅(Eames Lounge Chair)、伊姆斯玻璃钢椅(Eames Fiberglass Armchair)等。

From

https://en.wikipedia.org/wiki/Charles_and_Ray_Eames

7.4 Eero Aarnio and His Masterpieces

Eero Aarnio (born on 21 July 1932 in Helsinki) is a Finnish interior designer, noted for his innovative **furniture designs** in the 1960s, such as his **plastic and fiberglass chairs** (Fig. 7-4-1).

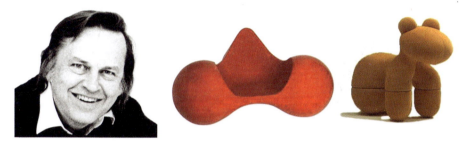

Fig. 7-4-1　Eero Aarnio, Tomato Chair and Pony Chair

Aarnio studied at the Institute of Industrial Arts in Helsinki, and started his own office in 1962. The following year, he introduced his Ball Chair, a **hollow sphere** on a stand, open on one side to allow a person to sit within. The similar **Bubble Chair** was clear and suspended from above. Other innovative designs included his floating **Pastil Chair** (similar to a solid inner tube), and **Tomato Chair** (more stable with a seat between three spheres). His **Screw Table**, as the name suggests, had the appearance of a flat head screw driven into the ground. He was awarded the American Industrial Design award in 1968.

Aarnio's designs were an important aspect of 1960s popular culture, and could often be seen as part of sets in period **science-fiction** films. Because his designs used very simple **geometric forms**, they were ideal for such productions. Eero Aarnio continues to create new designs, including toys and furniture for children. Eero Aarnio opened his official webshop and first Design Eero Aarnio Showroom, in Helsinki, where you can find Aarnio's latest design, prototypes and latest news.

Bubble Chair by Eero Aarnio 1968

Based on the idea of the Ball Chair, the Bubble Chair is a reduction of this design. As Ludwig Mies van der Rohe said: Less is more!

Aarnio about Bubble Chair: "After I had made the Ball Chair, I wanted to have the light inside it and so I had the idea of a transparent ball where light comes from all directions. The only suitable material is acrylic which is heated and blown into shape like a soap bubble. Since I knew that the **dome-shaped** skylights are made in this way, I contacted the manufacturer and asked if it would be technically possible to blow a bubble that is bigger than a **hemisphere**.① The answer was yes. I had a steel ring made, the bubble was blown and cushions were added and the chair was ready. And again the name was obvious: BUBBLE."

"There is no nice way to make a clear pedestal." Eero Aarnio notes. That is the lucky reason why the

Bubble Chair hangs from the ceiling.

Like the Ball Chair, the Bubble Chair also impresses the user by the special acoustic. The Bubble Chair swallows the sounds and you feel isolated inside in a pleasant way, even when you are in a crowded place. At the EXPO 2000 in Hannover, eleven Bubble Chairs were installed in the Cycle Bowl "Blue Box" of the Grüne Punkt Deutschland Pavillion as small, individual information spaces within the library.

The Norwegean phone company Telenor has installed some Bubble Chairs in the entrance hall of their new building in Oslo to offer calm "rooms" for mobile phoning. The transparent chair is used in music videos, advertising and fashion magazines.

Celebrities like Darryl Hannah, Donnatella Versace and Nina Hagen have enjoyed the Bubble Chair on photo shootings and Carmen Electra on cover of the December 2000 issue of Playboy. Adelta offers different materials for the cushion of the Bubble Chair(Fig. 7-4-2).

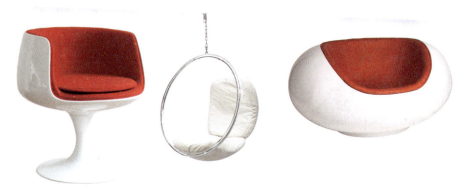

Fig. 7-4-2　Cup Chair, Bubble Chair and Pastil Chair

专业词汇

plastic and fiberglass chairs　塑料和玻璃纤维椅
hollow sphere　空心球
Pastil Chair　糖果椅
Tomato Chair　西红柿椅
Screw Table　螺旋桌
science fiction　科幻小说
Bubble Chair　泡泡椅
geometric forms　几何单形
dome-shaped　圆顶状的
hemisphere　['hemɪsˌfɪə(r)]　半球

难句翻译

① Since I knew that the dome-shaped skylights are made in this way, I contacted the manufacturer and asked if it would be technically possible to blow a bubble that is bigger than a hemisphere.

我知道圆顶天窗就是这样做的,所以我联系了生产商问他们有没有可能吹出一个超过半球大小的气泡。

Eero Aarnio(艾洛·阿尼奥)

艾洛·阿尼奥是芬兰著名的设计师,1932年出生于芬兰。1954年至1957年在赫尔辛基的工艺学院求学,1962年成立了个人工作室,从事室内设计与工业设计。成立工作室后,许多作品享誉全球,成为国际知名设计师,并获得许多工业设计奖项。其主要作品有球椅(Ball Chair)、西红柿椅(Tomato Chair)、泡泡椅(Bubble Chair)等。20世纪60年代,他开始用塑料进行实验,让家具告别了由支腿、靠背和节点构成的传统设计样式。

From
 http://www.eero-aarnio.com/23

单元词汇总结

Shape:	Geometric forms; Dome-shaped; Spiral-shaped; Mimic the shape; Hemisphere; Fan shaped; Hexagon; Pentagon; Isosceles triangle; Equilateral triangle; Circle; Regular square
Material:	Glass; Concrete; Bent plywood; Playwood; Fiberglass
Interior:	Dramatic sweeping staircase; Auditorium; Opera House
Structure:	Hand-construct; Welded metal frame; Staircases; Prefabricated steel part; Flat-roofed; Windows
Style:	Miesian style; Functionalism; Neo-futuristic expressionism; Neo-futuristic style; Abstract expression painting
Furniture:	Ant Chair; Egg Chair; Bubble Chair; Tulip Chair; Swan Chair; Womb Chair; The Eames Lounge Chair; Splint and stretcher; Pre-fabricated steel part; Shock mounts; Plastic and fiberglass chairs; Pastil Chair; Tomato Chair; Screw Table

单元8

建筑风格介绍

Unit 8　　Architecture Styles

8.1 Romanesque Architectures (8th Century—1150)

Romanesque Architectures (8th Century—1150)

Romanesque architecture derives its name from its similarity to ancient Roman buildings. Most notably, it relies on the round **arch** and articulation of individual parts to create unity. Creating an international style with numerous regional variations, the builders look to older construction methods and forms for ways to respond to functional needs. Primarily appearing in churches, Romanesque structural developments, such as the **rib vault**, will be carried further in the subsequent **Gothic** style.

HISTORICAL AND SOCIAL

Institutions and precedents that significantly affect Romanesque and Gothic life and art arise during the Early Middle Ages (5th—9th centuries). After the Roman Empire disintegrates in the 5th century C.E., Europe fragments into groups of tribal alliances. The Catholic Church is the only surviving major institution. Through **evangelism**, Europe becomes Christianized, and the church exerts greater spiritual, political, and economic influence. The church becomes central to **medieval** life and thought, but its unifying abilities are limited where local rulers do not acknowledge its authority.

Beginning in the 6th century, various religious orders establish monasteries, which become important medieval institutions. These devout societies combine a strict religious rule with intellectual and artistic endeavors. Members include architecture, mathematics, and medicine in their studies. They also write books and copy ancient **manuscripts**, thereby preserving knowledge and culture. Their schools maintain and disseminate education. Religious rule requires manual labor, so the priests and monks also clear forests, build roads, and cultivate gardens and fields.

Feudalism and seignorialism organize society into classes of **warrior-nobility** and commoners. Under feudalism, a king or noble grants a fief (usually land) to a nobleman who, in turn, swears loyalty and political and military service to the lord, The system maintains order and controls territory when governments are nonexistent or weak. Seignorialism or manorialism, closely related to feudalism, forms social, political, and economic relationship between a lord or landholder and his dependent farmers or peasants (serfs). Both systems dominate medieval society until the 14th century.

Constant warfare and poor economic conditions characterize the period before the 11th century. Consequently, there is little significant building or artistic endeavor, minimal trade, and for most people there is great hardship, numerous famines, widespread disease, and short life spans. But the 11th and 12th centuries are a turning point in Western Europe as it emerges as a separate entity from Byzantium and Islam. Eventually, the great invasions cease, but lack of political unity, widespread illiteracy, and poor communication remain. Feudalism and seignorialism continue to dominate society, while individual nations struggle to arise.

Mediterranean trade routes reopen, which stimulates the economy and produces a new middle class of artisans and merchants. The expansion of towns, commerce, industry, and populations creates a building boom.

More important, Christain influence, and with it education and culture, spreads across Europe. The Catholic Church provides stability and unity through shared faith, diplomacy, and administration of justice. Monasteries flourish even more, fostering and supporting intellectual and artistic expression, with many of them becoming wealthy and instrumental in the building of numerous churches. Clergy and laypeople sponsor and join the Crusades to liberate Jerusalem from the Muslims beginning in 1095. This joining of secular and religious forces creates the ideal of the warrior-priest that, in turn, influences knighthood and its code of chivalry. Although men dominate, a few women, such as Eleanor of Aquitaine, hold power and exert influence. Illiteracy remains widespread.

Pilgrimages to favored sites such as Jerusalem and Rome reflect the period's religious zeal. Neither is easily accessible, so Santiago de Compostella in Spain becomes the most important sacred site. People, buildings, and wealth concentrate along the four main pilgrimage routes to Santiago. Stimulated by the Crusades, pilgrimages, and the needs of cities, many churches are constructed, renovated, or rebuilt. Romanesque architecture flourishes throughout France, England, Italy, Germany, and Spain.

CONCEPTS

Concepts come primarily from the period's emphasis on religion. The church guides ways of thinking about tradition, honor, **chivalry**, education, ceremony, and family life. These ideas shape and define social, cultural, and design progress. The **Crusades, pilgrimages**, churches, and monasteries give sanctuary, unity, and stability, while bringing numerous changes during this period of turmoil and unrest. For example, churches, which are often situated along pilgrimage routes, increase in size, become more multifunctional, and provide safe havens for travelers.

MOTIFS

Important motifs include the round arch, figures, corbel tables, animals, **grotesques** and fantastic figures, **foliage, heraldic devices**, linen-fold, zigzags, **lozenges**, and geometric forms. Molding designs include the zigzag, star, billet, and lozenge (Fig. 8-1-1, Fig. 8-1-2 and Fig. 8-1-3).

Fig. 8-1-1 Norman Romanesque ornament

ARCHITECTURE

Romanesque architecture, an international style, springs up across Europe as builders grapple with the problems of providing larger, structurally stable churches to accommodate crowds of pilgrims and worshippers, as well as good light and acoustics and **fire resistance**. Builders often look to local surviving Roman architecture and construction methods and assimilate influences from Byzantine, Islam, Carolingian, Ottonian, Celtic, German, and Norman design. This new approach produces a common architecture language, one that is more thoughtful and deliberate and replaces tradition and intuition. Construction innovations spread quickly as clergy, pilgrims, and master-builders travel from site to site.

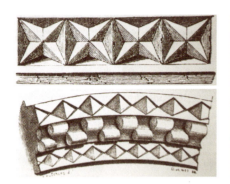
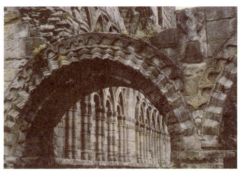

Fig. 8-1-2 Architectural Details and Moldings

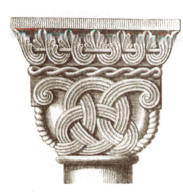
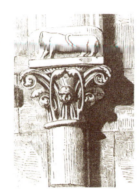
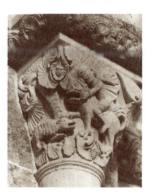

Fig. 8-1-3 Capitals from various churches including S. Madeleine, Vezelay, France

Exterior and interior architectural elements provide order, unity, readability, and monumentality. Emphasis is on solidity, weightiness, architectural elements such as the arch and the compositions are symmetrical and ordered, often with few openings. Romanesque revives the use of figural and nonfigural sculpture, particularly around windows, portals, and arches. Regional variations include the Lombard style in Northern Italy, the Pisan style in Italy, and the Norman style in England.

Responses to individual needs and the variety of models produce numerous regional church styles that differ in appearance, but relate in their use of such Roman architectural characteristics as vaults and round arches, **delineation** of parts, and masonry construction to create larger and more fireproof structures. Innovations include variations of pier forms, original capitals, and the **triforium**. Other common characteristics include regularly repeated modules in plans and facades, towers, **buttresses**, ribbed vaults, ambulatories, and thick walls with few openings. Forms, features, and aesthetic elements partly come from technological advances in response to practical and liturgical needs.

Churches (Fig. 8-1-4, Fig. 8-1-5, Fig. 8-1-6 and Fig. 8-1-7) and **monasteries** are the primary building types.

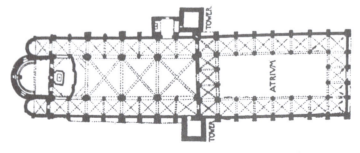

Fig. 8-1-4 S. Ambrogio, floor plan, a significant example of the Lombard-Romanesque style

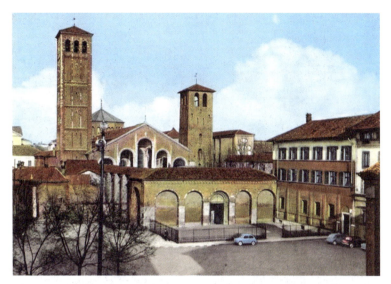

Fig. 8-1-5　S. Ambrogio, Milan, Italy

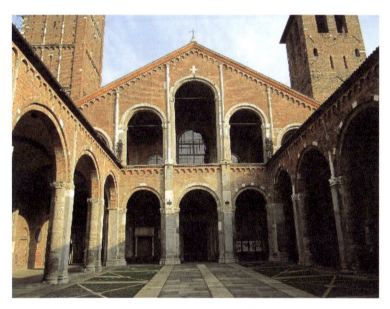

Fig. 8-1-6　S. Ambrogio, courtyard, Milan, Italy

Churches serve as places of worship, eateries, and hostels. Other types of architecture include public buildings, townhouses, **castles**, **manor house**, and farmhouse. The few secular structures that survive are mainly castles, which rarely exhibit Romanesque stylistic characteristics.

Public and Private Buildings

Site Orientation

Churches are usually located along pilgrimage routes or in town centers. In monasteries, the **cloister**, dormitory, **refectory**, and kitchen surround the church, a visual metaphor for its centrality to monastic life.[①] Other structures include guesthouses, schools, libraries, barns, stables, and workshops. Monasteries are walled for protection and privacy.

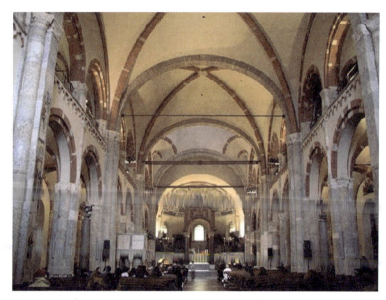

Fig. 8-1-7　S. Ambrogio, interior, Milan, Italy

Floor plans

Many churches follow what is known as the pilgrimage plan in which the side aisles flanking the nave extend around the transept and circular apse. Besides adding needed space, this innovation allows clergy to continue their duties despite the crowds. Plans are based on a module composed of one nave bay. Aisles are half of this unit in width. Modules allow infinite variation in size and configuration. The crossing is square or nearly so and marked by a tower or octagonal dome. Some Italian churches retain the Early Christian colonnaded forecourt or atrium (Fig. 8-1-7) and narthex.

Materials

Churches are primarily of masonry to prevent fires. A few retain wooden ceiling and roofs. Most use local stone because of transportation difficulties. Exteriors often feature several types in contrasting colors. Areas lacking good building stone use brick, such as in the Lombard style in Italy, which features plain brick exteriors. A few churches are of marble.②

Facades

Round arches and delineated architectural elements are key features. Fronts may have three parts, each with a portal that coincides with the interior nave and flanking aisles. Twin towers are common. Buttresses, engaged columns, or **pilasters**, often corresponding to interior units, divide front and sidewalls into bays. Corbel tables, a definitive characteristic, emphasize roof angles, spires, and parapets (Fig. 8-1-8).

Doors and Windows

Rounded doors, windows, and arcades display figural and nonfigural sculptures. Previously, stone sculpture had all but disappeared in Europe, so its revival is an important innovation. Romanesque sculpture relates to the architecture. For example, columns with sculpture form the **jamb** of recessed portals, and reliefs fill the tympanum and cover the archivolts. Sculpture programs range from simple to elaborate. To help educate the parishioners, sculpture programs illustrate biblical stories and history and incorporate Christian symbols. Windows are as large as construction permits. Stained glass emerges late in the period.

Roofs

Timber roofs are usually gabled. Chapels and towers may have conical or pyramidal roofs. The nave and

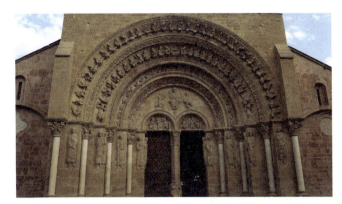

Fig. 8-1-8　Architectural facade of Église Sainte-Foy de Morlaàs, 1080; Morlaàs, France

flanking sometimes have their own roofs.

Later Interpretations

Romanesque influences reappear in the German Rundbogenstil and Romanesque Revival elsewhere during the 19th and early 20th centuries. Characteristic elements are also evident in the work of Henry Hobson Richardson in such examples as Trinity Church in Boston, Massachusetts.

INTERIORS

Church interiors have many of the common Romanesque characteristics: round arches, repeated modules, ribbed vaults, compound piers, triforium, thick walls, and masonry ceilings. Like exteriors, architectural elements create identity, individuality, rhythm, and order, unlike the earlier simple basilica spaces with flat ceilings and walls.③ Romanesque interiors also are quite different from the glittering, otherworldly interiors of Early Christian and Byzantine churches. Like Byzantine, architectural elements delineate individual bays or units, but emphasis is on weight and mass instead of decoration. Sculpture is mostly architectonic-outlining the nave and transverse arches, windows, and moldings, and forming capitals.

Few Romanesque domestic interiors survive intact. Emphasis seems to have been on textile hangings instead of woodwork or furniture. Interiors reflect the importance of ceremony and rank through lavish appointments, textiles, and furniture. Living patterns do not change significantly from the Romanesque to the Gothic period.

Public Buildings

Color

The walls and ceilings of Romanesque churches sometimes are painted to enhance and emphasize their architectonic nature. Treatments vary from simple washes of color to extensive figural and decorative schemes. Colors include yellow ochre, sandstone, gray, or red. Contrasting color, borders, or ornamental patterns highlight architectural elements. Some transverse arches have structural or painted voussoirs in contrasting colors(Fig. 8-1-9). Italian examples often continue the Byzantine traditions of mosaics and colored marble panels.

Floors

Floors are important design elements because there are no pews or seats and few furnishings. Treatments vary from plain stone or brick with simple washes of color to elaborate patterns in tile or marble.

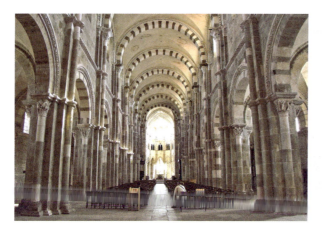
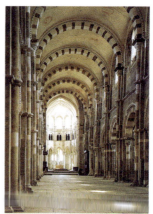

Fig. 8-1-9　Madeleine interior

Walls

Nave walls, which may be two or three stories, have round arches, reminiscent of those used Roman aqueducts, basilicas, and baths. The lowers portion is arcade carried by piers. Above is the triforium, composed of two or more round arches on columns. Clerestory windows, also with round arches, appear only in groin or rib-vaulted naves. Openings reveal wall thickness and emphasize weight. In Britain, Normandy, Germany, and Italy, churches often have passages within their thick upper walls. Largely an articulation device, columns and arches separate these passages from the main space.

Nave Vaults

The earliest nave vault is the barrel vault, which requires thick walls for support. Consequently, there are no **clerestory** windows in this area. A variation is a pointed barrel vault with pointed transverse arches and a nave arcade. Besides allowing greater height, pointed forms permit the addition of a triforium and clerestory windows. Some builders experiment with groin vaults for naves, but do not generally adopt them, except in France. Ribbed vaults are a significant Romanesque innovation. One of the earliest dated instances of their use are the choir vaults and, slightly later, those in the nave at Durham, in England. The combination of pointed arches, ribbed vaults, the triforium, and clerestory windows seen at Durham begins to dematerialize thick Romanesque walls. Gothic innovations will complete this process.④

Piers and Transverse Arches

Complex piers emphasize bays and define church interiors. Piers may by compound, cluster, single spiral, double fluted, plain round, and quadrangular. Capitals, when present, are similar in form to Corinthian capitals but are decorated with animals, figures, and foliage. They also exhibit geometric designs such as the chevron, zigzag, and **guilloche**. A center pier may extend upward and across the nave ceiling to form a transverse arch. Most masonry ceilings have transverse arches, but more often for articulation than support.

Ceilings

When defense is not a concern, ceilings are flat and beamed. When defense or fireproofing is necessary, ceilings are of masonry and vaulted.

Textiles

Few textiles from the period survive but the best is the Bayeux Tapestry (Fig. 8-1-10). It has embroidery of wool on linen that depicts the Norman defeat of the Anglo-Saxons at the battle of Hastings in 1066, which unites England. The **tapestry** celebrates William the Conqueror's victory and the beginning of Norman rule.

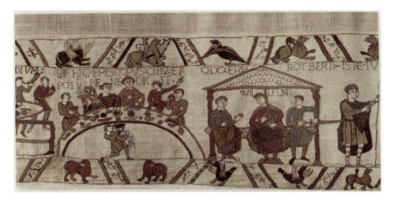

Fig. 8-1-10　Bayeux Tapestry, 1066—1082. embroidered wool on linen

FURNISHINGS AND DECORATIVE ARTS

Church furnishings consist mainly of altars, canopies, and shrines. Accessories, such as silver chalices, are particularly luxurious and elaborate. Simple board construction, which pegs or nails boards together, is characteristic; sophisticated construction methods and decorative techniques, such as **veneer** and **inlay**, are unknown. Turning, carving, and painting in bright colors are the main forms of decoration.

Materials

Local woods, such as oak, walnut, and elm, are used because transportation difficulties prevent obtaining wood from any distance.

Seating

Few chairs are used during the period. Elaborate, massive thrones proclaim the status of the ruler or important cleric. Other chairs are large, heavy, and simpler in design. Stools in various forms provide most seating.

Storage

Chests and ivory caskets with decorative patterns store important materials. Rosettes, animals, and figures may embellish the surface.

Decorative Arts

Illuminated manuscripts, produced in monasteries, have flat spaces, lively lines and patterns, ornamental initials, and bright colors.

DESIGN SPOTLIGHT

Architecture and Interior

The Madeleine basilica church claims to own the body and relics of Mary Magdalene, so it becomes a major destination for pilgrimages. Additionally, the Second and Third Crusades, 1146 and 1190, respectively, begin here. This necessitates a new and larger church, which was begun in 1104. The west front or main facade is originally Romanesque in style, but the Gothic central gable and tower are built in the 13th century. Three portals, corresponding to the nave and aisles, highlight the facade, and round arches dominate the composition. A complicated sculpture program covers the tympanum, the large arch over the central portal, and the narthex

portals and continues in the interiors. Viollet-Ie-Duc adds the Romanesque-style tympanum of the Last Judgment in the narthex portal as part of a significant restoration in 1840. S. Madeleine's plan lacks the traditional transept but has chapels surrounding the apse. The original plan was extended with the addition of a narthex in 1132 to accommodate the large crowds of pilgrims.

Inside, transverse arches with colored voussoirs rhythmically delineate the barrel-vaulted nave, which is one of the oldest parts of the church, and the round-arched nave arcade. Decorative carving accentuates the nave arcade, clerestory windows, stringcourses, and transverse arches. Column capitals depict Bible stories, ancient legends, and mythological creatures. The interior has more light than most Romanesque churches because of its carefully planned placement. Twice a year, at the summer and winter solstices, the nave is flooded with light cascading down to the altar. This masterpiece of Burgundian Romanesque art and architecture becomes a UNESCO world Heritage Site in 1979 (Fig. 8-1-11).

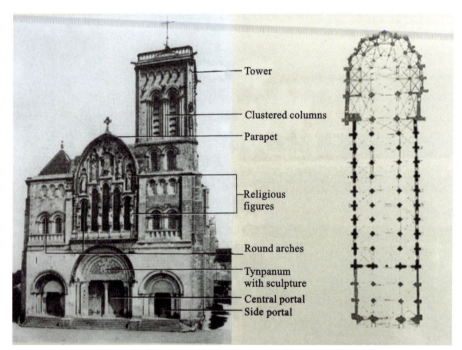

Fig. 8-1-11 S. Madeleine, floor plan and interior, c. 1104—1132 and later 9 (restoration completed in 1859 by Viollet-le-Duc); Vezelay, France

专业词汇

arch ［ɑːtʃ］ 拱门
Romanesque 罗马式
rib vault 扇形肋穹顶
manuscript ［'mænjuskript］ 手稿
feudalism ［'fjuːdəlizəm］ 封建制度
Gothic ［'gɒθik］ 哥特式
evangelism 福音传道
warrior-nobility 武士贵族
medieval ［ˌmediˈiːvl］ 中世纪的
chivalry ［'ʃivəlri］ 骑士制度

guilloche ［giˈlɒʃ］ 联结环、扭索状装饰
portal ［ˈpɔːtl］ 入口、大门
buttress ［ˈbʌtrəs］ 飞扶壁、扶壁柱
pointed arch 肋拱拱顶
inlay ［ˈinlɛi］ 镶嵌、镶嵌物
mediterranean ［ˌmeditəˈreiniən］ 地中海地区
crusades 十字军东征
pilgrimage ［ˈpilgrimidʒ］ 朝圣之旅
grotesque ［grəʊˈtesk］ 奇形怪状的东西、菱形
foliage ［ˈfəʊliidʒ］ 树叶
heraldic device 纹章
lozenge ［ˈlɒzindʒ］ 菱形
fire resistance 防火
delineation ［diˌliniˈeiʃn］ 描绘
triforium ［traiˈfɔːriəm］ 教堂拱门上的三拱式拱廊
monastery ［ˈmɒnəstri］ 修道院
castle ［ˈkɑːsl］ 城堡
manor house 庄园
cloister ［ˈklɔistə(r)］ (修道院,教堂等)回廊
refectory ［riˈfektəri］ (修道院等)食堂
round arches 半圆拱
pilaster ［piˈlæstə(r)］ 壁柱
jamb ［dʒæm］ 侧柱
clerestory ［ˈkliəstɔːri］ 天窗
tapestry ［ˈtæpəstri］ 挂毯
veneer ［vəˈniə(r)］ 饰面、表层饰板

难句翻译

① Churches are usually located along pilgrimage routes or in town centers. In monasteries, the cloister, dormitory, refectory, and kitchen surround the church, a visual metaphor for its centrality to monastic life.

教堂一般建在朝圣途中或城中心。修道院的回廊、宿舍、食堂和厨房都围教堂而建,这也隐喻着教堂在修道生活中的中心地位。

② Exteriors often feature several types in contrasting colors. Areas lacking good building stone use brick, such as in the Lombard style in Italy, which features plain brick exteriors. A few churches are of marble.

外墙一般有几种风格,均使用对比色。有些地区因缺乏优质石材而采用砖砌。比如意大利的伦巴第风格,教堂外墙全部用砖头砌成。少数教堂使用大理石。

③ Church interiors have many of the common Romanesque characteristics: round arches, repeated modules, ribbed vaults, compound piers, triforium, thick walls, and masonry ceilings. Like exteriors, architectural elements create identity, individuality, rhythm, and order, unlike the earlier simple basilica spaces with flat ceilings and walls.

教堂内部装饰有许多典型的罗马式风格特点:圆拱、重复构件、肋架拱顶、组合柱、三拱式拱廊、厚墙与石砌天顶。不同于早期简单的平顶直墙巴西利卡式构造,建筑元素产生与外墙一样能产生身份、个性、节奏与秩序。

④ The combination of pointed arches, ribbed vaults, the triforium, and clerestory windows seen at Durham begins to dematerialize thick Romanesque walls. Gothic innovations will complete this process.

在达拉谟出现的尖拱、肋架拱顶、三拱式拱廊与天窗最早开始消解罗马式的厚墙。哥特式风格的创新进一步完善了这一过程。

Romanesque（罗马式建筑）

罗马式建筑是10—12世纪欧洲基督教地区流行的建筑内格,多见于修道院和教堂。其传统形式依赖于圆形拱门和独立部分的接合来创造一体性设计。得益于神职人员、朝圣者和监工从一个地方到另一个地方的旅行,建筑革新传播得非常快,对后来的哥特式建筑也产生了很大影响。

From

Buie Harwood, Bridget May, Curt Sherman. ＜Architecture and INTERIOR DESIGN: an integrated history to the present＞. New Jersey: Pearson Education, 2012.

8.2 Great Rococo(1715—1760)

Great changes occur in the Western world during the 18th century. At the century's beginning, aristocrats and nobles rule politically, culturally, and socially with little influence from the middle and lower classes. Europe is largely agrarian. By the end of the century, the rising middle class expands its influence, and Europe is beginning to industrialize. Throughout the period, exploration and colonization of new lands continues, and trade increases with the Far East and the Americas. Scientists make advances in **botany**, biology, and the physical sciences. Women occupy positions of influence in several countries, including Madame de Pompadour in France, Maria Theresa in Austria, and Catherine the Great in Russia.

The 18th century is known as the Age of Enlightenment or the Age of Reason. The term refers to trends in thought and ideas advocating the application of reason philosophy and life. Thinkers and writers of the period promote the scientific method, empiricism and disciplined, rational thought over religion and myth.① They believe that reason, judiciously applied, can solve human problems and generate progress. They see themselves emerging from centuries of darkness into a newly enlightened world. Ideas of the Enlightenment come from the writings of John Locke of England. From them, Voltaire and others in France develop new **ideologies** and theories for humankind and society. However, these theories are only marginally accepted until the middle of the 18th century, when the Enlightenment gradually becomes an **international movement**. It greatly influences the French and American Revolutions.

Rococo dominates the first half of the century in the Continent. Originating in France during the late Baroque period, Rococo affects all aspects of interiors and furnishings, but has little effect on architecture. The light, **asymmetrical style** exhibits unity and continuity of parts in its forms and motifs, which flow in an uninterrupted manner. Complex, **curvilinear silhouettes** and organic **ornament** define the visual image.

Attenuated, graceful curves suggest **femininity**. Rococo largely abandons the Classical language in favor of naturalism and themes and motifs alluding love and romance, pastoral or country life, exoticism, pleasure, and gaiety.

Neither England nor her American colonies completely embraces Rococo because of its origins in and association with the French aristocracy. Also the influence of classicism in the Neo-Palladian style of architecture and the somber rationalism of the Restoration style of interiors remains strong in both areas. Rococo influences do begin to appear, shortly after mid-century, mostly in ornament and embellishment in interiors and on furniture and decorative arts. It coexists and commingles with Chinese and Gothic motifs and forms.

Le Régence and Louis XV (Rococo) 1700—1760

Rococo is the style and symbol of the French aristocracy in the first half of the 18th century. The name comes from **rocaille** (small rockeries) and coquille (cockle shell); the latter is a common motif. The French call the style rocaille, goût pittoresque, or style moderne. A reaction to the **stiff** formality of the Baroque, the style is asymmetrical, light in scale, and defined by curvilinear, **naturalistic ornament**. Themes and motifs include romance, country life, the **exotic**, fantasy, and gaiety. The style's finest and most complete expression is in interiors, which display complete unity between decoration and furniture.

As a transition between the massive, rectilinear, classical French Baroque and the smaller, curvilinear, naturalistic Rococo, Le Régence features characteristics of both styles. Like Rococo, Le Régence primarily appears in interiors and furniture and has a minimal effect on architecture.

HISTORICAL AND SOCIAL

When Louis XIV dies in 1715, his grandson, who is next in line, is only five years old. The Duc d'Orleans becomes regent until Louis reaches the age of 13. Louis XIV had left France heavily in debt from various wars and the royal building campaigns, so the Duc d'Orleans attempts to restore financial and social order. Because he lives in Paris rather than at Versailles, the court follows him, making Pairs the artistic, social, and intellectual center of Europe. Louis XV obtains his legal majority and the throne in 1723. However, he fails to halt the political and economic decline begun in the last decades of his grandfather's regime. Unlike his grandfather, Louis XV has little interest in government. Along with his nobles and courtiers, he pursues pleasure and gaiety and is often influenced by his mistresses. His policies at home and abroad are inconsistent. High taxes, wars, loss of the New World colonies, corruption, and mismanagement cripple France and increase dissatisfaction and unrest among the middle and lower classes. In the last years of his reign, Louis attempts some reforms with the help of his ministers, but the new policies are reversed after his death in 1774. France and the monarchy continue their downward slide toward the Revolution.

CONCEPTS

The Rococo of Louis XV, in contrast to the Baroque of Louis XIV, reflects the taste of the nobility, not the king. Upon Louis XIV's death, the aristocracy reacts to the rigidity and formality of court life by seeking comfort and enjoyment. This polished bur hedonistic society devotes itself to pleasure, fantasy, and gaiety, which are reflected in Rococo's forms, themes, and motifs of romance, exoticism, comfort, individuality, and novelty. The tastes of women, especially the king's mistress Madame du Pompadour, dictate fashions, and the feminine shape is reflected in the prevalent curvilinear forms. For the first time since the Renaissance, a style does not model itself on classical antiquity. This will help lead to its demise after mid-century.

MOTIFS

Engaged columns, pilasters, **pediments**, **quoins**, **stringcourses**, **brackets**, and corbels appear sparingly and discretely on exteriors. Interior and furniture motifs (Fig. 8-2-1, Fig. 8-2-2, Fig. 8-2-3) include flowers, bouquets tied with ribbon, baskets of flowers, **garlands**, shells, **Chinoiserie** and singerie designs, romantic landscapes, Italian comedy figures, musical instruments, hunting and fishing symbols, cupids, bows and arrows, torches, shepherds and shepherdesses, Turkish arabesques and figures, pastoral emblems such as shepherd crooks, and an allover trellis pattern with flowers in the center of intersecting lines.②

Fig. 8-2-1　Textile detail with asymmetrical curves and flowers

Fig. 8-2-2　Panel detail with shell motif

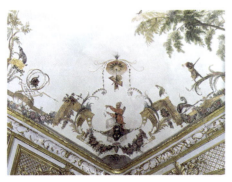 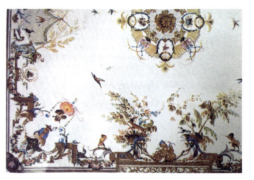

Fig. 8-2-3　Ceiling detail with Chinoiserie and singerie, Chateau de Chantilly, France

ARCHITECTURE

Le Régence and Louis XV architecture continue the classicism of the Baroque era, but with an increased elegance and lightness in scale and appearance. Plain walls with surface decoration concentrated around doors and windows are characteristic. Larger windows reduce wall space and help to integrate outside and inside. Classical elements, such as the orders, are less common but still adorn noble house to demonstrate rank and wealth. Hotels or townhouses built in Paris for the aristocracy are the chief Rococo building type. As in earlier periods, most sit at the rear of large plots of land in the city to create gracious **forecourt** with majestic gates of entry. Architects experiment with courtyard shapes that relate to the site's shape.

Private Building

Floor Plans

Plans are generally symmetrical with rectangular rooms. A few plans have **oval** spaces. As before, designers carefully plan the distribution of rooms to give the appropriate dignity and grandeur required for the nobility while still providing comfort and privacy. As earlier, organization centers on apartments. Each has a variety of spaces within it. Apartments include rooms for ceremonies, such as receiving important guests, and for socializing with friends and private spaces that include bedchambers and ladies' **boudoirs**.

Materials

Most hotels are of local stone and **trabeated construction**.

Facades

Hotels exhibit a scale suitable for the nobility. Facades are symmetrical and horizontal with more continuity and refinement than Baroque building. As before, architects emphasize centers and/or ends (and important interiors) by projecting them forward and with defining architectural elements or pavilions. Articulation and details are subordinate to the whole to create a unified volume. To further achieve unity, facades have less movement and fewer contrasts of light and dark than in the Baroque style. Subtle rustication sometimes highlights lower stories and surrounds openings. Smooth upper stories have larger windows usually separated by plain wall surfaces. Pediments, columns, or rustication accentuate entrances, and stringcourses mark stories. Rectangular or arched windows have simple lintels above them. Curvilinear ironwork may distinguish lower portions of windows. For emphasis, doorways are centerpieces in compositions and surrounded by columns, pediments, coats of arms, and other ornamentation.

Roofs

Mansard, **hipped**, or low-pitched or flat roofs with **balustrades** are typical.

INTERIORS

Interiors and furnishings are the primary expressions of the Le Regence and Louis XV (Rococo) styles. Although associated with the reign of Louis XV, the Rococo style does not confine itself to those years. Attributes of Rococo begin to manifest in the late 17th century in the published designs and ornament of Jean Berain and others and in the early-18th-century rooms at Versailles.

The first three decades of the 18th century are a transitional period between late Baroque and Rococo called Le Regence. During this time Rococo characteristics begin to appear on and modify Baroque forms and details. Le Regence characteristics include a general lightening in size of rooms and scale of finishes and decoration; asymmetry; and the appearance of naturalistic, curvilinear ornamentation.③ During the 1670s and 1680s, rooms become less formal. Wood paneling replaces heavy marble-paneled walls, columns and pilasters

disappear, and cornices diminish in size. Corners and tops of paneling, doors, and windows begin to curve. Naturalistic, **exotic**, or fanciful ornamentation, which is usually asymmetrical, replaces classical.

Rocaille decoration with its asymmetrical profusion of curving tendrils, foliage, flowers combined with shells, and minute details defines the Louis XV interior. Also characteristic are themes and motifs of gaiety, pleasure, romance, youth, and the exotic. In all but the grandest and most formal rooms, classical elements are rare. Most rooms maintain a rectangular form, but curving lines, continuity of parts, and asymmetrical arrangements of naturalistic decorations characterize wall panels and finishes, ceilings, textiles, furniture, and decorative arts. Paneling may be designed to incorporate sofas, consoles, tables, beds, and/or mirrors.

Ornate Rococo interiors contrast with refined, plainer exteriors. Important and ceremonial spaces retain their monumental scale, whereas private rooms become smaller and more intimate. Some spaces are designed for special purposes, such as music rooms, but dinning rooms remain uncommon. The planning and decoration of private spaces reflects a desire for comfort and convenience, whereas state apartments continue to proclaim wealth and rank. To a greater degree than ever before, Rococo achieves a complete synthesis of interior design, furniture, and decorative arts.

Room decoration remains hierarchical as earlier. The more important the space, the larger its size and more lavish its decoration. As the main reception for important persons, the chambre de parade is the most formal and lavish room in the house and least likely to exhibit Rococo characteristics. The room has rich colors, costly materials, the orders, portraits, tapestries, antiques, and formal furniture that demonstrate and reinforce the owner's social position. Similarly, the state bedchamber and its antechamber retain their formal and opulent decor. Social rooms, such as salon, usually feature Rococo themes and less formal decorations.

Private Buildings

Color

During Le Regence, most paneling is painted white with gilded details. By the 1730s, a yellow, blue, or green palette joins white and gold. Single hues and contrasting values of the same hue decorate paneling (Fig. 8-2-4).

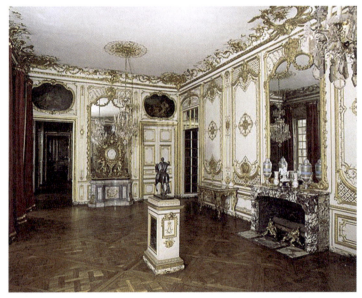

Fig. 8-2-4　Cabinet de la Pendule (Clock Room), Palais de Versailles, mid-18th century

Floors

The most common flooring is wood blocks or **parquet**. Entries, halls, landings, and grand salons may have marble or stone in blocks or squares. Rugs include Orientals, Savonneries, and Aubussons. The latter two are made in Rococo colors and motifs.

Walls

Boiserie with alternating wide and narrow panels is the most common wall treatment. French **boiserie**, in contrast to earlier French Baroque and coeval, English paneling, shows a continuity of wall surface. Panels, moldings, and other architectural elements do not greatly project, giving little interruption in the flatness and smooth articulation of the walls. In contrast to its ornament and moldings paneling remains symmetrical even to the point of a false door to balance a real one, and it retains the tripartite divisions of earlier which implies an order, although no columns are evident. Asymmetrical curves, foliage, and shells soften the corners, bottoms and tops of panels. Decoration, which at times obscures form, extends beyond moldings and borders. Curves may be free form or/on resemble a woman's upper lip; complex compositions feature multiple C, reverse C, and S scrolls. Boiserie may be left natural, painted, or lacquered. Panels and moldings may contrast in color or be two shades of the same hue. Panel centers may have fabrics or colorful painted **arabesques** with or without figures and naturalistic motifs or landscapes.

Tapestries

Tapestries are usually limited to grand rooms, depict Rococo themes in numerous colors and the subtle shadings of paintings. Wallpapers gain favor but are not used in rooms of state. Types include hand-painted Chinese papers, flocked English papers, and patterns imitating textiles. English papers dominate the French market until the late 1750s when war between the two countries halts their importation. Larger and more numerous mirrors with complex curvilinear frames are located on walls, over fireplaces on ceilings, inside fireplaces in summer, and on window shutters.

As the focal point, the fireplace sets proportions for paneling. The mantel shelf is slightly higher than the **dado**. The panel above the fireplace is the same size as larger ones in the room and features a trumeau. The chimneypiece (Fig. 8-2-5) is smaller and projects less than before. The marble mantel itself is curvilinear, and its color may match tabletops in the room. Red is the most desired color, followed by yellow, gary, and **violet**.

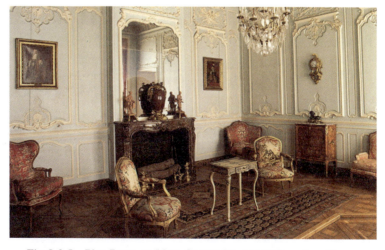

Fig. 8-2-5 Blue Room, at Muse Carnavalet, mid-18th century, France

Windows and Doors

Windows are larger than before and have curving tops. Most have interior shutters that match the paneling. Divided curtain panels and festoons are common in important room. Fabric valances come into general use after 1720. Door panels match those of walls. Above most doors are paintings of pastoral, mythological, or romantic scenes in asymmetrical curvilinear frames. Important rooms have portieres that help prevent drafts and add to the interior opulence.

Ceilings

Coved ceilings, curving corners, and rocaille decoration extending onto the ceiling proper are the most common treatments. Some ceilings are plain with a central plaster rosette.

Textiles

Heavy brocades and **damasks** are no longer in vogue. Silks, linens, **chintzes**, and other printed cottons are used in summer, while plain or patterned **velvets** or damasks replace them in winter. Sets of furniture often have matching tapestry covers. Textile colors are strong and brilliant. (Fig. 8-2-6, Fig. 8-2-7, Fig. 8-2-8) Crimson is most favored, followed by blue, yellow, green, gold, and silver. Patterns, which are frequently asymmetrical, depict Rococo themes and motifs. In 1760, Christophe-Philippe Oberkampf opens a textile factory in Jouy-en-Josas near Verailles that quickly becomes known for its toile de Jouy. These fabrics are frequently used in bedrooms and boudoirs.

Fig. 8-2-6　Flower pattern

Fig. 8-2-7　Toile de Jouy in a transitional style to Louis XVI

Lighting

Large windows, light-colored walls, shiny surfaces, and numerous mirrors, along with ornate lighting fixtures, help to light rooms. Lanterns are more common than the Crystal Chandelier in salons and stair halls. Small and large appliques, flambeau, and candelabra on mantels and tables, and torcheres also provide light.

Fig. 8-2-8　Indian palampore, mid-18th century, France

Elaborate gueridons may hold either a candelabra or large flambeau. To multiply light, candles often are placed in front of mirrors. Fixtures are made of ormolu, porcelain, or silver in asymmetrical, naturalistic shapes. Some have crystal or lead glass drops.

Later Interpretations

Beginning in the 1840s, Rococo Revival interiors repeat the curves and naturalistic ornament of the 18th century Rococo style, primarily in details such as mantels, wallpaper, textiles, and furniture. The goal is to evoke images of the style, not to recreate it. A more accurate rendition of Rococo occurs in the late 19th century as paneling and furnishings copy original scale, curves, and ornament.

Neo-Rococo becomes a fashionable interior style in the early 20th century as critics and designers recommend it in place of heavy Victorian styles. The asymmetry, naturalistic ornament, and sensuous curves of Rococo also influence the fin-de-siecle style, Art Nouveau, of the late 19th and early 20th centuries. Human scale and curvilinear appeal ensure Rococo's continued use today.

FURNISHINGS AND DECORATIVE ARTS

Louis XV or Rococo furniture perfectly suits interiors in size, silhouette, and decoration because of its curves and naturalistic, asymmetrical rocaille decoration. Furnishings exhibit the highest standards of construction and craftsmanship. Matched sets of furniture may include a canapé; several fauteuils, bergeres, and stools; a console or consoles; mirrors; a fire screen; a folding screen; and sometimes a lit. Pursuit of novelty gives rise to multipurpose pieces after 1750. New pieces, such as lounging furniture, that support comfort and convenience are introduced. Gaming pieces, small tables, and ladies' writing furniture are especially fashionable.

When not in use, furniture is arranged around the perimeter of the space as before. Grand rooms are sparsely furnished, but private ones are often cluttered with small pieces of furniture, such as tables and seating. Beds sit in alcoves or behind a balustrade in staterooms.

As in interiors, Le Regence is a transition period in which furniture combines the elements and of Baroque and Rococo. Pieces become smaller in size, less formal, and more curvilinear. Chair backs become lower and begin to curve. Wood frames begin to surround backs and seats. Arms curve, have pads, and are set back from the seat comer. Cabriole legs replace straight ones, and stretchers disappear. Naturalistic, asymmetrical ornament highlights legs and frames. The most characteristic pieces are chairs, tables, and commodes.

Louis XV furniture is characterized by asymmetrical rocaille decoration and an absence of straight lines.

The period's emphasis on comfort results in small pieces and more use of upholstery. Any part that can curve does, including legs, backs, sides, and facades. Curves are slender, graceful, and drawn out. Seating has cabriole legs ending in whorl feet and curvilinear wooden frames around seats and backs. Joints and intersecting points are not articulated in the classical manner. Instead, the parts of the frame flow together, creating the characteristic continuity of parts. Low, upholstered backs and scrolled arms with machetes also are common. Other defining characteristics of the style include ormolu, marquetry, undulating shapes, and ornament and moldings that flow into one another, uninterrupted across facades. Pieces are often colored and decorated for specific rooms.

Private Buildings

Materials

Cabinetmakers use more than 100 types of local and exotic woods to create colorful veneers and marquetry. Mahogany, first imported during Le Regence, comes into vogue after 1760. Makers also incorporate lacquered panels from the Orient into commodes, armoires, and screens. They favor Chinese, Japanese, and Coromandel lacquers, but also develop their own lacquers in colors more suited to interiors. Although furniture sometimes is painted to match the room's colors, white or natural with painted decoration is more common. Caning is very fashionable for seats and backs; cushions add softness and comfort. Finely crafted curvilinear gilded bronze mounts are used for decoration, as hinges or handles, and on corners and points of strain.

Seating

Seating comes in many sizes and forms for maximum comfort. Fauteuils (Fig. 8-2-9) and chaises have either flat or concave upholstered backs. The bergere (Fig. 8-2-10) has a wider seat; a loose cushion; and closed, upholstered arms. The most common form of canapé has a back resembling three fauteuils or bergeres put together. Lounging furniture becomes more important and includes the chaise longue and a duchesse bergere.

Fig. 8-2-9　Sofa by Rococo Style

Fig. 8-2-10　Caned armchair, 18th century

Tables

The many types of tables include game, card, work, and toilet tables. Rooms usually have varieties of ambulantes in many sizes and shapes to fulfill different functions. None is exclusively for eating. The bureau plat may be centered in a room. Consoles, an integral part of room decoration, usually are placed between two

windows or opposite the fireplace. They are exquisitely carved and gilded with marble tops and mirrors in carved and gilded frames hanging above.

Storage

Commodes first appear during Le Regence. During the Louis XV period, they are the most fashionable and lavishly decorated piece of furniture in the room, requiring the greatest skills of cabinetmaker and metalworker. Many have undulating horizontal and vertical shapes that are a challenge to veneer. Some are lacquered; others have porcelain plaques. Their magnificent ormolu or gilded bronze mounts often obscure divisions between drawers.

Beds

The most fashionable beds are the lit à la duchesse a bed with an oblong tester or canopy as long as the bed attached to the wall or posts and the lit d'ange. Both have a low headboard and footboard but no posts. The lit à la polonaise a bed with four iron rods that curve up to supports hangings has four iron rods that curve up to support a dome-shaped canopy. The lit à la francaise a bed that has a headboard and footboard of equal height; the long side sits against the wall and a canopy above supports hangings has a headboard and footboard of equal height; the long side sits against the wall and a canopy above supports hangings above supports hangings.

Decorative Arts

Decorative arts follow the curvilinear, asymmetrical shapes and naturalistic and exotic ornament of Louis XV. Accessories include mirrors, porcelains, andirons, and fire screens. Many rooms have a lacquered, upholstered, or mirrored folding screen with three or four panels. Andre-Charles Boulle introduces the gilt bronze mantel clock about 1700. Mantel clocks with complex curvilinear shapes and ornament often have matching candlesticks. Tall case clocks with extravagant marquetry and ormolu are important pieces in Rococo interiors.

Porcelain

Although the Chinese have made true porcelain for centuries, the first porcelain created by Europeans is soft-paste or artificial porcelain beginning in the 16th century. In the 18th century, the Germans make the first hard-paste or true porcelain, and it dominates European porcelain until the mid-18th century when it is surpassed by French products. For the luxury market, Sevres, (Fig. 8-2-11) the premier French factory, produces table and tea services, trays, bowls and covers, clock cases, vases, potpourri, and candelabra. It creates exquisite biscuit or unglazed figures as part of dinner sets. The Sevres factory uses rich ground colors, such as rose pink, royal blue, and green with painted scenes and flowers and gilding. The factory switches from soft-paste to hard-paste porcelain after 1768.

DESIGN SPORTLIGHT

Interior: The Varengeville Room shows the Rococo emphasis on symmetrical balance in the distribution of architectural elements such as the centered chimneypiece, arches, and double doors. The curvilinear, marble chimneypiece is smaller and projects less than before. The mantel shelf is slightly higher than the dado. The alternating wide and narrow white and gold panels have an abundance of curves and naturalistic embellishment. The door frame also curves, and above is a painting in a frame with small curves. The furniture includes a Rococo bergere, fauteuils, a bureau plat and fire screen. Appliques flank the mirror to enhance the

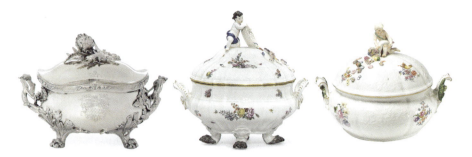

Fig. 8-2-11　Covered tureen mid-18th century, France

parquet de Versailles floor. The room and its furnishings show the graceful, feminine character of Rococo (Fig. 8-2-12).

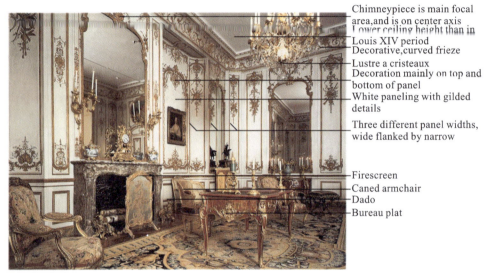

Fig. 8-2-12　Varengeville Room, Hotel de Varengeville, 1736—1752; Paris, France
(Mr. and Mrs. Charles Wrightsman gift, 1963)

DESIGN SPOTLIGHT

Furniture: Scaled down from Louis XIV, pasts of the carving frame of this armchair flow into one and other in typical Rococo fashion. The shield-shaped back is composed of small curves. The cabriole legs have whorl feet. Typical characteristics include the horizontal arms with manchettes resting on curving supports and set back from the edge of the seat, and asymmetrical naturalistic carving on the frame. The Beauvais tapestry upholstery features a subject from La Fontaine's Fables (Fig. 8-2-13).

DESIGN SPOTLIGHT

Furniture: Curving forms and decoration and asymmetrical ornament characterize commodes, one of the most fashionable and elaborate Rococo piece. As is common, this commode has bombe sides and a serpentine front with complex Chinoiserie and extravagant ormolu. The naturalistic, asymmetrical ormolu flows uninterrupted over the two drawers and inconspicuously incorporates the drawer pulls, illustrating the continuity of parts characteristic of Rococo. Typical also are the marble top and cabriole legs. It was common

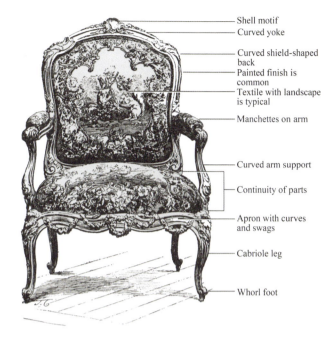

Fig. 8-2-13　Fauteuil

practice in salons to place pairs of commodes with mirrors above them on opposite sides of the room (Fig. 8-2-14).

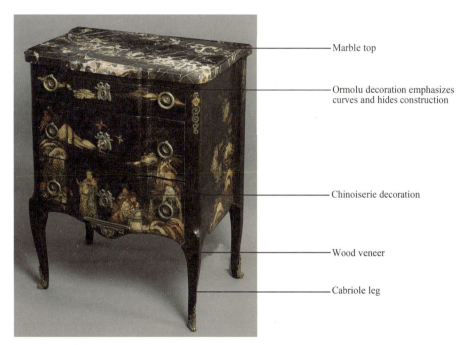

Fig. 8-2-14　A 9th Century Lacquered Commode or Chest of Drawers

专业词汇

botany　['bɒtəni]　植物学

ideology　[ˌaɪdi'ɒlədʒi]　思想意识

asymmetrical style　非对称的风格
silhouette　[ˌsiluˈet]　轮廓
international movement　启蒙运动
attenuated　[əˈtenjueitid]　纤细的
rocaille　[rə(ʊ)ˈkɑi]　似贝壳的装饰物
exoticism　[igˈzɒtisizəm]　异国的,外来的;异国情调的
feminity　[feˈminiti]　女性气质学
fireplace　[ˈfaiəpleis]　壁炉
curvilinear　[ˌkɜːviˈliniə(r)]　曲线的
ornament　[ˈɔːnəmənt]　装饰物
pediment　[ˈpedimənt]　山形墙,三角墙
cabinetmaker　细木工
armoire　[ɑːmˈwɑː(r)]　大型衣柜,橱柜
ormolu　[ˈɔːməluː]　镀金,镀金物
quoin　[kɔin]　楔子
string course　束带层
bracket　[ˈbrækit]　支架
garland　[ˈgɑːlənd]　花环,花冠
chinoiserie　[ʃinˈwɑːzəri]　具中国艺术风格的物品
oval　[ˈəʊvl]　椭圆形
boudoir　[ˈbuːdwɑː(r)]　闺房
mansard　[ˈmænsɑːrd]　双层斜坡屋顶
hipped roof　四坡顶
balustrade　[ˌbæləˈstred]　栏杆,扶手
parquet　[pɑːˈkei]　镶木地板
boiserie　房间墙壁细木护壁板
arabesque　[ˌærəˈbesk]　阿拉伯式花饰,图案
trabeated construction　横梁式结构
dado　[ˈdeidəʊ]　护墙板
violet　[ˈvaiələt]　紫罗兰
damask　[ˈdæməsk]　缎子
chintz　[tʃints]　印花饰布
velvet　[ˈvelvit]　丝绒
tureen　[tjuˈriːn]　盛汤碗

难句翻译

① The 18th century is known as the Age of Enlightenment or the Age of Reason. The term refers to trends in thought and ideas advocating the application of reason philosophy and life. Thinkers and writers of the period promote the scientific method, empiricism and disciplined, rational thought over religion and myth.

18世纪又称启蒙时代或理性时代。这一术语指代崇尚用理性指导生活的思想趋向。这一时代的思想家和

作家推崇科学方法论、实验和有据可循的理性思考,而非宗教或神话。

② Engaged columns, pilasters, pediments, quoins, stringcourses, brackets, and corbels appear sparingly and discretely on exteriors. Interior and furniture motifs (Fig. 8-2-1, Fig. 8-2-2, Fig. 8-2-3) include flowers, bouquets tied with ribbon, baskets of flowers, garlands, shells, Chinoiserie and singerie designs, romantic landscapes, Italian comedy figures, musical instruments, hunting and fishing symbols, cupids, bows and arrows, torches, shepherds and shepherdesses, Turkish arabesques and figures, pastoral emblems such as shepherd crooks, and an allover trellis pattern with flowers in the center of intersecting lines.

外墙上点缀着附墙柱、方壁柱、山形墙、隅石、层拱、托架和枕梁。内装与家具的主题包括鲜花、系缎花束、花篮、花环、贝壳、中式装饰、猴戏图设计、浪漫派风景、意大利喜剧演员、乐器、渔猎符号、丘比特、弓箭、火炬、牧羊人同羊群、土耳其蔓藤花纹同任务,还有田园符号如牧羊杖,更有节点饰有鲜花网状图案。

③ The first three decades of the 18th century are a transitional period between late Baroque and Rococo called Le Regence. During this time Rococo characteristics begin to appear on and modify Baroque forms and details. Le Regence characteristics include a general lightening in size of rooms and scale of finishes and decoration; asymmetry; and the appearance of naturalistic, curvilinear ornamentation.

18 世纪头 30 年是从晚期巴洛克过渡到洛可可的摄政时期。这一时期洛可可风格开始涌现并逐渐修饰了巴洛克式的造型与细节。摄政风格的特点包括房间面积的减少、装饰的增多、不对称性、自然主义以及曲线装饰。

Great Rococo(洛可可建筑风格)

洛可可建筑风格主宰着 20 世纪上半叶的欧洲大陆,它起源于 18 世纪的法国,从巴洛克后期开始盛行。洛可可风格影响着室内装饰和家具设计的各个方面,但对结构的影响不大。不对称的形式和图案在室内的墙面、顶面形成较为统一、连续的视觉效果。复杂的曲线轮廓和有机装饰定义的视觉形象及优美的曲线都体现出女性气质。洛可可风格的主题与图案在很大程度上都暗示着爱情与浪漫、田园或乡村、愉悦和欢乐。洛可可风格后来被新古典主义取代。

From

Buie Harwood, Bridget May, Curt Sherman. ＜Architecture and INTERIOR DESIGN: an integrated history to the present＞. New Jersey: Pearson Education, 2012.

8.3 Islamic Architecture (7th—17th Centuries)

The unique form and decoration of Islamic art and architecture are influenced by **religion**, the design traditions of its various peoples, and the aesthetic sensibilities of its artists and builders. Common to all the arts are dense, flat patterns composed of geometric forms and curving tendrils. This decoration dematerializes forms and creates visual complexity. Unique also to Islam is calligraphy, which is effectively integrated into the decoration of almost all structures and objects.

HISTORICAL AND SOCIAL BACKGROUND

Islam, meaning "to surrender to the will of God," is the third of the great monotheistic Semitic religions following Judaism and Christianity. Established in the 7th century C. E., it derives from the teachings of the prophet Muhammad. A wealthy merchant in Mecca on the Arabian peninsula, he receives revelations from God and begins proclaiming a new faith in one god, Allah. Local citizens strongly oppose him, so Muhammad flees to Medina in 622 C. E. There he establishes the first community of followers who meet in his living compound for teachings and prayer, As converts increase, the prophet becomes a spiritual and political leader. At his death in 632 C. E. Muhammad has become the leader of a large and increasingly powerful Arab state. Subsequently, his followers continue conquests for land in the name of Islam. In just over a century, they extend their territories as far as southern France and North Africa to the west and north, and into northern India to the east.

The new faith unites the peoples of the vast territories. Believers, called Muslims, live according to the Koran (recitation), the sacred book of the prophet's revelations. There are no formal **rituals** or ceremonies, as each believer has individual access to God. Rules for living are simple, and members adhere to five important pillars, which include prayer and fasting. Families are patriarchal, and extended families of two or three generations are common. Islam extends some rights to women, but their freedom varies by time period and geographic location. Some women even become prominent rulers and art patrons. A few become artists and calligraphers.

The **prophet** establishes a new theocratic social order that replaces traditional nomadic tribal government. After his death, **caliphs**, who claim descent from him or his early followers, continue his model of a single ruler, in whose hands are political and spiritual leadership. The first dynasty of caliphs, the Umayyads (ruling 661—750 C. E.) in the Middle East, extend Islam's holdings to India and southern France. Builders during this period synthesize elements from their conquered cultures, resulting in structures that express great power. In Spain, the next dynasty of caliphs, also called Umayyads (ruling 756—1031), are great art patrons. The Abbasid caliphate in the Middle East (ruling 750—1258) also extends Islamic territory and promotes culture, learning, science, and the arts.

After the caliphates disintegrate in the 9th century, the empire fragments into many smaller regions. Iran and surrounding areas become the most important region politically, socially, and artistically. Noteworthy dynasties with distinctive art styles include the Seljuk Turks (ruling mid-11th century—1157), the Timuritds (ruling western Iran 1378—1502), and the Safavids (ruling all of Iran 1502—1736). Between 1299 and 1922, the Ottomans rule Turkey. They expand the empire into Egypt and Syria, are great builders, and conquer **Constantinople** in 1453.

Between the 9th and 13th centuries, Islam expands education and science, and its university system promotes cultural development. Muslim men and women are probably more literate than others during the Middle Ages because of Islam's emphasis on studying the **Koran**.① Scholars excel in mathematics and philosophy and make important discoveries in medicine, the natural sciences, and astronomy. Various rulers or wealthy patrons support their efforts.

CONCEPTS

Islamic art and architecture evolve from and reflect a strong societal emphasis upon religion, which creates consistency in examples across and among the various regions. Forms and ornament express a common

worldview that unites the secular and the religious and art with science and mathematics.② Unity and order symbolize the unity and order of nature and the universe as created by Allah (god). Repetition and repeating themes evident in architecture and decoration, specifically the arabesque, suggest infinity and Allah's infinite power. Bold forms, such as domes and courtyards, convey power and majesty. Emphasis upon the individual's position in society and the family creates separation of both public and private and gendered spaces in cities and public and private buildings. Consequently, much of the beauty of Islamic architecture is not visible from the outside. The lavish decoration of allover surface patterns and **calligraphy** expresses the geometry and precision of nature, science, and mathematics as revealed in the universal principles of Allah's creation and power. Because of the Koran's admonitions against idolatry and the matchlessness of Allah, the human figure never appears in religious art and architecture.

MOTIFS

Common motifs are **meanders**, stars, **swastikas**, **frets**, rosettes, **vines**, scrolls, palm leaves, tendrils, and calligraphy(Fig. 8-3-1).

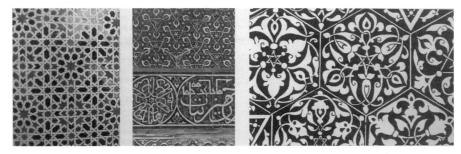

Fig. 8-3-1 Motifs: Tiles from Spain, Turkey, and Persia

ARCHITECTURE

Islamic architecture is consistent in form, construction, and decoration throughout its empire and across its cultures. Because **nomads** lack an architectural tradition, early builders assimilate construction techniques and ornamentation from their conquered peoples in **Byzantium**, Greece, Egypt, and the Middle East. This aids them in creating their own distinctive building types and unique forms that arise from their culture's strong emphasis on religion and climactic needs for heat and shade from the relentless desert sun. Despite differing regional resources and climates, this new architectural image is universally identifiable as Islamic.

The most common building types are those associated with religion or protection, such as **mosques**, madrasahs, **mausoleums**, and **forts**. Rulers and the wealthy build large urban and desert palace complexes (called alcazars in Spain) and townhouses.③ Often fortified, they are walled for seclusion as well as protection. Both palaces and larger dwellings have one or more interior courtyards with more rooms and courtyards added as needed. These major structures contribute forms to lesser ones such as public baths and smaller **dwellings**.

The architectural response to the Koran's emphasis upon **hierarchy** of individuals within society translates into clear distinctions between public and private sectors in cities and buildings.

Streets and commercial areas are public, while private houses focus inward behind plain walls. Guests, male friends, and business associates are received and entertained in public selamlik or Men's area. The haremlik or women's areas are private and secluded, and house women, children, and servants. Plans clearly separate these two areas. Similarly, building complexes are centrally organized, but often incorporate a random arrangement of separate spaces linked together. Rulers and the wealthy live splendid, luxurious lives. Others live as comfortably as their finances permit.

Distinguishing characteristics of Islamic architecture include order, repetition, radiating structures, and dense patterns covering many, if not most, surfaces. Common architectural elements are columns, piers, unique arches (Fig. 8-3-2), and interwoven and repeating sequences of niches and small columns. Arch forms, such as the horseshoe or multilobed arch, also are unique to Islamic buildings. Domes in various shapes also are characteristic.

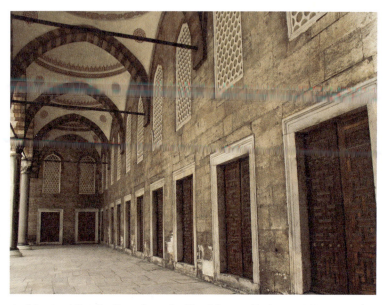

Fig. 8-3-2　Architectural Details: Door from the Blue Mosque, Turkey and horseshoe (Moorish) arch

All over surface patterns and visual complexity distinguish Islamic art and architecture, giving it a unique character that is remarkably consistent among the arts and across regions. Decoration consists of dense, flat repeating patterns that are independent of structure and/or specific architectural features. Patterns cover exteriors and interiors from foundations to roofs, creating visual complexity and dematerializing form. Unity and variety within a geometric grid are common. Although there is uniformity, each element is distinguished according to its importance. There is no focal Point, but infinite unity and variety exist in this intricate decorative system, known as arabesque, which can expand in size, direction, or form, as need demands. Patterns are generally nonfigural and derive from geometric and stylized naturalistic forms and calligraphy.

Calligraphy (Fig. 8-3-3) forms an important pattern on objects, architecture, and illuminated manuscripts. Because the Koran is in Arabic, copying this venerated book becomes a holy task.④ Designers exploit the decorative nature of Arabic script by beautifully integrating sayings from the Koran into architecture, interiors, and objects in borders, **cartouches**, and **medallions**. Islamic calligraphy assumes many styles including the early Kufic (vertical script) and Muhaqqaq (horizontal script). Manuscript illumination also is a highly developed art form practiced by both men and women.

Structural Features

Arches

Characteristic arches include the horseshoe, pointed or ogival, and scalloped or multilobed arches. These forms develop from a desire for visual complexity instead of structural innovation. Islam's pointed arches do not cover spaces of different heights, nor are they part of a structural system as in Gothic design. Surface

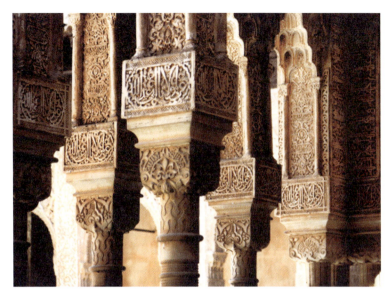

Fig. 8-3-3 Calligraphy forms in architecture

decoration on arches is common. Elaborate **stuccowork**, tile work, or mosaics cover exterior and interior arches. Voussoirs may be in alternating colors.

Domes

Domes cover prayer halls and other spaces. Squinches carry Islamic domes instead of the pendentives used in **Byzantine architecture**. On the exterior, domes may be **melon shaped** or **ogival**, giving rise to the Western name onion dome. Inside, domes may be round, **octagonal**, multilobed, or star shaped and have complex, nonstructural bracketing. Some feature **muqarnas**, which become more complex in form. Made of stucco, they resemble stalactites in caves. Muqarnas may also cover arches(Fig. 8-3-4).

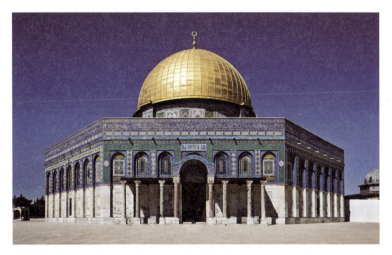

Fig. 8-3-4 Dome of the Rock, begun in 688CE; Jerusalem, Israel; built on the spot where the prophet is believed to have been carried to heaven

Public and Private Buildings

Mosque

Mosques are the first buildings of Islam, and the earliest are fairly simple. As Islam grows in faith and

power, so the mosque evolves into a large and elaborately decorated structure that befits the faith. As the most important building, the mosque serves as a gathering place for prayer, a school, and a town hall. Its unique form, which is consistent throughout time and place, responds to the new faith that requires space for prayer but has neither formal ceremonies nor a priesthood.⑤ Forms and spaces develop from the open-air courtyard of the prophet's house as well as cultural requirements. Following the conquest of syria in the late 7th century C. E., Muslims adapt the aisled spaces of basilica churches into mosques.

Madrasahs

These theological colleges or schools of religion are usually attached to the mosque. Four vaulted halls surround a center courtyard. The qibla side hall is the largest. Apartments, schoolrooms, and other spaces surround the halls. Exterior decoration, unlike that on other public buildings, only surrounds openings and marks the roofline.

Mausoleum

As memorials to holy men or rulers, mausoleums are centrally planned and domed. The most famous is the Taj Mahal(Fig. 8-3-5), built by a Muslim Indian ruler as a memorial to his wife. It features lacy marble walls, large portals, minarets, domes, and elaborate decoration.

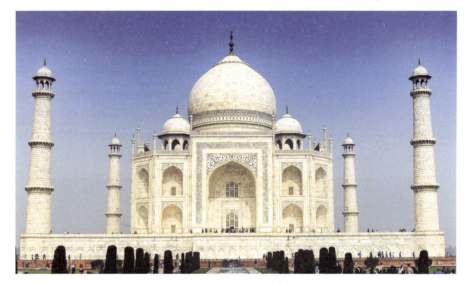

Fig. 8-3-5　Mausoleum of the Taj Mahal, 1630—1653; Agra, India

Site Orientation

Religious structures are strategically located on hills, near ruler's palaces, or at the intersections of main roads. Forts and palaces may be sited on high promontory points or in defendable areas. In cities, residential districts are separate from public and commercial areas. Wealthy areas have wide streets with parks and squares. Poorer districts have narrow, winding streets.

Floor Plans

Three plans characterize mosques throughout the empire for centuries. The earliest consists of a courtyard and **hypostyle** hall. The four-iwan mosque plan, similar to that of religious schools, has four barrel-vaulted spaces facing a central courtyard. Later mosques are centrally planned with domes. All plans are axial, oriented toward Mecca, and have similar components that include large open prayer halls, spaces for ablution or washing, at least one courtyard, and an entry. Additional spaces may include kitchens where meals are

prepared for the poor, libraries, and hospitals.

When praying, Muslims face the **qibla** (prayer wall), which looks toward Mecca. Centered in the qibla is the **mihrab** or **niche** (Fig. 8-3-6). A dome on the exterior often signals the interior mihrab. Nearby is the minbar, a pulpit in which the imam (leader) declares the khutba (sermon and affirmation of allegiance by the community). It may have a maqsurea (screen or enclosure) for protection. A screen may separate males from females in the prayer hall, or women may have their own prayer hall.

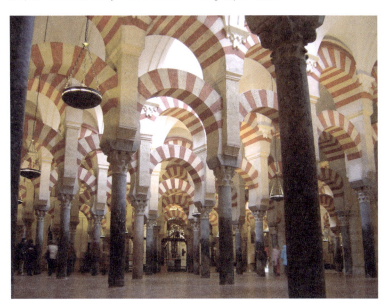

Fig. 8-3-6　Great Mosque, begun in 785

Palaces and houses consist of groups of rectangular rooms interconnected around courtyards and gardens. An arcaded loggia surrounding the courtyard provides a transition and filters light from the sunny exterior to the darker interior. Entrances generally open into important public spaces, such as reception hall, which are always located in men's quarters. The main reception hall(s) or iwan is located on the north (summer) or south (winter) side of the main courtyard and may have its own fountain. Enclosed on the three sides, it is the most elaborately decorated room in the house and has the finest furnishings to convey the wealth and status of the household. Men's areas are separated from women's by location. Each has its own reception room(s) surrounded by sleeping rooms and storage places. Most dwellings have many guestrooms due to the Middle Eastern emphasis on hospitality. Upper floors mat have balconies overlooking the garden. Ancillary spaces may include baths similar to those of the Romans, offices, and mosques. Kitchens and other service areas are separate from the main rooms.

Materials

Materials include brick, local stone, marble, stucco, glazed tile, wood, and metals for roofs, grilles, and tie-rods. Most domestic structures, even palaces, are of wood on stone or brick foundations because they were expected to last only as long as the ruler lived. Tiles, **mosaics**, marbles, and paint give much color, an important design element. Typical tile colors are blue, red, green, and gold. Tile shapes include stars and rectangles. A Muslim innovation is luster, a shiny glaze resembling metal that is used on tiles and objects.

Facades

Mosques usually have a large entrance portal, one or more minarets to call the people to prayer, an arcaded portico, and an imposing dome. Elaborate surface decoration with Islamic motifs is characteristic.

Although not apparent on the facade, the interior courtyard has arcades that are lavishly embellished and carried on piers or columns, plants and flowers, and often a **fountain**.

Both palaces and houses focus inward for protection and privacy. Facades are plain with little architectural detailing except at the main portal and rooflines. Townhouses have two or three stories that may project over each other. Carved beams that support the projecting floors may be the only embellishment. Like palaces, private homes have plain facades that conceal the luxury within. Like those in mosques, interior courtyards are lavishly decorated with elaborate stuccowork on arches and surrounds. Vertical surfaces have arabesques and calligraphy and colorful tile dadoes. Courtyards also have lush gardens in geometric patterns with fountains and water channels prominent as a type of Muslim paradise.

Windows and Doors

Windows vary in size and placement, depending on the function of the interior space, on both public and private buildings. They may be rectangular or have distinctive arched shapes. Many have tile surrounds with iron or wood grilles and shutters for privacy. Mosque windows, usually placed high in the wall, may have decorative wood, stone, or stucco grilles and/or colored glass.⑥ Similarly, windows on palaces and dwellings are small and situated high in the wall. Wooden doors exhibit paneling or marquetry in many colors, and inlay of silver, ivory, and other materials.

Roofs

Roofs are flat or vaulted and of masonry, wood, metal, or rusticated Mediterranean. Domes and the pinnacles of minarets are sometimes of lead. Clay tile roofs are common on domestic structures.

Later Interpretations

Westerners do not generally copy Islamic building types because the structures are unsuitable for Western lifestyles and expensive to build and decorate. Individual elements, such as arches or domes, appear beginning in the 18th century and continuing into the 21st century. Building types are limited to those with some association with exoticism, such as some fraternal organizations. A notable example in the 19th century is the Royal Pavilion at Brighton in England (Fig. 8-3-7).

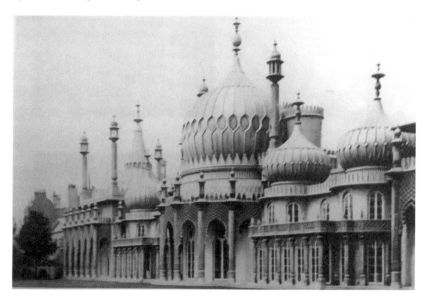

Fig. 8-3-7　Later Interpretation: Royal Pavilion, 1815—1821; Brighton, England; Henry Holland, remodeled by John Nash. English Regency

INTERIORS

As with exteriors, most public and private interiors exhibit complex surface patterns and color on floors, walls, and ceilings and arched (Fig. 8-3-8), vaulted, or domed spaces. The complex, abstract patterns remind Muslims of **infinity** and the divine presence whose creation features eternal patterns. Although lavishly decorated, mosque interiors, intended for prayer and contemplation, neither awe nor exalt in the same manner as western churches.⑦

In homes, the decoration of walls, floors, and ceilings conveys the owner's status. Water and light are important design elements. Room use is flexible, several activities may occur within a space. For example, the multifunctional reception room serves as a dining, entertaining, and at times a sleeping space. Public and private, male and female spaces are clearly distinguished through separation. Limited furnishings are typical in both mosques and houses.

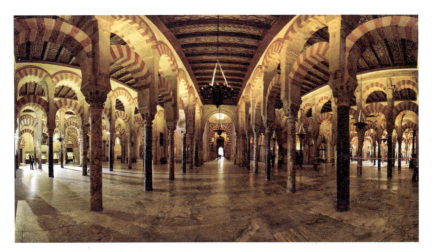

Fig. 8-3-8　Interior and floor plan, Great Mosque, begun in 785, Cordoba, Spain

Public and Private Buildings

Color

The interior palette mainly derives from decorative tiles, stucco, painting, and rugs. Typical colors include rich tones of red, blue, green, gold, black, and cream (Fig. 8-3-9).

Floor

Floors feature tile or mosaic patterns, often with borders, medallions, and geometric forms. Iwans and other important spaces often have more than one level. For example, the tazar or main reception area in the iwan is a step or two higher than the entry. Rugs usually cover floors (Fig. 8-3-10).

Rugs

Originally made by nomadic tribes for many utilitarian purposes, rugs (Fig. 8-3-11). Evolve into a high art form. At one time made in imperial factories, rugs are given by rulers as gifts, for recognition, or as political favors. In the 19th century, rugs begin to be woven specifically for Western markets. Rugs exhibit the same decorative system, colors, and visual complexity as other ornaments. Handmade rugs with a knotted pile are known as Oriental, Turkish, or Persian.

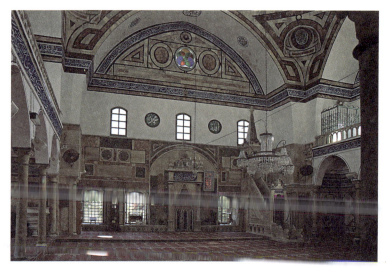

Fig. 8-3-9　Interior, Jezzar Pasha Mosque, 1781—1782; Acre, Isral

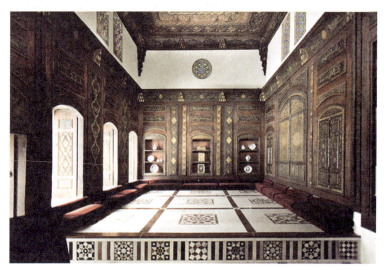

Fig. 8-3-10　The Damascus (Nur ol-Din) Room, 1707; Damascus, Syria

Fig. 8-3-11　Rugs: Ghiordes and Senna carpet knots, and Persian rugs, 17th—19th centuries

Rug Construction and Decoration

Oriental rugs have piles of wool, silk, and occasionally, cotton. The warp and weft are usually cotton Yarns originally are colored with natural dyes, but later synthetics are used. The pile consists of numerous

Turkish (**ghiordes**) or Persian (**senna**) knots (Fig. 8-3-8) tied around two warps. The Persian knot yields a finer pile and more defined pattern. The finer the rug, the more knots per square inch Rugs have major and minor borders and central fields with geometric or curving patterns (Fig. 8-3-12). Colors are rich and **vibrant. green** and yellow are rare. Patterns consist of repeated motifs, such as **gulls** or **cluster of leaves**, all-over patterns such as garden or hunting designs, prayer patterns, and center medallions. The and Persian rugs, 17th-19th centuries. modem paisley motif comes from the pinecone.

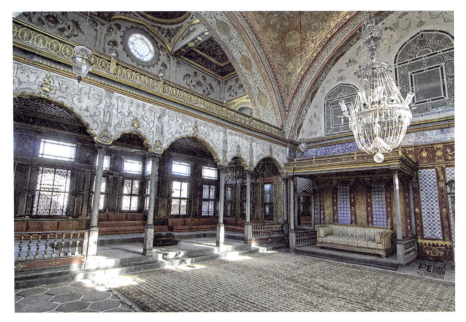

Fig. 8-3-12　Interiors (above and right) of the harem, Topkapi Palace, started 1454; Istanbul, Turkey

Walls

Walls are decorated with marble, tile, stuccowork, wood, yeseria, painting, and calligraphy (Fig. 8-3-10). Decoration may be in bands or panels. Often tile dadoes are at least four feet high. Poems or inscriptions in calligraphy invite closer study are remind of the divine presence. Cupboards and niches display prized objects. Small arches high on the wall filter air and light from one space to another.

Doors

Dark wood doors, either plain or with geometric paneling or carving, are typical. They have iron hinges and door handles. Some are accented with decorative nailheads. Tiled lunettes often embellish the area over the door.

Ceilings

Ceilings may consist of domes, vaults, or beams and are highly decorated. Some are decoratively pained or tiled. In Spain, the artesonades ceiling is a distinctive architectural detail. A honeycomb or stalactite dome may cover important reception halls.

Textiles

The use of numerous textiles adds to the feeling of luxury and comfort. Rugs, hangings, curtains are at doors or between columns, covers, or cushions are both functional and décorative, adding richness, warmth, pattern, and color. Patterns of textiles, ceramics, and applied decoration on walls, floors, and ceilings are similar to architectural ones. Types include plain and embellished silks, damasks, velvets, and printed cottons in highly saturated colors.

FURNISHINGS AND DECORATIVE ARTS

Because of the nomadic heritage of the Arabs, most Islamic interiors have litter movable furniture. Dining sets, beds, sideboards, and the like, are not used until European influences appear in the 19th century. Area rugs cover floors and, along with pillows, provide general seating areas. Coffers (chests) serve as storage. Important personages sit under canopies. Only rugs, basins for ablutions, Koran stands, and lamps appear in mosques.

Public and Private Buildings

Seating

Large cushions or rugs provide general seating. A divan outlines the perimeters of walls of important rooms; its name derives from the name of the privy council of the Ottoman Empire. Seats often vary in height, and the tallest is reserved for the most important guest. Movable seating, such as chairs and stools, is rare in households.

Tables

Small movable tables of wood inlaid with ivory and ebony are noteworthy for their hexagonal shape and overall decorative treatments. The Koran stand (Fig. 8-3-13), which holds the holy document, is important and typically very elaborate.

Fig. 8-3-13　Koran stand made of inlaid and pierced wood

Decorative Arts

Decorative arts consist of glassware, metalwork, ceramics (Fig. 8-3-14), and ivories. All have the same motifs and decorative systems of the architecture and interior.

DESIGN SPOTLIGHT

Architecture

Originally in hypostyle form, the Masjid-i-Shah Mosque was remodeled in the 17th century into a four-iwan plan. Minarets flank the impressive recessed entrance. Plain and decorated colored tiles cover the walls. The two domes accentuate the vestibule and prayer hall. Colored tiles cover the larger, bulging dome of the prayer hall. The curving tendrils enhance the shape without obscuring it. Pierced and solid patterns

dematerialize its form(Fig. 8-3-15).

Fig. 8-3-14　Decorative Arts:Plate and vase with floral and Islamic motifs

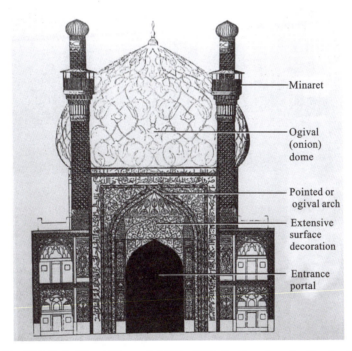

Fig. 8-3-15　Masjid-i-Shah (Great Mosque),1612—1638;Ispahan,Iran;by Maydan Naqshi-i-Jahan

DESIGN SPOTLIGHT

Architecture and Interiors

Once the fortress complex and later palace of Muslim rulers in Granada, the Alhambra (meaning red fortress) is the best surviving Moorish structure in Spain and features some of Islam's best stuccowork. As is common for Islamic buildings, the plain, austere, unembellished exterior gives no hint of the lavish courtyards and interiors inside. Proportioned according to the Golden Mean, the Court of the Lions (Fig. 8-3-16) has slender single, double, and triple columns of white marble with richly carved capitals. They carry multilobed arches covered with colored stucco decorations that obscure and deny the stonework beneath them. Pavilions

projecting into the courtyard at each end have elaborately decorated walls and domed roofs. Yeseria, common in Spain, enhances the organic, lacy image on the gallery walls. Colored tiles pave the square and in the center is the fountain with twelve carved lions supporting an alabaster basin, which gives the courtyard its name.

Similarly, the interiors boast elaborate decoration with brightly colored tile work on walls and floors, artesonades ceilings, and horseshoe arches. The Iwan or Reception Hall has the common design features of elaborate tile and yeseria, horseshoe arches, a honeycomb or stalactite dome, small arches in the upper wall, tiled floors, and a fountain.⑧ The color palette has rich tones of red, blue, green, gold, black, and cream. [World Heritage Site](Fig. 8-3-16, Fig. 8-3-17 and Fig. 8-3-18).

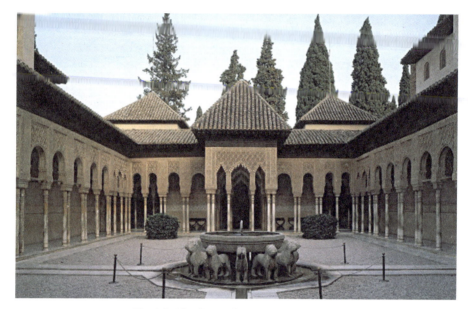

Fig. 8-3-16 Court of the Lions Courtyard

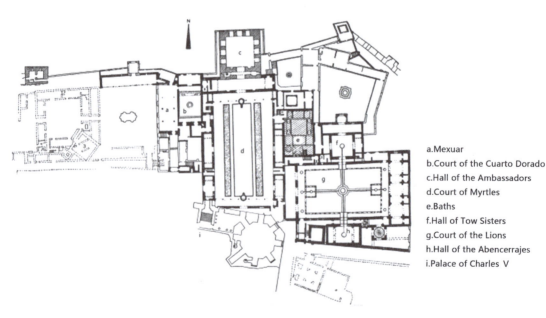

a. Mexuar
b. Court of the Cuarto Dorado
c. Hall of the Ambassadors
d. Court of Myrtles
e. Baths
f. Hall of Tow Sisters
g. Court of the Lions
h. Hall of the Abencerrajes
i. Palace of Charles V

Fig. 8-3-17 Court of the Lions Floor plan

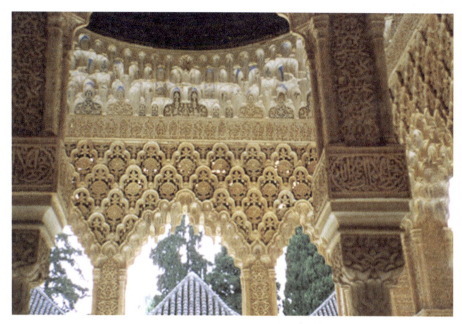

Fig. 8-3-18　Wall decoration and Iwan or Reception Hall at the Alhambra, 1338—1390 and later; Granada, Spain

DESIGN SPOTLIGHT

Interior

Part of a complex of rooms, this iwon or main reception hall is the most elaborately decorated room in the Alcazar, as suits its purpose. An rectangular panel and molding frames the triple horseshoe arches supported by pink marble color. Above is a balcony with gilded metal balustrade. Gilded muqarnas accent the dome. Geometric and curvilinear stucco decoration and colored tiles create complex surface patterns and visual complexity on the walls. Red tiles with small patterned accents cover the floor. Cross-axial circulation supports movement to secondary spaces and to the adjacent courtyard. Originally the space would have had the finest furnishings, such as divans, ottomans, hexagonal tables, and Persian and Turkish rugs in rich colors, to convey wealth and status. [World Heritage Site](Fig. 8-3-19).

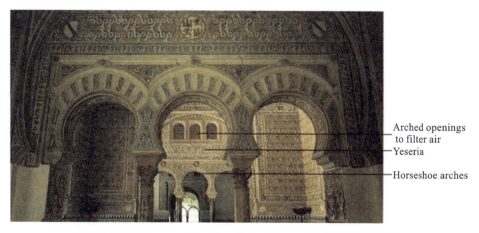

Fig. 8-3-19　Iwan or Reception Hall, Alcoazar, 1364; Seville, Spain

专业词汇

religion　[riˈlidʒən]　宗教
ritual　[ˈritʃuəl]　宗教仪式
Constantinople　[ˌkɒnstæntəˈnəupəl]　君士坦丁堡
calligraphy　[kəˈligrəfi]　书法
nomad　[ˈnəumæd]　游牧民
Byzantium　[biˈzæntiəm]　拜占庭
mosque　[mɒsk]　清真寺
mausoleum　[ˌmɔːsəˈliːəm]　陵墓
fort　[fɔːt]　堡垒,要塞
dwelling　[ˈdweliŋ]　居民,住处
stuccowork　泥灰工,拉毛粉饰
muqarnas　壁龛
medallion　[məˈdæliən]　圆形浮雕
cushion　[ˈkuʃn]　垫子
ceramic　[səˈræmik]　陶瓷,陶瓷制品
cupola　[ˈkjuːpələ]　圆屋顶
hypostyle　[ˈhaipəuˌstail]　多柱式建筑
mosaic　马赛克
fountain　[ˈfauntən]　喷泉
melon shape　瓜形
Byzantine architecture　拜占庭建筑
octagonal　[ɒkˈtægənl]　六边形
gull　[gʌl]　海鸥
vibrant green　绿油油
prophet　[ˈprɒfit]　语言家,先知
Caliph　[ˈkeilif]　哈里发(伊斯兰领袖的称号)
Koran　《古兰经》
qibla　[ˈkiblə]　朝向风

难句翻译

① Between the 9th and 13th centuries, Islam expands education and science, and its university system promotes cultural development. Muslim men and women are probably more literate than others during the Middle Ages because of Islam's emphasis on studying the Koran.

9世纪与13世纪间伊斯兰世界对外发展了教育、科学、大学体系并鼓励文化的发展。中世纪的穆斯林男女很有可能比其他人更有文化因为伊斯兰民族重视对《古兰经》的研习。

② Islamic art and architecture evolve from and reflect a strong societal emphasis upon religion, which creates consistency in examples across and among the various regions. Forms and ornament express a common worldview that unites the secular and the religious and art with science and mathematics.

伊斯兰艺术与建筑不断发展其造型并反映出宗教方面的强烈社会性。这种特点在不同地区的样本中均有

体现。造型与装饰表达了一个共同的世界观,即通过科学与数学将世俗、宗教与艺术统一起来。

③ The most common building types are those associated with religion or protection, such as mosques, madrasahs, mausoleums, and forts. Rulers and the wealthy build large urban and desert palace complexes (called alcazars in Spain) and townhouses.

最常见的建筑风格存在于宗教与安保建筑中,如清真寺、学校、陵墓与要塞。统治者与富人在城市里和沙漠中建造巨型宫殿群,在西班牙这些宫殿被称为城堡。

④ Calligraphy (Fig. 8-3-3) forms an important pattern on objects, architecture, and illuminated manuscripts. Because the Koran is in Arabic, copying this venerated book becomes a holy task.

书法形式作为一种重要的图案在日用品、建筑及手工绘本中出现。由于《古兰经》由阿拉伯语书写,传抄这部经书成了一份神圣的工作。

⑤ As the most important building, the mosque serves as a gathering place for prayer, a school, and a town hall. Its unique form, which is consistent throughout time and place, responds to the new faith that requires space for prayer but has neither formal ceremonies nor a priesthood.

清真寺是最重要的建筑,集祈祷所、学校和市政厅于一身。它造型独特,因时代地区而异。清真寺应新信仰需要提供祈祷的场所但从不举办正式祭典或设立神职。

⑥ Mosque windows, usually placed high in the wall, may have decorative wood, stone, or stucco grilles and/or colored glass.

清真寺的窗户常常开在墙壁高处。有时装饰着木材、石材或粉饰窗栅和彩色玻璃。

⑦ The complex, abstract patterns remind Muslims of infinity and the divine presence whose creation features eternal patterns. Although lavishly decorated, mosque interiors, intended for prayer and contemplation, neither awe nor exalt in the same manner as western churches.

这种复杂抽象的图案提醒着穆斯林信徒永恒与神性的存在,因为神依据永恒的图案造物。虽然装饰丰富,但清真寺的内部装潢为祈祷和冥想而服务,这与意图唤起敬畏与崇高感的西方教堂不同。

⑧ Similarly, the interiors boast elaborate decoration with brightly colored tile work on walls and floors, artesonades ceilings, and horseshoe arches. The Iwan or Reception Hall has the common design features of elaborate tile and yeseria, horseshoe arches, a honeycomb or stalactite dome, small arches in the upper wall, tiled floors, and a fountain.

内部装饰同样精细,墙上、地上、天花板和马蹄形拱门都用颜色鲜艳的瓷砖装饰。伊万或接待厅采用典型伊斯兰设计如精密瓷砖工艺、石膏镂雕、马蹄形拱门、蜂巢状穹顶或钟乳石穹顶、墙壁上部的小拱门、瓷砖地面和喷泉。

Islamic Architecture(伊斯兰建筑)

伊斯兰建筑的独特装饰形式受到宗教的影响,各种民族传统和审美情感在建筑装饰图形中表达出来,常见的建筑装饰都是紧致平整的几何形状和弯曲的植物形卷须,这种非物质化的装饰形式创造了视觉的复杂性。同时,书法对伊斯兰建筑的影响也是独特的,它几乎影响了所有的建筑装饰结构。伊斯兰建筑的显著特征还包括秩序、重复和密集的模式,常见的建筑元素如柱、桥墩、拱都很独特,壁龛和小柱的交织,拱的形式,也都是唯一的造型。各具特色的建筑穹顶形成了伊斯兰建筑独特的艺术风格,其形态在清真寺、陵墓、宫殿、要塞、学校等建筑上均有体现。

From

Buie Harwood, Bridget May, Curt Sherman. ＜Architecture and INTERIOR DESIGN: an integrated history to the present＞. New Jersey: Pearson Education, 2012.

8.4 Japanese Architecture

Influenced by China and evolving largely in isolation, Japan is a 2000-year-old civilization that **epitomizes** the concepts of **aesthetic** beauty, **simplicity**, **modularity**, and attention to detail. Various religions shape activities of daily life and establish rituals that define design character, which also emphasizes relationships to nature. Within the confines of a strict society governed by hierarchy and tradition and ruled by emperors and warlords, the culture nourishes artists, designers, and scholars. Trade with Asian countries and later with the west provides numerous venues for the receipt and distribution of design influences. Elements of Japanese architecture, interiors, furnishings, and decorative arts, like those of China, are widely imitated in western countries after the establishment of trade routes in the 17th century and continuing through the 18th, 19th, 20th, and early 21st centuries.

HISTORICAL AND SOCIAL BACKGROUND

From prehistoric times, Japanese cultural and building traditions evolve largely independent of outside influence. However, in 552 C. E., with the introduction of **Buddhism** from China via Korea, a cultural transformation occurs. From China, the Japanese incorporate a centralized government, a form of writing, and Buddhism, which is the national religion by the end of the period. During the next century, Buddhism expands and peacefully **coexists** with the native Japanese religion, **Shinto**. During the 7th and 8th centuries, Chinese and Korean artists immigrate to Japan and bring with them Chinese concepts of art, city planning, and court protocol.

In the capital of Kyoto, throughout the 9th century, wealthy families surrounding the imperial court form a highly refined court culture in which good taste, manners, and carefully controlled emotions are supremely important. Art, architecture, poetry, and prose become more nationalistic as artists and writers choose and assimilate those Chinese influences that best suit their own culture. Feudalism develops around large estates of the daimyo (lord) who controls his domain with the help of his samurai① (warriors).

Throughout the ensuing Kamakura period (1185—1392), shoguns (military dictators) from powerful families rule, maintaining political and military authority. **Feudalism** increases in strength, and individual ownership of land disappears. Restored contacts with China bring new architectural styles, tea drinking, and **Zen** Buddhist sect. Warriors find its emphasis on self-reliance, simplicity, and attaining enlightenment through everyday activities, such as archery or the tea ceremony. Eventually, Zen concepts affect all aspects of Japanese life including the arts.

In the Muromachi period (1392—1568), Chinese influence brings another cultural Renaissance as court nobles again become great art patrons. Traders from Spain and Holland as well as Christian missionaries arrive. In the mid-16th century, the Japanese begin exporting goods to the West, and a period of economic growth ensues. The cha-no-yu (formal tea ceremony) becomes a social institution. Its equalizing rituals unite host and guest in the common pleasure of conversations about everyday things, and it takes place in a specially

designed tea house. The tea house's characteristic **simplicity**, textural contrasts, and integration with nature affect the design of **dwellings**. ②

From 1568 to 1603, civil wars devastate the country in part because the court is more interested in art and the Zen philosophy than in government. In 1603, peace comes, but at the cost of an increasingly repressive government and isolation from the world. Neo-Confucianism, which demands loyalty to the State, begins to replace Zen Buddhism as the state religion. The Edo period (1603—1868) is a golden era for the arts, and the middle class gains affluence. However, in 1635, the government fears that the influx of European traders and numerous Japanese converts to Christianity may precipitate an invasion. This leads to a prohibition of travel aboard and expulsion of many foreigners.

Throughout the 18th century, the powerful merchant class, continued peasant unrest, and an increasing awareness of the Western world contribute to the demise of feudalism in 1871. In the early 19th century, more and more traders and explorers visit Japan. In 1854, after a show of force, U. S. Commodore Matthew Perry signs a treaty that permits trade between the United States and Japan, and Japan establishes trade relations and embassies in various European cities. New policies modeled after Western countries encourage industry and trade.

CONCEPTS

Through periods of isolation and contact, the Japanese acquire and assimilate outside characteristics that suit their own cultural preferences. As in China, ideas of unity, **harmony**, and balance govern Japanese art and architecture. ③ **Shibui**, the highest aesthetic level of traditional Japanese design, is expressed through simplicity, **implicitness** or inner meaning, humility, silence, and the use of **natural materials**. These characteristics shape all visual arrangements and daily activities. Because an individual's relationship to nature is important, the Japanese view the physical division between nature and the man-made differently than do Westerners. In Japan, for example, houses usually open directly onto gardens so the division of space is **seamless**, and elements of nature appear throughout the interiors.

MOTIFS

Naturalistic, geometric, and figurative motifs (Fig. 8-4-1, Fig. 8-4-2) embellish surface designs. Those derived from nature include flowers such as the **cherry blossom**, the iris, the **chrysanthemum**, and wisteria along with **bamboo** leaves, birds, waves, and whirlpool designs. Geometric designs are **stripes**, **grids**, **swirls**, **latticework**, and **frets**. Figurative motifs show men and women in traditional dress. The family crest, a highly stylized design appearing in art and on clothing, often develops within a circular form that may also evolve into a decorative repeat pattern.

Fig. 8-4-1　Motifs: Katagami (textile stencil patterns) illustrating fan, flower

Fig. 8-4-2　Botanical motifs and lacquer box with landscaope, 19th century

ARCHITECTURE

Public and private buildings appear as works of art in beautiful, natural environments. Like Chinese models, architecture is governed by ordering systems such as **axiality** and hierarchy. Unlike the Chinese, the Japanese place greater emphasis on asymmetry than on symmetry. The asymmetric balance between right and left creates a **dynamic** and appealing sense of beauty. This appreciation appears in the way a building rambles as well as in roof layers, details, spacing, and overall image. Fixed proportional relationships define architecture, and contrasts dominate: simple versus ornate, traditional in relation to new, logical as opposed to contradictory.

As distinctive expressions of the country, traditional building forms vary little over time. Public complexes often are monumental in scale to impress, but may be composed of many separate buildings that individually offer personal intimacy. Construction, detailing, decoration, and color reflect the various religions and the importance of nature.

Public buildings include **shrines** (Fig. 8-4-3), temples (Fig. 8-4-4), pagodas, and shops. Typical domestic building types include noble residences, palaces (Fig. 8-4-5) or castles, townhouses, besso (country houses), and farmhouses. Because of the possibilities of earthquakes and fire, houses are constructed so they are easy to rebuild. Townhouses, which often include areas for shops, are generally smaller than country houses because there is less land available in the city. During the 8th through 12th centuries C. E. , the appearance of rambling country houses marks Japan's first major indigenous expression of architecture.

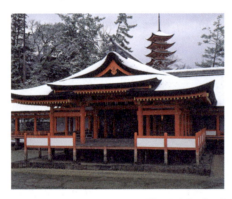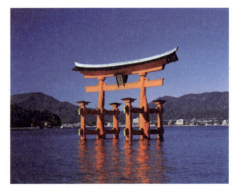

Fig. 8-4-3　Itsukshima Shinto Shrine

Most dwelling complexes are situated within a landscaped garden on the edge of a pool. [Gardens, which are intended for meditation and **seclusion**, combine natural and man-made elements and mix broad vistas with small views that surprise and delight. Unlike the Western custom, Japanese people view their gardens from

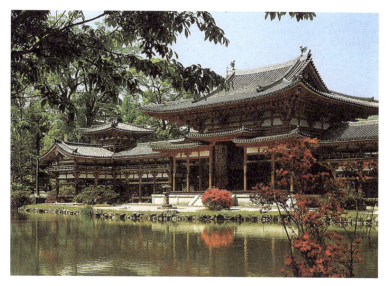

Fig. 8-4-4 Byodo-in temple

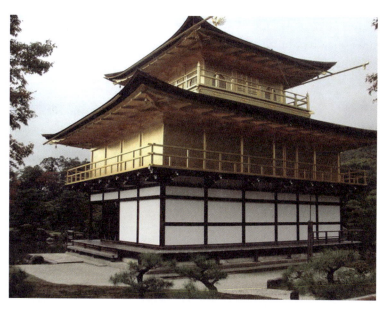

Fig. 8-4-5 Golden Pavilion of yoshimitse

verandahs as well as walking through them. Small stones comprise the **paths**, requiring the viewer to continually look down and consciously stop to examine the landscape, features, and buildings.]Zen gardens feature rectangular forms, raked gravel grounds, and a few **asymmetrically** placed rocks representing natural features.

Timber Construction

Timber construction is used exclusively beginning in the 5th century C. E. Like the Chinese construction, it is composed of foundation, timber columns, and most important, the roof. After the roof is completed, the division of spaces begins within the structure. Since there are few fixed walls, movable **partitions** divide spaces, allowing the interior volumes and the relationship between interior and exterior to be modified easily. The openness of plan also accommodates the need for cross **ventilation** in the hot, humid Japanese summers. While the Chinese are known for decoration integrated into the structure, the Japanese are known for the beauty of their construction methods and joinery and their use of natural materials.

Public and Private Building

Shrines

The **Shinto** religion requires shrines (dwellings for gods) more than temples, unlike Buddhism. The shrine complex is located on a sacred site isolated by forests, mountains, and/or water. The torii (main entrance) gate, formed by two columns topped by two horizontal beams, introduces the complex. Constructed of wood that is often left unpainted, shrines are composed of a floor raised by columns, thatched or wooden gable roofs, and one or two interior spaces. Human scale and **simplicity** are characteristic. Although traditional form is important, shrines eventually become more formal and often attached to Buddhist complexes.

Temples

Following Chinese models, Buddhist temple complexes layering technique with entrance from a main south-facing gate that leads to the chumon (middle gate), which connects to a kairo (roofed corridor) that surrounds the sacred area. Common structures within the complex are a pagoda, a kondo (image hall), a kodo (lecture hall), quarters for priests, and storage areas. Covered walkways connect the main building to smaller pavilions. Early examples organize axially and **symmetrically**, but with off-center gates as in China. Later temple complexes maintain axiality, but position structures asymmetrically within the grounds. Japanese complexes integrate more fully with the landscape than Chinese examples.

Dwellings

Houses are generally one or two stories with the important rooms in the rear facing the garden. The besso or dwelling develops from a series of connecting rectangles that ramble to create asymmetry and informality, therefore appearing less formal and austere than palaces. Most townhouses are close to the street and have a formal entry that often becomes an area for conducting business. Townhouses usually are compact or narrow to take maximum advantage of limited space. Because of crowded conditions, they focus centrally on small gardens on one or more sides. The most private rooms face the garden. Castles may be composed of a large complex of wooden buildings, usually covered with plaster, grouped around a keep or tenshu (main structure) or multistoried complexes of stone with high, battered protection walls surrounding the castle complex.

Floor Plans

Early temple plans have a large central space flanked or surrounded by smaller spaces or aisles. Eventually, the need for space for worshippers dictates the addition of another space in front of the central space.

Beginning in the 12th century, house plans are usually modular based on Ken, a system derived from the arrangement of structural pillars and **tatami** mats (Fig. 8-4-6). The mats are modules approximately 3'-0" wide by 6'-0" long and 2" or 3" thick with a woven rush cover and a rice straw core, and are bounded by black cloth. They are positioned parallel and perpendicular to one another in various configurations, Room dimensions derive from the arrangement of the tatami mats, with important rooms increasing in size accordingly and rooms labeled as to the number of mats they contain. The mats rest on the structure of the building and are easily removed for recovering. Spaces are fluid, interlocking, and flow one into another in a casual, informal manner with no major room defined by a specific function.

Materials

As there are numerous forests in Japan, wooden posts and beams compose the structural framework. Cedar, pine, fir, and cypress are common building woods. This variety produces a deep appreciation for the diversity in wood color, luster, texture, and fragrance. Non-load-bearing walls are of plaster, wood panels, or

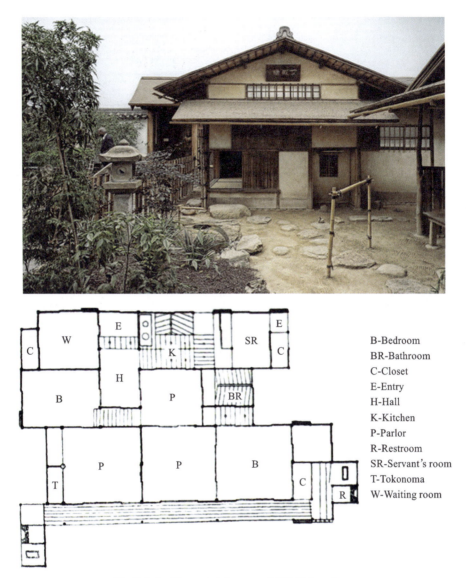

Fig. 8-4-6　Floor plan, house, c, 1880; Tokyo, Japan

B-Bedroom
BR-Bathroom
C-Closet
E-Entry
H-Hall
K-Kitchen
P-Parlor
R-Restroom
SR-Servant's room
T-Tokonoma
W-Waiting room

lightweight sliding partitions. Pillar bases, foundation platforms, and fortification walls are of stone, which is less readily available for construction. Stone buildings emphasizing defensibility are common during the turbulent 16th and 17th centuries.

Facades

Facades of both public and private buildings are generally plain and unembellished and characterized by repeating modules composed of dark wooden frames with light rectangular center spaces. These modules surround the perimeter. Solids juxtapose with voids, light areas with dark ones, and large rectangles adjoin small ones, creating a quiet rhythm and harmony. Exterior surfaces are either of natural wood, painted black wood, or natural wood with sections of plaster infill. Large repetitively spaced columns support the verandahs that surround the building. In traditional architecture, the shin-kabe or plaster wall with exposed structure is typical. On some buildings, the wall area under the eaves has painted decoration in bright colors, such as red, blue, or yellow. Entries are important and usually feature some type of emphasis through placement, design, materials, or color.

City houses are entered through gates on the side or corner, while those for castles are larger, more

important, and placed prominently on the center axis. Walls usually surround the landscaped area of large complexes and castles to ensure privacy and protection. Castle facades have small slits and/or battlements from which to shoot.

Windows and Doors

Shoji screens(Fig. 8-4-7) serve as both windows and doors on many Japanese buildings. They shield the

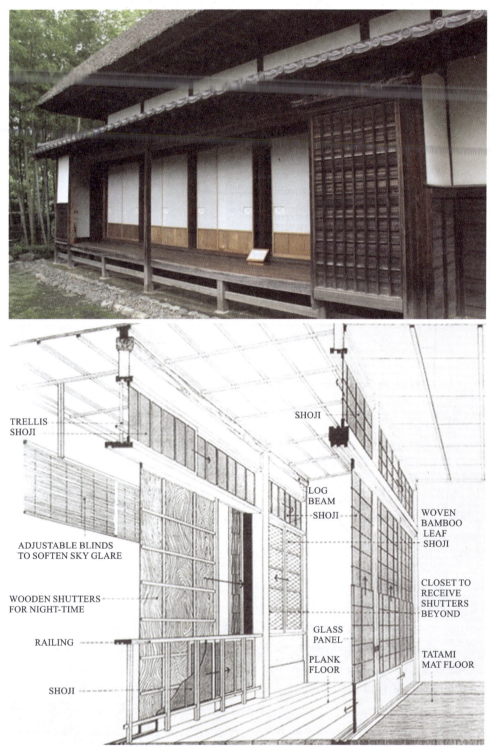

Fig. 8-4-7 Wall detail showing shutters, verandah, and sliding screens

outer portions of a building during poor weather, establish a visual rhythm, help integrate inside and outside, and subdivide the interior spaces. Each lightweight panel is approximately 3'-0" wide by 6'-0" high and consists of a wooden lattice grid traditionally covered with rice paper. When open, the shoji frames a natural garden setting that serves as a landscaped mural. Solid sliding screens and wooden doors with latticework, carved decoration, or covered decorative painting are also common. Wooden doors are the gates separating the public and private worlds. Most doors are sliding panels 6'-0" high. Exterior ones generally are shoji, as their paper coverings admit light. Tatami mats determine door widths.

Roofs

Roofs are low and gabled, or single or double hipped with wide, upturned overhangs to protect walls from rain. On residences, roof overhangs create verandahs that become transitional spaces between the outside and inside directions. Surfaces are either shingled or tiled. As in China, a complex bracket system usually supports the roof and provides ornament. Parts may be highlighted with color. In traditional architecture, kokera-buki construction usually has a shibi accenting each end of the roof ridge. The pagoda roof stacks in many layers with a hosho crown.

INTERIORS

Defined by exposed structure, Japanese interiors express beauty, harmony, flexibility, and serenity. Economy of line, colors from nature, textural harmony with diversity, meticulous detailing, uncluttered space, and modularity are trademarks. A strong ordering system based on the positioning of **tatami** mats defines spaces. Interior walls reflect exterior design features and structural divisions. A variety of screening devices subdivide interior spaces and support spatial flexibility by enlarging the size of a room or rooms in succession or by closing off one or more rooms. Fusumas and shoji are the most common. Interior ceilings are low, as a reflection of the overall building module, the Japanese stature, and the fact that people sit on the floor rather than on chairs. Backgrounds generally are neutral with decorative objects providing color and pattern contrasts.

Interiors feature the same strong geometry, respect for materials, contrasts, and harmony as exteriors. Sliding partitions open spaces to the outside (Fig. 8-4-8), unlike in the West, creating little need for solid doors and windows. Exterior-interior relationships and harmony with the landscape create a total environment. Unlike in the West, domestic and some temple interiors are multipurpose so size, shape, and use change as needed. In residences, the formal entry serves as a separating point between the outer (unclean) world and the (clean) privacy of the home. Here, the outside life is left behind as people remove their shoes, store them, and

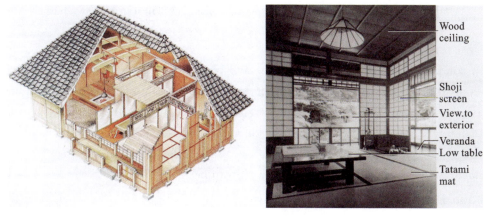

Fig. 8-4-8 Construction drawing, Japanese house and interior illustrating shoji screens, fusuma, and tatami mats

put on slippers. Living areas generally face to the south or southeast to take advantage of the light, but may move to a darker and cooler side during summer months. The main reception space in a noble dwelling may have a raised area for emphasis and to support the noble's authority.

Public and Private Building

Materials
Untreated natural materials, including plaster, straw, linen, wool, paper, and natural wood, are common.

Color
Colors reflect nature and harmonize with the structure. The palette contains primarily white, brown, black, straw, and gray. Other interior colors, which may be bright, mainly come from the display of decorative arts.

Floors
Raised floors covered with tatami mats are common in all areas except service spaces. Wood planks cover floors in corridors, verandahs, and **lavatories**. Earthen floors are typical in service areas. Temples have wooden floors instead of earthen ones (Fig. 8-4-9).

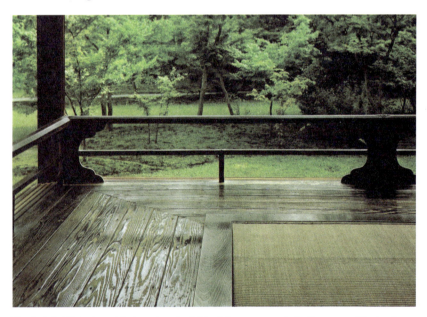

Fig. 8-4-9 Interior with taami mats, table, tokonoma, and shoji screens; Kyoto, Japan

Walls
Walls often composed of sliding solid partitions and paper-covered screens, may be plain or decorated. Fusumas partition the spaces and support movement and interchangeability in function. Folding screens may also temporarily divide space. Within formal or reception rooms in the Japanese house, the architectonic tokomoma or tana integrates with the wall composition and showcases changing arrangements of special items related to the various room functions. A transom area above the sliding panel features a ramma, often perforated or elaborately carved for air flow and light filtration.

Windows and Doors
Fusumas and shoji become doors and/or windows. Other screening devices separating the outside from

the inside include woven bamboo blinds, reed screens, wooden grilles, and norens (split curtains). These flat hanging cloth or hemp curtains can also act as shades blocking on desirable views.

Ceilings

Ceilings of traditional buildings may vary in height to articulate and define spaces. They may be coved, coffered, or latticed, and may possess elaborate truss and bracketing systems. In temples, a false lower ceiling for decoration hides irregularities in the spacing of rafters. In residences, low ceilings are common, primarily because of the custom of sitting on the floor.

Textiles

Woven and dyed textiles are important sources of color and pattern in interiors. They may cover screens, hang at doors, or embellish seating. Designs are asymmetrical. Japanese woven silk differs from Chinese in its geometric motifs, such as zigzags or diapers. One of the most popular dyed textiles, katagami comes from elaborately cut paper stencils. Appearing in Japanese wood-block prints, it obtains its characteristic deep blue color from indigo dyes.

Lighting

Natural light filters softly through the translucent paper of shoji, adding to the feeling of serenity. Inside, lamps, usually on stands, and metal candlesticks provide artificial light. Lanterns are an important aspect of most gardens. Those of stone are popular as well as the chochin, a portable spiral of thin bamboo covered by a layer of rice paper that folds flat when not in use(Fig. 8-4-10).

Fig. 8-4-10　Larterns with curves and filigree decoration

FURNISHINGS AND DECORATIVE ARTS

Japanese interiors feature little freestanding furniture and several carefully selected decorative accessories. People sit on their knees on zabutons, and often the focus of a group seating arrangement will be the hibachi or charcoal heater. Furnishings are often built in, and individual pieces are usually parallel to the walls. In contrast to the simplicity, strong geometry, and neutral colors of exteriors and interiors, some furnishings may have gilding or colored floral motifs. Brighter hues of red, pink, gold, green, blue, brown, white, and black in decorative arts enhance the overall color effect. The Japanese, who prefer simplicity to abundance, do not display their entire collections at once, preferring to show one or two objects at a time.

Public and Private Buildings

Materials

Oak and chestnut are common furniture woods. Lacquer-work is common and usually has a black or red background and may have floral motifs in gold. **Lacquer** usually covers small objects, such as writing boxes and accessories associated with the tea ceremony.

Seating

Because the Japanese sit on the floor, there are few chairs or stools. Brightly colored textiles often provide a soft and warm place to sit on floors. Samurai, because of their elaborate uniforms, sit on folding stools that may be elaborately carved or painted.

Tables

The most important table is the one used for dining and the tea ceremony. It is wooden, square, very low to the floor, has straight carved legs, and often features a top with a series of small curves. Small lacquer-covered tables provide surfaces for writing, presentation, or the **tea ceremony**.

Storage

Often works of art, chests or coffers in various sizes store possessions. The tansu is often located behind a **fusuma** as in a closet. Generally, built-in or freestanding cupboards line walls for storage. A variety of small decorative boxes may store stationery supplies.

Beds

People can sleep in almost any room where the soft tatami mats provide a resilient base. Thick rolled futons (comforters) serve as bed and bed covering; they are stored when not in use. A small box with an attached cushion becomes a pillow and provides head support.

Screens

The byobu or decorative folding screen (Fig. 8-4-11), an important accessory in the interior, adds color and pattern, provides privacy, and protects from drafts. It may have two, three, or six folding panels approximately 3'-0" to 5'-0" high with decorative designs on both sides.

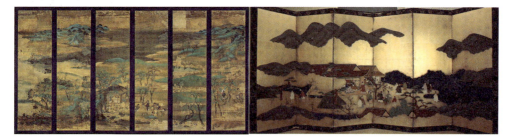

Fig. 8-4-11　Byobu (folding screen)

Porcelains and Ceramics

Dutch traders first bring Japanese pottery and porcelains to Europe during the 17th century. Two types of **porcelain** (Fig. 8-4-12) are particularly popular with Westerners. Kakiemon porcelain has simple, asymmetrical designs in red, yellow, green, and blue, sometimes with gilding. Imari porcelain features crowded, elaborate patterns in strong blue, red, and gold.

 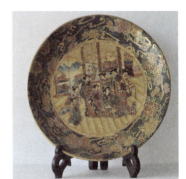

Fig. 8-4-12　Porcelain

DESIGN SPOTLIGHT

Architecture

Sitting within a carefully planned landscaped garden, the rambling Katsura Imperial Villa and tea house were constructed during the reigns of the imperial Hachijo-no-miya family and Prince Toshitada. Emphasizing Japanese principles of beauty, they exhibit a peaceful harmony between buildings and environment. The main villa was built in three connected stages: the old shoin, middle shoin, and new palace, reflecting a change from the Shoin style of the late middle ages to the Sukiya style of the early Edo period. The buildings have repeating geometric modules of natural wood on the exterior contrasted with the infills of white plaster. Verandahs and platforms, often used for moon-viewing, connect the outside garden areas with the inside spaces. A modular plan based on the Ken controls the order of the villa. Spaces interconnect and flow informally into one another in a zigzag pattern. Shoji and fusuma screens partition the spaces and support fluid movement. Furnishings are limited primarily to zabutons, small tables, and tansus[World Heritage Site](Fig. 8-4-13).

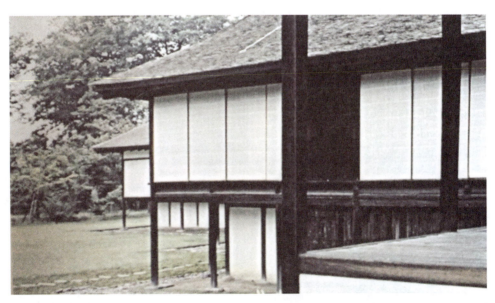

Fig. 8-4-13　Katsura Detached Palace (also known as Katsura Imperial Villa) with Shokin-Tei Pavilion (tea house) and Rooms of Hearth and Spear, c, 1615—1663; Kyoto, Japan; Rooms of Hearth and Spear by Kobori Enshu

DESIGN SPOTLIGHT

Interiors

This wood-block print illustrates the Shoin style of architecture, which arose in the 15th century from elements taken from Zen Buddhist religious dwellings and tea houses. Also ordered by tatami mats, the interiors reflect the relationship of inside to outside, sitting at floor level, the limited use of furnishings, and an architectonic character. Shoji, fusuma, and tristate screens define the spaces. The transom area features a perforated ranma to support air flow and light filtration. Furnishings include small tables, metal candlesticks, and decorative accessories (Fig. 8-4-14).

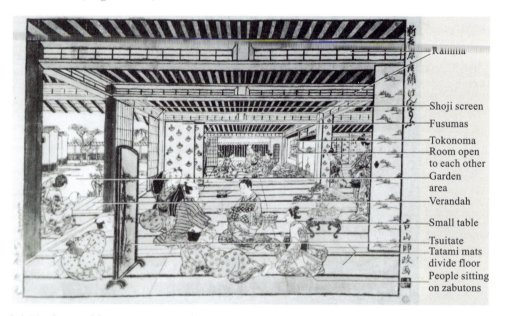

Fig. 8-4-14 Interor, Moromasa, a house of Pleasure 18th century, Yoshiwara. Frederick C. Hewitt Fund, 1911

专业词汇

ink stone ['iŋkˌstəʊn] 砚台
wardrobe ['wɔːdrəʊb] 衣柜，行头
epitomize [iˈpitəmaiz] 概括，缩影
modularity 模块性
Buddhism ['bʊdizəm] 佛教
coexist [ˌkəʊigˈzist] 共存，并存
shibui ['ʃibəui] 雅致的，典雅的
aesthetic [ɛsˈθetik] 美学的，审美的
simplicity [simˈplisəti] 朴素，简易
implicitness 含蓄
seamless ['siːmləs] 无缝的
cherry blossom 樱花
axiality [ækˈsaiəliti] 轴对称性

bamboo ［,bæm'bu］ 竹子
chrysanthemum ［kri'sænθəməm］ 菊花
seclusion ［si'klu:ʒn］ 隐退,隐居
Zen ［zen］ 禅宗
asymmetrically ［eisi'metrikli］ 不对称的,不平衡的
ventilation ［,ventl'eiʃn］ 通风设备
shrine ［ʃrain］ 神社
tatami　榻榻米
harmony ［'hɑ:məni］ 协调
fusuma　日式房屋中的拉阖门
lacquer ［'lækər］ 漆,漆器
shoji　木房屋中的纸糊木框
porcelain ［'pɔ:səlin］ 瓷器
kakiemon　赤绘瓷器
Imari ［i'mɑ:ri］ 伊万里瓷器
dwellings ［'dweliŋ］ 寓所
stripes ［straips］ 条纹布
grid ［grid］ 网格
shinto　日本神教道
feudalism ［'fju:dəlizəm］ 封建制度
partition ［pɑ:'tiʃn］ 隔断
swirls ［swɜ:lz］ 旋涡
villa ［'vilə］ 别墅
latticework ［'lætiswɜrk］ 网格,格子细工
frets ［frets］ 磨损,腐蚀
verandahs　游廊,走廊
paths ［pɑ:θz］ 路径
tea ceremony　茶道
lavatory ［'lævətri］ 盥洗室
natural material　天然材质的
dynamic ［dai'næmik］ 动态的,动力的
symmetrically ［si'metrikli］ 对称地、平衡地

难句翻译

① Art, architecture, poetry, and prose become more nationalistic as artists and writers choose and assimilate those Chinese influences that best suit their own culture. Feudalism develops around large estates of the daimyo (lord) who controls his domain with the help of his samurai (warriors).

随着艺术家与作家从中国影响中选取并吸收最适合本文化的元素,日本的艺术、建筑同诗歌散文变得越来越具民族性。封建制度在大名的广袤田产周边发展起来。大名利用武士的帮助来维护其辖区的统治。

② The cha-no-yu (formal tea ceremony) becomes a social institution. Its equalizing rituals unite host and guest in the common pleasure of conversations about everyday things, and it takes place in a specially designed tea house. The tea house's characteristic simplicity, textural contrasts, and integration with nature affect the

design of dwellings.

茶汤(茶道)成为社交制度。茶道在特殊茶室内举办,它让仪式主持和访客在日常交谈中共享乐趣。茶室的简洁性、质地对比和与自然的和谐性影响了住宅设计。

③ Through periods of isolation and contact, the Japanese acquire and assimilate outside characteristics that suit their own cultural preferences. As in China, ideas of unity, harmony, and balance govern Japanese art and architecture.

封闭与开放的交替让日本人从外界获得并吸纳了适合本地文化的特色。同中国一样,统一、和谐与协调的理念统领着日本的艺术与建筑。

Japanese Architecture(日本古代建筑)

木架草顶是日本建筑的传统形式。房屋采用开敞式布局,地板架空,出檐深远。居室小巧精致,柱梁壁板等一般都不施油漆。室内木地板上铺设垫层,通常用草席作成,称为"叠",坐卧起居都在上面。古代日本风俗,一屋只住一代,下一代另建新屋居住。随着与亚洲其他国家的贸易往来和西方设计文化的渗透,日本建筑的室内设计、家具和装饰艺术有重大变革,同时日本风格的建筑形态和设计思路对西方国家18—21世纪初的建筑也有着重要影响。

From

Buie Harwood, Bridget May, Curt Sherman. <Architecture and INTERIOR DESIGN: an integrated history to the present>. New Jersey:Pearson Education, 2012.

8.5 Chinese Architecture

China is one of the world's oldest civilizations. Forms and motifs develop early and repeat often due to the culture's respect for age and tradition. From early time, **Taoism**, **Confucianism**, and **Buddhism** form Chinese thought and subsequently affect its art and architecture. Separately and together, three philosophies reflect a cultural vision that is very different from that of the West. Characteristics such as careful **orientation**, order, symmetry or asymmetry, and **hierarchy** evolve from the cultural vision. While significant in themselves, Chinese art, architecture, and culture nevertheless influence various European historical periods beginning with ancient Rome. Trade activity between Asia and Europe, and later with America, during the 17th to 19th centuries provides new and different influences affecting European and American art, architecture, interiors, furnishings, and decoration. During the late 20th century, travel, exhibits, movies, and books focused on Asia highlight the increasing interest in Chinese art, architecture, design, and health, while a booming Chinese economy supports a growing international design exchange(Fig. 8-5-1).

HISTORICAL AND SOCIAL

Chinese history is influenced by the rise and fall of dynasties. Throughout much of this long history, emperors and their various dynasties govern an **agrarian**, **feudal** society. Trade and contacts with Europe begin

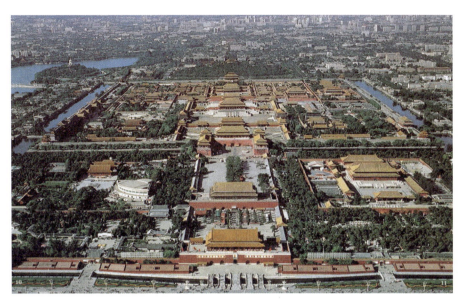

Fig. 8-5-1 Aerial view of the Forbidden City

during the Han dynasty(206B. C. E. —220C. E.). **Caravan** routes, established around the 1st century C. E. , support trade along the "silk road", the only land route out of China. During this time, Oriental silks and lacquers arrive in Rome. Taoism and Confucianism, two seemingly opposing philosophies, develop during the period. Taoism concerns itself with the individual and his or her relationship to nature, while Confucianism focuses on ethics and groups of people, which promotes the idea that one can attain peace through correct relationships and respect for order and **authority**.

China's first golden age occurs at the inception of the Tang dynasty(618—907C. E.). Times are stable with economic and cultural **prosperity**. Emperors establish diplomatic relationships with the eastern Roman Empire, Japan, and Korea. However, civil wars end this prosperity. Buddhism, which had entered China in the 5th century B. C. E. from India, becomes the national religion during the Tang dynasty. The period of the Five Dynasties(907—1368C. E.) ushers in a second golden age when China reestablishes trade with Europe. Venetians Marco Polo, his father, and uncle travel extensively in Asia and China in the late 1260s and 1270s. Polo's written account of his travels gives Europeans their first glimpses of China. Trade routes across Central Asia bring such Chinese innovations as gunpowder, paper, printing methods, and the compass into Europe From the 14th century onward.

During the Ming dynasty(1368—1644)in the early 17th century, the British East India Company organizes trade routes, through the port of Canton, between China, India, and England. In the late 17th century, the Dutch East India Company establishes import and export routes through Indonesia and Japan with stops in China. Soon, Chinese silks, spices, and porcelains begin flooding Europe.

During the Qing dynasty(1644—1911)in the 19th century, China and Britain clash in the Opium Wars, resulting in the loss of Hong Kong to Britain and an influx of Western influences. Later, China seek to rid the country of foreigners during the **Boxer Rebellion** of the early 1900s. Also during this time, the United States and Canada bring in Chinese laborers to work on the westward expansion of the railroads, bringing a new cultural influence to North America.

Dynastic rule ends in China with the emergence of the new Republic of china(1911—1949), a period characterized by the dominance of **warlords**. The Cultural Revolution of 1949 brings stability, communism, and authoritative control to the country along with significant upheaval and isolation. During the late 20th

century, China reopens contact with the Western world, engendering economic prosperity, design changes, new buildings, and cultural reforms. Chinese traditional ideas about health, wellness...

CONCEPTS

Unity, harmony, and balance govern Chinese art and architecture. Forms develop early and are maintained throughout China's long history. Religious influences from Confucianism, Buddhism, Taoism, and Christianity cultivate the inner character and affect rituals, symbols, and spatial ordering. The **duality** of yin (negative, feminine and dark) and yang (positive, masculine, and light) guide universal life. The laws of the five elements of wood, fire, earth, metal, and water govern relationships in the natural environment. Feng shui (wind and water), a system of orientation, uses the earth's natural forces to balance the yin and yang to achieve harmony. All affect design components of architecture, interiors, and furnishings including relationships, spacing, color, **orm**, and patterns.

MOTIFS

The Chinese employ numerous motifs, many symbolic, used alone or in combinations. Common motifs (Fig. 8-5-2) for architecture, interiors, furnishings, and decorative arts are lions, dragons, the phoenix, fret, the lotus (purity), clouds, fruits, chrysanthemums, the shou (long life), and calligraphy. Others include the bat (happiness-five bats represent the Five Blessings-longevity, wealth, serenity, virtue, and an easy death), the pine or evergreen, the stork, and the tortoise (longevity). The eight Immortals are a Tao symbol. The flaming wheel, the endless knot, and state umbrella are Buddhist emblems. Animal motifs include Lions of Buddha, the tiger, the dragon, and the phoenix. Naturalistic motifs are the lotus, peonies, chrysanthemums, and bamboo. Also evident are the meander motif and diaper patterns.

Fig. 8-5-2 Motifs and Architectural Details: Dragons; flowers; and geometric patterns

ARCHITECTURE

The Chinese value the site, the pattern of the building, and tradition over the building itself. Architecture, as a **framework** for the country's social system, is governed by ordering systems such as **axiality** and hierarchy. Compositions emphasize **modules** with definite and fixed proportional relationships. Chinese conservatism and control is evident in the repetition of form and hierarchy in building plans. Symmetry is very important, but uneven numbering systems based on religion and nature often defines roof layers, details, and spacing. **Silhouettes** are **distinctive**, but few stylistic changes appear over time. Landscapes emphasize Taoist qualities such as asymmetrical compositions, empty space, infinity, parts of elements representing the whole, and nature. This contrasts sharply with the Confucian order of symmetry, balance, finiteness, and regularity.①

Traditional palace complexes (Fig. 8-5-3), as centers of government, continually reflect historical design features that inspire through their monumental scale and beauty. Construction, detailing, decoration, and color articulate a design language of beauty based on the principles of feng shui. Forms and elements grow out of construction methods and are governed by traditions that develop in the Zhou dynasty. Characteristic buildings

include pagodas, shrines, temples, monasteries, mausoleums, commercial structures, and urban and rural imperial palaces and residences.

Fig. 8-5-3　The Hall of Supreme Harmony in the Forbidden City

Structural Features

Construction and Decoration

Timber frame construction is composed of **foundation**, columns, and roof. A complex bracketing system creates non-load-bearing walls and adds decoration. Consequently, Chinese architecture is known for decoration that is integrated into the structure(Fig. 8-5-4, Fig. 8-5-5). Bright color often highlight the various elements. Color, form, and orientation may be symbolic. Social position and function determine the size, plan, and amount of embellishment.

Fig. 8-5-4　Pogoda in Chinese temple

Public and Private Buildings

Site Orientation

Sites and orientation are carefully chosen and planned practically and spiritually. Structures orient to the south(superiority), toward the sun, and away from the cold(evil) north from which barbarians many come. Main buildings are sited on a north-south **axis** with lesser structures on an east-west axis. The most important structure is the greatest distance from the entrance. Buildings stand in isolation from one another but bridges, courtyards, gates, and other structures create a series of views and connections.

Fig. 8-5-5　Chinese wallpaper with house scene, Qing Dynasty (1644—1912)

Gateways

Chinese architecture is noteworthy for its variety of gateways. Varying in size, they serve as important focal points of entry and emphasize procession along a linear axis. Elaborate designs include geometric shapes that may be round, scalloped, rectangular, or angled.

Floor Plans

Plans are modular, consisting of rooms and courtyards, which can be added or subtracted at will. Function and respect for tradition govern the placement of individual rooms. Important public rooms such as the reception room are large, centrally located, and placed on a processional axis.

Materials

Buildings stand on foundations of earth with **terraces** of marble, brick, or stone. Wooden or stone columns rise from stone bases. Columns may be round, square, **octagonal**, or animal shaped. Above, a bracketing system supports the roof, which is tiled. This construction method is resistant to earthquakes and easily standardized.

Facades

Facade design varies from plain to elaborately embellished. Because entries are important, they usually feature decoration and color. Those on dwellings often are recessed with **inscriptions** to ensure happiness and protection. Windows are rectangular with wooden shutters or **grilles**. Doors are rectangular, made of paneled wood, and often embellished with carving, painting, and **gilding**.

Roofs

Upward-curving roofs are a distinguishing feature designed to deter evil spirits. Roofs may be single or double hipped or gabled on important buildings. Ceramic roof tiles in rust, yellow, green, or blue are secured to rafters by fasteners with decorative animal motifs (chi shou).

Later Interpretations

Chinese influences in Western architecture are evident in styles of the 18th, 19th, and 20th centuries. Most often architects apply Chinese forms and motifs to western structures instead of designing in the Chinese manner. This begins to change in the late 19th century when some begin to exhibit a greater appreciation for Chinese architecture by directly copying architectural images for gateways and garden houses (Fig. 8-5-6).

INTERIORS

Chinese interiors are as carefully planned and arranged as the buildings themselves. Like exteriors,

Fig. 8-5-6　Tea house at Marble House, late 19th century, Newport, Rhode island

interiors reflect strong axial relationships and hierarchy based on age and status. Symmetry is important. Some rooms have large windows and doors that open to exterior courtyards and gardens. Fretwork and grilles in windows and doors provide openings that integrate interiors with the landscape. Formality and symmetry govern room shapes, the arrangement of doors and windows, and furniture placement.② Some public and important rooms are lavishly decorated. The few furnishings are of high quality.

Public and Private Buildings

Color

Colors are strong and bright because **pigments** are seldom combined or grayed. The palette includes red (for fire, symbolizing happiness on doors or buildings), yellow (earth), gold, green (prosperity), and blue (heaven). Walls, columns, doors, and window frames may be red. Color and gilding may highlight details and motifs. Interior color comes from applied decorations such as painting and carving.

Floors

Floors may be of dirt, wood, or masonry. Marble floors highlight important rooms in imperial palaces. Felt rugs, mats, and pile rugs may cover floors.

Rugs

Rug weaving apparently comes late to China. The earliest surviving examples date from the end of the 17th century. Chinese rugs differ in colors, density of patterning, pile density, and motifs from Middle Eastern rugs. Like them, Chinese rugs may be of wool or silk and made of Persian knots with borders around an open field. But colors are brighter and clearer with much less dense patterns than Middle Eastern rugs.③ Motifs, which are symbolic, include flowers, buildings, and religious images. Some Chinese rugs are carved; that is, the pile around motifs is cut away to create three-**dimensionality** (Fig. 8-5-7).

Walls

Walls may be plain or partially **embellished**. Natural wood enriches surfaces, with architecturally integrated and elaborately carved wooden grilles often defining and accenting walls, particularly in the frieze area.

Fig 8-5-7　Textiles: Embroidered textile and rug, late 19th—early 20th century

Ceilings

Ceilings in important public spaces may feature repetitive geometric designs with traditional motifs. Large beams that are elaborately carved and painted often divide ceilings into sections.

Textiles

Chinese are known for their silks, the production of which dates back 4000 years. Traditional motifs such as clouds or the lotus are characteristic. All European silk comes from China until the 12th century, when a silk industry is established in Italy. Common fabrics exported to Europe include damasks, brocades, and embroideries.

FURNISHINGS AND DECORATIVE ARTS

Chinese furniture, like interiors, exhibits formality, regularity, symmetry, and straight lines. Furniture generally relies on simplicity, structural honesty, and refined proportions for beauty instead of applied ornament. Designs reflect boxy forms with limited diversity in visual image. Most furniture is of polished wood or bamboo, but lacquered sets are found in imperial palaces. ①Joinery is intricate with no nails or dowels and very little glue; mitered and mortise and tenon joints are typical. Pieces are shaped by hand instead of by turning. Most moldings are part of the furniture, not applied. Furniture generally is against or at right angles to the wall, but is never angled. The place of honor is as far from the door as possible, facing south, and at the host's left. Armchairs are seats of honor.

As trade routes develop between China and Europe, numerous furnishings and **decorative** arts find their way into homes in England, France, and other countries from the 16th century on wards. Chinese influences become evident in styles of the 18th, 19th and 20th centuries. Designers adapt Chinese elements and motifs to western furniture forms, most notably in Queen Anne, Chippendale, English Regency, Art Deco, and Scandinavian designs.

Public and Private Buildings

Materials

Most furniture is constructed of solid local hardwoods such as tzu-t'an (red sandalwood), hua-li (rosewood), chestnut, elm, or oak. Some woods, such as **ebony**, are imported. Several types of wood may be combined in one piece. Furniture from the south incorporates bamboo. Some pieces feature gilding or inlay.

Lacquer protects against insects. Red lacquer colored with cinnabar is highly prized.

Seating

Chairs are important symbols of authority and honor(Fig. 8-5-8). Yokes, splats, aprons, and legs may be simple or elaborately decorated. Carving is common, and painted decoration may appear on important chairs. Stretchers hold legs together on uneven floors. Front stretchers are raised so feet are protected from cold drafts. Stools have four legs or may be cylindrical drums. Couches, also used for sleeping, are large with low backs and arms.⑤ Backs may be solid or feature fretwork. Legs may be quadrangular with soft corners, circular, elliptical, or cabriole. The hoof foot with a slight inward curve is typical. Originally, Chinese homes featured a movable or built-in platform for sitting or reclining called a k'ang.

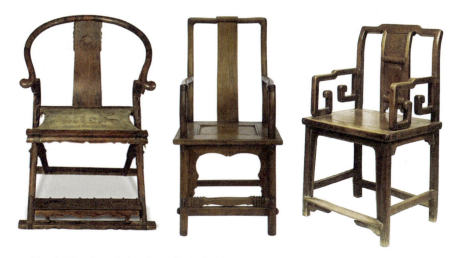

Fig. 8-5-8　Armchair with yoke back and solid splat, and horseshoe armchair; China

Tables

Tall tables with stools support dining, writing, or from units with two chairs. Dining tables generally and may be used for display, writing, and painting(Fig. 8-5-9). Some have four legs, while others have trestle bases. Stretchers, single or double, may be near the apron, which is usually shaped and/or carved.

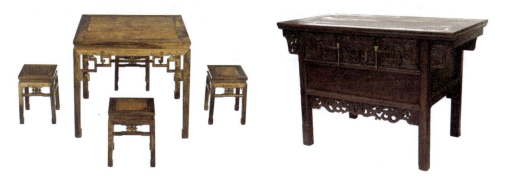

Fig. 8-5-9　Side table and desk, late 19th century

Storage

Chests and cabinets, small and large, store items in the Chinese house. Doors and surfaces may be plain with beautiful wood grains or elaborately decorated. Metal hardware, an important and integral part of the design, may be round, square, or bat shaped(Fig. 8-5-10).

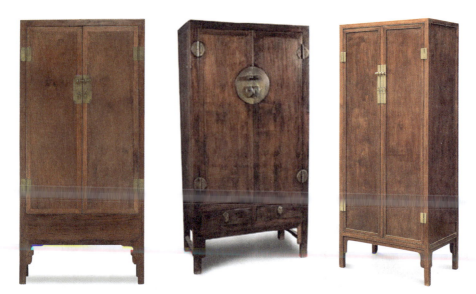

Fig. 8-5-10　Cabinet with brass hardware, late 19th century

Beds

Similar to a k'ang and lower than a chair seat, the movable **canopy** bed(Fig. 8-5-11)is rectangular, has low railings, features four or six posts, and is embellished with carving, **latticework**, **fretwork**, and draperies. People sit or recline in beds during the day. The short legs often terminate in hoof feet. Footstools are usually placed in front of the bed.

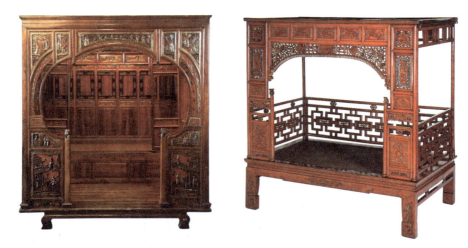

Fig. 8-5-11　Carved canopy bed, c. early 20th century; China

Screens

Interiors commonly feature screens, folding or set in a frame. They are lacquered or painted in bright colors with symbols of health and happiness. Coromandel, a polychrome lacquer with inlays of mother-of-pearl and other materials, is the best known(Fig. 8-5-12, Fig. 8-5-13).

Porcelain

Porcelain originates in China during the T'ang dynasty. A search for a pure white body produces true porcelain, which contains kaolin(china clay) and pai-tun-tzu(china stone). The subsequent Sung period produces many pieces of excellent design decorated with monochrome glazes, such as **celadon**(the color varies

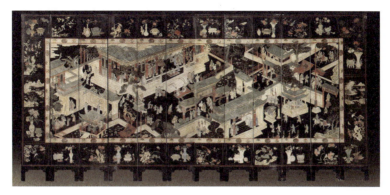

Fig. 8-5-12　Coromandel screen, c. 1690, and detail from a Coromandel screen

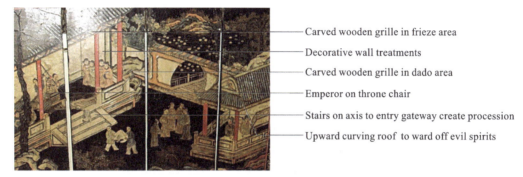

Fig. 8-5-13　Screen Details

from delicate green to gray blue). Ming period blue and white (Fig. 8-5-14) is the best known of Chinese porcelains. Reaching Europe in the 15th century, Chinese porcelains cause a sensation, particularly among the wealthy, who display them proudly. The Chinese quickly begin marketing porcelains for the Western market, known as Chinese Export Porcelain.

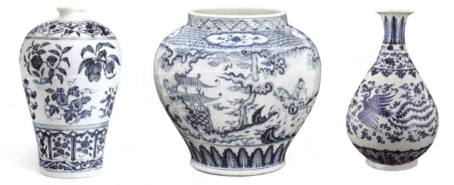

Fig. 8-5-14　Decorative Arts: Blue and white vase, 19th century, and celadon charger, Ming Dynasty (1368—1644)

DESIGN SPOTLIGHT

Architecture

The Forbidden City is a walled complex of 980 public and government buildings in Beijing. During the Ming and Qing Dynasties, it is the Emperor's home and the ceremonial and political center for the Chinese government. Centrally located and restricted to court use, the City houses the royal residences of the emperor.

The largest and most important building in this compound is the Hall of Supreme Harmony, the ceremonial center of power. Procession to the Hall is along a major north-south axis through a series of gated pavilions that lead to the inner Court.⑥ A visual layering of pierced walls and smaller buildings accents the processional path of arrival. Behind the Hall on the same axis is the Gate of Heavenly Purity, which leads to the Palace of Heavenly Purity. The palace's name reminds citizens of the divinity and character of the emperor. The Palace houses the emperor's living quarters, and it is where he deals with matters of state. Originally constructed in 1420, the building was burned several times, so the present structure dates from 1798. Built of wood and resting on a stepped marble terrace, it features a rectangular floor plan, boxy shape, nine bays with red-columned facade, and double tiered red-tiled roof. Ornate animals in uneven numbers related to Chinese symbolism accent the roof corners. Richly carved and painted wooden door with lattice work enhance the entry level(Fig. 8-5-15, Fig. 8-5-16).

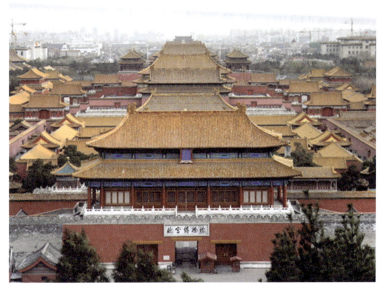

Fig. 8-5-15　Forbidden City

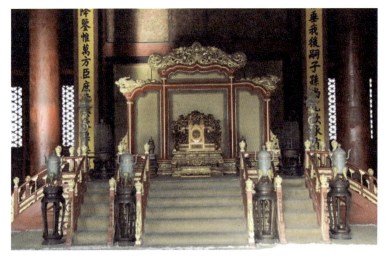

Fig. 8-5-16　In the audience hall of the Palace of Heavenly Purity

The Emperor meets with various officials during the day. His throne and a desk area are raised on an elaborately embellished platform, which is surrounded by red columns. Above the throne are five dragons and

an inscription meaning "justice and honor". Behind the throne is a richly carved five-wooden screen. The ceiling above is carved and accented with ornate decorative painting. The floor is composed of dark marble tiles. Gold accents signifying royalty appear throughout the space.

Entry gates, passageways, building facades, ceilings, and interiors are also richly embellished throughout other buildings in the compound. The Forbidden City became a World Heritage Site in 1987.

DESIGN SPOTLIGHT

Furniture

Chairs are important symbols of authority and honor. Backs may be rectangular and yoked with splat, a round or horseshoe-shaped back that also forms the arms, or a fretwork back. Back splats may be pierced, carved, or painted or feature decorative panels of marble or porcelain. Trapezoidal or rectangular seats are wood, rattan, or cane and usually are higher than those of European chairs. Stretchers connect the four legs. The front stretcher often is high to raise the feet off cold, damp floors (Fig. 8-5-17).

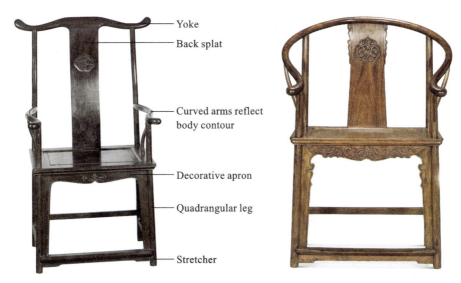

Fig. 8-5-17 Armchair with yoke back and solid splat

专业词汇

Taoism ['tauizəm] 道教
Confucianism [kən'fjuːʃənizəm] 儒家思想
hierarchy ['haiəraːki] 层级、等级
Boxer Rebellion 义和团运动
orientation [ɔːriən'teiʃən] 方向,定向
agrarian [ə'greəriən] 土地的,耕地的
feudal ['fjuːdl] 封建制度的
caravan ['kærəvæn] 旅行队
authority [ɔː'θɒrəti] 权威,权力
prosperity [prɒ'sperəti] 繁荣
warlord ['wɔːlɔːd] 军阀

duality ［djuːæləti］ 二元性
orm 对象关系映射
framework ［ˈfreimwɜːk］ 框架,骨架
axiality 轴对称性
module ［ˈmɒdjuːl］ 模块
silhouette ［ˌsiluˈet］ 轮廓
foundation ［faʊnˈdeiʃn］ 基础
axis ［ˈæksis］ 轴线,轴心
axiality ［ækˈsiɑiləti］ 同轴度、轴对称
terrace ［ˈterəs］ 露台
octagonal ［ɒkˈtægənl］ 八角形
façade 正面
inscription ［inˈskripʃn］ 铭文,碑文
grille ［ɡril］ 格栅
gilding ［ˈɡildiŋ］ 镀金
dimensionality ［dimenʃəˈnæliti］ 维度、幅员
embellished 美化
ebony ［ˈebəni］ 乌木,黑檀
canopy ［ˈkænəpi］ 华盖,遮篷
fretwork ［ˈfretwɜːk］ 浮雕细工,回纹装饰
decorative ［ˈdekərətiv］ 装饰性的
distinctive ［diˈstiŋktiv］ 有特色的
pigment ［ˈpiɡmənt］ 颜料
latticework 格子
coromandel ［kɒrəˈmænd(ə)l］ 乌木
celadon ［ˈselədɒn］ 青瓷花

难句翻译

① Symmetry is very important, but uneven numbering systems based on religion and nature often defines roof layers, details, and spacing. Silhouettes are distinctive, but few stylistic changes appear over time. Landscapes emphasize Taoist qualities such as asymmetrical compositions, empty space, infinity, parts of elements representing the whole, and nature.

对称性是非常重要的。但受宗教与自然的影响屋顶的层次、建筑细节和间隔往往成奇数排列。建筑造型很有特色,但随着时间的推移,风格并无大的变动。景观设计强调道家特色,如不对称构图、留白、无限性、局部代表整体以及自然主义。

② Some rooms have large windows and doors that open to exterior courtyards and gardens. Fretwork and grilles in windows and doors provide openings that integrate interiors with the landscape. Formality and symmetry govern room shapes, the arrangement of doors and windows, and furniture placement.

有些房间开了大窗与阔门直通外面的庭院。门窗上的浮雕与窗格利用开口将室内与室外风景打通。房间形状、门窗安装及家具摆放都谨遵造型与对称要求。

③ Chinese rugs differ in colors, density of patterning, pile density, and motifs from Middle Eastern rugs. Like them, Chinese rugs may be of wool or silk and made of Persian knots with borders around an open field.

But colors are brighter and clearer with much less dense patterns than Middle Eastern rugs.

中式地毯的颜色、图案疏密与毛圈密度都不同于中东地毯。有的中式地毯也用羊毛或丝绸制成并采用波斯节法,其毯缘保留一圈开阔纹样。但中式地毯比中东地毯颜色更鲜明、图案更疏松。

④ Designs reflect boxy forms with limited diversity in visual image. Most furniture is of polished wood or bamboo, but lacquered sets are found in imperial palaces.

家具以方形设计为主且样式较固定。大部分家具由抛光木料或竹料制成,但皇宫中也设有漆制成套家具。

⑤ Carving is common, and painted decoration may appear on important chairs. Stretchers hold legs together on uneven floors. Front stretchers are raised so feet are protected from cold drafts. Stools have four legs or may be cylindrical drums. Couches, also used for sleeping, are large with low backs and arms.

雕饰很常见,主人椅有时会画有装饰。管脚枨保证椅腿在不平整的地面上也能共立。为避免双脚受凉,前枨较高。凳子分为四足凳和鼓凳。可卧的长榻体形较大且椅背与扶手较低。

⑥ The largest and most important building in this compound is the Hall of Supreme Harmony, the ceremonial center of power. Procession to the Hall is along a major north-south axis through a series of gated pavilions that lead to the inner Court.

建筑群中最大型并最重要的建筑是太和殿,这是皇权的仪式中心。通往太和殿的南北向主轴上建有一系列门亭直与内宫相接。

Chinese Architecture（中国建筑）

中国是世界上最古老的文明古国之一。早期深受道教、儒教和佛教的影响,因此其艺术与文化也渗透到建筑中。这三种理念无论是单独提出还是共同叙述,都反映了中国文化视野的独特性。中国传统建筑在设计中注重等级、秩序、对称或不对称的视觉文化与发展层次。到17—19世纪,中国与美国、欧洲之间的贸易活动加强,其建筑形式也融入西方文化的元素,翻开了崭新的篇章。到20世纪末,中国建筑已成为世界建筑中匠心独运的重要组成部分,突显出其特有的文化魅力。

From

Buie Harwood, Bridget May, Curt Sherman. ＜Architecture and INTERIOR DESIGN: an integrated history to the present＞. New Jersey: Pearson Education, 2012.

8.6 Italian Renaissance Architecture(1400—1600)

The **Italian Renaissance** is a return to classicism in culture, art, and architecture. Designers, artists, scholars, patrons, and other influential individuals in the period regard the Renaissance as a new era, separate from the Middle Ages, and a rebirth (**rinascita** in Italian) of classical antiquity. Artists and architects study Roman buildings and strive to compete with and/or surpass the achievements of the ancients. Consequently, the period is extraordinarily creative and produces numerous significant buildings, architects, and artists. Italian architecture, interiors, and furnishings are widely imitated throughout Europe and become foundations

for numerous later stylistic developments.

HISTORICAL AND SOCIAL

Italy in the 15th century is a country of individual republics or city-states. Those around and north of Rome, which are ruled by bankers, merchants, and traders, are extremely prosperous. This affluent, urban, commercial society contrasts with most of Europe, which remains medieval, feudal and rural. It also provides the ideal conditions for renewed interest in the classical past, language, poetry, history, philosophy, and humanism, which values the creative efforts of the individual.

The Renaissance begins in Florence around 1400, where prosperity in trade and banking creates a strong economy with much building activity. Great families, such as the Medici, Pitti, and Strozzi, possess the money and leisure to commission fine homes and great works of art. Their circles foster the study of classicism, which produces enthusiasm for Ancient Roman art and architecture. During the second half of the 15th century, the Renaissance spreads to other cities north of Rome. As in Florence, wealthy and powerful families in Pisa, Milan, Venice, Mantua, and Urbino embrace the Renaissance and extend commissions to artists who have studied or worked in Florence (Fig. 8-6-1).

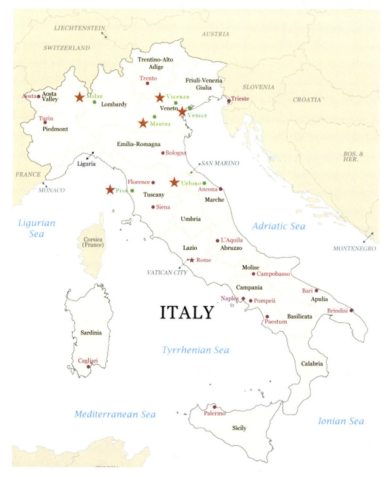

Fig. 8-6-1　Italy map

Despite the favor of great patrons, artists and architects still are regarded as **craftsmen** because their works lack a sound theoretical base. But as they associate with scholars and poets throughout the 15th

century, they come to see themselves also as intellectuals and scientists. The notion of the Renaissance man who distinguishes himself in several arts or in both art and science takes hold. Artists and architects begin to write treatises espousing their ideas and theories. The invention of the printing press in the mid-15th century aids the spread of these works and the conceptual base of the Renaissance throughout Europe.

By the beginning of the 16th century, political turmoil interrupts artistic progress in northern Italy.

The city of Rome becomes the artistic center, where popes and wealthy families commission architecture and works of art. Pope Julius II aspires to transform Rome from a medieval town to a modern ideal city based on classical forms.① He wants to return the city to its former Roman glory. Subsequent popes who are scholars and patrons of the arts continue to support the transformation of the city. During this time, artists are more highly regarded than ever before. The period produces great accomplishments in art and science, as well as a few individual artistic geniuses, such as Leonardo da Vinci, Raphael, and Michelangelo.

Prosperity and progress are short lived, disrupted by the **Protestant Reformation** beginning in 1517, a plague in 1522—1524 that devastates Rome's population, and the sack of Rome in 1527 by Charles V, Holy Roman Emperor. Artists and architects leave Rome for work elsewhere, spreading the Renaissance throughout other parts of Italy and into the rest of Europe.

CONCEPTS

Italian Renaissance design is based on, but does not copy, classical **antiquity**. Designers recognize that centuries separate them from the ancients, so instead of reviving the ancient styles, they aspire to create modem works that vie with or even surpass antiquity. To these ends, they adopt classical language, classical approaches to design, and the direct observation of nature. Architects study and measure extant **Greco-Roman** monuments and **pore** over previously unknown ancient texts, such as **Vitruviu's Ten Books on Architecture** (late 1st century B. C. E.). To emphasize the rational basis of art and architecture, designers use a mathematical design approach coming from linear perspective and composed of simple **proportional** ratios.

MOTIFS

Classical motifs are used extensively as embellishment and include columns, pediments, moldings, the classical figure, **cherub**, swag, rinceau, **rosette**, **scroll**, **cartouche**, and geometric patterns (Fig. 8-6-2, Fig. 8-6-3).

Fig. 8-6-2 Classical motifs: Cherub, Rosette, Scroll

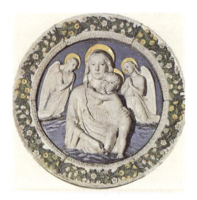

Fig. 8-6-3 Ceiling painting of grotesques & Della Robbia roundel

ARCHITECTURE

Key concepts in architecture are a return to the classical orders, the adoption of classical forms, and a mathematical approach to design. Following Brunelleschi, architects begin to relate the parts of buildings using simple whole-number proportions, usually derived from musical harmonies.② Harmonious proportions and classical elements create a stable, articulate, and rational language for Renaissance architecture. A fundamental design problem for architects throughout the Renaissance is the application of classical elements and forms to nonclassical structures such as churches or chapels.

The most important building types are churches (Fig. 8-6-4), public structures (Fig. 8-6-5), palazzo, and villas. Buildings are often large to impress, but relate to humans in scale, reflecting the humanism of designers and patrons. Classical elements and attributes, such as **symmetry**, regularity, unity proportion, and harmony, are important design principles. Designers carefully articulate parts, which relate to each other and the whole in proportional relationships.

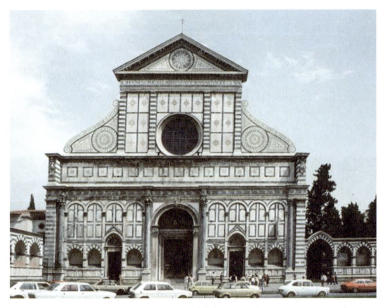

Fig. 8-6-4 S. Maria Novella, Latin cross plan 1278—1350; facade

Structures and plans follow geometric forms—**rectangles**, squares, and circles. Important architectural features include columns, engaged columns, pilasters, arches, pediments, **moldings**, and modillioned cornices.

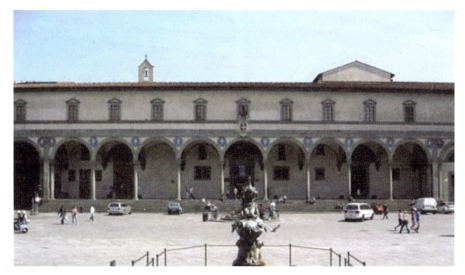

Fig. 8-6-5　Ospedale degli Innocenti (Founding Home), begun 1419; Florence, Italy; Filippo Brunelleschi. Early Renaissance

Designers also use triangular and segmental pediments as decoration.

Early Renaissance (1420—1500)

Filippo Brunelleschi reintroduces the orders in the dome of the Florence cathedral in 1420, thus ushering in the Early Renaissance in architecture. He and others experiment with the orders, proportions, and ancient construction techniques. With the exception of palaces, which retain a fortified appearance, Early Renaissance structures look light visually because of slender architectural elements. Often there is a feeling of tension or awkwardness as designers learn to use classical design principles. Classical details sometimes are used incorrectly, and designers borrow freely from antiquity and the Middle Ages.

High Renaissance (1500—1527)

Following the development of architectural theory, architects have a better understanding of classicism. They begin to experiment with forms and elements but only within the rules of classicism. Numerical ratios and geometric forms dominate designs. Although architects of the High Renaissance use the same vocabulary as those of the Early Renaissance, the feeling is very different, one of balance, repose, rationality, and stability. Architecture emulates, but does not copy, antiquity. Architects tend to fall into two categories: those who follow classical rules and a few who follow Michelangelo inventiveness. Rome is the artistic center of the High Renaissance(Fig. 8-6-6).

Late Renaissance (1527—1600)

No single city dominates the Late Renaissance. Some architects continue to follow High Re-naissance principles(Fig. 8-6-7), while others create a parody of classicism known as Mannerism, in which they deliberately break rules and manipulate classical principles to create confusion and disorder. Classical elements are put together incorrectly or in odd ways. Classical proportions are rejected, and lightness and tension reappear.

Fig. 8-6-6　The details of Ospedale degli Innocenti (Founding Home)

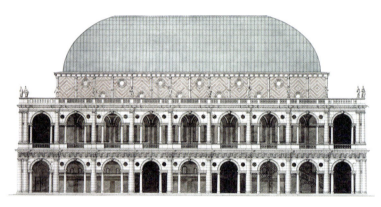

Fig. 8-6-7　Palazzo della Ragione(Basilica),1545—1617;Vicenza,Italy;Andrea Palladio. Late Renaissance

Public Buildings

Site Orientation

Most Renaissance public buildings and urban palaces stand in self-contained isolation and do not reach out to their surroundings.③ Palazzi or palaces face streets or squares in towns and cities such as Florence. Architects design villas individually in rural locales to suit function, site, region, and patron. Palladio introduces functional winged villas with central residential pavilions for Venetian noblemen who occupy and farm land in the countryside. These villa designs consider functional needs of farmers and the landscape for the first time in Western architecture. The Villa Rotunda, best known of Palladio buildings, lacks wings, because it is set upon a hill giving broad vistas from each of its four porticoes.

Floor Plans

The most common church plan is a Latin cross composed of carefully articulated square or rectangular modules. Some architects, beginning with Brunelleschi, experiment with centralized plans but find them unsuitable for the liturgy of most churches. But small memorials, such as the Tempi-etto, or chapels often have centralized plans. Public buildings, such as the Palazzo della Ragiorte in Vicenza, have rectangular, usually symmetrical plans with rooms arranged by function.

Palazzo plans are rectangular with square and rectangular rooms that focus inward to a central courtyard

or **cortile**. Symmetry, although desirable, depends on the site. Interior walls are parallel or at right angles to the facade, and dimensions may be proportionally derived. The most important rooms are on the piano nobile, the first floor above ground level, particularly the sala or main reception room. Facing the street, these lavishly decorated spaces support entertaining and family activities. Rooms for important family members also are on the piano nobile, whereas rooms for lesser family members or servants are on the third floor. The camera (owner's bedroom) usually has a studio, a small private space where the most treasured possessions are kept. The apartment, a series of rooms associated with one person, appears in the late 15th century. Usually arranged in linear sequence, these rooms progress from public to private and from larger to smaller. Most houses have no grand staircases or hallways but do have small passages for servants near the camera and apartments. Shops and family businesses are on ground floors during the Early Renaissance hut are later replaced by service areas.

Materials

Builders use marble, often colored, local stone, or brick for private and public buildings. They do not experiment with concrete like the Romans. The Renaissance does not introduce any new construction techniques, so the most common construction system for churches is arcuated. Dwellings are of local stone or brick. The most common construction system for houses is trabeated. Some lower stories are vaulted.

Church Facades

Classical elements and attributes typify church facades. Although designs vary, two types are common. One has a taller central portion with lower sides, which reflects the interior nave and side aisles, in the traditional manner. Towers are not typical, however. The other is found mostly on High and Late Renaissance church facades, which resemble the gable ends of ancient temples, with triangular pediments supported by arches, pilasters, and engaged columns. Architects use repeating modules and mathematical proportions to create facade compositions. Architectural details evolve from being relatively flat in the Early Renaissance to bolder and more three-dimensional during the High and Late Renaissance. Palladian facades have superimposed temple fronts, monumentality, and strong visual organization by architectural details. Similarly, classical imagery, details, and organization are characteristic of other buildings.

Dwelling Facades

Most palaces and villas are two or three stories high, separated by stringcourses, and capped by a large, prominent cornice. Early Renaissance palaces (Fig. 8-6-8) have heavy rustication on lower stories that become smoother and less deeply cut as it ascends; thereby appearing to lighten on each story.④ High Renaissance palace examples are less heavily rusticated and exhibit more and bolder classical details. Palladio's studies of ancient architecture lead him to believe that Roman houses had been embellished with classical details and temple fronts for dignity and distinction, so he introduces them on his villas (Fig. 8-6-9). Late Renaissance facades exhibit less unity, slender **proportions**, tension, and confusion through studied misuse of classical details.

Windows and doors

Windows and doors on public buildings are arched or rectangular, usually with some embellishment at least arched or rectangular, at least on the main story. In Early Renaissance, the common bifora windows(Fig. 8-6-10) have round arches with colonnettes dividing the lights. High Renaissance windows are pedimented or framed with aedicula adding three-dimensionality. Architect Sebastino Serlio is the first to publish an elaborately articulated **tripartite** window/door form with a centered round arch flanked by rectangular

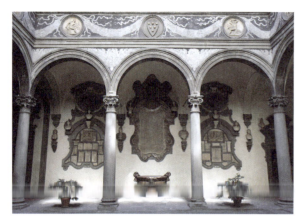
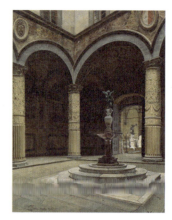

Fig. 8-6-8　Palazzo-Medici-Riccardi and cortile, begun 1444; Florence, Italy; Mechelozzo di Bartolommeo. Early Renaissance

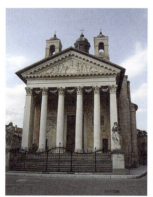

Fig. 8-6-9　Villa Barbaro, c. 1570, from I Quattro Libri dell'architecture (Four Books on Architectute); Palladio; and Sala, 1550s; frescoes by Paolo Veronese. Late Renaissance

openings. Palladio adopts this form for the first time at Palazzo della Ragione, and it becomes known as the **Palladian** window.

Roofs

Roofs on public buildings are gabled and/or domed. Brunelleschi's dome for S. Maria del Fiore (Florence Cathedral) displays the first use of the orders since antiquity. Terra-cotta roof tiles cover the first use of the orders since antiquity. They are used in many public and private buildings. Roofs on dwellings are generally lat or low-pitched and are often hidden behind cornices.

Later Interpretations

Numerous **subsequent** public and private buildings follow Italian Renaissance precepts including those in the Louis XIV, Baroque, Early Georgian, American Georgian, Late Georgian, Renaissance Revival (Fig. 8-6-11), Beaux-Arts, Colonial Revival, and Post Modern periods.

INTERIORS

Interior unity becomes important during the Renaissance particularly because artisans and craftsmen of various trades work in a common vocabulary that of classicism.⑤ Few Renaissance architects design entire interiors. They occasionally work out a general concept and design a few details, such as chimneypieces, but for the most part, they leave interiors to artisans. Architectural treatises discuss interior planning and illustrate details, but do not focus on entire rooms. Most interior rooms are regular and rectangular, reflecting the

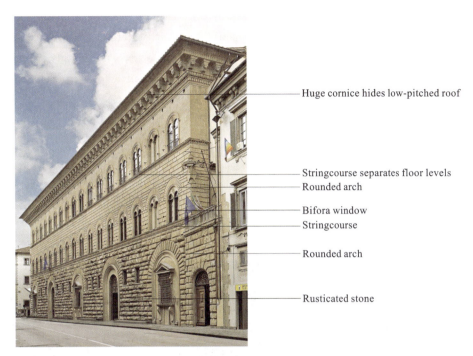

Fig. 8-6-10　Palazzo-Medici-Riccardi

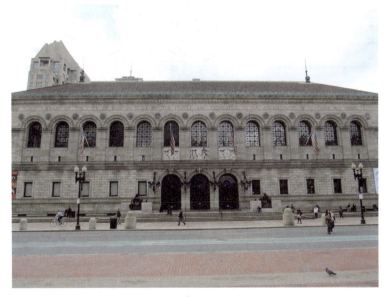

Fig. 8-6-11　Later Interpretation: Boston Public Library, 1887—1893; Boston, Massachusetts; McKim, Mead, and White. Renaissance Revival

orderly arrangement of the exterior. Designs of large architectural surfaces—walls, floors, and ceilings—usually relate to one another and feature classic detailing. Unified and often lavishly decorated, domestic interiors are sparsely furnished. Grotesques, which are Renaissance interpretations of colorful wall decorations of temples, figures, flowers, and classical details found in Roman interiors, are an important introduction. Beginning in the 14th century, artists begin to study the few ancient Roman interiors available to them. Most of these sites are underground, so they coin the term grotesques, meaning derived from grottoes, to describe the ancient paintings they find on walls and ceilings. Widely published, grotesques appear in paintings, interiors, and on furniture throughout the 15th and 16th centuries.⑥

Church interiors follow traditional patterns and are symmetrical, regular, formal, and majestic. Carefully planned spatial and proportional relationships are often mathematically derived with appropriate adjustments made in height and width. Early Renaissance spaces are light in scale and simply treated. In the Early Renaissance, nave arcades are often composed of round arches mounted atop slender columns. Later, large piers carry nave arcades.

Public and Private Buildings

Color

Interior color comes from construction materials and fresco paintings in public and private buildings(Fig. 8-6-12). In residences, textiles and wallpapers give color to domestic spaces. Typical colors include scarlet, cobalt blue, gold, deep green, and cream.

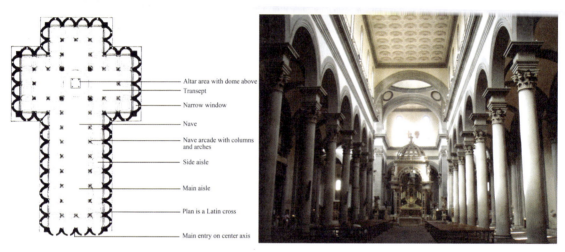

Fig. 8-6-12　Nave and plan, Santo Spirito, begun 1434 by Filippo Brunelleschi and completed 1481 by others; Florence, Italy. Brunelleschi never completed the facade, which is plain and unadorned. Early Renaissance

Floors

Stone or tile floors are common in both public and private buildings. Brunelleschi uses different colors of stone to define interior modules on floors in his churches. Tiles and bricks commonly cover floors, with herringbone being the most favored pattern. Some tiles have inlaid or relief patterns in contrasting colors. The best rooms featuring marble or terrazzo-wood in boards or patterns is most common on upper floors. During the 16th century, floor designs often correspond to ceilings. Knotted pile rugs, imported from Spain or the Near East, cover floors and tables. Natural fiber matting usually is used on floors in summer.

Walls

Walls in public and some private buildings display a classical organization that includes a dado, fill, and entablature or cornice. These elements correspond to the base, shaft or center portion, and capital or cornice of ancient columns and pedestals. Walls may be plain or embellished with painted trompe l'oeil decoration. During the Early Renaissance, some churches have sedate color schemes often of white with architectural details in pietra serena, a grey stone, after the manner of Brunelleschi. Michelangelo uses a similar scheme in the vestibule of the Laurentian Library to accentuate important architectural details, emphasizing the height and narrowness of the space and increasing its feelings of tension and uneasiness. In the Late Renaissance, Palladian churches are mostly white, relying on the architectural elements and details, spatial and architectural

relationships, and light for interest. Many Renaissance churches have elaborate frescoes, sculptures, and decoration added to them over the years.

Domestic walls may be plain stone or plaster or have architectural details, such as pilasters. Common treatments include paneling, painting, and textiles. Wood paneling either is plain, inlaid, or painted(Fig. 8-6-13). Plastered walls have at least a white or colored wash. Frescoes in repeating patterns, imitations of textiles or marble, trompe I'oeil architecture, or actual textile hangings cover the walls in important rooms. Palaces and villas often have elaborate frescoes, executed by important artists such as Veronese. Fresco compositions are often allegorical depictions of the owners' virtues or accomplishments surrounded by trompe I'oeil architectural details and sculpture. Small panels of printed paper or larger panels of engravings sometimes are applied to walls for embellishment, although actual wallpaper develops later.

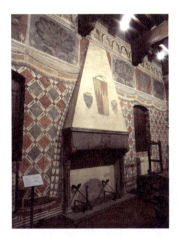 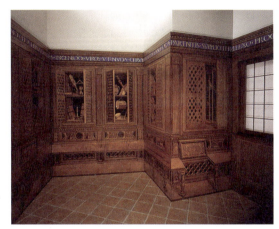

Fig. 8-6-13 The old fireplace design

Fireplaces are a focal point for decoration. Flat pyramids or **wedge-shaped** hoods replace earlier conical ones because the former are easier to decorate. **Embellishment** includes cornices, moldings, and coats of arms. Hoods disappear by the 16th century, and mantel decoration becomes more architectural with columns or pilasters, architrave, frieze, and cornice.

Windows and Doors

At windows, shutters block light and heat and give privacy so curtains are very rare in dwellings. Windows have plain surrounds but some have moldings and entablatures. As important decorative features, doors are carved, inlaid, painted, or surrounded by aedicula. Portieres of plain or embroidered cloth or woven tapestries hang at very grand doorways.

Ceilings

Most interiors in public buildings and some private ones have groin or barrel-vaulted ceilings. Nave ceilings in churches are high to accommodate windows; some, especially in the Early Renaissance have flat and coffered ceilings with vaulted side aisles. Crossings are usually domed.

Ceilings in churches and other public buildings may be plain, have coffers or compartmentalized ceiling paintings, or feature painted trompet'oeil decoration.

Ground-floor ceilings in private buildings are usually vaulted. Those on upper floors either are beamed with large supporting corbels, revealing the joists of the floor above, or are covered by compartments or coffers. Painting, gilding, or carving decorate both types. By the second half of the 16th century, frescoes dominate ceiling decoration, and wall, floor, and ceiling decorations relate to one another.

Textiles

Interiors display a variety of domestic and imported fabrics at doorways, on walls and furniture, as canopies and bed hangings, and, occasionally, as window treatments.⑦ Silk in plain and damask weaves or stripes is a luxury fabric especially when woven with gold or silver threads. The affluent proudly display their costly fine linens from France and Flanders on tables and the best beds. Many types of plain and patterned woolens cover walls and some furniture. Woolen bed hangings are used in winter. Cottons, made locally or imported from India and the Near East, replace other fabrics in summer. Lace, needlework, and leather may be used on walls, for trim, or as upholstery.

Armchairs and side chairs have velvet or leather seats and decorative panels between the back uprights. Some seat covers, cushions, and coverlets are made of tapestries. Bed hangings provide privacy and warmth.

Lighting

Interiors in public and private buildings are usually dark both night and day. Torches, candles, and chandeliers provide some illumination in public buildings. In dwellings, candles and firelight give minimal illumination at night, so rooms have strong colors and furnishings with high reliefs and shiny surfaces. Fixtures, such as **candleholders**, floor stands, and wall sconces, are made of wood, iron, brass, and bronze. Candlesticks and candelabra may be placed on a table or put in a stand or ornament. Chandeliers and oil lamps are rare in dwellings(Fig. 8-6-14).

Fig. 8-6-14　Lighting: Torchiera, candelabrum, candlestick

FURNISHINGS AND DECORATIVE ARTS

Furniture is rectilinear and massive with classical treatment and proportions. Classical details, such as columns or pediments, first appear on church furniture and later spread to domestic examples. The most common decorations are carving, turning, inlay, painting, and gilding. Early Renaissance furniture is simple with sparse carving in low relief or inlay. High Renaissance furniture is grander and more influenced by architecture. Late Renaissance furniture derives many concepts from Michelangelo, particularly his love of figures, exaggerated scale, and unusual architectural motifs. High-relief carving dominates, while classical proportions and purity of ornament decline.

Public and Private Buildings

Materials

Walnut is the main wood, but oak, cedar, and cypress also are used. Some stools are made of iron. Construction gradually increases in complexity. Inlay may be of wood (intarsia) or other materials, such as certosina, an inlay of **ivory** or bone in geometric patterns.

Seating

Common seating pieces include the **sedia**, [a box_shaped arm chair with runners] folding chairs of X-form (Fig. 8-6-15) like Savonarola, ladder-backs with rush seats, and the sgabello or stool chair used for dining (Fig. 8-6-16). Armchairs and side chairs have quadrangular or turned legs with side runners terminating in lion's heads. Back legs form the back uprights, and front arm posts form the front legs. Some have carved stretchers beneath the seat. Other seating includes stools, benches, and the cassapanca (Fig. 8-6-17), a long wooden bench with a seat and back and storage beneath the seat. Introduced in the mid-15th century in Florence, the cassapanca is sometimes placed on a dais at the end of a room to emphasize importance.

Fig. 8-6-15　Folding X-Chair or Savonarola; 15th century; Florence, Italy. Named for Savonarola, a monk

Tables

Tables include long, narrow, oblong trestle tables for dining (Fig. 8-6-18), tables with marble or pietra dura tops, folding tables, and small tables similar to box stools. Small side tables or sideboards help with meal service. A carved or arcaded horizontal stretcher connects dining table trestles, and some tables with rectangular tops have richly carved slab ends like Ancient Roman examples.

Storage

Cassones or chests (Fig. 8-6-19), used for storing possessions and seating, are the most important storage pieces and come in various shapes and sizes. Design and decoration vary according to intended use, such as wedding gifts, and wealth. Some have cartouches carved with the owner's coat of arms or initials. Large ones may rest on animal feet. Chests of drawers are introduced at the end of the 16th century. A variation is the credenza, an oblong cupboard with drawers in the frieze and doors beneath separated by a narrow panel or pilaster.

Fig. 8-6-16　Sgabello, 16th century

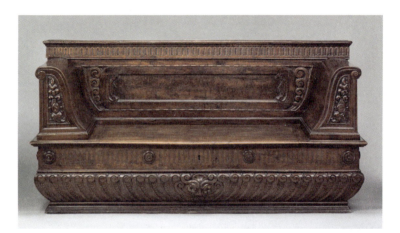

Fig. 8-6-17　Casapanca, 15th century

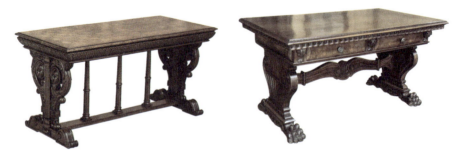

Fig. 8-6-18　Table, 16th century

Beds

Beds include the lettiera, which has a high headboard and rests on a platform made of or surrounded by three chests; four-poster beds, and simple boards with legs like those of the Middle Ages. Bed hangings, which

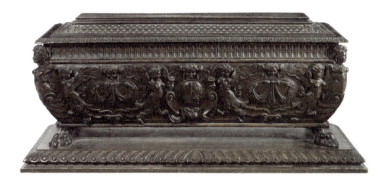

Fig. 8-6-19 Cassone, 16th century

are often elaborate, provide privacy and warmth. Before poster beds become common during the 15th century, hangings are suspended from hooks, rods, or a dome attached by a cord to the ceiling.

Decorative Arts

Most mirrors are of polished steel until the 16th century, when Venice begins producing small glass mirrors. By 1600, most room have at least one print or painting. Decorative objects and informal dinnerware are made of Italian maiolica, tin-glazed earthenware. The Della Robbia family in Florence makes the most outstanding maiolica, producing monochromatic and colorful devotional reliefs and decorative tiles of religious figures, fruits, and flowers. Della Robbia ornament appears both on exteriors and in interiors. Italians also highly prize Chinese porcelain and try to reproduce it. Among the most notable attempts to make porcelain is the Medici porcelain made in Florence between 1575 and 1585.

DESIGN SPOTLIGHT

Architecture

Designed by Donato Bramante and the first important example of the High Renaissance, this small, centrally planned **shrine** where S. Peter was supposedly crucified is one of the most influential buildings in architectural history. Bramante's design incorporates classical elements such as a dome, balustrade, and tuscan columns and classical attributes such as stability, clarity, and repose. It follows Vitru-vian concepts for proportional relationships and imitates Roman (and Greek) temples. The conical form is one of the most visually stable because it is larger at the base. The simple Tuscan columns lead the viewer's eye upward to the entablature where motifs of the papacy compose the **frieze**. The balusters above and the ribs of the dome continue to lead the eye upward to the apex of the dome, which is topped by a cross. Although small in size, the building appears monumental due to its geometric form, restrained ornament, and classical elements and attributes. In the manner of the High Renaissance, the Tempietto demonstrates Alberti's definition of beauty in which "harmony and concord of all the parts achieved in such a manner that nothing could be added, taken away or altered except to worsen"[8] (Fig. 8-6-20).

DESIGN SPOTLIGHT

Furniture

Armchairs are rare before the 16th century, but by the end of the century, they are used in most rooms,

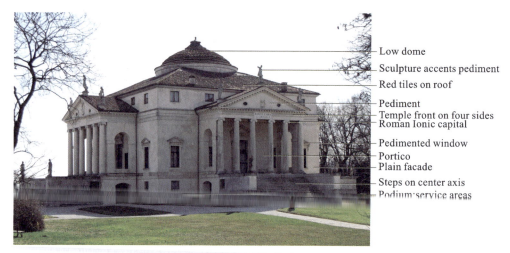

Fig. 8-6-20　Villa Rotunda, 1565—1569; Vicenza, Italy; Andrea Palladio. Late Renaissance

although not in great numbers. Some grand dining spaces have sets of armchairs. Size denotes high status-the larger the chair, the higher the sitter's status. Arm supports and front legs may be quadrangular or turned. Runners and/or stretchers may connect legs. Sometimes beneath the seat is an elaborately carved stretcher. Leather or fabric backs and seats may be trimmed with fringe and attached with nails. Decoration, usually carving, becomes more elaborate as the period progresses (Fig. 8-6-21).

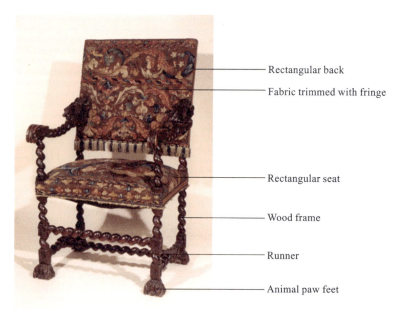

Fig. 8-6-21　Sedia, 15th—16th centuries

DESIGN SPOTLIGHT

Architecture and Interior

Designed by Andrea Palladio and completed after his death, the Villa Rotunda is his most famous work and his only freestanding pavilion. It was built as a country retreat for entertaining, not farming, so it lacks the winged appendages common to Palladian working farms. Appearing as a visual monument, the house is

situated on a hill with views of surrounding farmlands from the four porticoes. The plan features bilateral symmetry defined by internal passageways connecting the four porticoes, which are adapted from Roman temples and have statues of classical deities on the ends and apexes. Entrance to each portico is by a flight of steps in the Roman manner, and the temple fronts are the central elements of the tripartite facades. Walls are smooth stucco over brick instead of stone for economy. Pedimented windows identify the piano nobile with smaller windows on the basement and upper story. Broad stringcourses separate the stories and continue as the cornice and bases of the porticoes. Vincenzo Scamozzi com-pletes the large dome crowning the composition after Palladio's death, so it is lower than Palladio intended.

Like most Palladian villas, this one has a symmetrical plan with rectangular or square rooms (occasionally round or apsidal) arranged around a large dominant sala rotunda, as here. Proportional room dimensions are calculated using numerical ratios derived from harmonic relationships in Greek musical scales. In the Villa Rotunda, the central rotunda serves as a circulation space leading to square and rectangular rooms primarily used for entertaining. Palladio commonly places service areas in wings (also called pavilions) or below ground as here in the Villa Rotunda. The service areas in the raised basement of the villa make the building appear smaller than it actually is.

Although Palladio's intentions for the interiors are not known, Paolo Americo, the owner, commissions Giovanni Battista Maganzia and Anselmo Canera to adorn the four principal salons and central circular hall or rotunda with allegorical frescoes on walls and ceilings and add bold stucco work around doors and on ceilings. In the rotunda, trompe I'oeil columns frame classical figures and carry an entablature. Above a balustraded balcony, the dome soars upward to the cupola. Open arches provide entrances to the main salons, and smaller doors surrounded by aedicula lead to the staircases(World Heritage Site)(Fig. 8-6-22).

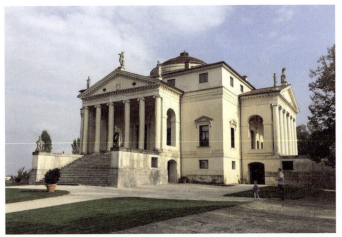
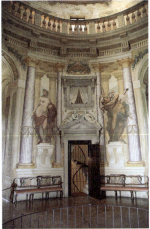

Fig. 8-6-22　Villa Rotunda, floor plan, and central hall

DESIGN SPOTLIGHT

Textiles

Textiles, more expensive than furniture, include brocades, velvets, taffetas, damasks, and brocatelles. The most common are domestic and imported woolens. Ogeerepeat patterns with stylized flower and fruit designs are the most common, usually woven in deep reds, golds, blues, and greens. Important textile factories are in Lucca, Genoa, and Palermo. Royalty and the affluent in other European countries highly prize Italian textiles,

which are a luxury item. Exporting textiles brings Italy great prestige and wealth (Fig. 8-6-23).

Fig. 8-6-23　Textiles

专业词汇

Renaissance　['renəsɑːns]　文艺复兴
Italy　['itəli]　意大利
rinascita　再生
craftsman　['krɑːftsmən]　工匠，手艺人
Protestant Reformation　新教改革
apsidal　['æpsidl]　拱点的，半圆形室的
Greco-Roman　希腊罗马式
scroll　[skrəul]　画轴
cartouche　[kɑːtuːʃ]　涡旋装饰
Maiolica　[məjɒlikə]　马爵利卡陶
antiquity　[ænˈtikwəti]　古老、古迹
trompe　[trɒmp]　水风筒
certosina　[ˌtʃəːtəˈsiːnə]　镶嵌术
cassone　意大利大箱
sedia　椅子
sgabello　五彩拉毛粉饰
cortile　中庭，内院
embellishment　[imˈbeliʃmənt]　装饰
cherub　['tʃerəb]　小天使
rosette　[rəuˈzet]　玫瑰花结
proportion　[prəˈpɔːʃn]　比例
geometric patterns　几何图案
pore　[pɔː(r)]　细看
modillion　[məˈdiljən]　飞檐托饰
Vitruvian's Ten Books on Architecture　维特鲁威《建筑十书》
rectangle　['rektæŋgl]　长方形
molding　['məuldiŋ]　凸凹型

Palladian　帕拉迪奥建筑型
tripartite　[traɪˈpɑːtaɪt]　三重的
subsequent　[ˈsʌbsɪkwənt]　后来的，随后的
wedge-shaped　楔形
candleholders　[ˈkændəlˌhəʊldə(r)]　烛台
ivory　[ˈaɪvəri]　象牙
shrine　[ʃraɪn]　圣坛
frieze　雕带,(墙顶的)饰带

难句翻译

① The city of Rome becomes the artistic center, where popes and wealthy families commission architecture and works of art. Pope Julius Ⅱ aspires to transform Rome from a medieval town to a modern ideal city based on classical forms.

罗马市成为艺术中心，教皇与豪门为建筑和艺术作品慷慨解囊。教皇尤里乌斯二世致力于按照古典形式将罗马从一个中世纪城镇改造成理想的现代城市。

② Key concepts in architecture are a return to the classical orders, the adoption of classical forms, and a mathematical approach to design. Following Brunelleschi, architects begin to relate the parts of buildings using simple whole-number proportions, usually derived from musical harmonies.

建筑的主要概念包括回归古典秩序、应用古典结构和依数理设计。建筑师们跟随布鲁内列斯基的脚步开始按照简单的整比来设计建筑局部，比例通常源于音乐的和谐性。

③ Most Renaissance public buildings and urban palaces stand in self-contained isolation and do not reach out to their surroundings.

大多数文艺复兴时代的公共建筑与市内宫殿都孑然独立，不与周边发生关系。

④ Most palaces and villas are two or three stories high, separated by stringcourses, and capped by a large, prominent cornice. Early Renaissance palaces (Fig. 8-6-8) have heavy rustication on lower stories that become smoother and less deeply cut as it ascends; thereby appearing to lighten on each story.

大多数宫殿或别墅高两到三层，由层拱相区隔，顶着巨大宏伟的飞檐。早期文艺复兴宫殿底层砌着粗琢的石料，随着层数的升高石面变得更光滑平整，显得建筑越往上越轻盈。

⑤ Interior unity becomes important during the Renaissance particularly because artisans and craftsmen of various trades work in a common vocabulary that of classicism.

文艺复兴时期内装的整体性变得尤其重要，这是由于不同行业的艺匠们受到通行的古典主义思潮影响。

⑥ Beginning in the 14th century, artists begin to study the few ancient Roman interiors available to them. Most of these sites are underground, so they coin the term grotes wes, meaning derived from grottoes, to describe the ancient paintings they find on walls and ceilings.

14世纪初艺术家开始研究可接触到的少数古罗马内部装饰。大多数遗址都在地下，所以建筑师们常用"grotes wes"来形容他们从墙壁与天花板上找到的古画，意思是"洞里来的"。

⑦ Interiors display a variety of domestic and imported fabrics at doorways, on walls and furniture, as canopies and bed hangings, and, occasionally, as window treatments.

玄关、墙面和家具的装饰使用了各种国产或进口布料制成的天篷、床幔还有部分窗饰。

⑧ In the manner of the High Renaissance, the Tempietto demonstrates Alberti's definition of beauty in which "harmony and concord of all the parts achieved in such a manner that nothing could be added, taken away or altered except to worsen".

处在文艺复兴高潮,礼拜堂体现了阿尔贝蒂的美学定义,其"不同部分的相互和谐与协调达到了极致,增一分则多、减一分则少"。

Italian Renaissance Architecture(意大利文艺复兴建筑)

意大利文艺复兴建筑在城市广场、园林等方面都取得了成就;多种建筑理论著作相继问世;大穹顶首次采用古典形式,打破了天主教堂的建筑构图手法。著名的建筑有罗马圣彼得大教堂,罗马的法尔尼府邸、圆厅别墅等。

From

Buie Harwood, Bridget May, Curt Sherman. ＜Architecture and INTERIOR DESIGN: an integrated history to the present＞. New Jersey:Pearson Education,2012.

单元词汇总结

Color:	Vibrant green;Plain;Ivory;Scarlet;Cobalt blue;Gold;Deep green;Cream;Sedate color;Celadon
Patterns:	Heraldic device;Attenuated;Rocaille;Cartouche;Medallion;Swirls;Axiality;Asymmetrically;Apsidal;Cartouche;Cherub;Rosette;Geometric patterns;Scroll;Modillion;Garland;Scroll;Cartouche;Geometric;Herringbone;Horseshoe;Module;Fretwork;Latticework;Ornament
Shape:	Lozenge;Curvilinear;Oval;Molding;Melon shape;Octagonal;Wedge shape;Grotesque;Oblong;Horizontal;Vertical;Rectangular
Material:	Foliage;Ormolu;Mosaic;Tile;Terrazzo;Marble;Ferroconcrete;Ebony
Wall decoration:	Tapestry;Veneer;Frieze;Dado;Plaster;curtain wall;Treatment;Paneling;Textile
Interior:	Cloister;Fireplace;Armoire;Parquet;Ceramic;Candleholder;Balustrade;Staircase;Grille
Structure:	Arch;Portal;Buttress;Pointed arch;Rib vault;Triforium;Round arches Pilaster;Jamb;Clerestory;Quoin;Stringcourse;Bracket;Apsidal;Fusuma;Verandah;Ventilation;Molding;Trabeate
Style:	Romanesque;Gothic;Exoticism;Asymmetrical style;Chinoiserie;Rococo;Greco-roman;Byzantium
Concept:	Evangelism;Feudalism;Medieval chivalry;International movement;Ideology;Protestant Reformation;Buddhism;Shinto
Building:	Monastery;Castle;Manor House;Constantinople;Mosque;Hypostyle;Shrine;Cloister;Pediment;Modillion;Apsidal;Vestibule;terrace;corridor

Furniture:	Inlay; Cabinetmaker; Apron; Cabriole leg; Whorl foot; Silk; Linen; Wardrobe; Tatami; Lacquer; Porcelain; Imari; Villa; Trompe; Canopy
Fabric:	Damask; Velvet
Roof:	Hipped; Mansard; Cupola

参考文献

[1] 明兰. 艺术设计专业英语[M]. 北京:清华大学出版社,北京交通大学出版社,2011.

[2] 谭淑敏. 艺术设计专业英语教程[M]. 4版. 北京:电子工业出版社,2015.

[3] Buie Harwood, Bridget May, Curt Sherman, Architecture and Interior Design: an integrated history to the present. New Jersey: Pearson Education, 2012.

[4] http://architect.architecture.sk/

[5] http://www.artic.edu/research/louis-sullivan-collection

[6] http://www.archdaily.com/91273/ad-classics-jewish-museum-berlin-daniel-libeskind/

[7] https://en.wikipedia.org/wiki/Daniel_Libeskind

[8] https://en.wikipedia.org/wiki/Frederick_Law_Olmsted

[9] https://en.wikipedia.org/wiki/Central_Park

[10] https://en.wikipedia.org/wiki/Frank_Gehry

[11] https://en.wikipedia.org/wiki/Millennium_Park

[12] 世界建筑导报, World Architecture Review

[13] http://photo.zhulong.com/proj/detail33740.html

[14] https://en.wikipedia.org/wiki/Kongjian_Yu

[15] http://www.landezine.com/index.php/2012/07/zhongshan-shipyard-park-by-turen-scape/

[16] http://www.todafu.co.jp/eng/yoshiki_toda/index.html

[17] http://www.todafu.co.jp/eng/works/place/china/138.html

[18] http://www.georgenelson.org/georgenelsonbiography.html

[19] http://www.homeportfolio.com/Designers/Details/29494/kelly-hoppen

[20] https://en.wikipedia.org/wiki/Kelly_Hoppen

[21] https://en.wikipedia.org/wiki/Philippe_Starck

[22] https://en.wikipedia.org/wiki/Andr%C3%A9e_Putman

[23] https://en.wikipedia.org/wiki/CAPC_mus%C3%A9e_d%27art_contemporain_de_Bordeaux

[24] https://en.wikipedia.org/wiki/Leonardo_da_Vinci

[25] https://www.nationalgallery.org.uk/artists/claude-monet

[26] https://www.nationalgallery.org.uk/artists/vincent-van-gogh

[27] https://en.wikipedia.org/wiki/Pablo_Picasso

[28] http://www.dali.com/about-us/about-salvador-dali/

[29] https://en.wikipedia.org/wiki/Michelangelo

[30] https://en.wikipedia.org/wiki/Auguste_Rodin

Furniture:	Inlay; Cabinetmaker; Apron; Cabriole leg; Whorl foot; Silk; Linen; Wardrobe; Tatami; Lacquer; Porcelain; Imari; Villa; Trompe; Canopy
Fabric:	Damask; Velvet
Roof:	Hipped; Mansard; Cupola

参考文献

[1] 明兰. 艺术设计专业英语[M]. 北京:清华大学出版社,北京交通大学出版社,2011.

[2] 谭淑敏. 艺术设计专业英语教程[M]. 4版. 北京:电子工业出版社,2015.

[3] Dule Harwood, Bridget May, Curt Sherman, Architecture and Interior Design: an integrated history to the present. New Jersey: Pearson Education, 2012.

[4] http://architect.architecture.sk/

[5] http://www.artic.edu/research/louis-sullivan-collection

[6] http://www.archdaily.com/91273/ad-classics-jewish-museum-berlin-daniel-libeskind/

[7] https://en.wikipedia.org/wiki/Daniel_Libeskind

[8] https://en.wikipedia.org/wiki/Frederick_Law_Olmsted

[9] https://en.wikipedia.org/wiki/Central_Park

[10] https://en.wikipedia.org/wiki/Frank_Gehry

[11] https://en.wikipedia.org/wiki/Millennium_Park

[12] 世界建筑导报, World Architecture Review

[13] http://photo.zhulong.com/proj/detail33740.html

[14] https://en.wikipedia.org/wiki/Kongjian_Yu

[15] http://www.landezine.com/index.php/2012/07/zhongshan-shipyard-park-by-turen-scape/

[16] http://www.todafu.co.jp/eng/yoshiki_toda/index.html

[17] http://www.todafu.co.jp/eng/works/place/china/138.html

[18] http://www.georgenelson.org/georgenelsonbiography.html

[19] http://www.homeportfolio.com/Designers/Details/29494/kelly-hoppen

[20] https://en.wikipedia.org/wiki/Kelly_Hoppen

[21] https://en.wikipedia.org/wiki/Philippe_Starck

[22] https://en.wikipedia.org/wiki/Andr%C3%A9e_Putman

[23] https://en.wikipedia.org/wiki/CAPC_mus%C3%A9e_d%27art_contemporain_de_Bordeaux

[24] https://en.wikipedia.org/wiki/Leonardo_da_Vinci

[25] https://www.nationalgallery.org.uk/artists/claude-monet

[26] https://www.nationalgallery.org.uk/artists/vincent-van-gogh

[27] https://en.wikipedia.org/wiki/Pablo_Picasso

[28] http://www.dali.com/about-us/about-salvador-dali/

[29] https://en.wikipedia.org/wiki/Michelangelo

[30] https://en.wikipedia.org/wiki/Auguste_Rodin

[31]　https://www.pinterest.com/19klida47/yayoi-kusama/
[32]　https://en.wikipedia.org/wiki/Anish_Kapoor
[33]　https://en.wikipedia.org/wiki/Millennium_Park
[34]　http://history-of-animation.webflow.io/
[35]　https://en.wikipedia.org/wiki/Walt_Disney
[36]　https://thewaltdisneycompany.com/
[37]　http://www.biography.com/people/walt-disney-9275533#disneyland
[38]　http://www.justdisney.com/walt_disney/biography/long_bio.html
[39]　https://en.wikipedia.org/wiki/Hayao_Miyazaki#Filmography
[40]　https://en.wikipedia.org/wiki/The_Wind_Rises
[41]　http://www.imdb.com/name/nm0594503/bio
[42]　https://en.wikipedia.org/wiki/Studio_Ghibli#Name
[43]　https://en.wikipedia.org/wiki/Digital_art
[44]　https://en.wikipedia.org/wiki/Nam_June_Paik
[45]　http://www.paikstudios.com/
[46]　https://en.wikipedia.org/wiki/Maurice_Benayoun
[47]　https://www.guggenheim.org/artwork/artist/bill-viola
[48]　https://www.guggenheim.org/artwork/4392
[49]　https://www.guggenheim.org/artwork/4390
[50]　https://www.guggenheim.org/artwork/10594
[51]　https://en.wikipedia.org/wiki/Bill_Viola
[52]　https://en.wikipedia.org/wiki/Arne_Jacobsen
[53]　https://en.wikipedia.org/wiki/Eero_Saarinen
[54]　https://en.wikipedia.org/wiki/Charles_and_Ray_Eames
[55]　http://www.eero-aarnio.com/23

致 谢

我深深感谢我所在的华中科技大学建筑与城市规划学院的同事、朋友和学生,他们为这本书提供了非常好的建议,并奉献了时间和精力。感谢华中科技大学出版社彭中军老师及多位编辑为文章的梳理给予的修改意见,没有他们的细心工作,本书也不能够顺利出版。特别感谢我的合作者白歌乐,她在翻译难句中付出了努力,她的认真仔细的工作态度让我钦佩。感谢汤佳、白雨、汤若濛、吴雅娴、肖璐瑶、荣升、呼泽亮等同学,他们在校对课文中付出了辛勤的劳动。感谢曾经帮助过我的人,以及在书中被收录参考的论著作者。希望本书为艺术设计专业的同学提供更为广泛的学习思路。

ACKNOWLEDGEMENTS

I extend my deepest appreciation to the colleagues in Architecture and Urban planning School at the Huazhong University of Science and Technology (HUST), as well as many friends and students. They provide many constructive suggestions and offer their precious time and energy. Thanks editor Mr. Peng Zhongjun and several others from HUST Press for their revised suggestion in the books organization. Without their meticulous work, the book cannot be published smoothly. Especial thanks should be contributed to my cooperator Ms. Bai Gele who has paid great efforts in translating difficult sentences; Thanks Tang Jia, Bai Yu, Tang Ruomeng, Wu Yaxian, Xiao Luyao, Rong Sheng, Hu Zeliang for their arduous labour in the collation. Thanks all persons who once offered help and the authors of the books included in the references. We are looking forward to the book providing more extensive learning ideas for art design majors.